The Annual of the American Institute of Graphic Arts **Graphic Design USA:** 8

The Annual of the American Institute of Graphic Arts

Written by Andrea Codrington, Michael Dooley,
Steven Heller, and Martha Scotford
Designed by Beth A. Crowell, Cheung/Crowell Design
Production by Mark F. Cheung, Cheung/Crowell Design
Jacket designed by Eric Baker, Eric Baker Design
 Associates, Inc.
Marie Finamore, Managing Editor

Distributed to the trade by Watson-Guptill Publications,
1515 Broadway, New York, NY 10036.

ISBN 0-8230-7232-0

First printing, 1998.

Distributed outside the United States and Canada by
Hearst Books International, 1350 Avenue of the Americas,
New York, NY 10019.

Printing: Syl, Barcelona, Spain
Color Separation: Syl, Barcelona, Spain
Paper: Creator Silk 135 gsm
Page layouts were composed in Adobe QuarkXPress
3.32r.5 on a Power Macintosh 8100/80.
Typefaces: Gill Sans and Janson

Contents

The AIGA Building Campaign

We would like to thank those individuals and corporations who have contributed to the renovation and restoration of the AIGA's new home at 164 Fifth Avenue, through either the building campaign or the Patrons' Endowment Fund. As of August 15, 1997, we have pledges totaling over $700,00. The campaign will continue through the end of 1998, in order to complete the renovation.

Friends $1,000+

Allworth Press
Charles Spencer Anderson
Art Center College of Design
Eric Baker Design Associates
Merrill Berman
Bernhardt Fudyma Design Group
Roger Black
Bruce Blackburn
R. O. Blechman
David Boorstin Associates
Roger Cook
Cooper Union
Paul Davis
Kenneth & Patricia Doherty
Lou Dorfsman
William Drenttel
Hugh Dubberly
John M. DuFresne
Lois Ehlert
Nancy and Joseph Essex
Stephen Frykholm
Arch Garland
Howard Glener
Roz Goldfarb
Peter Good
Robert M. Greenberg
Richard Grefé
Carla Hall
Sylvia Harris
Jessica Helfand
Cheryl Heller
Jerry Herring
Jennifer Howard
Heidi Humphrey
JMK/Wynn Medinger
Richard Koshalek
David Leigh
Sheila Levrant de Bretteville
Leo Lionni
Lippincott & Margulies Inc.
Ellen Lupton
Michael Mabry Design, Inc.
Judith A. Majher
Anthony McDowell
James Miho
Mohawk Paper Mills
Jennifer Morla
John D. Muller

Murphy Design Inc.
Janou Pakter
Arthur Paul
Chee Pearlman
Grant Pound
Paul Rand
Red Ink Productions
David Rhodes
Silas H. Rhodes
Robert Miles Runyan
Karen Salsgiver
Paula Scher
Shapiro Design Associates Inc.
Paul Shaw
Lucille Tenazas
Think Corporation
Bradbury Thompson
George Tscherny
Clare Ultimo Inc.
Véronique Vienne
Wiggin Design Inc.
Fo Wilson
Henry Wolf
Allen Woodard
Richard Saul Wurman

Contributors $3,000+

Adams/Morioka
BlackDog
Doug Byers
Bob Callahan Design
Margo Chase
Mark Coleman
Concrete [The Office of Jilly Simons]
Concrete Design Communications, Inc.
Michael Cronan
James Cross
David Cundy
Joe Duffy
Joseph and Susan Feigenbaum
Martin Fox
Georgia-Pacific Papers
Hornall Anderson Design Works, Inc.
Kent Hunter
Meyer Design Associates, Inc.
J. Abbott Miller
Milocraft, Inc.
Monadnock Paper Mills, Inc.
Elizabeth O'Keefe
Poulin + Morris
Wendy Richmond
Dugald Stermer
Vanderbyl Design Inc.

Donors $5,000+

Primo Angeli
Bass/Yager & Associates
Carbone Smolan Associates
Richard Danne & Associates

Graffito/Active8
Diana Graham
Hansen Design Company
Hawthorne/Wolfe
Steven Heller
The Hennegan Company
Alexander Isley
Karen Skunta
Sussman/Prejza & Co., Inc.
Typogram, Inc.
Wechsler & Partners, Inc.
Weyerhaeuser

Sponsors $10,000+

Addison Corporate Annual Reports
Harvey Bernstein Design Associates
Chermayeff & Geismar Inc.
Designframe, Inc.
Donovan and Green
Fine Arts Engraving Company
Frankfurt Balkind Partners
Milton Glaser
Mirko Ilic
Steve Liska
Clement Mok
The Overbrook Foundation
Stan Richards
Anthony Russell
Arnold Saks Associates
Siegel and Gale Inc.
TeamDesign
Vignelli Associates

Patrons $25,000+

Crosby Associates Inc.
Drenttel Doyle Partners
Pentagram Design, Inc.

Benefactors $50,000+

Champion International Corporation

Special Benefactors $100,000

Adobe Systems Incorporated
Strathmore Paper

AIGA Chapters Leadership Circle $8,000+

AIGA/Atlanta
AIGA/Boston
AIGA/Chicago
AIGA/Los Angeles
AIGA/New York
AIGA/San Francisco
AIGA/Washington

AIGA Chapters
AIGA/Minnesota
AIGA/Denver

The AIGA Corporate Partners The AIGA gratefully acknowledges the following corporations for their in-kind and financial contributions this past year, September 30, 1996, to October 1, 1997. We appreciate and value their support and recognize the contribution they make to the success of the AIGA's conferences, programming events, competitions, publications, and much more. The AIGA will continue to build alliances with corporate partners that are strategic and mutually beneficial to meet the needs of our membership and their long-term objectives.

Adobe Systems Incorporated

AGFA

AGI, Inc.

Anderson Lithograph

Apple Computer

Appleton Papers, Inc.

Beckett Paper

The Campbell Group

Cedar Graphics, Inc.

Champion International Corporation

Crown Vantage, Curtis Fine Papers Division

Daniels Printing

Dickson's Inc.

DIGEX, Inc.

Empire Graphics

Fine Arts Engraving Company

Fox River Paper Company

Fraser Papers

Georgia-Pacific Papers

Gilbert Paper

Graphis, Inc.

Hammermill Paper

The Hennegan Company

Island Paper Mills

Katz Digital Technologies, Inc.

Lithographix, Inc.

Luxana Fine Paper

Mead Coated Papers

Milocraft, Inc.

Mohawk Papers Mills, Inc.

Monadnock Paper Mills, Inc.

Neenah Paper

PCW 100

PhotoDisc, Inc.

Potlatch Corporation

Stinehour Press

Strathmore Papers

Tanagraphics

Typogram, Inc.

Unisource

Van Nostrand Reinhold Company

Wausau Papers

Westvaco Corporation

Weyerhaeuser

Williamson Printing Corporation

About the AIGA The American Institute of Graphic Arts is the national non-profit organization that promotes excellence in graphic design. Founded in 1914, the AIGA advances graphic design through an interrelated program of competitions, exhibitions, publications, professional seminars, educational activities, and projects in the public interest.

Members of the Institute are involved in the design and production of books, magazines, and periodicals, film and video graphics, and interactive multimedia, as well as in corporate, environmental, and promotional graphics. Their contributions of specialized skills and expertise provide the foundation for the Institute's programs. Through the Institute, members form an effective, informal network of professional assistance that is a resource to the profession and the public.

Separately incorporated, the thirty-nine AIGA chapters enable designers to represent their profession collectively on a local level. Drawing upon the resources of the national organization, chapters sponsor a wide variety of programs dealing with all areas of graphic design.

By being a part of a national network, bringing in speakers and exhibitions from other parts of the country and abroad, focusing on new ideas and technical advances, and discussing business practice issues, the chapters place the profession of graphic design in an integrated and national context.

At the AIGA's Strathmore Gallery in New York, exhibitions include both the AIGA's annual award shows, based on its design competitions, and visiting exhibitions. The visiting exhibitions of the past year are highlighted in this annual and include collaborative efforts with the Cooper-Hewitt, National Design Museum. Acquisitions have been made from AIGA exhibitions by the Popular and Applied Arts Division of the Library of Congress.

The AIGA sponsors two biennial conferences, which are held in alternating years: the National Design Conference and the Business Conference. *Jambalaya: The Design of Culture Meets the Culture of Design,* the National Design Conference, was held in November 1997, while *D2B,* the AIGA's second business conference, took place in New York in October 1996. The next National Design Conference will be held in Las Vegas in late 1999.

The AIGA also sponsors an active and comprehensive publications program, featuring the ongoing publications *Graphic Design USA,* the annual of the Institute; the *AIGA Journal of Graphic Design,* published three times a year; and the *Membership Directory,* published yearly. Other publications include *Design Culture: An Anthology of Writing from the AIGA Journal* (co-published with Allworth Press in November 1997), *The Ecology of Design* (1995), *Graphic Design: A Career Guide and Education Directory* (1994), the *Salary and Benefits Survey* (1994), and *Symbol Signs,* second edition (1993).

More information about the AIGA can be found by visiting our website: http://www.aiga.org.

The AIGA Medal

The medal of the AIGA, the most distinguished in the field, is awarded to individuals in recognition of their exceptional achievements, services, or other contributions to the field of graphic design and visual communication. The contribution may be in the practice of graphic design, teaching, writing, or leadership of the profession. The awards may honor designers posthumously.

Medals are awarded to those individuals who have set standards of excellence over a lifetime of work or have made individual contributions to innovation within the practice of design.

Individuals who are honored may work in any country, but the contribution for which they are honored should have had a significant impact on the practice of graphic design in the United States.

Past Recipients

Norman T.A. Munder, 1920
Daniel Berkeley Updike, 1922
John C. Agar, 1924
Stephen H. Horgan, 1924
Bruce Rogers, 1925
Burton Emmett, 1926
Timothy Cole, 1927
Frederic W. Goudy, 1927
William A. Dwiggins, 1929
Henry Watson Kent, 1930
Dard Hunter, 1931
Porter Garnett, 1932
Henry Lewis Bullen, 1934
Rudolph Ruzicka, 1935
J. Thompson Willing, 1935
William A. Kittredge, 1939
Thomas M. Cleland, 1940
Carl Purington Rollins, 1941
Edwin and Robert Grabhorn, 1942
Edward Epstean, 1944
Frederic G. Melcher, 1945
Stanley Morison, 1946
Elmer Adler, 1947
Lawrence C. Wroth, 1948
Earnest Elmo Calkins, 1950
Alfred A. Knopf, 1950
Harry L. Gage, 1951
Joseph Blumenthal, 1952
George Macy, 1953
Will Bradley, 1954
Jan Tschichold, 1954
P. J. Conkwright, 1955
Ray Nash, 1956
Dr. M. F. Agha, 1957
Ben Shahn, 1958
May Massee, 1959
Walter Paepcke, 1960
Paul A. Bennett, 1961
Wilhelm Sandberg, 1962
Saul Steinberg, 1963
Josef Albers, 1964
Leonard Baskin, 1965
Paul Rand, 1966
Romana Javitz, 1967
Dr. Giovanni Mardersteig, 1968
Dr. Robert R. Leslie, 1969
Herbert Bayer, 1970
Will Burtin, 1971
Milton Glaser, 1972
Richard Avedon, 1973
Allen Hurlburt, 1973
Philip Johnson, 1973
Robert Rauschenberg, 1974
Bradbury Thompson, 1975
Henry Wolf, 1976
Jerome Snyder, 1976
Charles and Ray Eames, 1977
Lou Dorfsman, 1978

Ivan Chermayeff and Thomas Geismar, 1979
Herb Lubalin, 1980
Saul Bass, 1981
Massimo and Lella Vignelli, 1982
Herbert Matter, 1983
Leo Lionni, 1984
Seymour Chwast, 1985
Walter Herdeg, 1986
Alexey Brodovitch, 1987
Gene Federico, 1987
William Golden, 1988
George Tscherny, 1988
Paul Davis, 1989
Bea Feitler, 1989
Alvin Eisenman, 1990
Frank Zachary, 1990
Colin Forbes, 1991
E. McKnight Kauffer, 1991
Rudolph de Harak, 1992
George Nelson, 1992
Lester Beall, 1992
Alvin Lustig, 1993
Tomoko Miho, 1993
Muriel Cooper, 1994
John Massey, 1994
Matthew Carter, 1995
Stan Richards, 1995
Ladislav Sutnar, 1995

The Design Leadership Award

The Design Leadership Award recognizes the role of perceptive and forward-thinking organizations that have been instrumental in the advancement of design by applying the highest standards, as a matter of policy.

Past Recipients

IBM Corporation, 1980
Massachusetts Institute of Technology, 1981
Container Corporation of America, 1982
Cummins Engine Company, Inc., 1982
Herman Miller, Inc., 1984
WGBH Educational Foundation, 1985
Esprit, 1986
Walker Art Center, 1987
The New York Times, 1988
Apple and Adobe Systems, 1989
The National Park Service, 1990
MTV, 1991
Olivetti, 1991
Sesame Street, Children's
 Television Workshop, 1992
Nike, Inc., 1993

The AIGA Medal

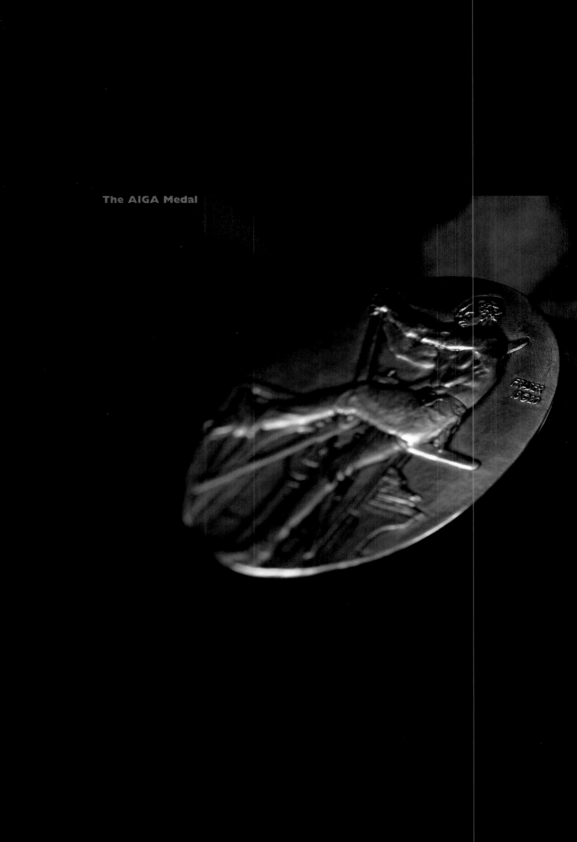

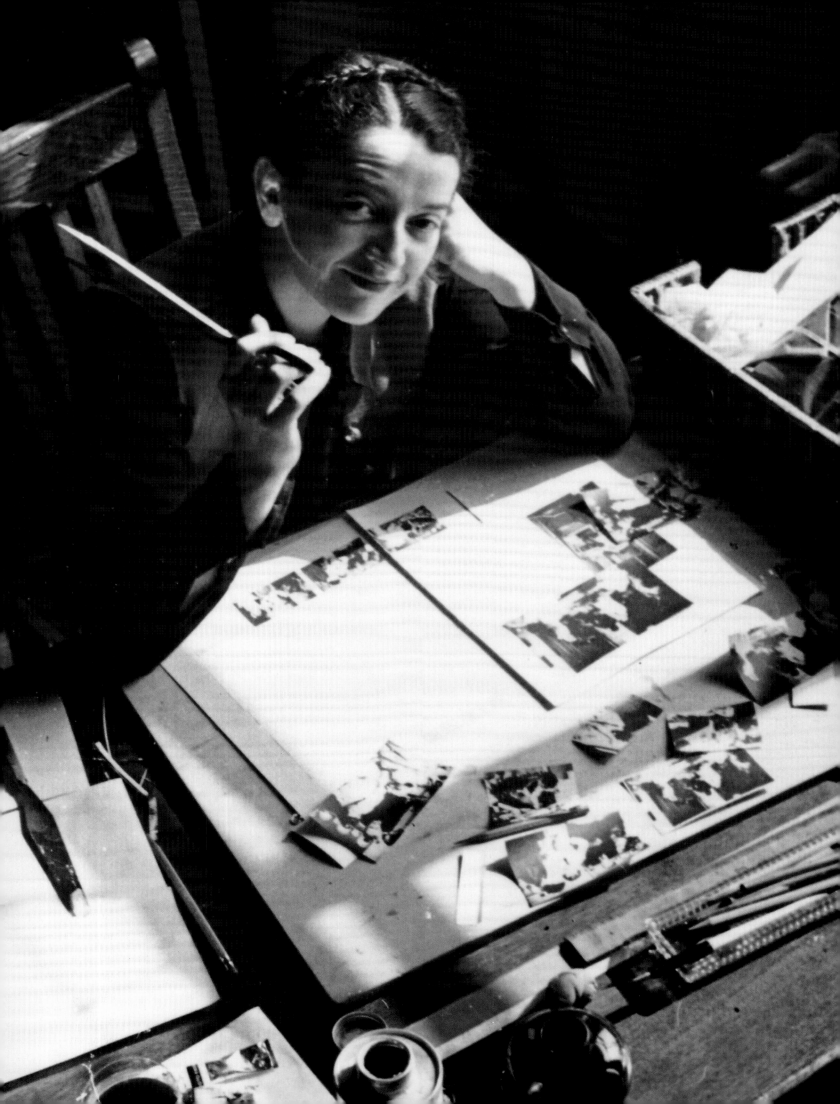

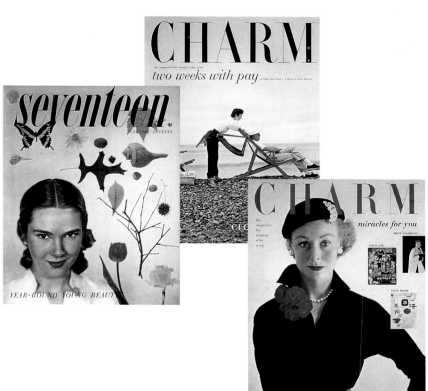

By Martha Scotford

Cipe Pineles: *The Artist as Art Director*

In the days when American graphic design seemed the province of European immigrants, the men were joined by a young woman born in Austria. The graphic design career of Cipe Pineles (pronounced SEE-pee pi-NELL-iss) began when she was installed by Condé Nast himself in the office of Dr. M. F. Agha, art director for Condé Nast publications *Vogue*, *Vanity Fair*, and *House & Garden.* Through the 1930s and early 1940s, Pineles learned editorial art direction from one of the masters of the era, and became (at *Glamour*) the first autonomous woman art director of a mass-market American publication. She is credited with other "firsts" as well: being the first art director to hire fine artists to illustrate mass-market publications; the first woman to be asked to join the all-male New York Art Directors Club and later their Hall of Fame. After experimenting on *Glamour*, she later art directed and put her distinctive mark on *Seventeen* and *Charm* magazines as well. Until her death in 1991, Cipe Pineles continued a design career of almost sixty years through work for Lincoln Center and others, and teaching at the Parsons School of Art and Design.

Pineles had piqued Nast's interest with some shoebox-sized models for store window fabric displays she had developed for Contempora, a design collaborative willing to tackle projects ranging in scale from a coffeepot to a World's Fair. The Contempora job was Pineles's first since graduating from Pratt Institute in 1929. It had taken her a year of portfolio reviews to land the position: the too-frequent pattern had been a positive reaction to the work followed by dismay when a woman showed up for the interview.

Working with Agha on the design of *Vogue* and *Vanity Fair*, she learned how to be an editorial designer. "Agha was the most fabulous boss to work for," Pineles reported later. "Nothing you did satisfied him. He was always sending you back to outdo yourself, to go deeper into the subject." He told his staff to visit galleries and museums and bring back new ideas. During the early 1930s Condé Nast publications were innovative in their use of European Modernism in magazine design. Typography was simplified and typefaces such as Futura became common. Headlines and text could be anywhere on the page. Photography took precedence over fashion illustration and was reproduced large on the page, bleeding off

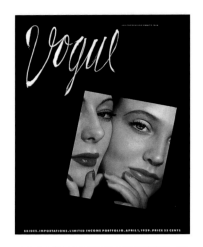

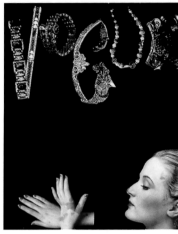

to create "landscapes" or transgressing across the gutter. Space expanded as purely decorative elements disappeared and margins were opened.

Watching and listening to Agha, Pineles also learned how to be an art director: "He spent a lot of time talking with his creative people… about problems related to type; pictures and the selection of pictures as satisfying an editorial concept or not." Creative people doing one thing were urged to take on another medium to gain a new perspective. Pineles, in addition to handling design and spot illustration, was one of his talent scouts for new illustrators and photographers.

Rising to the position Agha had been preparing her for, Pineles was named art director of *Glamour* in 1942. Ignoring her publisher, who turned out to have little respect for this middle-market fashion audience, Pineles used the best talent of the day, among them photographers Andre Kertesz, Herbert Matter, Cornell Capa, Toni Frissell, and Trude Fleischmann; designer Ladislav Sutnar; and artists S. E. and Richard Lindner and Lucille Corcos.

After a short hiatus during World War II when she worked in Paris on a magazine for servicewomen, Pineles became the art director of the three-year-old *Seventeen* magazine, a radical invention directed toward a hitherto undefined audience: teenage girls. The founder and editor, Helen Valentine, addressed her readers as serious and intelligent young adults, rather than as the silly, only-marriage-minded girls other publishers saw. In support of Valentine's mission to educate teenage girls, Pineles moved *Seventeen* out of the common idealized and sentimental school of illustration to use the best contemporary artists working in America. The reader's visual education would begin with the best artists' work.

Pineles is credited with the innovation of using fine artists to illustrate mass-market publications. Important because it brought fine art and modern art to the attention of the young mainstream public, it also allowed fine artists access to the commercial world. Pineles commissioned such artists as Ben Shahn and his wife, Bernarda Bryson, Richard Lindner, Jacob Lawrence, Reginald Marsh, John Sloan, and Dong Kingman. Some young artists "discovered" by the magazine became well known: Richard Anuszkiewicz and Seymour Chwast. An artist and illustrator herself, Pineles was the perfect art director: she left the artists alone. She asked them to read the whole story and choose what they wanted to illustrate. Her only direction was that the commissioned work be good enough to hang with their other work in a gallery.

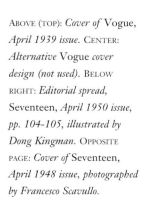

ABOVE (TOP): *Cover of* Vogue, *April 1939 issue.* CENTER: *Alternative* Vogue *cover design (not used).* BELOW RIGHT: *Editorial spread,* Seventeen, *April 1950 issue, pp. 104–105, illustrated by Dong Kingman.* OPPOSITE PAGE: *Cover of* Seventeen, *April 1948 issue, photographed by Francesco Scavullo.*

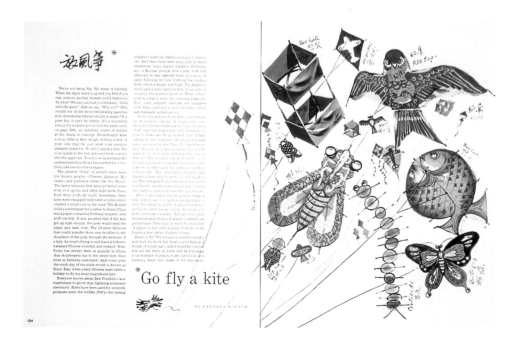

seventeen

APRIL 1948 · 25 CENTS

GIRL·

MEETS

BOY

ISSUE

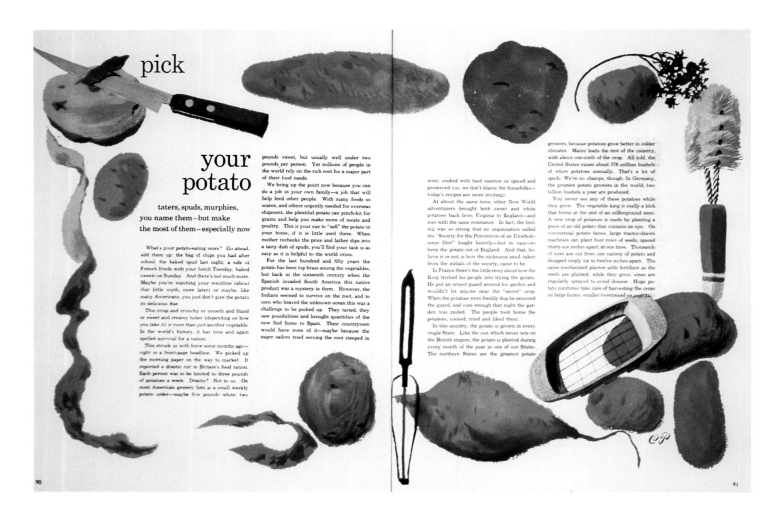

Neither was Pineles averse to using her own talents. She had an affinity for food painting and used objects, furniture, and even her own large-scale country house as props and locations for many photographs in the magazine. In one instance, finding potatoes too ugly for photos to go with her story, the food editor turned to Pineles, who recalled: "I thought they were pretty, so I dug out my kitchen tools, bought ten cents' worth of potatoes, painted them on a double-page size sheet of paper, indicated the type layout and left town. Total time, an hour and a half. Two weeks later, when finished art was needed, I went about the job more seriously. I nursed the potatoes, considered the type more carefully, and then tore the whole thing up. The rough was more fun. Total time, eighteen hours." The potatoes won her an Art Directors Club gold medal.

In Pineles's hands, the design of *Seventeen* followed the more classical tradition of magazine and typographic design. For the fiction, the quiet and bookish typography supported the primacy of the artwork. For editorial and fashion pages, the type was more playful, even showing early tendencies in American figurative typography where objects replaced letters as visual puns. Bear in mind, this was during a golden age of magazine design when art directors had thirty pages of uninterrupted editorial well in which to develop their visual ideas in a more cinematically dynamic way than is possible now. Pineles remained at *Seventeen* for three years, leaving to art direct *Charm* magazine in 1950.

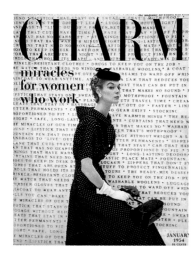

Twelve years before *Ms.* and twenty-six years before a magazine called *Working Woman*, the cover of *Charm* boldly carried the subtitle: "The magazine for women who work." The audience needed, but did not yet have, a service and fashion magazine that helped them fit together their two jobs. In *Charm* (as in *Seventeen*), surrounded by the advertisements that reflected society's limits on girls and women, the editorial pages showed something different: ways for American females to see themselves involved in the wider world and in possession and

control of knowledge, money, and their destinies. Consciously, she turned her professional challenges at *Seventeen* and *Charm* into opportunities; less consciously, she turned them into places where, while addressing women's usual beauty and fashion interests, their values and changing roles also might be addressed and supported.

Charm's presentation of fashion revealed its take on its readers. The clothes for working women were shown in use: at the office, commuting, lunch-hour shopping, and as practical answers for quotidian problems. As Pineles put it, "We tried to make the prosaic attractive without using the tired clichés of false glamour. You might say we tried to convey the attractiveness of reality, as opposed to the glitter of a never-never land…" Pineles used modern architecture and modern industrial design as locations and props for the photo shoots. For a repeated series of cover articles called "She Works in [City Name]," Pineles designed entire

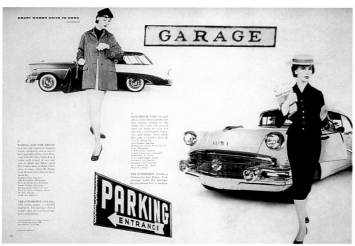

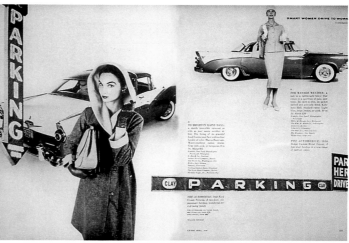

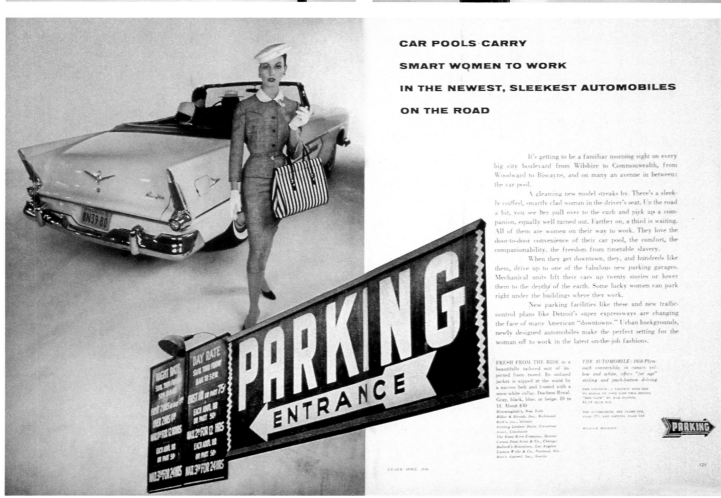

CAR POOLS CARRY
SMART WOMEN TO WORK
IN THE NEWEST, SLEEKEST AUTOMOBILES
ON THE ROAD

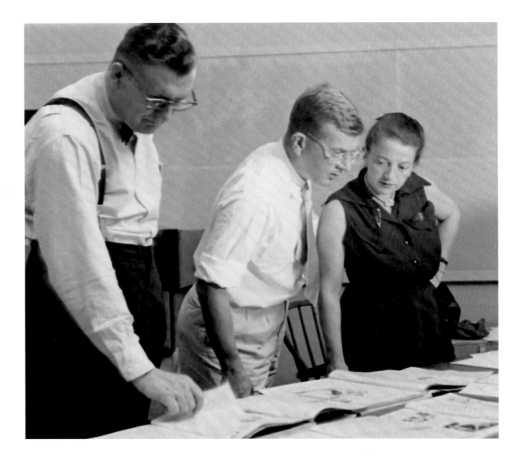

issues to reflect each city theme. In the Detroit issue, for example, Pineles used the city as a backdrop for the fashion pages, constructing the layouts from photos of buildings and expressways and in other ways reflecting the city's connection to the automotive industry. An extension of the theme included the vernacular typography of the parking garage.

In 1961, briefly following Bradbury Thompson's long tenure as AD at *Mademoiselle*, Pineles became an independent consultant designer and a design teacher. During the mid-1960s, when the Lincoln Center complex was rising, Pineles took on the difficult task of coordinating much of the educational and promotional material. Working for the corporation that managed the fundraising and public information for an uneasy consortium of arts groups, she established a graphic system for publications, an identifying mark, and attempted to educate management and the arts groups about the value of a unified visual image and organized information distribution. By the late 1960s, Lincoln Center's monetary problems distracted attention from this area, which needed constant political and financial support, and Pineles moved on.

At the same time, Pineles was discovering the intense pleasures of teaching by offering a course in editorial design at Parsons, a course she taught until the mid-1980s. The course required the student to identify a topic and its audience and develop a magazine for that audience: to design the publication from cover to interior spreads, as well as the marketing materials needed to find the audience. Several current art directors are products of this course; one — Melissa Tardiff, AD of *Town and Country* in the '80s — described the Pineles approach in this way: "She didn't teach style — she taught content. She taught you to start with the content of the magazine and then work from there, rather than just think about what design was going to look nice on the page." Pineles later developed a follow-up course in which students developed, designed, and printed a college "yearbook," first redefining what a yearbook could be. The most famous product of that course, the *Parson's Bread Book*, went into a trade edition and was named one of the AIGA's Fifty Books of the Year in 1975. Pineles was at Parsons during years of rapid growth when it became part of the New School and expanded to Los Angeles.

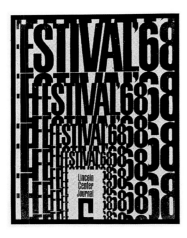

She became the director of publications for an extensive promotional program. Using students, faculty, and others to supply art and photography, Pineles established a strong, colorful, often amusing and varied visual identity for the school. The conceit of identifying New York and Los Angeles with apples and oranges was probably the most powerful hit on the public's consciousness, though there were many smaller taps. She continued to teach at Parsons into her mid-seventies though she handed off the promotional design program and production duties a few years before retiring.

Until the mid-1950s, when much younger women started making their way into positions of independent responsibility in magazines and graphic design, Cipe Pineles was by herself and a "first" in many respects. She had accumulated innumerable art direction and publication design awards over the years from the Art Directors Club, AIGA, Society of Publication Designers, and others. While there were some other women receiving awards, they were always paired with their hovering (male) art director, while Pineles got single credit. Though she paid her professional dues early and often — awards, juries, panels, presentations, lectures, committees, and boards, including the AIGA — and though Dr. Agha had been proposing her for ten years, the New York Art Directors Club would not offer her a membership. The club did not budge until faced with this dilemma: it offered membership to William Golden, the energetic design director of CBS, who pointed out that the ADC was hardly a professional club if it had ignored his fully qualified wife (he and Pineles had married in 1942). Both became members in 1948; she was the first woman member. Also in 1948, Pineles and Golden became the first couple to win individual Gold Medal awards in the same year. In 1975, she was the first women inducted into their Hall of Fame.

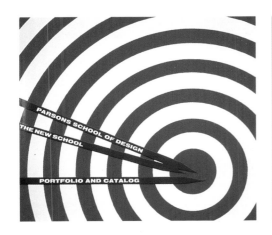

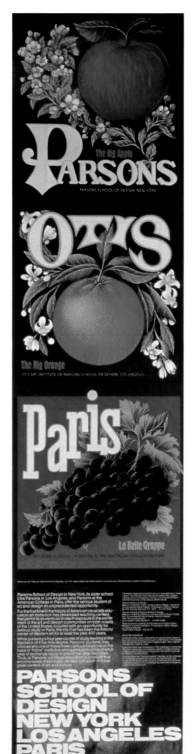

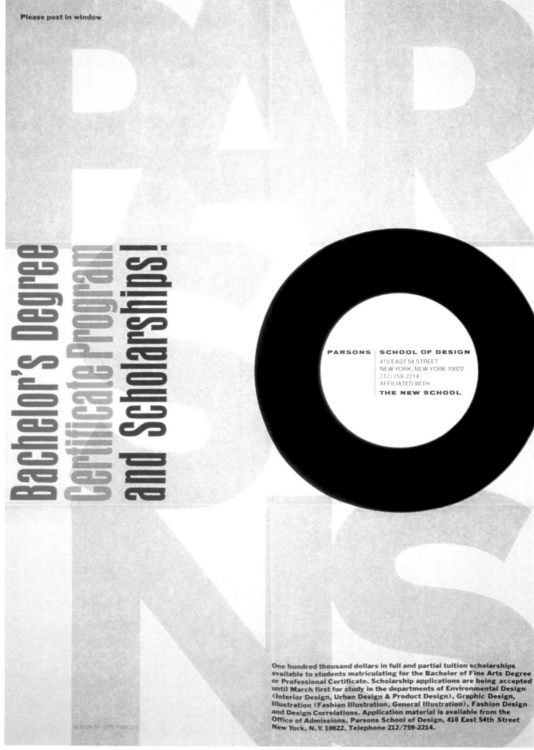

Please post in window

Bachelor's Degree Certificate Program and Scholarships!

PARSONS | SCHOOL OF DESIGN
410 EAST 54 STREET
NEW YORK, NEW YORK 10022
212/759-2214
AFFILIATED WITH
THE NEW SCHOOL

One hundred thousand dollars in full and partial tuition scholarships available to students matriculating for the Bachelor of Fine Arts Degree or Professional Certificate. Scholarship applications are being accepted until March first for study in the departments of Environmental Design (Interior Design, Urban Design & Product Design), Graphic Design, Illustration (Fashion Illustration, General Illustration), Fashion Design and Design Correlations. Application material is available from the Office of Admissions, Parsons School of Design, 410 East 54th Street New York, N.Y. 10022. Telephone 212/759-2214.

ABOVE: *Parsons/Otis fruit crate labels poster, illustrated by Janet Amendola.* ABOVE RIGHT: *Parsons School of Design scholarships poster.* OPPOSITE PAGE: *Cipe Pineles with William Golden in* 1948, *holding their Gold Medals from the New York Art Directors Club. Cover and spreads from the 1974 trade paperback edition of the* Parsons Bread Book, *originally a student yearbook.*

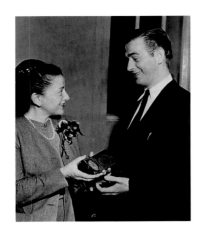

As a "first" female allowed on some closely protected male professional turf, Pineles was pleased to be included with all her friends. Although these rewards were late in coming, Pineles was of a generation and demeanor that were gracious and patient. She has remained, unfairly and unfortunately, a footnote to American graphic design history, overshadowed by the attention paid to her two husbands, but this is soon to change.

Cipe Pineles was an established designer at Condé Nast when she met William Golden in the late 1930s and helped him get a job with Agha. Golden went on to direct the corporate identity for CBS and to become a standard bearer for high quality and ethical corporate design. (He was a posthumous AIGA Gold Medalist in 1988.) Golden died at a young age in 1959, leaving Pineles with their young son. Within two years, Pineles married the recently widowed Will Burtin, who with his wife and daughter had been very close friends of the Goldens. Burtin, for his part, was a wartime German immigrant who quickly established himself in New York as an art director, corporate designer, teacher, extraordinary exhibition designer, and a founding member of the Aspen Institute conferences. He received the AIGA Gold Medal in 1971. With an AIGA Gold Medal going to Pineles, the three will now be the largest "family" of medalists, each medal bestowed for independent achievement.

Talented, assertive, with charm enhanced by her lingering Austrian accent, Cipe Pineles became the first independent woman American graphic designer. As art director of *Glamour*, *Seventeen*, *Charm*, and *Mademoiselle* for over twenty years, she collaborated with hundreds of artists, illustrators, photographers, and editors. She mentored her assistants and later formally taught a generation of designers at Parsons. As an art director, she provided an encouraging, enthusiastic, and collaborative model: as a professional woman in a predominantly male field, she was a model for the next generation of women in design. A friend and colleague to legions of creative people across the globe, Cipe Pineles was always ready with good food and lively conversation as well as advice, a letter of support, a contact, or a commission.

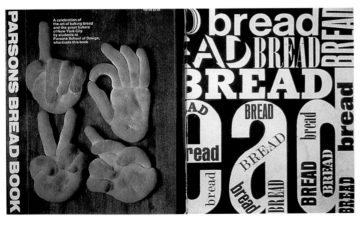

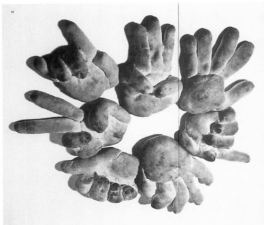

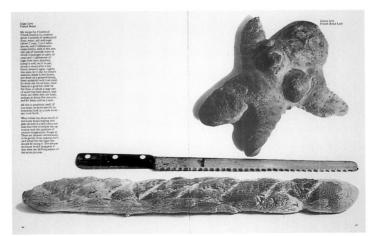

By Andrea Codrington

George Lois: *George of the Jungle*

In today's market research–driven advertising industry, visceral instinct has all but been replaced by irony, the stark effect of image and text by a sly, focus group–inspired wink. Ask legendary New York adman George Lois what he thinks of this, and step out of the way. "Advertising is not a fucking science," he roars, "advertising is an art — no question about it." And Lois should know. As one of this century's most accomplished progenitors of Big Idea advertising, the 66-year-old ad luminary has given birth to an astonishing array of commercial campaigns and imagery that have meshed high-minded design with hard-core sell. "Great ideas can't be tested," emphasizes Lois. "Only mediocre ideas can be tested."

So impassioned by his work is Lois that it is difficult to imagine the hulking adman — his athletic, 6' 3" frame only slightly diminished by his years — at rest. "I sleep three and a half hours in two shifts," he confesses. "I think it's part work ethic and part craziness." Whether such perpetual motion is the product of metabolism or habit is difficult to ascertain. After all, Lois was born in 1931 into a family of hard-working, early-rising Greek immigrants who spent their days and nights making their way in the tough Kingsbridge section of the Bronx. Working with his florist father from the time he was five years old, Lois was witness to long hours and back-breaking labor. The image of his father's fingers tattooed with cuts and scratches has left an indelible mark. Lois's hands may be smooth, but as he drums his fingers across the table or pounds a fist for dramatic emphasis, his opinion comes through loud and clear. "If you don't burn out by the end of each day," he maintains, "you're a bum."

It is easy to picture the young George Lois fighting his way through the all-Irish neighborhood on his way to school. An exquisitely crooked nose and a jolting propensity for wedging an emphatic "Yo!" into the middle of a sentence are testament to the street kid within. And Lois had a lot to fight about. There was the matter of ethnicity, of course. And then there was the art thing. "I was so involved with drawing all the time," Lois says. "I remember sitting in my fire escape and drawing converging lines when I was six or seven years old. I would draw 3-D lettering on everything." While the young Lois was defending

OPPOSITE PAGE: *George Lois, 1997.* ABOVE (LEFT TO RIGHT): Esquire *covers from the Vietnam era: November 1970, October 1966, and April 1968 issues.*

WHAT DO YOU WANT OUT OF AMERICA?

Freedom? And the benefits of freedom for yourself and your family? We want these things too. There are those among us who remember the sweatshops before the Union. Now in forty-one states, 353 cities, hundreds of thousands of ILGWU members work in dignity. We have won for them and their children the chance for a fuller life. We have built housing, recreation and health centers, education, medical, and insurance programs in which all Americans can take pride. Now the International Ladies Garment Workers Union has a label. You will see it soon in every dress, every skirt, every woman's and child's garment that is union-made. The label means more than better workmanship. More than better styling. It has a deeper value. The knowledge that somewhere a human being who sewed the garment you will wear earns a living wage, and has a decent place to work. Look for this ILGWU label. It feels good to support democracy.

ILGWU

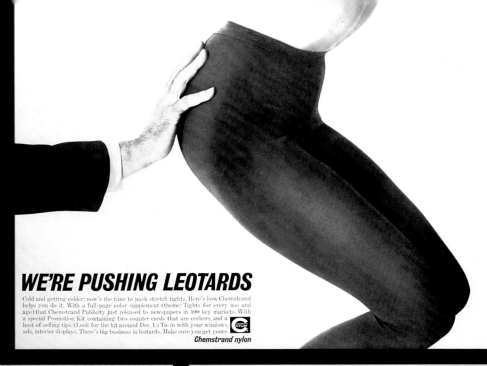

WE'RE PUSHING LEOTARDS

Cold and getting colder: now's the time to push stretch tights. Here's how Chemstrand helps you do it. With a full-page color supplement (theme: Tights for every use and age) that Chemstrand Publicity just released to newspapers in 100 key markets. With a special Promotion Kit containing two counter cards that are corkers, and a host of selling tips. (Look for the kit around Dec. 1.) Tie in with your windows, ads, interior displays. There's big business in leotards. Make sure you get yours.

Chemstrand nylon

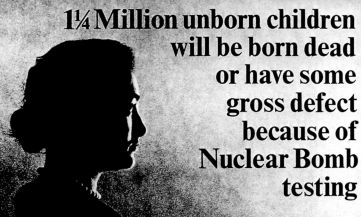

1¼ Million unborn children will be born dead or have some gross defect because of Nuclear Bomb testing

1¼ million is a maximum number indicated by the report of the Federal Radiation Council of May, 1962. Other authorities regard this figure as a minimum. Of these, 250,000 children will be born with some gross defect. According to the report, this includes "such things as congenital malformation, blindness, deafness, feeble-mindedness, muscular dystrophy, hemophilia, and mental diseases." The number of children who will die in infancy or be born dead, will be, the report states, "perhaps five times larger than the number of induced defects of the type" mentioned above.

In addition, "there may be an unknown but probably a considerable larger number of mutations with less obvious effects such as minor physical abnormalities, mild diseases, impairment of physiological functions and reduced resistance to infection or other stresses of life." All this means the next children will have a lower chance of surviving after birth. The Federal Radiation Council report is entitled "Health Implications of Fallout from Nuclear Weapons Testing through 1961." As too little includes it makes no allowances for fallout from any test since 1961 either now or in the future.

To find out what you can do about it, write to:

SANE
17 East 45th Street, New York 17, New York OX 7-2265

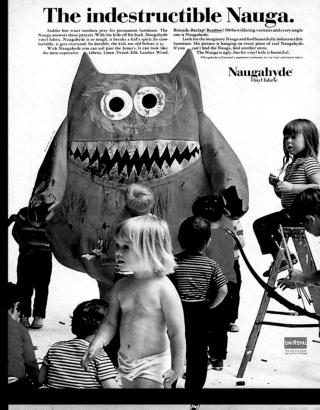

The indestructible Nauga.

Sadder but wiser mothers pray for permanent furniture. The Nauga answers those prayers. With the hide off his back. Naugahyde vinyl fabric. Naugahyde is so tough, it breaks a kid's spirit. So comfortable, it gets overused. So durable, the kids are old before it is. With Naugahyde you can sail past the Jones's. It can look like the most expensive fabrics. Linen. Tweed. Silk. Leather. Wood.

Brocade. Burlap! Bamboo! 500 bewildering varieties and every single one is Naugahyde.

Look for the imaginary Nauga and find beautifully indestructible furniture. His picture is hanging on every piece of real Naugahyde. If you can't find the Nauga, find another store.

The Nauga is ugly, but his vinyl hide is beautiful.

Naugahyde vinyl fabric

UniRoyal

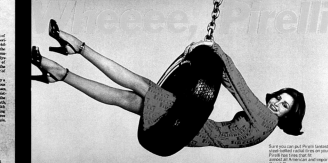

Wheeee, Pirelli!

Sure you can put Pirelli fantastico steel-belted radial tires on your car. Pirelli has tires that fit almost all American and imported cars. Capish?!

PIRELLI

OPPOSITE PAGE (CLOCKWISE FROM TOP LEFT): *International Ladies Garment Workers Union newspaper ad (1959); leotard magazine ad (1959); ad featuring "the Nauga," a mythical beast created to brand Naugahyde (1966); advertising poster for Pirelli tires (1969); controversial anti-nuclear poster created for the organization SANE (1963).*

BELOW (CLOCKWISE FROM TOP LEFT): *Packaging for Stevens hosiery (1968); Finesse hosiery packaging (1964); name and logo created for a Manhattan chain of German fast-food sausage restaurants (1963); logo, name, and concept created for Ma Bells restaurant (each table featured a working telephone) (1966).*

his besieged masculinity, his public school teacher Ida Engle was collecting the hundreds of drawings that he had produced over the years: a portfolio that gained him entrance into the prestigious High School of Music and Art.

"I always knew I was the most talented kid in the school," says Lois of his time at Music and Art. "I also knew I was a lucky son of a bitch to be there." Exposed to the city's best art education, not to mention school concerts directed by the likes of "a young Lennie Bernstein and Maestro Toscanini," Lois thrived in the Bauhaus-based atmosphere and impressed his instructors, who for the most part were able to see the diamond of his talent in his street-rough demeanor. But not everybody appreciated — or understood — Lois's emerging conceptual sensibilities. A sophomore-year incident in which his class was given a sheet of paper to design "yet another Bauhaus rectangle composition" almost led to his being flunked. "I sat there and didn't move with this 18 by 24 sheet in front of me for an hour and a half," laughs Lois. "The teacher was getting furious. At the end, she went to grab my blank paper and I held up my hand to stop her. I signed my name to it and said, 'Here's the ultimate rectangle design.' The teacher just didn't get it."

Despite such scrapes with authority, Lois made it through Music and Art and came out the other end with a diploma, a basketball scholarship to Syracuse, and an acceptance to Pratt. "One-third of my life is playing basketball," confesses Lois, who nonetheless chose

Salvaging the 20th Century.

OCTOBER 1968
$1.50

MAY 1969
PRICE $1

THE MAGAZINE FOR MEN

The final decline and total collapse
of the American avant-garde.

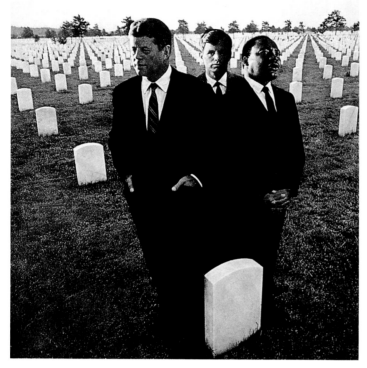

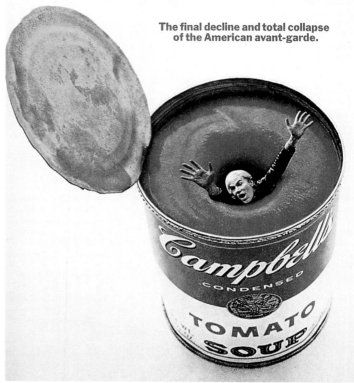

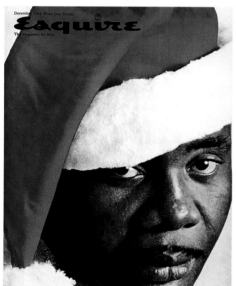

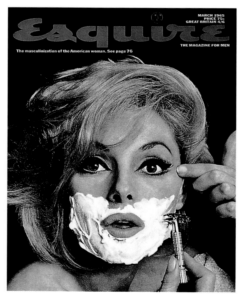

The masculinization of the American woman. See page 76

THE MAGAZINE FOR MEN

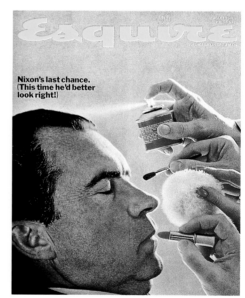

Nixon's last chance.
(This time he'd better
look right!)

ABOVE (CLOCKWISE FROM
TOP LEFT): *Some of the many*
Esquire *covers Lois designed:*
October 1968; May 1969;
May 1968; March 1965;
December 1963 (with Sonny
Liston as Santa Claus).

to go to Pratt for its proximity to home and its reputable commercial arts program. "I was the wild man of the class," Lois recalls of his first year at Pratt, whose foundation course was old news to the Music and Art graduate. Rather than concentrate on his schoolwork, Lois set himself to winning over a beautiful blonde classmate (he did, despite her initial reaction of "Me Rosemary, you arrogant") and impressing advertising professor Herschel Levit. Life began in earnest Lois's sophomore year, when he decided, at Levit's urging, to leave Pratt for a job in the design studio of Reba Sochis and eloped to Baltimore with his Polish Catholic bride.

Lois adored Sochis — a great designer and a great curser, it turns out — but spent only a short time working with her. Having left college, he became subject to the draft and got

nailed for a two-year Army stint, landing in the thick of the Korean War. When he returned in 1953, Sochis was eager to make him a partner in her studio, but Lois wanted to go out into the world. William Golden's renowned advertising and promotions department at CBS was Lois's next port of call, where the experience-hungry Lois designed booklets, mailers, letterheads, theater marquees, program notices and ads and was further exposed to the work of such design and illustration Masters of the Universe as Ben Shahn, Kurt Weihs and Lou Dorfsman.

"People who don't think they owe something to somebody are crazy," says Lois with emphatic gratitude. The list of creative giants who inspired and facilitated his own creative vision is lengthy, and he is the first to proclaim this. After leaving CBS and taking on short, stormy stints at the ad agencies Lennen & Newell and Sudler & Hennessy — where he

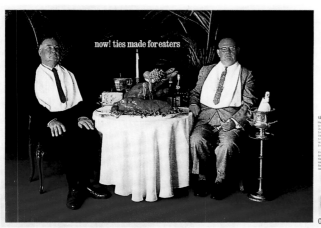

now! ties made for eaters

Chemstrand nylon

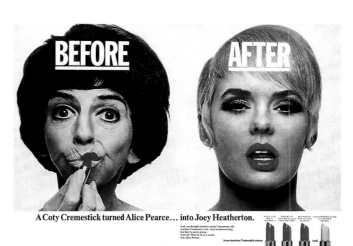

BEFORE AFTER

A Coty Cremestick turned Alice Pearce… into Joey Heatherton.

"Remember darling— Never pay more than 25¢ a leg."

Spirit by Stevens 25¢ a leg!

Sheer glamour: 25¢ a leg. (Any woman who pays more than 25¢ a leg for stockings ought to have her knees examined.)

Joe Namath is an Olivetti girl.

If you don't believe it, watch Joe type in that Olivetti commercial on TV!

Obviously, not all Olivetti girls are girls.
Joe Namath uses an Olivetti Electric Typewriter.
(Not a bad typist either.
Bats out 38 words a minute when he's in top form.)
Lots of guys use it.
Authors.
Journalists.
Male secretaries.
The copywriter who wrote this ad.
They like it because it has a brain inside
that intercepts the four most common typing mistakes
before the keys can strike.
(No flying caps.
No improper spacing.
No shading.
No crowding or piling.)
For example,
when Joe did the commercial he made a few mistakes.
And our typewriter compiled a record
that would be envied by every football team
he ever faced.
It intercepted him 23 times!

olivetti
The American Dream Machines

office typewriters
portable typewriters
adding machines
calculators
word processing systems
accounting systems
electronic billing systems
microcomputers
on-line systems
office copiers

hooked up with another design legend, Herb Lubalin — in 1959 Lois landed at Doyle Dane Bernbach, the agency that gave birth to Big Idea Thinking, the basis of truly modern advertising. "I always understood concept," says Lois, who felt at home at DDB, where the art director was king. Combining shrewdly shot visuals with irreverent text, Lois and his colleagues came up with such seminal advertising moments as the Volkswagen "Think Small" campaign. "Everything I did was looking for the Big Idea," recalls Lois, "but you're not going to get to an idea thinking visually in most cases. You have to think in words, then add the visual. Then you can make one plus one equal three."

Lois's powerful individualism and unconventional antics — hanging out the window yelling at a client, "You make the matzoh, I'll make the ads," to name one instance — made it inevitable for him to leave DDB in 1960 to open up his own agency, Papert Koenig Lois. Unconstrained by convention and static corporate hierarchies, PKL soon became the world's hottest agency, creating memorable campaigns for everything from gourmet pickled Dilly Beans and Xerox to Aunt Jemima and National Airlines. But Lois has always been given to remaking himself and his businesses: since 1967, he has created three wildly successful agencies — Lois Holland Callaway, Creamer Lois and Lois Pitts Gershon, which is now his present agency, Lois/EJL.

Throughout his career, Lois's talent has always been to capture the zeitgeist of an age — whether in the form of a senatorial campaign for Bobby Kennedy (1964), a composited *Esquire* cover that has Andy Warhol drowning in an oversized can of Campbell's soup (1969), the concept and name for the low-calorie Stouffer's product, Lean Cuisine (1979), or those entertainment industry–transforming words, "I want my MTV" (1982).

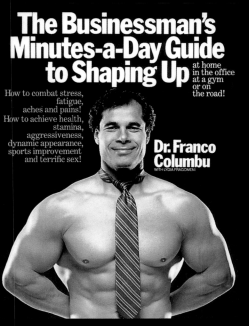

The Businessman's Minutes-a-Day Guide to Shaping Up

at home in the office at a gym or on the road!

How to combat stress, fatigue, aches and pains!
How to achieve health, stamina, aggressiveness, dynamic appearance, sports improvement and terrific sex!

Dr. Franco Columbu
WITH LYDIA FRAGOMENI

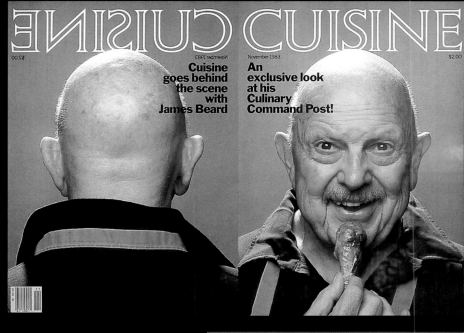

CUISINE

$2.00

November 1983

November 1983

$2.00

Cuisine goes behind the scene with James Beard

An exclusive look at his Culinary Command Post!

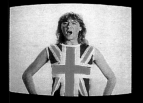
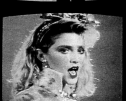
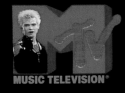

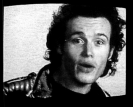
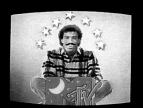

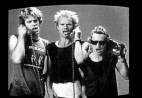

Lois Pitts Gershon Pon/GGK (the "I want my MTV" ad agency) thanks the terrific artists who graciously appear in our TV campaigns.

OZNO

OZNO IS THE NAME 3 DICE IS THE GAME

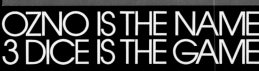

ATLANTIC BANK

ANNUAL REPORT 1987

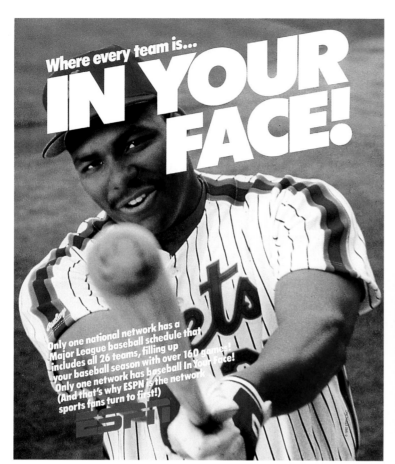

"I'm the crossover guy," says Lois of his career, which has borrowed as much from graphic design as it has from guerrilla advertising tactics. Lois laughs when he remembers his advertising colleagues' reaction when seeing him cut his type apart at his desk with all the earnest intensity of a Bauhaus student. "'Geez,' they'd say, 'He's a real dee-signer.' I took that kind of design sensibility and put it together with a kind of kick-ass sensibility and made my own kind of advertising." The most memorable manifestation of this hybrid talent undoubtedly came in the form of the covers he created for *Esquire* in the '60s and early '70s. Blessed with the partnership of editor Harold Hayes, who allowed the art director creative control, Lois gave this particularly vibrant and turbulent era a memorable face: Muhammad Ali as the Christian martyr St. Sebastian; Svetlana Stalin with a drawn-on mustache; mean-assed boxer Sonny Liston as the first-ever African-American Santa Claus. And an all-black cover punctuated only by reversed-out type reading "Oh my God — we hit a little girl," Lois's stark commentary on a war that was anything but black and white.

Lois has come far with his visceral approach to art direction. (An appearance on the David Suskind show many years ago had him claiming: "Advertising is poison gas. It should absolutely attack you; it should rip your lungs out!") Stripping aside all hyperbole, however, George Lois is able to appreciate the more subtle indicators of his life-long success. Lois may have made his fortune, been inducted into the Art Director's Club Hall of Fame, the Creative Hall of Fame and been awarded the AIGA Gold Medal. But nothing compares to a phone conversation he had a few years ago with his beloved pal, the late Paul Rand. Lois's full lips form a tender smile as he remembers Rand saying, "'You son of a bitch, did you see the *Times* this morning? You were an answer in the crossword puzzle!"

ABOVE (LEFT TO RIGHT):
ESPN campaign to position the channel as a vital sports programmer (1992); Hue hosiery ad (1995).

Bali Hai
"Smoke of the Gods"

We thank the gods
Columbus collected New World plants from Cuba.
(He knew a good thing when he smoked it.)
And we thank the gods tobacco seed is so genetically stable.

Because Columbus brought seeds of this 'smoking plant' back to Europe, where they soon became a trade commodity. Especially in Indonesia.

For 500 years, Indonesia has raised this direct descendent of Cuban tobacco, creating cigars which aficionados rank with the world's finest.

For a double reason! These full-flavored cigars are also exquisitely *mild*. (With an evanescent hint of the spices this royal land is famous for.)

For the first time, they are available to you. They are called: *Bali Hai*. "The Smoke of the Gods." (And now they're joined by *Islands*; another Indonesian triumph.)

Don't thank us. Thank Christopher.

Puff my cigar, Bali Hai Puff my cigar, Islands

WWW.INDOTOBACCO.COM

Where you meet Your Other Face!

TOURNEAU®

no **excuses**
AWARD OF THE MONTH:
Dedicated to the principle that to err is human, but to take the heat and make no excuses for it, is divine!

To Exxon
For moving The Black Sea to the Alaska coastline.

no **excuses**
AWARD OF THE MONTH:
Dedicated to the principle that to err is human, but to take the heat and make no excuses for it, is divine!

To Malcolm Forbes
For feeding 880 hungry people in Africa!

no **excuses**
AWARD OF THE MONTH:
Dedicated to the principle that to err is human, but to take the heat and make no excuses for it, is divine!

To Leona Helmsley
Hey...since when is it a crime to redecorate?!

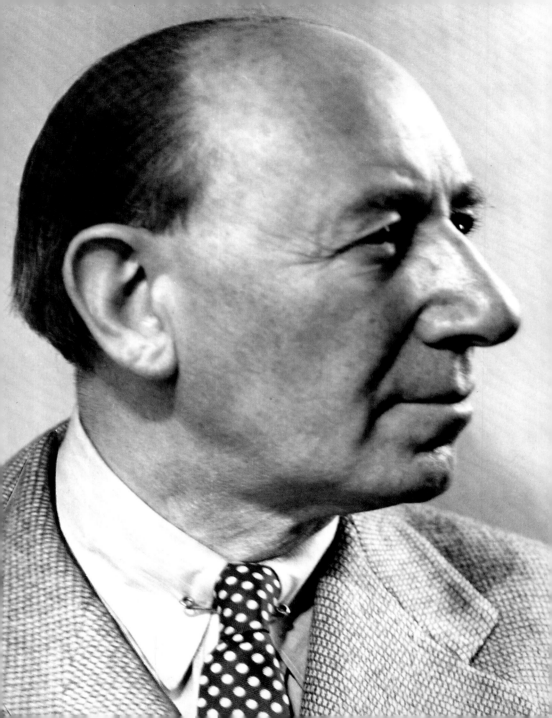

BY STEVEN HELLER

Lucian Bernhard *Proto-Modernist*

The Priester Match poster is a watershed document of modern graphic design. Its composition is so stark and its colors so startling that it captures the viewer's eye in an instant. Before 1906, when the poster first appeared on the streets of Berlin, persuasive simplicity was a rare thing in most advertising: posters, especially, tended to be wordy and ornate. No one had yet heard of its young creator, who, thanks to this poster, was to influence the genre of advertising known as the *Sachplakat*, or object poster. Over the course of his career, which progressed from the turn of the century to the 1950s, Lucian Bernhard became a prolific designer not only of innovative posters but of trademarks, packaging, type, textiles, furniture, and interior design. From his studio in New York City (he left Berlin in 1922), he developed some of the most recognizable American business advertising and trademarks, for such clients as Cat's Paw, ExLax, and Amoco. He also designed more than thirty-five popular display typefaces, including Bernhard Gothic.

But who was this BERN HARD (as his two-tiered signature read on posters and billboards)? And what influenced him to create imagery that was so distinct from that of his contemporaries? The answers are not easy to determine, because Bernhard deliberately invented most of his early biographical accounts. As his son Karl explains, Lucian believed that the actual facts of his youth had little relevance in judging his adult life and work, and enjoyed toying with the details of his life, revising his stories depending on his audience or mood. But past conversations with his children — Karl, Manfred, and Ruth (the renowned photographer) — and with various now-deceased friends, including Fritz Eichenberg, Aaron Burns, and Cipe Pineles, yield some biographical threads that can be sewn together.

Bernhard's formative years (he was born in 1883) coincided with the explosion of Art Nouveau and Jugendstil. As a teenager, Bernhard visited Munich's Glaspalast, where he saw a major exhibition of European Art Nouveau applied arts, including the wildly colorful cabaret and theater posters of Jules Chéret, Toulouse-Lautrec, and Alfonse Mucha. Also on view were maquettes for the economical advertising posters done by the famed Beggarstaffs, James Pryde and William Nicolson, which exerted a strong influence on the young Lucian's

own poster making. Bernhard later said that he recalled "walking drunk with color" through this exhibit.

So inspired was he that when he returned to his parent's drab Wilhelmian-style home, he took the opportunity of their chance absence to repaint every last wall and stick of furniture with the new modern colors he had just seen. Upon returning, his father was so outraged that he is said to have disowned his son, literally throwing him out of the house.

Though Munich was the center of the more "radical" German graphic arts, Bernhard decided to go to Berlin, where the wonders of industrial production and commercialism were manifest. Poster competitions were routinely sponsored by Berlin business establishment to identify new talent for the expanding advertising industry. One in particular, sponsored by the Priester Match company, awarded 200 marks (then about $50) to the winner. Bernhard jumped at the opportunity, and with precious little time to produce his own entry, he made some instinctive design decisions that had stunning repercussions.

First he decided to use a brown/maroon background — an unusual color, since posters at that time either used black or bright primaries — on which he rendered an ashtray with a pair of matches along its side. Seeing that the ashtray needed some other graphic element to balance the composition, he drew in a cigar. Logically, from the cigar came smoke, and from the smoke what else but a few scantily clad Jugendstil dancing girls. The ashtray needed grounding so he placed it on a checkered tablecloth. At the top of the poster he hand-lettered the word "Priester." Proud of his work, he showed it to a caricaturist, who congratulated him on his wonderful cigar poster. Bernhard immediately realized his error

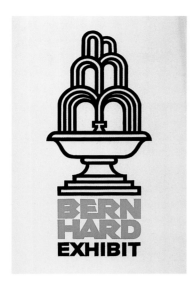

Die Erziehung zur Hetäre, von Max Brod

and proceeded to deconstruct the image by painting out cigar, smoke, ashtray, and tablecloth, leaving only the red matches with yellow tips and the brand name.

The judges, finding the poster odd, threw it unceremoniously into the trash, where it would have remained had not the most important judge arrived in the nick of time. Ernst Growald, sales manager for Berlin's leading proto-advertising agency and poster printer, understood the role of advertising in Germany's expanding economy. He also had taste. Not seeing any noteworthy entries on the table, he glanced at the discarded poster and exclaimed: "This is my first prize. This is genius!" Bernhard had won both the contest and a long-term benefactor.

Bernhard capitalized on the Priester success. Although his subsequent designs were good — often gorgeous — Bernhard never really surpassed Priester's serendipity in any of his other posters. He did, however, produce countless images for a range of different German (and later foreign) products. By the ripe old age of twenty-three, he had become so sought after that he was compelled to open his own studio. Within ten years his elegant new studio employed around thirty artists and their assistants. In 1920, he was made the first professor of poster art at the Berlin School of Arts and Crafts.

The first decade of the twentieth century was significant for Bernhard and German arts and crafts because the marriage of art and industry was being promoted through organizations like the German Werkbund and celebrated at frequent industrial expositions. Urban areas became hotbeds of advertising: bold, reductive graphic imagery was necessary to capture the viewer's attention on crowded poster hoardings. Bernhard's *Sachplakat* epitomized this new form, which also included other kinds of imagery in which unusually bright, yet aesthetically pleasing colors replaced more subtle hues. Text was pared to a minimum. Growald encouraged others to work in this manner, and formed a loose-knit school known as the Berliner Plakat.

As a charter member, Bernhard become involved with many of the movement's supporters. One such was Dr. Hans Sachs, a Berlin dentist, who founded the Friends of the Poster Club. Bernhard designed its logo, text typeface, and was co-founder of its journal, *Das Plakat*, which devoted one issue almost entirely to his work. *Das Plakat* made German commercial artists and buyers of printing aware of the new poster developments abroad as well as the best new German artists. Bernhard got involved because he was acutely aware that industry required radical forms of graphic publicity, and the designer was in a unique position to influence the influential.

Bernhard made inroads into German typography as well. When the formidable Berthold Type Foundry issued a "block" letter in 1910 that looked suspiciously like Bernhard's own poster lettering, he was forced to seriously design his own alphabets to protect his inventions. In 1913 Bernhard's first typeface, Antiqua, was released by the Flinsch Foundry in Frankfurt; it was a good book face. He promised more but the Great War put a temporary halt to his output.

After the war, Bernhard, who was avowedly apolitical, gladly accepted an invitation to come to the United States in 1922 for an unspecified time. Roy Latham, who ran a lithography firm in New York, proposed that Bernhard speak before various art directors' clubs in New York and elsewhere about advertising and logo design. Despite his poor mastery of English, Bernhard accepted. It was Latham's notion that Bernhard also be shuttled around the country to promote his own work and perhaps convince American art directors to consider modern design as an alternative to the overly rendered, often saccharine, painted illustration that represented American practice. Sadly, the exercise was a failure. American advertising was ruled by the copywriter. Moreover, advertisers believed

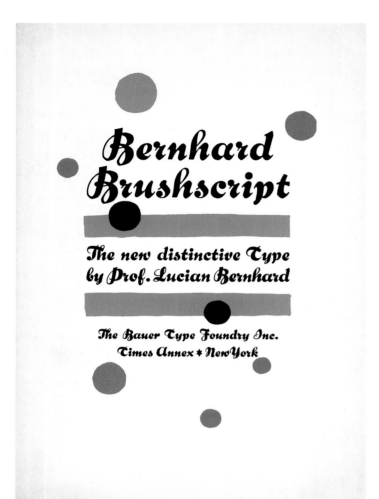

that Bernhard's work was ahead of its time. Remember that the Bauhaus was beginning its truly radical experiments at this time, which by comparison made Bernhard's work look conservative. The United States was even more backward.

Despite the disappointment of his poor reception, Bernhard was seduced by New York City. He decided to stay on for another six months, which turned into a permanent residency, leaving him to forsake his adopted Berlin, flourishing studio, and loving family. In 1932 Bernhard's wife and sons, Karl and Manfred, came to New York from Germany (his daughter, Ruth, from a previous marriage, was already in the United States), and though they did not live with their father, they worked with him as assistants at the studio.

Latham then arranged for Bernhard to exhibit his work at the New York Art Center on 56th Street (and later at the Composing Room Gallery 303). Though the show was well attended and favorably covered in the press, business commissions were slow in coming. During his first years in New York, Bernhard was occasionally called on to render advertising sketches, but most were rejected. Although his German style was not appreciated in New York, he refused to compromise to American tastes. Until around 1927, he worked exclusively on interior and furniture design for wealthy clients on Fifth and Madison avenues.

During the late twenties Bernhard helped found, with the financial backing of a prosperous emigrant furrier, the first international design consortium, called Contempora. It was founded on the Weiner Werkstatte's credo: the "complete work of art." It was a quirky mix of contributors — Bruno Paul (the former Jugenstil cartoonist), in Munich, Paul Poiret (the fashion designer) in Paris, Rockwell Kent (the illustrator) in New York, and Erich Mendelson (the architect) in Vienna. They produced everything from graphics to textiles,

ABOVE: *Type specimen book covers from* (LEFT) *Bernhard Brushscript, c. 1933, and* (RIGHT) *Bernhard Types, c. 1935.*

accessories to furniture. Contempora even produced a line of chairs for the Grand Rapids Furniture Company. But despite a reasonable popularity, the venture failed during the Great Depression.

With all of his varied activities, one might get the impression that Bernhard was sympathetic to the goals of the Modern movement. Actually, he was not. Bernhard used to say he was a doer, not a theorist or an ideologue. Though well reasoned and carefully designed, his work was based not on systems but instinct. He apparently disapproved of the Bauhaus and any form of ism that made more (or less) of the advertising process. If Bernhard had a philosophy, and he would never give it such weight, it might be found

NEW ENGLAND

AMERICAN
AMOCO
GAS

The sign
of Greater
Values

AMERICAN OIL CO.

NO. 19

Buy REM
bye-bye
cough!

REM

ATLANTIC
WHITE
FLASH

A SUPER FUEL
–NO EXTRA COST

in his words: "You see with your eyes, not with your brain. What you do with your hands should express the physical process and should never be mechanical."

Beginning in the late twenties and lasting for nineteen years, Bernhard produced one 24-sheet poster a month for Amoco and a lesser, but sizable, number for White Flash gasoline. Because advertising was still a copywriter's game, many of these posters were dominated by lettering, often one word or a short slogan accompanying the logo. Indeed, most of the ideas took Bernhard less than an hour to sketch. Another very harmonious working relationship grew between Bernhard and the president of ExLax. What began as a rather simple job to design the firm's matchbook ended in a long-term commission to create packaging, a new trademark, and the interior design of its Brooklyn factory and offices. Other regular accounts included Radio City Music Hall, Marlboro Shirts, the Theater Guild, Westinghouse, and Cat's Paw, the logo for which is now considered a vernacular treasure.

Bernhard had developed typefaces for Flisch and Bauer Typefoundries in Germany, including a transitional bold brush script. He designed his first elegant script, Bernhard Kursive, in 1922 while traveling from Germany to New York on a steamship. In 1928 he joined forces with American Type Foundry, for whom he produced his family of gothics. He believed that sans serif type should not be used for text, once writing: "There is no doubt that the best type for continuous reading is the one in which schoolbooks, novels, and newspapers are printed: Garamond, Jenson, or Goudy Old Style." Understanding that display faces were subject to the whims of fashion, however, he cluttered the market with new advertising faces.

After World War II Bernhard turned away from graphic design and focused almost exclusively on painting. Since the thirties he had painted mundane portraits of women. He asserted that painting was his true art; some might say it was his real folly. The switch in emphasis came because the advertising business was changing and decisions were being made by committees and middle-level art directors. Bernhard found that art directors were bringing in specialists to do portions of campaigns or identities and, since he was accustomed to doing the entire job, he had no taste for the limitations that specialization imposed. He once said, "If I am going to be forced to specialize, I will do it with painting." Increasingly, Bernhard's sons saw to the daily studio operations and continued to do packaging and advertising into the early 1960s.

Toward the end of Bernhard's ninety-plus years, the old master decided that he wanted to return to graphic design. His comeback was stifled, with the exception of a few random jobs, by a new generation of art directors who had no idea who Bernhard was or what he did. All they could see when Karl dutifully brought his father's portfolio around was a lot of old-fashioned work. However, though Bernhard's life's work was made passé by changes in technology and style, this extraordinarily prolific man left behind a significant body of work. If he were remembered only for creating the paradigm of twentieth-century poster art, that alone would ensure his place in the history of graphic design.

ABOVE: *Cat's Paw logo, 1947.*

(A Magazine for Exiles)

BY MICHAEL DOOLEY

Critical Conditions *Zuzana Licko, Rudy VanderLans, and the Emigre Spirit*

OPPOSITE PAGE: *Zuzana Licko and Rudy VanderLans, 1997. Photograph by Hope Harris.*
ABOVE (LEFT TO RIGHT): *Cover, Emigre no. 1 (1984). Typeface: Customized Empire (by Morris F. Benton). Title page, Emigre no. 8 (1987). Typefaces: New Alphabet (by Wim Crouwel) and Matrix. Cover, Emigre no. 12 (1989). Typefaces: Customized Empire (by Morris F. Benton) and Oakland.*

ALL *EMIGRE* COVERS AND SPREADS WERE DESIGNED BY RUDY VANDERLANS AND ALL FONTS DESIGNED BY ZUZANA LICKO, EXCEPT AS NOTED.

For over a decade of typeface design and magazine publishing, Zuzana Licko and Rudy VanderLans have withstood virulent attacks from an entrenched design establishment as well as from their contemporaries. Throughout it all, they have continued to pursue their unique visions and, consequently, have been a prime force in revolutionizing the industry and cultivating a spirit of exploration.

Brian Eno's quip about the Velvet Underground — that only a few thousand people bought their record but every one of them went on to form a band — could apply as well to *Emigre*. Although the print run of the first issue was 500 copies and its circulation peaked at 7,000 several years ago, its reverberations are still being felt around the world. The magazine that VanderLans published and art directed, and the fonts Licko developed for it, have stimulated designers to defy, and even overthrow, entrenched rules and to set new standards.

Neither Licko nor VanderLans set out to transform the face of modern design. They achieved their notoriety rather unconventionally. Bay Area designer Chuck Byrne, who has closely observed their careers from the beginning, explains: "In the last fifty years or so, making a reputation for yourself was basically a process of winning competitions, getting your work published, and going around pontificating to the world about how great you are. What drove the establishment crazy was that Rudy and Zuzana totally short-circuited this apprenticeship and became famous simply by designing for this international group of admirers."

Licko was born in Bratislava, Czechoslovakia, and moved to the United States at the age of seven. Her father, a biomathematician, provided her with access to computers and the opportunity to design her first typeface, a Greek alphabet, for his personal use. She entered the University of California at Berkeley in 1981 as an undergraduate. She had planned to study architecture, but changed her major to visual studies and pursued a graphic communications degree. Being left-handed, she hated her calligraphy class, where she was forced to write with her right hand.

VanderLans was born in the Hague, Holland, and attended the Royal Academy of Fine Art from 1974 to 1979. Initially aspiring to become an illustrator, he enrolled in the graphic

design department. After an apprenticeship at Wim Crouwel's Total Design studio, he did corporate identity work at Vorm Vijf and Tel Design. When his application to the UC Berkeley graduate program was accepted in 1981, he moved to California, where he met Licko. They were married in 1983.

Also in 1983, mistakenly thinking he was applying for a job at Chronicle Books, VanderLans found himself at the *San Francisco Chronicle*. He was hired by the editorial art director to do illustrations, cover designs, and graphs. His frustrations with the harsh demands of a daily newspaper motivated him to seek other creative outlets.

Emigre was originally intended as a cultural journal to showcase artists, photographers, poets, and architects. The first issue was put together in 1984 in a 11.5" by 17" format by VanderLans and two other Dutch immigrants. Since there was no budget for typesetting, the text was primarily typewriter type that had been resized on a photocopier.

Working with the newly invented Macintosh computer and a bitmap font tool, Licko began creating fonts for the magazine. Emperor, Oakland, and Emigre were designed as coarse bitmapped faces to accommodate low-resolution printer output. They were used in issue two, and, after several readers inquired about their availability, she began running ads for them in issue three.

By 1987, the other founders had left *Emigre*. Working under the title Emigre Graphics, Licko edited screen fonts at Adobe Systems, Inc., while VanderLans, who had left the *Chronicle*, designed new magazines: *GlasHaus* for an organizer of party events and *Shift* for San Francisco's Artspace gallery. He also continued to publish *Emigre* while Licko constructed more fonts with bold, simple geometry, such as Matrix and Modula. Their cold, rational appearance served to anchor VanderLans's free-spirited layouts.

Emigre became a full-fledged graphic design journal in 1988 with issue ten, produced by students at the Cranbrook Academy of Art in Michigan. VanderLans concentrated on work that was being neglected by other design publications, either because it didn't adhere to traditional canons or it was still in its formative stages. The issues, each built around a theme, have featured Ed Fella, Rick Valicenti, and David Carson from the United States, Vaughan Oliver, Nick Bell, and Designers Republic from Britain, several Dutch designers, and many others who were exploring new territory. Several controversial articles and interviews have appeared over the years, provoking other design publications to become more opinionated.

In 1989, the fonts had become enough of a commercial success that Licko and VanderLans gave up freelancing and concentrated exclusively on their own business. *Emigre*, which had been published erratically, settled into a quarterly schedule.

In designing *Emigre*, VanderLans rejected standardized formats in favor of organic grid structures that reflected his enthusiasm toward the contents. Computerized page composition gave him the flexibility to reinvent the look of the magazine with every issue. Sometimes several articles would run through the pages concurrently, each text differentiated by font, size, leading, and column width, creating an impression of eavesdropping on several simultaneous conversations. Nuanced type variations within sentences created the mood and rhythm of spoken words. Even the logo has gone through several permutations.

When their work began to receive public attention, it was attacked for promulgating visual incoherence and viewed as a threat to Modernist ideals and an affront to universal notions of beauty. Massimo Vignelli was their most vociferous critic. Throughout the early '90s, he denounced the magazine and fonts as garbage, lacking depth, refinement, elegance, or a sense of history.

The text and typography were hardly indecipherable to its intended audience. In fact,

EMIGRE №19:
Starting From Zero

Price: $7.95

EMIGRE

Ô

neo-

mania

EMIGRE

Nº 24

Price $7.95

Hello?

Is anybody there?

RUDY

I'd love to (Hungary)

But I can't

—`OVER`—
WHELM—
=ED— ´

WITH STUFF
(PLEASE) ASK ME
AGAIN

thanks
Honored
TIBOR

y please

mediately.

EMIGRE

re.designing stereotypes

Emigre #13, Price $7.95

3...days atCran-Brook

ROUTE 666

TRANSGRESSING THE INFORMATION SUPERHIGHWAY

BY PUTCH TU

When I was 8, I fixed a toaster that all others had given up on, including my much older brothers, all of whom were or wo uld soon be engineers. It c ould have been that the mere fact of taking it apart and putting it back together one more time had done the trick, or it could have been that going strictly on the visual patterns the wires made, I had seen something not quite right and repatterned it. In any case, we used that toaster for another few years. No one ever mentioned that I fixed it—that was taboo. In fact, I got quite a verbal whapping for playing with "dangerous adult things, things that could hurt" me. Where I had a great deal of pride in fixing the thing, sharing that fact at the dinner table led only to disaster. They just thought I was a dumb little kid who wouldn't know any better than to stick bobby pins into a light socket. I got the scolding of my life, and my brothers wouldn't let me near their tools and gizmos again. I wondered what sin I had committed, confused because I fixed something essential to our mornings, and all I got in return was disbelief and verbal abuse.

THIS STORY IS TRUE

06 07

ABOVE (CLOCKWISE FROM TOP LEFT): *Spread from Emigre no. 19 (1991). Typeface: Template Gothic (Barry Deck). Spread from Emigre no. 27 (1993). Typefaces: Helvetica (Max Miedinger) and Times Roman (Stanley Morison). Page spread, Emigre no. 32 (1994). Designers: Rudy VanderLans and Gail Swanlund. Typefaces: Template Gothic and Arbitrary (Barry Deck) and Triplex.*

OPPOSITE PAGE (ABOVE): *Flyer announcing Emigre nos. 13 and 14 (1990). Typefaces: Triplex and Senator. (BELOW): Spread, Emigre no. 24 (1992). Photographer: Anne Burdick. Typeface: Arbitrary (Barry Deck).*

#13

Emigre #13. Redesigning stereotypes.
It's time for the Big Bens, wooden shoes, lederhosen, cowboys & Indians, towers of Pisa, bowler hats, kangaroos, and exotic beaches to move over. For this issue, designers from around the world update their national symbols. Featuring Wolfgang Weingart, Rick Delicotti, Neville Brody, Steven R. Gilmore, John Weber, Malcolm Garrett, Mitsuhiro Miyazaki, Allen Hori and many others. Price $7.95 plus $1.50 postage & handling.

emigre no. fourteen

young swiss designers

Emigre was quite inviting and involving for its readers, who had a high degree of visual sophistication. "People read best what they read most" has become a credo for Licko and VanderLans and has been adopted as a rallying cry by designers eager to challenge preconceptions of type design and magazine layout.

While Licko and VanderLans were being pilloried by traditionalists, designers who had once championed their work for its aggressiveness began to condemn it as too readily identifiable, and therefore unusable. *Beach Culture* magazine published an issue with a cover line that boasted "no Emigre fonts," although the logo itself was set in Licko's Senator.

Much of the initial opposition has abated, as the same designs and font styles once considered ugly have become assimilated throughout mainstream print and electronic media. The *Emigre* sensibility has achieved commercial acceptance by popularizers like David Carson. No longer viewed as radical or unique, the work of Licko and VanderLans regularly garners accolades from many notables in the field.

In 1995 *Emigre* reduced its page size to more conventional magazine proportions and adapted a relatively staid, conservative appearance. The contents also underwent a dramatic change. VanderLans explains, "Instead of focusing on the designers' intentions and the designers' work, we decided to turn the tables and look at how this work is impacting our culture." CalArts instructor Jeffery Keedy, who has been affiliated with the magazine for nearly a decade and whose Keedy Sans typeface is distributed by Emigre Fonts, is now a frequent contributor, as are North Carolina State University professor Andrew Blauvelt and writer/designer Anne Burdick.

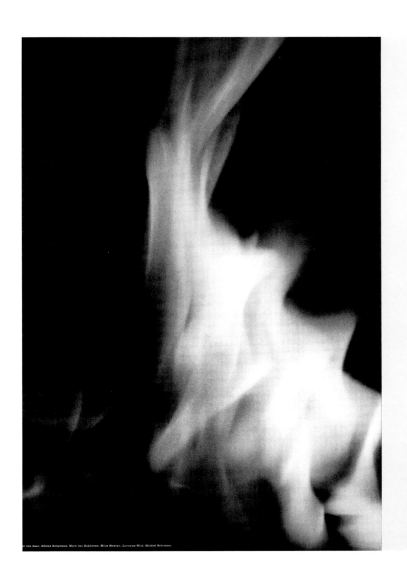

Continued from 12

RAY GUN

I am really not worried about issue Nº 24. Right now I'm worried about issue Nº 2. I want to develop something with a strong enough voice so that it can remain independent of editorial staff changes and business pressures and still remain a piece of work that speaks to an audience. Although I haven't really thought about the long term, what makes *Ray Gun* attractive is that it has an element of change conceptually built in, because you are talking about cutting edge music aimed at an audience that should be receptive to that, and an industry that needs something like that because there is nothing else out there that really captures music in a conceptual way. E M I G R E : But this sounds somewhat like it could be the editorial outline of *Spin* magazine. N E I L : There is no question that *Spin* is a really great magazine. But I don't think that *Spin* is a very pretty magazine. I don't think it is design oriented and I think that *Spin* plays a ton of favorites. E M I G R E : It's not designed like *Beach Culture* because *Spin* probably chose to remain more neutral in their design in order to not be out of fashion after six issues. N E I L : I don't know, maybe that has more to do with the fact that it changes editors far more frequently than it does art directors. But I read *Spin*. I like their attitude a lot. E M I G R E : How will *Ray Gun* be different from *Spin*? N E I L : *Ray Gun* is going to be similar to *Beach Culture* in that we are going to spend a lot more attention with the design and the marriage of design and words. We're obviously going to be covering Sonic Youth like *Spin* and every other music magazine. We're going to have, I imagine, a more West Coast orientation just because David and I are here. As far as I am concerned, and I might differ with Marvin here, I am completely indifferent to whole areas of rock journalism, in particular reviews: that is, feeling the need to be on the PR junket circuit and to always be pushing current product. I am far more interested in the quirkiness, the history, the artists, the indies, etc. It's how we feature the artists that makes us slightly different. The cover article of our first issue is on Henry Rollins and we focussed on his publishing efforts and his workaholism, as opposed to his music. There will be a very lengthy article on Sonic Youth. This will also set us apart from *Spin* and other magazines; we give them more pages. David gave six artists he liked an assignment to do an illustration of their favorite song and I don't think *Spin* would do that; you can't sell ads doing that (because advertisers want their ads positioned next to editorial). I picked an anonymous article that I like a lot, which is about what happens if a feminist falls in love with a rock singer. And we have a fashion piece photographed by Mat Mahurin. It's six or seven pages long, and there are no clothes in it. It's a very funny piece. Anyway, David and I went gonzo over this feeling that *Ray Gun* had to be different. I can't cover bands in many different ways because they're all the same bands that are on the same circuit and at least fifty or sixty percent of them are going to be in every music magazine out there. But I can try to find the angles that don't have anything to do with music, at least in a very literal sense, and throw them out there and see if there is a need and an audience for them.

13

Some readers have become put off by the academic, often pedantic tone of what they consider diatribes and manifestoes rather than essays. VanderLans is intrigued by "the readers who categorically dismiss design writing and design criticism of any kind. Many designers simply do not see how it connects to them and their profession. How to make it relevant is a great challenge."

Keedy sees the new emphasis on theory and analysis as a necessity. "*Emigre* couldn't continue as this subcult anomaly, a fanzine for the avant-garde, because the avant-garde is over. Rudy and Zuzana were in the middle of a moment of change in the eighties and the next generation is still doing the same thing. There hasn't been another paradigm shift, so there just isn't enough hip, groovy new stuff to show."

As the text has become foregrounded, many who purchased *Emigre* for visual rather than intellectual stimulus have lost interest. Chuck Byrne still sees much that is praiseworthy in the magazine's layout. "The emphasis has gone from individual spreads to these astounding studies in form spread out over a large number of pages. Rudy's fiddling with Modernist concepts the way an accomplished jazz musician might play with a theme. His work has always been a lot more formal than most people realize."

Licko's fonts are also evolving in reflection of the magazine's changing contents. After a variety of releases, including a set of pinwheel dingbats and a French-tickler version of Modula, she is putting her own spin on classical serifs with Mrs. Eaves and Filosofia, reinterpretations of Baskerville and Bodoni.

Respected typographers now publicly acknowledge the legitimacy of Licko's font designs. Matthew Carter, a 1995 AIGA gold medalist, commented, "Two ideas seem to me to stand behind the originality of Zuzana's work: that the proper study of typography is type, not calligraphy or history, and that legibility is not an intrinsic quality of type but something acquired through use."

Licko's ascendance in a primarily male-dominated profession and her bypassing of traditional training have been an inspiration to a generation of font designers with access to computer technology. The market has been deluged with knockoffs of her style. She says: "It's funny: when I look back on my work over the last twelve years, I realize that at first I had trouble getting people to take my work seriously, while now I have trouble getting them to stop copying my work."

To the surprise of those who recall Massimo Vignelli's earlier excoriations of *Emigre*,

ABOVE TOP: *Page, Emigre Fonts Catalog* (1994). Designers: Rudy VanderLans, Gail Swanlund, and Zuzana Licko. Typeface: Citizen. Cover, *Emigre Fonts Catalog* (1996). Typefaces: Dogma and Base. BELOW RIGHT: *Spread, Emigre Catalog* (1997). Typefaces: Emigre, Emperor, and Whirligig (Zuzana Licko) and ZeitGuys (Eric Donelan and Bob Aufuldish).

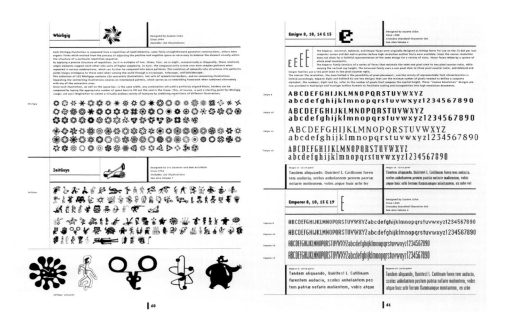

BELOW (CLOCKWISE FROM TOP LEFT): *Spread, More Mrs Eaves booklet. Typeface: Mrs Eaves Smart Ligatures. Spread, Emigre no. 42 (1997).* *Typefaces: Ottomat (Claudio Picinnini) and Base. Spread, Emigre no. 37 (1996). Typefaces: Indelible Victorian (Stephen Farrell) and Base.*

THE AARDVARK

Deconstructivist theorists

HERO GOGGLES

We be freeky and flippy

SUPER SCHOOL

If you find energy sticky

AMBIENT LAVA LAMP

Scruffy poetry sprees

THINK VANILLA

Affinity with happy gifts

New RELEASE

INTRODUCING
213
MRS EAVES LIGATURES

Designed by Zuzana Licko

At first I was suspicious of the richness and illusory depth of Stephen Farrell's graphic design. The moves were too smooth, facile, even. A Chicago-based graphic designer, Stephen is a strong proponent of visual/verbal experimentation and poetics in graphic design. Nonetheless, when I received his submission to the Mouthpiece project, I set his package aside, preferring at the time discord and the unfamiliar. But I couldn't get Stephen's design for Brooke Bergan's review of The Gregg Bendian Project out of my mind. A slinky and jazz. It was just so perfect. So I submitted to the seduction, to the visceral play with language, structure and rhythm that resulted from his attentiveness to the written and spoken word. It is this sensitivity that enables Stephen to collaborate with two very different writers whose only commonality is a belief in the communicative capacity of form. Stephen's "joint ventures" with poet/performance artist/independent publishing entrepreneur Daniel X. O'Neil frequently serve the interests of both parties: Dan's poetry, which he self-publishes through Juggernaut, and Stephen's typefaces, which are distributed through [T-26]. On the other end of the spectrum, Stephen's projects with (meta-)fiction writer Steve Tomasula for the literary journal *Private Arts* are strictly a labor of (language) love.

» Anne Burdick «

Page spread from *Boilerplate*
Text by Daniel X. O'Neil
Design by Stephen Farrell
Published by Juggernaut

An interview with Stephen Farrell

Anne Burdick: Could you tell me a little about your collaborative relationships with Daniel X. O'Neil and Steve Tomasula?
Stephen Farrell: I first met Dan while I was designing a promo book for [T-26] and we decided to display the typefaces using Dan's poetry. Dan writes for the spoken word; he's a performer first and a poet second. A lot of his work deals with local issues, local politics and national news, snippets that he gets. Our collaborations have mainly focused on verse essays or I've taken some of his poetry that's been published in his books or that he's brought over on legal pads or things that he's faxed. Our collaborations are fairly spontaneous and erratic – if a poem grabs me, I'll work with it even if it's been published in another form by another artist. That's the interesting thing about these joint

ventures. There is no definitive form, not even a definitive medium. A single poem like *Injured Child Flown to London* may unfold as a performance piece, a limited edition print, a page in a book and a piece of music. One of his poems was first published on his face. The cover of our booklet, *Boilerplate*, was printed on shooting range targets. In some cases, I've used his pieces to promote my fonts. As I'm finishing up a font, he might pass me a poem that seems to speak in that font.
The work with Dan led to me to *Private Arts*. One of my students was working with Steve Tomasula. *Private Arts* needed somebody to design the journal and work with some of the writers. I had a meeting with Steve [Tomasula] and we argued the first time we got together. (Laughs) It was kind of a strange meeting. I showed him some of the

things that Dan and I had done. But *Private Arts* was a much larger organization, with a board of directors. They were just getting their feet wet with the idea of consciously merging poetry and design. And so they wanted to take it slow. But that relationship has blossomed. And I'll tell you, Steve has donned the mask and cape many times in our defense.
A: With the board of *Private Arts*?
S: Right, with the board, with the president. They ended up sending out sheets to all of the writers who were going to be in the journal. Basically, they had them rank from one to five how much they would allow their pieces to be designed. Some of the writers circled one; they vehemently wanted their work to be very standard, very traditional. Other poets latched onto the idea. They were fives. (Laughs) They

Indelible Victorian
Typeface design and layout by Stephen Farrell
Text by Daniel O'Neil
First published in the [T-26] type catalog

wanted us to really experiment with the union of image and text. It was nice because I first worked with the editors, Brook Bergen, Dale Heiniger and Steve Tomasula. We used these pieces as standards to show the others: this is what's possible.
Some of the writers were already working with artists, so they had a very definite form that they wanted to attach to their work. But there were a lot of writers who were very suspicious and very protective of their work. An iconoclastic notion of authorship kept coming in, a fear of the loss that might come from a speaking surface. I think a lot of the writers see it as an infringement, a trespassing – if it's not done well, that is.
A: In the letter that you and Steve Tomasula sent me, you wrote, "It is no more possible to have form without content and content without form. Even the most designerless prose, the justified block of type, is a design instilled with value (in this case, standardization and simulated transparency)." It's the whole simulated transparency aspect of it that these writers believe in.
S: Right. We're familiar with the standardized block of copy and we are programmed to look through its design. I think that's what the writers want in a lot of cases. I think they see their words as the things packed with...
A: All the meaning?
S: Yeah.
A: You guys use content and form, what I would consider an artificial breakdown. As soon as you switch the word "content" to "meaning," it becomes a much different thing. Content is understood as the intention, as coming from the source. Whereas meaning is now increasingly understood as occurring at the site of the reader. The meaning is different from the form; the form is the actual thing itself. The meaning is, I guess, what the whole of it says.
S: I think that there is a common notion that content is the writing and form is the design and meaning is the reader. But maybe it would be better to say that writing and design are interdependent modes of representation.
A: Do you think that the writers would say that the meaning that the readers take away comes from the "content" as opposed to the "form"?
S: Yes. (laughs) Like I said, it depends. For somebody like Steve or Brooke, they definitely see the two as crisscrossing and not only inseparable, but as having equally valid things to say. The form, especially in Brooke's piece, *The Gregg Bendian Project*, is very prevalent; the surface has been marred quite a bit. And that's for a good reason. Jazz has so much to do with form. I think good design opens up. Like we said in that letter, "Design functions as a grammar

Continued ›

...and wrote as many poems as we could before our languages became strange again.

Indelible Victorian

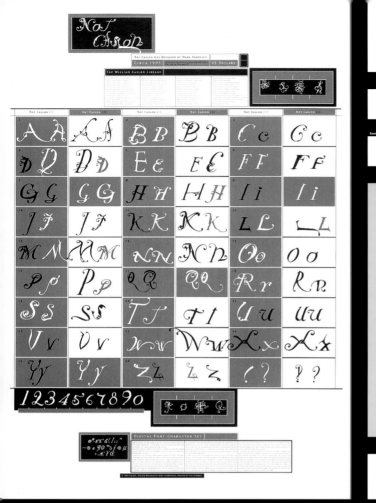

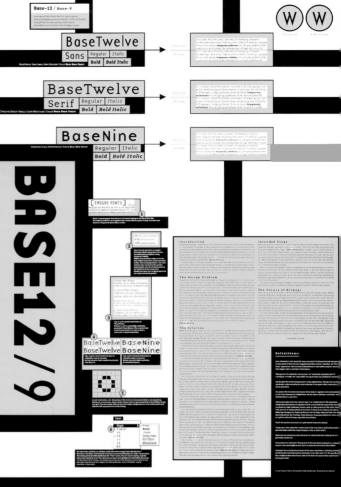

My Favorite Type Face

Before the age of personal computers, when I used to spec typefaces out of photo typesetters' style books, my favorite typeface was Bodoni. I was attracted to its clean lines and geometric shapes, and the variety of headline style choices. However, for practical reasons, I often decided against using Bodoni for long texts, as the extreme contrast made it difficult to read at small sizes.

Since then, there have been many digital font revivals and reworkings of Bodoni's typefaces, some of which have brought to light the numerous variations in Bodoni's type designs not evident in the earlier photo types.

For example, the recent ITC Bodoni was released in three variants, each optimized for a range of sizes, and each with very distinct features, reflecting the variety of Bodoni's work.

In fact, Bodoni spent his entire life building a large collection of over 400 fonts. He started with Fournier's types as a model, and over time developed a general style that tended toward simplicity, austerity and a greater contrast between the vertical stems and hairlines than previously seen, resulting in what we know today as the modern face.

In the preface of his "Manuale Tipografico" Bodoni stated: "It is proper here to offer the four different heads under which it seems to me are derived the beauties of type, and the first to these is regularity—conformity without ambiguity, variety without dissonance, and equality and symmetry without confusion."

This apparent development toward the geometry of Modern Face may explain the prevalence of excessively geometric Bodoni revivals which may have gone a step further in this progression than Bodoni intended.

Bodoni's many fonts also included small increments in sizes, sometimes down to half point sizes. As was common practice at the time, each size varied in design to accommodate the effects of the printing process. The characters comprising small text sizes were slightly widened to accommodate ample counters which resisted the tendency to clog up, as well as reduced contrast to ensure that the hairlines would not break up. The display sizes, in turn, were slightly narrower with more contrast, yielding graceful and delicate features which the letterpress process could only maintain at the larger sizes.

This practice disappeared with the introduction of photo type since it became most efficient to simply scale a single design to the various sizes as needed. Since then, technical advancements, including improvements in the printing process itself, have made it less necessary to have size specific design variations. However, it does remain a necessity for the optimum legibility of certain designs, such as Bodoni, which were designed for different manufacturing and printing processes than those used today. In fact, the extreme contrast problem of many Bodoni revivals may be the result of choosing a display size for the model, which subsequently cause the hairlines to erode when reduced to small text sizes.

Although the computer is capable of addressing multiple size masters more readily than photo type did, (Adobe's Multiple Master format can accommodate this), optical scaling remains to be added as a standard feature to the popular font formats, and probably never will, since most contemporary typefaces which are designed for today's technology do not so critically demand such technical wizardry.

Because Bodoni created so many variations, many different Bodoni revivals and interpretations are possible. However, determining which most truly reflect Bodoni's work can be eternally debated. Filosofia is my interpretation of a Bodoni. It shows my personal preference for a geometric Bodoni, while incorporating such features as the slightly bulging round serif endings which often appeared in printed samples of Bodoni's work and reflect Bodoni's origins in letterpress technology. The Filosofia Regular family is designed for text applications. It is somewhat rugged with reduced contrast to withstand the reduction to text sizes. The Filosofia Grand family is intended for display applications and is therefore more delicate and refined.

An additional variant, included in the Grand package, is a Unicase version which uses a single height for characters that are otherwise separated into upper and lower case. This is similar to Bradbury Thompson's Alphabet Twenty Six, except that Thompson's goal was to create a text alphabet free of such redundancies as the two different forms which represent the character "a" or "A," whereas Filosofia Unicase does have stylistic variants to provide flexibility for headline use.

Zuzana Licko

'It's their Bodoni'

he recently produced a direct-mail promotion for Filosofia, which led Licko to speculate on the possibility that "Massimo's willingness to collaborate on our announcement reflects *Emigre*'s ability to bridge different approaches."

Although quite flattered to be the first of a new generation of designers to be selected for the Gold Medal, the adversarial VanderLans is "not so deluded by the praise not to also realize that the award is part of the AIGA's concerted effort to appeal to a younger generation in order to remain significant as an organization. And I can appreciate that kind of thinking. If you believe you have a valid idea, which the AIGA has, then it makes sense to try and sell that to as large an audience as possible."

Licko and VanderLans have always claimed to eschew marketing strategy, maintaining that they produce their products primarily to please themselves. They have never denied accusations of self-indulgence. In fact, it is a point of pride. As a self-published, self-supporting venture, the self-proclaimed "magazine without boundaries" has been free to engage in highly experimental research and development. The fact that they have parlayed their passions into a successful international enterprise is simply a fortuitous byproduct.

Emigre Fonts now offers around fifty type families designed by close to twenty designers. The best known is Barry Deck's Template Gothic, a nod to vernacular signage, while the most notorious is Jonathan Barnbrook's Mason, initially named Manson. From an office in Sacramento, Emigre Graphics also sells posters, T-shirts, and other peripheral items through its catalogue and Internet website. A music label that was launched in 1990 is presently "dormant," as VanderLans puts it.

Licko and VanderLans invest as much time and effort in the business side as in the creative side. "Without our personal involvement in licensing contracts, distribution agreements, legal matters, accounting, etc., *Emigre* would simply not exist. Fact of the matter is, we consider ourselves as much businesspeople as we consider ourselves designers." Byrne strongly agrees, pointing out, "Anyone who considers Rudy a wild primitive who doesn't know anything about organizing information should look at any *Emigre* order form. They have always been the clearest, most concise designs for sending in money."

Emigre, which has been famous for making the most of low-budget production values, has converted to full color with its 42nd issue, which was sent to the *Emigre* mailing list of 43,000 and is being offered free to anyone who fills out a reply card. The increased circulation is part of an attempt to attract advertisers.

Keedy sees this as a smart move, one that will expand their audience. "There's not a huge demand for the magazine right now, but I think this strategy will, in fact, create that demand. I see *Emigre* ten years from now as a slick, glossy special-interest magazine that has its own niche.

"Naturally, people are going to say Rudy and Zuzana are selling out and going mainstream. They're in a weird phase right now, and the question is, can they make it? I think they will. They have always been ahead of the market, not behind it. They're very much in their time and always on the move. That's the critical factor in all they've done."

Irrespective of the medium or form, the design of understanding is not just about graphics, charts, maps, and exploded diagrams. Providing context and a point of view that inspires, provokes, and compels ideas into action is the design of understanding. It's not rocket science. It's social science — the science of understanding people's needs and their unique relationship with art, literature, history, music, work, philosophy, community, technology and psychology. The act of design is structuring and creating that balance. This show celebrates the triumphs of that endeavor.

Clement Mok
CO-CHAIRMAN

Designers visualize messages directed at their clients' audiences in ways that are meant to enlighten and inform. But as Raymond Loewy put it: ugliness doesn't sell. Often, we must entertain in order to attract attention. And designers — including the newly defined subset of information designers and information architects — have a responsible role to play. We are interpreters — not merely translators — between sender and receiver. What we say and how we say it makes a difference. If we want to speak to people, we need to know their language. In order to design for understanding, we need to understand design.

Eric Spiekermann
CO-CHAIRMAN

CALL FOR ENTRY
Design Clement Mok, Studio Archetype

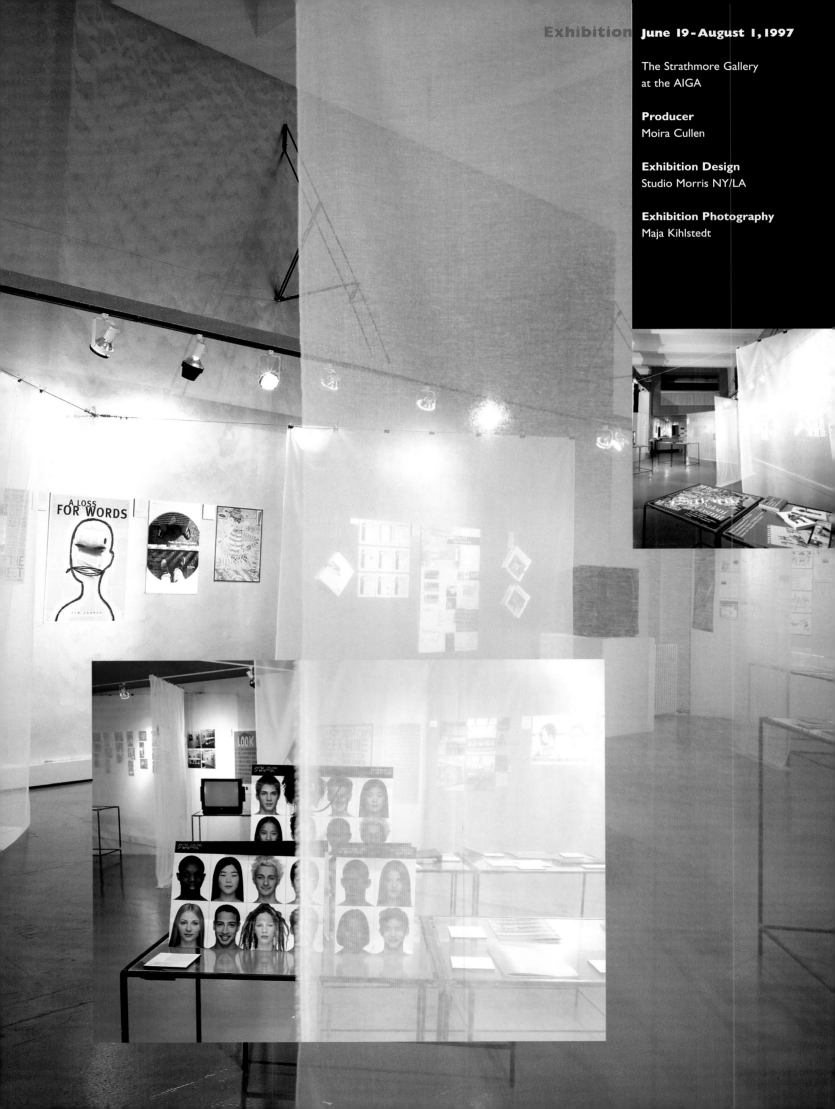

Exhibition **June 19 - August 1, 1997**

The Strathmore Gallery
at the AIGA

Producer
Moira Cullen

Exhibition Design
Studio Morris NY/LA

Exhibition Photography
Maja Kihlstedt

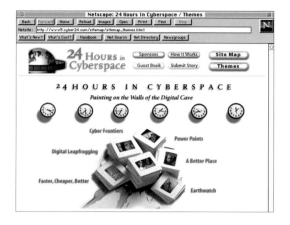

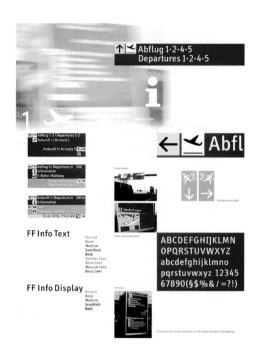

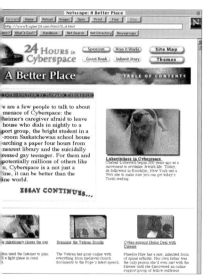

Clement Mok (co-chair) is a self-described "media agnostic" who creates meaningful connections between people, ideas, art, and technology through his many design and consulting projects — everything from cyberspace theme parks and expert publishing systems to major identity programs. Currently chairman and information architect of Studio Archetype (San Francisco), Mok is the founder of two successful products companies: CMCD (publisher of the award-winning Visual Symbol Library, a collection of royalty-free photographs and spot animations) and NetObjects (one of *Fortune* magazine's "25 Coolest Technology Companies in 1996"). Formerly creative director at Apple Computer, he has published internationally and has received hundreds of awards in many industry categories. He is a charter board member of the New Media Centers and the author of *Designing Business: Multiple Media, Multiple Disciplines* from Adobe Press, a book about applying design and business principles in the context of digital media.

Erik Spiekermann (co-chair) is an internationally recognized graphic designer whose typeface Meta has become one of today's most popular fonts. In the international design and typographic community, he is a tireless spokesman for the need for the functional yet aesthetic design of everything from typefaces to transportation time schedules. Founder and managing partner of MetaDesign (Berlin and San Francisco), Spiekermann was the first German to own a Macintosh computer. He continually pushes the limits of desktop typography and design and is currently a partner in FontShop, an international franchise of mail-order type libraries for Macs and PCs with a catalogue of over 3,000 typefaces. He is a visiting professor of communication design at Bremen University and has written several books on design and typography, most notably *Stop Stealing Sheep* for Adobe Press.

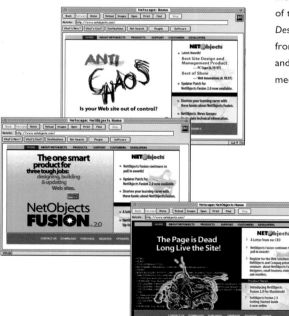

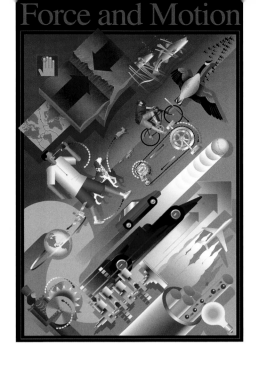

Force and Motion

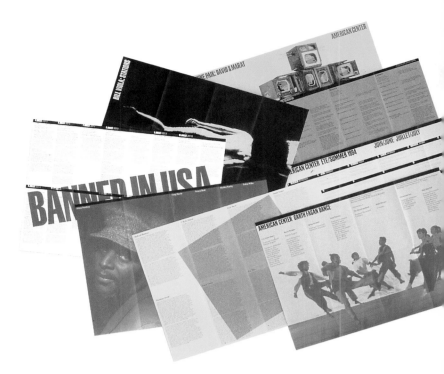

Richard Curtis, a founding editor of *USA Today*, is the newspaper's managing editor of graphics and photography. A graduate of the School of Design at North Carolina State University, Curtis returned there in 1992 as the Hearst Visiting Professional in graphics and design. In 1978, he co-founded the Society of Newspaper Design, where he also served as a past president. He founded, and was for several years the editor, of the SPD's quarterly journal *Design* as well. He has lectured throughout the United States and Europe and co-founded the Freedom Forum's flying short course in photojournalism in Eastern Europe. As an independent publications design consultant, he has won numerous gold and silver medals and awards of excellence from the Society of Newspaper Design, the Society of Publication Designers, and *Print* magazine's annual regional design contest. His work has twice received the American Journalism Review's award for best-designed newspaper. He is co-editor of *Portraits of the USA*; editor and designer of *USA Today's Weather Book* and *The USA Today Weather Almanac*; and designer and editor of the Freedom Forum's 1994 book *Death by Cheeseburger: High School Journalism in the 1990s and Beyond*. His work has been noted in several books, most recently Richard Saul Wurman's *Information Architects*.

Wendy Richmond is recognized internationally as an innovator and commentator on visual communication and technology. She has been involved with computer-based media since 1977, beginning with research in design at MIT. She has participated in the formation of software companies to develop new communication media and tools, and co-founded the Design Lab at WGBH-TV. The questions at the heart of her research, writing, and teaching are: How is technology affecting the way we communicate? Does technology hinder or enhance our ability to express ourselves? Does technology divide or bind? She is an NEA grant recipient and has served on the AIGA national board. Her column has appeared in *Communication Arts* since 1984, and her book is titled *Design & Technology: Erasing the Boundaries*. She teaches at Harvard University.

Massimo and Lella Vignelli studied architecture in Venice and at MIT. Together they established the Vignelli Office of Design and Architecture in Milan (1960), as well as the offices of Vignelli Associates (1971) and Vignelli Designs (1978) in New York. Their work includes graphic and corporate identity programs, publication design, architectural graphics, and exhibition, interior, furniture, and consumer product design for many leading American and European companies and institutions, including American Airlines, IBM, Xerox, Knoll, and the New York subway. An exhibition of the Vignellis' work toured Europe between 1989 and 1993, traveling to St. Petersburg, Moscow, Helsinki, London, Budapest, Barcelona, Copenhagen, Munich, Paris, and Prague. Among their many awards are the American Institute of Architects (AIA) Industrial Arts Medal (1973); the AIGA Gold Medal (1983); Interior Design Hall of Fame (1988); The Brooklyn Museum Modernism Design Award for Lifetime Achievement (1995); the Gran Premio Triennale di Milano; the Compasso d'Oro; and the first Presidential Design Award, presented by President Ronald Reagan. Massimo Vignelli has taught and lectured on design in the major cities and universities in the United States and abroad.

1 TITLE **Environmental Graphics for Recreational Equipment, Inc.** DESIGN FIRMS **The Leonhardt Group (Seattle, WA) and Corbin Design (Traverse City, MI)** GRAPHIC DESIGNERS **Robert Brendman and Mark Popich** PHOTOGRAPHER **Marco Prozzo** ARCHITECT **Mithun Partners** CLIENT **Recreational Equipment, Inc. 2** TITLE **"Sense of Government" Installation** DESIGN FIRM **BJ Krivanek Art & Design, Chicago, IL** DESIGN DIRECTOR **BJ Krivanek** ENVIRONMENTAL DESIGNER **Joel Breaux** PHOTOGRAPHER **Jeff Kurt Petersen** WRITERS **The Children of Riverside, Illinois** TYPEFACE **Futura (digitally modified)** FABRICATOR **Fabrication Arts** CLIENT **The Riverside Arts Foundation 3** TITLE **Architectural Graphics and Signage, NYPL Science, Industry, & Business Library** DESIGN FIRM **Spagnola & Associates, New York, NY** CREATIVE DIRECTOR **Tony Spagnola** GRAPHIC DESIGNERS **James Dustin and Robert Callahan** PHOTOGRAPHERS **Christopher Little/Peter Aaron, ESTO** TYPEFACE **Futura** FABRICATOR **Signs & Decal Corp., Walter Sign Corp., Sunrise Systems, Inc. (LED/Electronics)** CLIENT **New York Public Library**

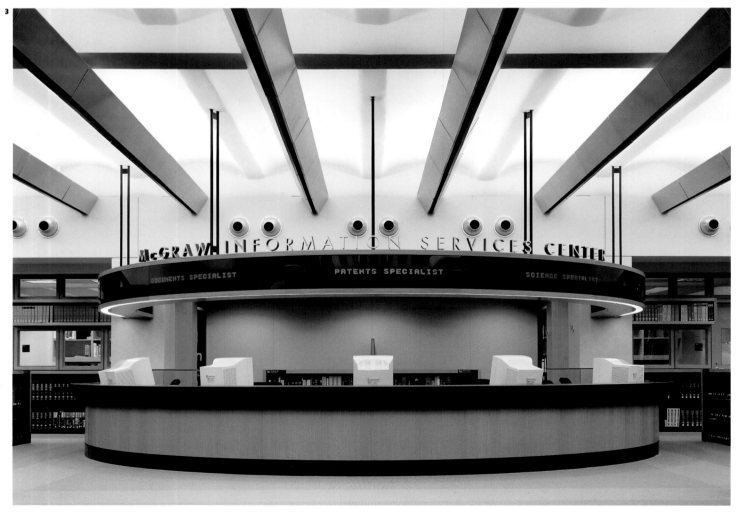

1 TITLE **Playmaze, Chicago Children's Museum** DESIGN FIRM **Peter J. Exley Architect, Chicago, IL** PROJECT MANAGER **Louise Belmont-Skinner** GRAPHIC DESIGNER **Peter J. Exley Achitect** SOFTWARE DEVELOPERS **Raul M. Silva and Peter J. Exley** PHOTOGRAPHER **Doug Snower Photography** FABRICATORS **Exhibit Partners, Inc., and LaBrosse Ltd.** CLIENT **Chicago Children's Museum** 2 TITLE **JM Lynne Exhibition Booth** DESIGN FIRM **Studio Morris, New York, NY** CREATIVE DIRECTOR **Jeffrey Morris** INTERIOR DESIGNER **Debbie Gordon** CLIENT **JM Lynne** 3 TITLE **DuPont Corian 1996 ICFF Trade Show Exhibit** DESIGN FIRM **Pentagram Design, New York, NY** PARTNER/ARCHITECT **James Biber** ASSOCIATE/ARCHITECT **Michael Zweck-Bronner** GRAPHIC DESIGNER **Nikki Richardson** CLIENT **DuPont**

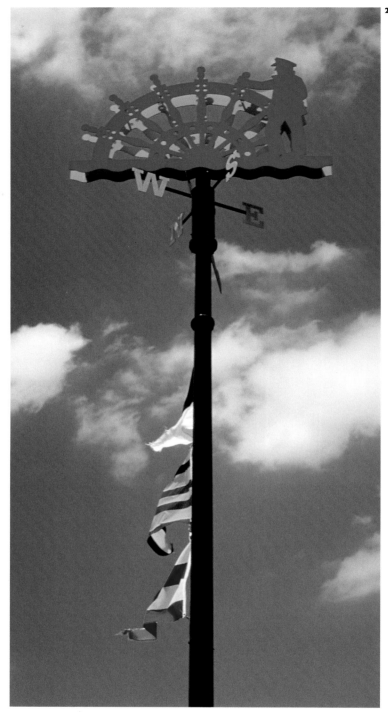

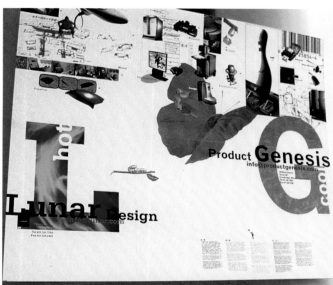

1 Title **Embarcadero Center Graphic Program** Design Firm **Poulin & Morris, New York, NY** Art Director **Richard Poulin** Graphic Designers **Richard Poulin, J. Graham Hanson, and Rosemary Simpkins** Typeface **Univers** Fabricator **Scott Architectural Graphics** Client **Pacific Property Services, L.P.** 2 Title **Newport Riverwalk Environmental Design** Design Firm **Firehouse Design Team, Cincinnati, OH** Creative Directors **Dan Hurley, Kelly Kolar, Gary Meisner, Robert Probst, and Heinz Schenker** Graphic Designers **Kelly Kolar, Gary Meisner, Robert Probst, and Heinz Schenker** Photographers **Robert Probst and Heinz Schenker** 3 Title **Lunar/Genesis Panels** Design Firm **MetaDesign, San Francisco, CA** Graphic Designers **David Nong, Rick Lowe, and Mike Abbink** Photographers **Various** Typefaces **Serifa, Grotesque** Fabricator **The Digital Pond** Client **Lunar Design/Product Genesis**

1 TITLE **Donut King Identity and Environment** DESIGN FIRM **Lorenc Design, Atlanta, GA** CREATIVE DIRECTOR **Jan Lorenc** PROJECT DESIGNER **Chung Youl Yoo** GRAPHIC DESIGNER/ILLUSTRATOR **Rory Myers** IDENTITY DESIGNER **Sook Lim** PHOTOGRAPHER **Rion Rizzo/Creative Sources Photography** ARCHITECT **Steve McCall** INTERIOR DESIGNER **Janice McCall** FABRICATOR **Designers Workship Inc.** CLIENT **Donut King** 2 TITLE **Summitry Works: Words into Action** DESIGN FIRM **StudioWorks, New York, NY** CREATIVE DIRECTORS **Bonnie Berlinhof (Unicef) and Keith Godard** DESIGNER **Keith Godard** INDUSTRIAL DESIGNER **Cecilie Voss** WRITER **Finn Rosted** TYPEFACE **Univers No. 65** PRINTER **All Color Graphics-Screen Print** FABRICATOR **Product & Design** CD-ROMS **NY City/Choose Me, Tate Interactive Systems** CLIENT **UNICEF, New York**

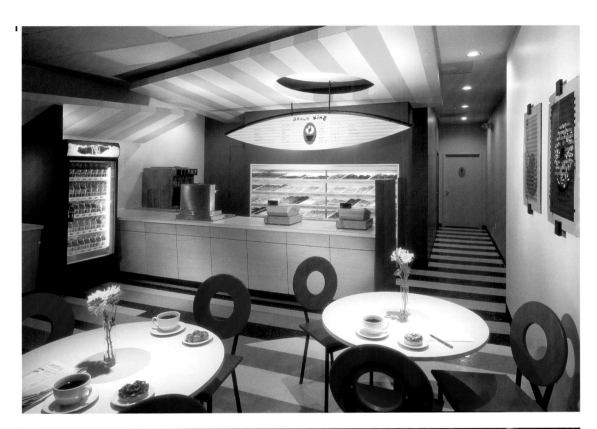

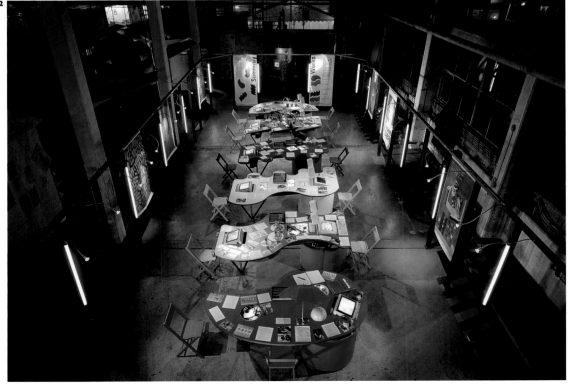

1 TITLE **Champion International Corporation Website** DESIGN FIRM **Jessica Helfand Studio, New York, NY** CREATIVE DIRECTOR **Jessica Helfand** GRAPHIC/INTERFACE DESIGNERS **Peter Cho, Jessica Helfand, Michelle Mierzwa, and Jeffery Tyson** TYPEFACES **Adobe Garamond and FB Interstate** PROGRAMMER **Electric Press, Inc.** CLIENT **Champion International Corporation** 2 TITLE **Leonhardt Group Website** DESIGN FIRM **The Leonhardt Group, Seattle, WA** ART DIRECTORS/ILLUSTRATORS **John Cannell and Greg Morgan** PHOTOGRAPHERS **John Cannell, Greg Morgan, Photodisk, and Marco Prozzo** COPYWRITERS **Greg Morgan, John Kovall, and Lisa Lindberg** TYPEFACE **Meta** PROGRAMMER **Jon King** CLIENT **The Leonhardt Group** 3 TITLE **TechWeb Brand Identity System** DESIGN FIRM **MetaDesign, San Francisco, CA** CREATIVE DIRECTORS **Terry Irwin and Rick Lowe** GRAPHIC DESIGNER **Michael Abbink** INFORMATION ARCHITECT/INTERFACE DESIGNER **Kevin Farnham** PRODUCTION **Jym and Anne Warhol** PROGRAMMERS **Kevin Farnham and Jym Warhol** CLIENT **CMP Publications** 4 TITLE **Font Bureau Website** DESIGN FIRM **Interactive Bureau, New York, NY** CREATIVE DIRECTOR **David Berlow** INTERFACE DESIGNER/PROGRAMMER **Jonathan Corum** TYPEFACE **Interstate** CLIENT **The Font Bureau, Inc.**

1 TITLE **Razorfish Website** DESIGN FIRM **Razorfish, Inc., New York, NY** CREATIVE DIRECTOR **Craig M. Kanarick** INTERFACE DESIGNERS **Thomas Mueller and Stephen Turbek** PROGRAMMERS **Oz Lubling and Marc Tinkler** CLIENT/PUBLISHER **Razorfish, Inc.** 2 TITLE **MetaDesign Website** DESIGN FIRM **MetaDesign, San Francisco, CA** CREATIVE DIRECTOR **Terry Irwin** GRAPHIC/INTERFACE DESIGNER **Conor Mangat** ANIMATOR **Annie Valva** PHOTOGRAPHERS **Various** EDITORS **Conor Mangat, Ken Coupland, William Owen, and Terry Irwin** TYPEFACES **Courier, Meta** PROGRAMMERS **Conor Mangat and Annie Valva** CLIENT **MetaDesign** 3 TITLE **Microsoft Encarta '97 Encyclopedia** DESIGN FIRM **Encarta Encyclopedia team at Microsoft Corporation, Redmond, WA** CREATIVE DIRECTOR **Adrienne O'Donnell** INTERFACE DESIGNERS **Sheila Carter, Bill Flora, and Adrienne O'Donnell** GRAPHIC DESIGNERS **Various** DEVELOPER **Amy Raby** CLIENT/PUBLISHER **Microsoft Corporation** 4 TITLE **Microsoft College Recruiting Website** DESIGN FIRM **Giordano Kearfott Design, Bellevue, WA** ART DIRECTORS **Jeff Boettcher and Susan Giordano** GRAPHIC DESIGNERS **Jeff Boettcher, Diane Christensen, Susan Giordani, Michael McIvor, and Charisa Martin** ANIMATOR **Brian O'Neill/Sitewerks** COPYWRITER **Bonnie Garmus** TYPEFACE **Courier** PROGRAMMER **Sitewerks** CLIENT **Microsoft**

1 TITLE **Communication Arts Interactive Design Annual 2** DESIGN FIRM **Smetts Stafford Media, Berkeley, CA** CREATIVE DIRECTOR **Jeff Stafford** ART DIRECTOR **Bonnie Smetts** GRAPHIC DESIGNERS **Jeff Stafford and Bonnie Smetts** PROGRAMMER **Stuart Easterling** SOUND EDITOR **Marc Pittman/Robert Berke Sound** PUBLISHER **Communication Arts Magazine** 2 TITLE **Novellus Angstromania 2 Invitation Materials** DESIGN FIRM **Larsen Design & Interactive, Minneapolis, MN** CREATIVE DIRECTORS **Tim Larsen and Donna Root** GRAPHIC DESIGNERS **Sascha Boecker and Peter de Sibour** ILLUSTRATORS/ANIMATORS **Dan Jurgens and Joe Rubinstein** WRITER **Dan Jurgens, Two Heads Communications** TYPEFACE **DIN Schriften** CLIENT **Novellus Systems, Inc.** 3 TITLE **Novellus Angstromania 2 Diskette Invitation** DESIGN FIRM **Larsen Design & Interactive, Minneapolis, MN** CREATIVE DIRECTORS **Tim Larsen and Donna Root** GRAPHIC DESIGNERS **Sean McKay and Jon Wettersten** ILLUSTRATORS/ANIMATORS **Dan Jurgens and Joe Rubinstein** WRITER **Two Heads Communications** TYPEFACES **OCRA, OCRB** PROGRAMMERS **Julie Cuddigan, Sean McKay, and Jon Wettersten** CLIENT **Novellus Systems, Inc.**

1 TITLE **Team Lucky Strike Suzuki "Physics"** DESIGN FIRM **Two Headed Monster, Hollywood, CA** ART DIRECTOR **Victor Mazzeo** GRAPHIC DESIGNER **David J. Hwang** COPYWRITER **Howard Roughan** TYPEFACES **Stamp Gothic, Cochin Italic** DIGITAL VIDEO **Two Headed Monster** CLIENTS **Bates Worldwide, Team Lucky Strike Suzuki**

2 TITLE **Team Lucky Strike Suzuki "Leaders"** DESIGN FIRM **Two Headed Monster, Hollywood, CA** ART DIRECTOR **Victor Mazzeo** GRAPHIC DESIGNER **David J. Hwang** COPYWRITER **Howard Roughan** TYPEFACES **Stamp Gothic, Cochin Italic** DIGITAL VIDEO **Two Headed Monster** CLIENTS **Bates Worldwide, Team Lucky Strike Suzuki**

3 TITLE **"Contradictions" — Molson Ice** DESIGN FIRM **Two Headed Monster, Hollywood, CA** ART DIRECTOR **Mike Comisky** GRAPHIC DESIGNER **David J. Hwang** COPYWRITER **David Dyer** TYPEFACES **Various, Custom** DIGITAL VIDEO **Two Headed Monster** CLIENTS **Young & Rubicam, Molson Brewing Co.** 4 TITLE **"Sight Bytes"** DESIGN FIRM **Two Headed Monster, Hollywood, CA** ART DIRECTOR **Greg Wilson** GRAPHIC DESIGNER **David J. Hwang** TYPEFACE **Meta** DIGITAL VIDEO **Two Headed Monster** CLIENTS **Red Ball Tiger, TCI** 5 TITLE **DirecTV "Wimp"** DESIGN FIRM **Two Headed Monster, Hollywood, CA** ART DIRECTOR **Richard Pass** GRAPHIC DESIGNER **Bill Dawson** COPYWRITER **Ed Gines** TYPEFACE **Bell Gothic** DIGITAL VIDEO **Two Headed Monster** CLIENTS **Campbell-Ewald, DirecTV**

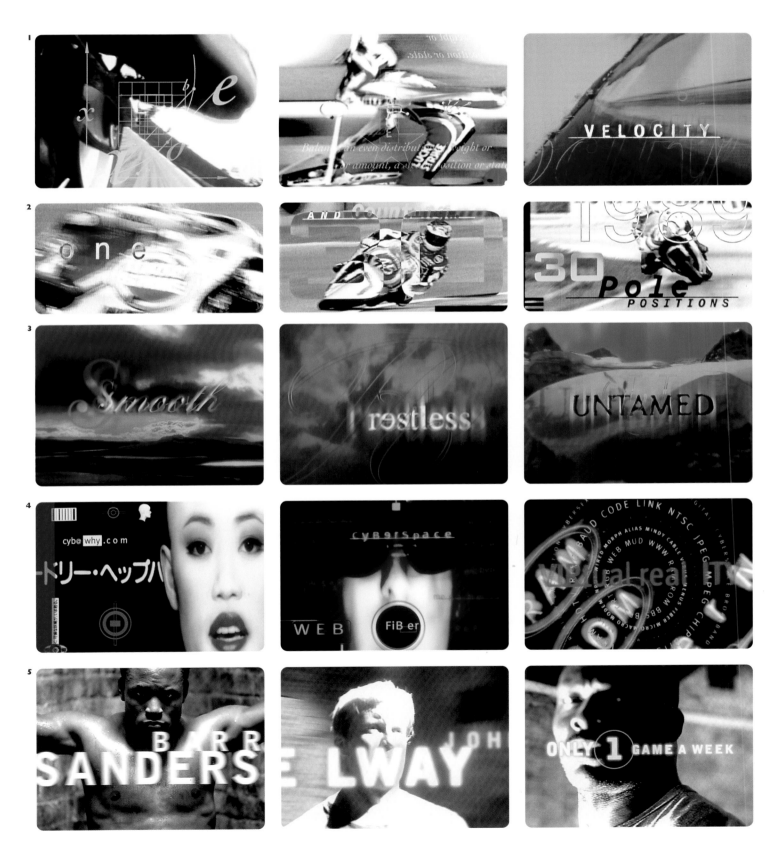

1 TITLE **Interactive Bureau Website** DESIGN FIRM **Interactive Bureau, New York, NY** CREATIVE DIRECTORS **Roger Black and John Schmitz** INTERFACE DESIGNERS **Theo Fels, John Miller, and Tom Morgan** COPYWRITER **John Miller** TYPEFACES **Giza, Interstate, Californian** PROGRAMMER **Frank Desiderio** CLIENT **Interactive Bureau** 2 TITLE **Peponi Website** DESIGN FIRM **Peponi, Seattle, WA** ART DIRECTOR **John Van Dyke** INTERFACE DESIGNERS **John Van Dyke, Danny Yount, and Eulah Sheffield** COPYWRITER **Peponi** CLIENT **Peponi** 3 TITLE **The Mead Annual Report Show: Forty Years of Ideas CD-ROM** DESIGN FIRM **Peponi, Seattle, WA** ART DIRECTOR **John Van Dyke** GRAPHIC DESIGNERS **John Van Dyke and Danny Yount** COPYWRITER **Peponi** PRINTER **MacDonald Printing** PROGRAMMER **Danny Yount** CLIENT **Mead Paper**

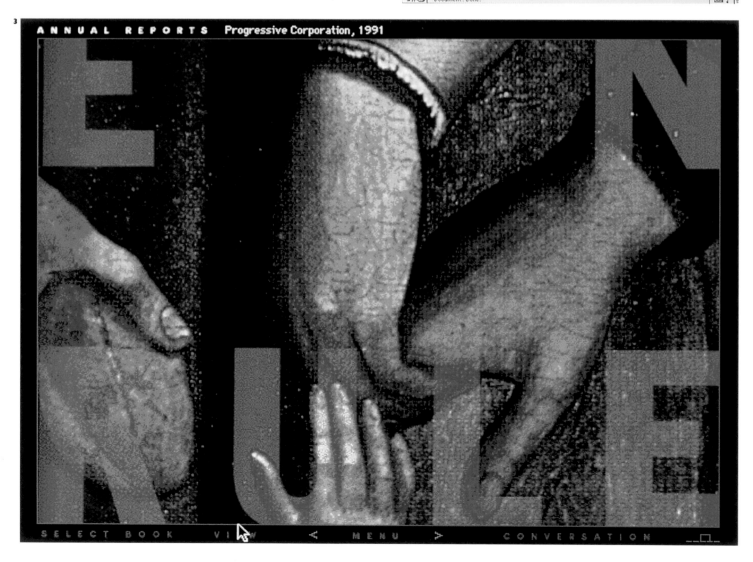

Morningstar
Principia Quarterly

The newsletter for
Morningstar
Principia™ subscribers.

Volume 1, Number 3
Fall 1996

Customizing a Report Using Layout

Principia offers two basic reports: the single-page Fund (or Subaccount) Detail report and the Summary List report. Although the single-page report is preformatted, there are several ways you can customize the Summary List report using the Layout menu. The Layout menu allows you to select which data columns appear onscreen and in a printout. The Rank section of the Layout menu also allows you to specify both a Primary and Secondary Ranking of the investment universe.

Better Tools for Building Portfolios

Morningstar Categories and the New Category Rating
by S. Olivia Barbee, Analyst

Fall Innovations

In the next few months, you can expect more new software features and enhancements. In November we are introducing the new Morningstar Categories and Category Rating (described on pages 4 and 7), which offer innovative ways to accurately compare mutual funds within investment groups and select the right combination of funds for your clients' portfolios. The November release of Principia also includes more-efficient graph functionality, and new mutual-fund regional exposure data. These changes are part of our effort to provide you with comprehensive investment data, presented in ways that best address your needs.

Do you have a new way of using Principia that you'd like to share with others? Please send us your comments and suggestions, and let us know what topics you'd like to see covered in the future. If you need assistance, contact our Technical Support team at 800-866-3472.

GSB REUNION '96
May 10–12, 1996

On May 10, the world is coming to Chicago.

You should be here, too.

UNIVERSITY OF CHICAGO
GRADUATE SCHOOL OF BUSINESS

1 TITLE **Morningstar Principia Quarterly Newsletter** FIRM **Morningstar, Chicago, IL** ART DIRECTORS **Colin Campbell and David Williams** GRAPHIC DESIGNER **Colin Campbell** WRITERS **Various** TYPEFACES **Adobe Garamond, Univers** PRINTER **First Impression** PAPER **Warren Patina 70# Text** CLIENT/PUBLISHER **Morningstar** 2 TITLE **University of Chicago Graduate School of Business Reunion '96** DESIGN FIRM **studio blue, Chicago, IL** ART DIRECTORS **Kathy Fredrickson and Cheryl Towler Weese** GRAPHIC DESIGNERS **Cheryl Towler Weese and Joellen Kames** ILLUSTRATORS **University of Chicago Map Room, Cheryl Towler Weese** WRITERS **Kathy Fredrickson and Pat Nedeau** TYPEFACES **Bauer Bodoni, Officina** PRINTER **Argus Press** PAPER **Finch 60# Text** CLIENT **University of Chicago Graduate School of Business**

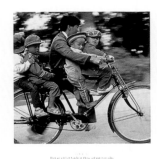

1 TITLE **Butterfield & Robinson Walking Trips** DESIGN FIRM **Viva Dolan Communications & Design, Toronto, Ontario** ART DIRECTOR/GRAPHIC DESIGNER **Frank Viva** PHOTOGRAPHER **Ron Baxter-Smith** WRITER **Doug Dolan** TYPEFACE **Joanna** PRINTER **Arthurs Jones** CLIENT **Butterfield & Robinson** 2 TITLE **Butterfield & Robinson Biking Trips 1997** DESIGN FIRM **Viva Dolan Communications & Design, Toronto, Ontario** ART DIRECTOR/GRAPHIC DESIGNER **Frank Viva** PHOTOGRAPHER **Ron Baxter-Smith** WRITER **Doug Dolan** TYPEFACE **Joanna** PRINTER **Arthurs Jones Lithography** CLIENT **Butterfield & Robinson** 3 TITLE **Estate Label Paper Swatchbook and Label Guide** DESIGN FIRM **Tharp and Drummond Did It, Los Gatos, CA** CREATIVE DIRECTORS **Rick Tharp and Charles Drummond** GRAPHIC DESIGNERS **Rick Tharp, Susan Craft, and Stan Cacitti** ILLUSTRATOR **James LaMarche** PHOTOIMAGE **Tom Landecker** COPYWRITER **Charles Drummond** TYPEFACES **Garamond and Copperplate** TYPOGRAPHER **FotoComp** PRINTER **Blake Printery** FABRICATOR **Hickey & Hepler** PAPER **Simpson Estate Label and Simpson Evergreen**

1 TITLE **New England Holocaust Memorial Brochure** DESIGN FIRM **Gill Fishman Associates, Cambridge, MA** ART DIRECTOR **Gill Fishman** GRAPHIC DESIGNER **Sze Tsung Leong** PHOTOGRAPHERS **John Earle and Sze Tsung Leong** COPYWRITERS **Deborah Bergeron, Steven Dickerman, and Hilary Rao** PRINTER **Daniels Printing** 2 TITLE **Offerings at the Wall** DESIGN FIRM **Turner Publishing, Atlanta, GA** CREATIVE DIRECTOR **Michael J. Walsh** PHOTOGRAPHERS **Claudio Vazquez and Taran Z.** WRITER **Thomas B. Allen** TYPEFACE **Bauer Bodoni** CLIENT **Turner Publishing** 3 TITLE **Auschwitz Memorial Exhibition Catalogue** ART DIRECTOR/GRAPHIC DESIGNER **Hannah Ueno-Olsen** PHOTOGRAPHER **Mark Olsen** WRITERS **Dr. Yehuda Bauer, Dr. Frank Fox, and Dr. Kate Ogden** PRINTER **GraphiColor** CLIENT **Stockton Art Gallery, The Richard Stockton College**

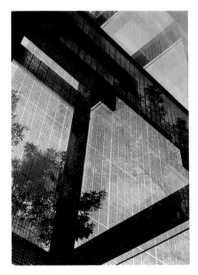

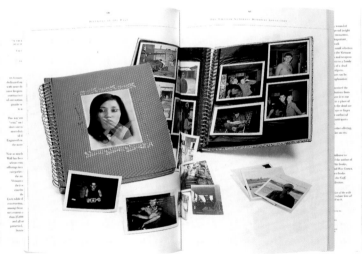

1 Title **Living Colors: The Definitive Guide to Color Palettes** Design Firm **Reuter Design, San Francisco, CA** Art Directors **Michael Carabetta (Chronicle Books) and William Reuter (Reuter Design)** Graphic Designers **William Reuter, Michael Bain, and Hannele Riihiniemi** Writers **Margaret Walch and Augustine Hope** Typefaces **Gill Sans, Stemple Garamond** Printer **Dai Nippon Printing Group** Paper **157 gsm Matte** Client/Publisher **Chronicle Books** 2 Title **Cooper Union DesignTalk Poster** Design Firm **Milton Glaser, Inc., New York, NY** Art Director/Graphic Designer **Milton Glaser** Photographer **Matthew Klein** Client **The Cooper Union for the Advancement of Science and Art** 3 Title **Public Space/Culture Wars** Design Firm **David Mellen Design, Los Angeles, CA** Creative Directors **Julia Bloomfield and David Jensen** Graphic Designer **David Mellen** Photographer **John Kiffe** Writer **David Jensen** Typeface **News Gothic** Printer **Gardner Lithograph** Client **The Getty Center for the History of Art and the Humanities**

A **fence** can be a place to meet with neighbors, a way to protect a garden, or a means to divide a school yard. Fences can protect things we value, but they can also become ways of keeping other people out. They can separate and even intimidate. We need to stop and ask, what kind of "cultural fences" is America building?

Join the Getty Center for the History of Art and the Humanities in a national conversation about fence building. *Public Space / Culture Wars: Redefining the Cultural Public Sphere* asks the question, what is the role of art and culture in shaping public life? Beginning in August 1995 and continuing through July 1996, the program will include lectures, community forums, television programs, and Internet conversations, as well as seminars, conferences, and symposia. The program will be held in collaboration with cultural institutions throughout the country. You, your family and communities, and people representing diverse points of view will have the opportunity to get involved into the discussion.

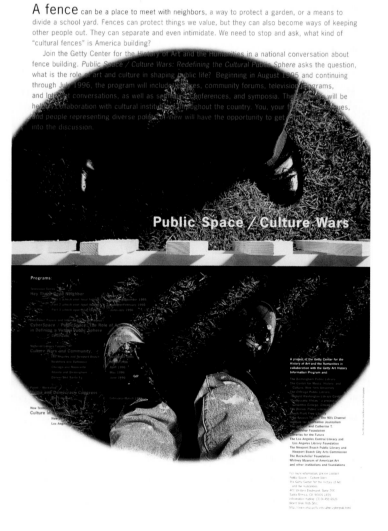

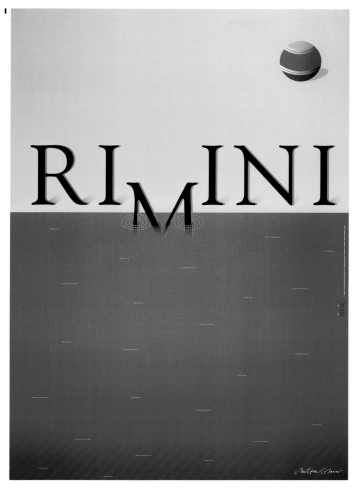

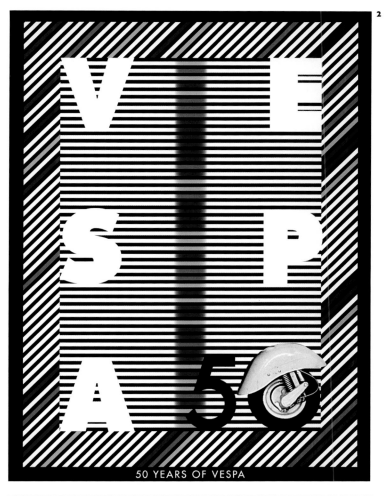

50 YEARS OF VESPA

Standards
of
Excellence

CRANE
BUSINESS PAPERS

1 TITLE **Rimini Poster** DESIGN FIRM **Milton Glaser, Inc., New York, NY** ART DIRECTOR **Milton Glaser** GRAPHIC DESIGNER **Milton Glaser** CLIENT **Rimini Tourism Council** 2 TITLE **Vespa 50 Poster** DESIGN FIRM **Milton Glaser Inc., New York, NY** ART DIRECTOR **Andrea Rauch/Rauch Design** GRAPHIC DESIGNER **Milton Glaser** CLIENT **Vespa Scooters** 3 TITLE **Crane's Standards of Excellence** DESIGN FIRM **Chermayeff & Geismar Inc., New York, NY** DESIGN DIRECTOR **Steff Geissbuhler** GRAPHIC DESIGNER **James McKibben** COPYWRITER **Paul Rosenthal** TYPEFACES **Joanna MT Roman & Italic, Univers Condensed** PRINTER **Presstime Inc.** BINDING **Wire-O Binding Company Inc.** PAPER **Crane's Cover 110# Fluorescent White with inserts of Crane's Bond, Crest, Crest R, and Distaff Linen** CLIENT **Crane & Co.**

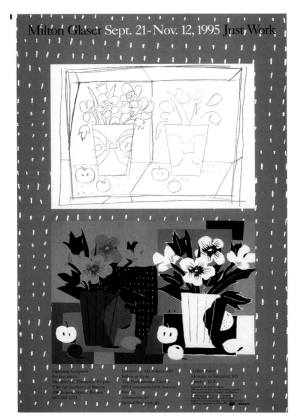

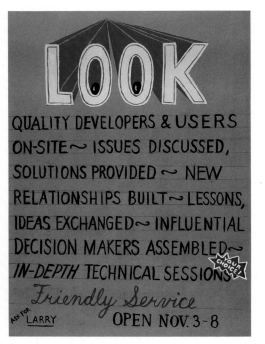

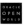

1 TITLE **Milton Glaser — Just Work Poster** DESIGN FIRM **Milton Glaser, Inc., New York, NY** ART DIRECTOR **Art Institute of Boston/Bonnell Robinson** GRAPHIC DESIGNER/ILLUSTRATOR **Milton Glaser** CLIENT **Art Institute of Boston** 2 TITLE **Oracle Open World "Look" Poster** DESIGN FIRM **Cahan & Associates, San Francisco, CA** ART DIRECTOR **Bill Cahan** GRAPHIC DESIGNER/ILLUSTRATOR **Bob Dinetz** COPYWRITERS **Craig Clark and Bob Dinetz** TYPEFACE **Futura** PRINTER **Sapir Press** PAPER **Simpson Starwhite Vicksburg** CLIENT **Oracle Corporation** 3 TITLE **Sentenced to Repay: Reform Social Security** DESIGN FIRM **Trudy Cole-Zielanski Design, Churchville, VA** ART DIRECTOR/GRAPHIC DESIGNER **Trudy Cole-Zielanski** COPYWRITER **Trudy Cole-Zielanski** PHOTOGRAPHER **Trudy Cole-Zielanski** PRINTER **Color Graphics**

1 Title **GVO Brochure Series** Design Firm **Cahan & Associates, San Francisco, CA** Series Art Director **Bill Cahan** Graphic Designers **Bob Dinetz and Kevin Roberson** Illustrators **Tom Barlow, Gary Baseman, John Craig, Nick Dewar, Bob Dinetz, and Mark Todd** Photographers **Ken Probst, Holly Stewart, and Others** Typefaces **Caslon, IBM Selectric, News Gothic** Copywriters **Danny Altman and Stefanie Marlis** Paper **Simpson Opaque 50# Smooth Book** Printer **Graphic Arts Center** Client **GVO** **2** Title **Kathleen Schneider: "I Could Make This More Accessible, But Once Again, I Don't"** Design Firm **Jager De Paola Kemp Design, Burlington, VT** Creative Director **Michael Jager** Graphic Designers **Janet Johnson and Jeremy Mende** Typeface **Univers Bold Condensed Italic** Silkscreening **Giroux Screen Printing** Paper **Discontinued Wallpaper** **3** Title **"A Loss For Words"** Design Firm **Viva Dolan Communications & Design, Toronto, Ontario** Art Director/Graphic Designer **Frank Viva** Illustrator **Frank Viva** Photographer **Hill Peppard** Typeface **Meta** Printer **Annan & Sons** Paper **Conqueror Bright White Wove Text** Client **PEN Canada**

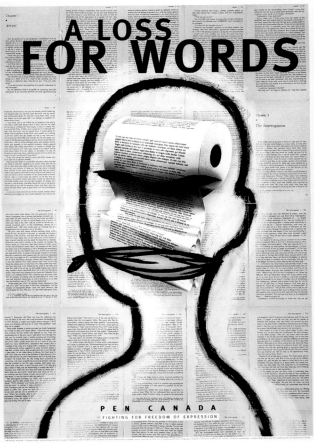

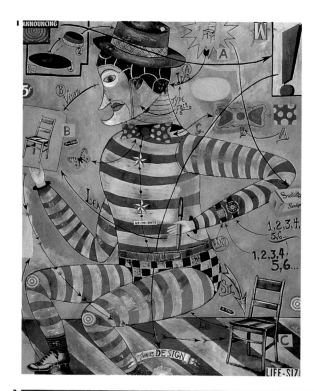

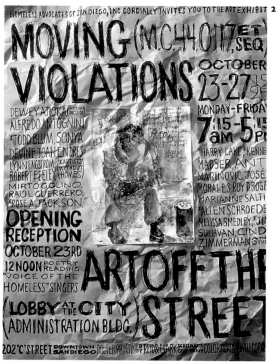

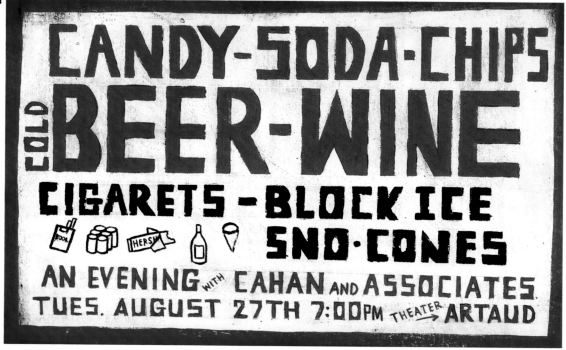

if you've ever used an ordinary

CELLULAR PHONE...

CONVER-SATION TO

2

BRIEFING

The **ULTIMATE**

Briefing makes a setting to discuss the visions, the values, the goals and the results. All the reasons you do what you do. Together.

Everyone is in one place to talk about the heart and soul of your mutual endeavor. Your work together is one-of-a-kind. So is a Gunlocke BRIEFING public conference table. Select materials, beautifully hand crafted. The ultimate statement of stability to emphasize the importance of your statements.

Gunlocke

3

Bibliology 101

Reproduction [fig.1.5] Self-replication is known to exist among many simple life-forms, but the reproduction of a complex structure such as a book requires collaboration among many organisms. The generation of multiple volumes from a single alpha book involves such exotic and imperfectly understood processes as imprinting, binding, and shrink-wrapping. (The process for determining how many copies of a given book are reproduced is known as "market research" and is described in an equation too complex to reproduce here.)

Adaptability [fig.1.6] A book is created when matter, shaped by the energy of organisms, is transformed into an ordered structure that acts on the environment. Its strength lies in its adaptability: As the environment changes, the form of the book can evolve as well. As an adaptable, essentially stable product, books represent the most advanced means to transfer text [T] and image [I] among organisms. This dynamic can be described by the equation

$$(T + I)^2 = (I \times \infty)$$

1 TITLE **QCP-800 Brochure** DESIGN FIRM **Jeff Labbé Design Co., San Francisco, CA** ART DIRECTORS **Jeff Labbé and Gothold-Bascopé** GRAPHIC DESIGNERS **Jeff Labbé and Marilyn Louthan** ILLUSTRATION **CSA Archive** PHOTOGRAPHER **Kimball Hall** WRITERS **Ed Crayton and Eric Springer** TYPEFACE **Helvetica Black, Helvetica** PRINTER **Calsonic Muir Graphics** PAPER **French Dur-O-Tone and Construction 100#, 80#** CLIENT **Qualcomm Inc. 2** TITLE **Gunlocke Tables Brochure** DESIGN FIRM **Michael Orr & Associates, Inc., Corning, NY** ART DIRECTOR **Michael Orr** GRAPHIC DESIGNER/ILLUSTRATOR **Gregory Duell** COPYWRITER **Gregory Duell** TYPEFACES **Univers, Bodoni** PRINTER **Oser Press** PAPER **Mohawk Vellum Flax** CLIENT **The Gunlocke Company 3** TITLE **Bibliology 101** DESIGN FIRM **studio blue, Chicago, IL** ART DIRECTORS **Kathy Fredrickson and Cheryl Towler Weese** ILLUSTRATOR **Cheryl Towler Weese** WRITERS **Kathy Fredrickson and Tom Fredrickson** TYPEFACE **FB Interstate** PRINTER **Dupli-Graphic** PAPER **French Dur-O-Tone Butcher and Packing Gray Liner** CLIENT **studio blue**

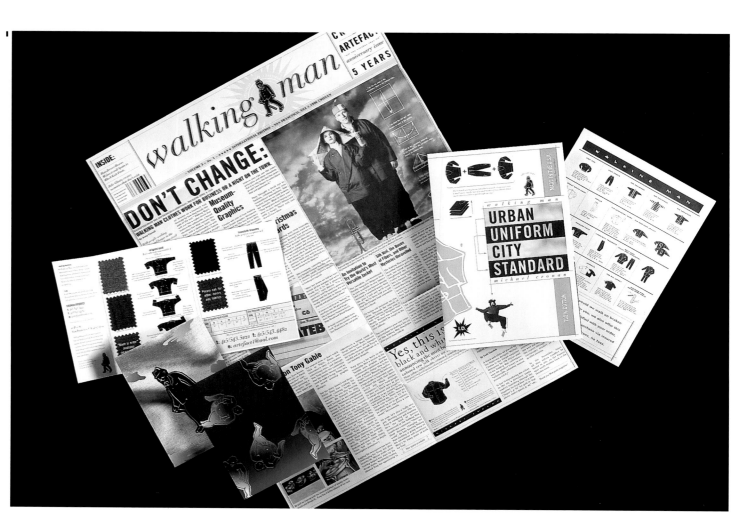

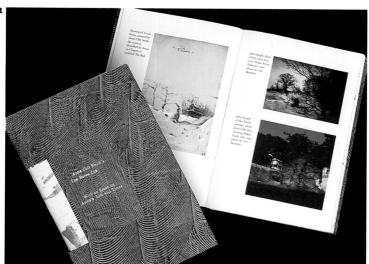

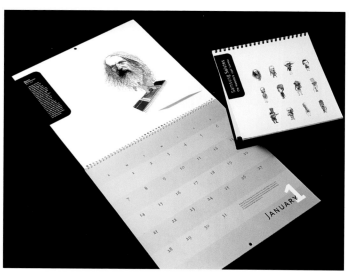

1 TITLE **Walking Man Correspondence** DESIGN FIRM **Cronan Design, San Francisco, CA** CREATIVE DIRECTOR **Michael Cronan** GRAPHIC DESIGNER **Joseph Stitzlein** PHOTOGRAPHERS **Terry Lorant and Jock McDonald** COPYWRITER **Mary Coe** PAPER **Simpson** CLIENT **Cronan Artefact** 2 TITLE **Anna Clift Smith's Van Buren Life, with an Essay on Anna's Life and Times** DESIGN FIRM **Fairbairn & Company, Fredonia, NY** ART DIRECTOR/GRAPHIC DESIGNER **Jan Fairbairn** PHOTOGRAPHER **Sue Besemer** WRITER **Wendy Woodury Straight** TYPEFACE **Adobe Garamond, Abobe Garamond Expert** PRINTER **Thorner Press** FABRICATOR **Lynne McElhaney-Kirk/Dun Bindery** PAPER **Mohawk Superfine Text, Soft White Eggshell; Cover, Mideggen, Paste Paper Surface Treatment** CLIENT/PUBLISHER **Friends of Reed Library, State University of New York College at Fredonia** 3 TITLE **Samsung Salutes the Inventors 1996 Calendar** DESIGN FIRM **Addison Design Co., New York, NY** ART DIRECTOR/GRAPHIC DESIGNER **Daniel Koh** ILLUSTRATOR **John Springs** COPYWRITER **Lyn Clerget** TYPEFACE **Meta** PRINTER **Samsung Moonwha** PAPER **Hansol Snow White Coated Matte** CLIENT/PUBLISHER **Samsung**

1 TITLE **Proof that a RISD Education Shapes Your World** DESIGN FIRM **Context, Bristol, RI** ART DIRECTOR/GRAPHIC DESIGNER **Katie Chester** COPYWRITERS **Katie Chester, Lisa Silander, Liz O'Neill** HAND LETTERING **Roger Mandle** PRINTER **Able Printing** PAPER **Domtar Plainfield Plus 65# Cover** CLIENT **Rhode Island School of Design** 2 TITLE **Proof That a RISD Education Raises Your Sights** DESIGN FIRM **Context, Bristol, RI** ART DIRECTOR/GRAPHIC DESIGNER **Katie Chester** COPYWRITERS **Katie Chester, Lisa Silander, Liz O'Neill** HAND LETTERING **Roger Mandle** PRINTER **Able Printing** EMBOSSING **W.E. Jackson & Co.** PAPER **Domtar Plainfield Plus 65# Cover** CLIENT **Rhode Island School of Design** 3 TITLE **Proof That a RISD Education Colors Your Perception** DESIGN FIRM **Context, Bristol, RI** ART DIRECTOR/GRAPHIC DESIGNER **Katie Chester** COPYWRITERS **Katie Chester, Liz O'Neill, and Lisa Silander** HAND LETTERING **Roger Mandle** PRINTER **Meridian Printing** PAPER **Neenah Classic Crest 65# Cover** CLIENT **Rhode Island School of Design**

1 TITLE **Morningstar 15(c) Report** FIRM **Morningstar, Chicago, IL** ART DIRECTORS **Nathaniel Burgos and David Williams** GRAPHIC DESIGNER **Nathaniel Burgos** WRITERS **Joe Sinha and Cindy Thompson** PROGRAMMERS **Xu Shi and Joe Sinha** TYPEFACES **Adobe Garamond, Univers Condensed** PAPER **Mohawk Opaque 65#, Mohawk Options 70#** CLIENT/PUBLISHER **Morningstar** 2 TITLE **Nike Visual Merchandising Manual** GRAPHIC DESIGNERS **Nike Design Team** ILLUSTRATORS **Nike Design Team** CLIENT/PUBLISHER **Nike, Inc.** 3 TITLE **Steelcase Specification Guides** DESIGN FIRM **Agnew Moyer Smith Inc., Pittsburgh, PA** CREATIVE DIRECTOR **Don Moyer** GRAPHIC DESIGNERS **Kurt Hess and Rita Lee** ILLUSTRATORS **Rick Henkel, Kurt Hess, and Mike Yolch** WRITER **Don Moyer** TYPEFACES **Helvetica, Helvetica Condensed, Custom Fonts by AMS** PRINTERS **The Etheridge Company, Gilson Graphics, and Integra Printing, Inc.** PAPER **50# Recycled Text, 65# Recycled Cover** CLIENT **Steelcase Inc.**

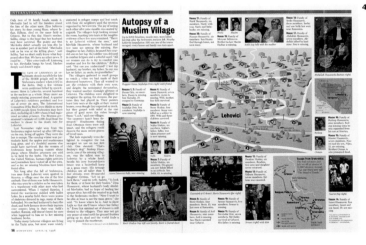

1 TITLE **Bugs That Eat Your House Poster** DESIGN FIRM **This Old House, New York, NY** DESIGN DIRECTOR **Matthew Drace** PHOTOGRAPHER **Darrin Haddad** COPYWRITER **Jeanne Huber** PRINTER **Continental Web** PAPER **Manistique 60#** 2 TITLE **Screws Poster** DESIGN FIRM **This Old House, New York, NY** DESIGN DIRECTOR **Matthew Drace** ILLUSTRATORS **Clancy Gibson and John Murphy** COPYWRITER **Jeanne Huber** PRINTER **Continental Web** PAPER **Manistique 60#** PUBLISHER **Time, Inc.** 3 TITLE **The Transatlantic Superhighway** DESIGN DIRECTOR **Robert Best** ART DIRECTOR **Carla Frank** ILLUSTRATOR **John Grimwade** CLIENT/PUBLISHER **Condé Nast Traveler Magazine** 4 TITLE **Autopsy of a Muslim Village** FIRM **Newsweek Magazine, New York, NY** DIRECTOR OF DESIGN **Lynn Staley** INFORMATION GRAPHICS **Bonnie Scranton** ILLUSTRATOR **Christoph Blumrich** REPORTER/WRITER **Rod Nordland** RESEARCHER **Brad Stone**

1

2

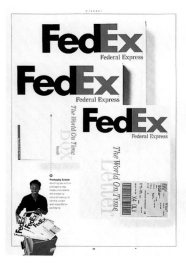

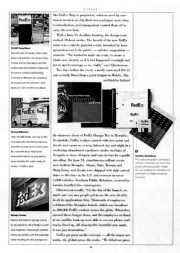

3

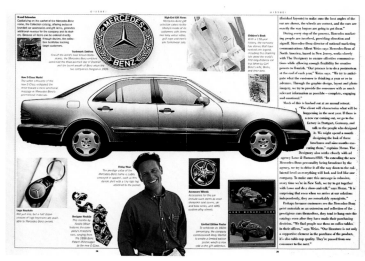

1 Title **@Issue (vol. 2, no. 1)** Design Firm **Pentagram Design, San Francisco, CA** Creative Director **Kit Hinrichs** Graphic Designer **Amy Chan** Illustrators **John Craig and Jack Unruh** Photographers **Bob Esparza, James Schnepf, Mark Swisher, and Robert Clark** Writer **Delphine Hirasuna** Printer **George Rice & Sons** Paper **Potlatch Vintage Remarque Gloss Cover and Velvet Book 100#** Client **Potlatch Corporation** **2** Title **@Issue (vol. 1, no. 1)** Design Firm **Pentagram Design, San Francisco, CA** Creative Director **Kit Hinrichs** Graphic Designer **Amy Chan** Illustrator **David Suter** Photographers **Barry Robinson and Jeff Corwin** Writer **Delphine Hirasuna** Printer **Anderson Lithograph** Paper **Potlatch Vintage Remarque Gloss Cover and Velvet Book 100#** Client **Potlatch Corporation** **3** Title **@Issue (vol. 2, no. 2)** Design Firm **Pentagram Design, San Francisco, CA** Creative Director **Kit Hinrichs** Graphic Designer **Amy Chan** Illustrator **Regan Dunnick** Photographers **Laurie Rubin, Bob Esparza, and Kevin Sprouls** Writer **Delphine Hirasuna** Printer **George Rice & Sons** Paper **Potlatch Vintage Remarque Gloss Cover and Velvet Book 100#** Client **Potlatch Corporation**

1 TITLE **Informix Software 1995 Annual Report** DESIGN FIRM **Cahan & Associates, San Francisco, CA** ART DIRECTOR **Bill Cahan** GRAPHIC DESIGNER/ILLUSTRATOR **Bob Dinetz** PHOTOGRAPHER **Daniel Arsenault** COPYWRITER **Michael Pooley** TYPEFACES **Caslon and Dinnschriften Mittelschrift** PRINTER **Alan Lithograph** PAPER **French Dur-O-Tone White Newsprint 50# Text** CLIENT **Informix Software, Inc.** 2 TITLE **Interactivity by Design** DESIGN FIRMS **Ignition and MetaDesign, San Francisco** CREATIVE DIRECTORS/INFORMATION DESIGNERS **Ray Kristof and Amy Satran (Ignition)** GRAPHIC DESIGNERS **Joshua Distler and Jeff Zwerner (MetaDesign)** TYPEFACES **Scala Sans and Myriad** PRINTER **Shepard Poorman** PUBLISHER **Adobe Press** 3 TITLE **Mercedes-Benz Technical Diskette** DESIGN FIRM **Cow, Santa Monica, CA**

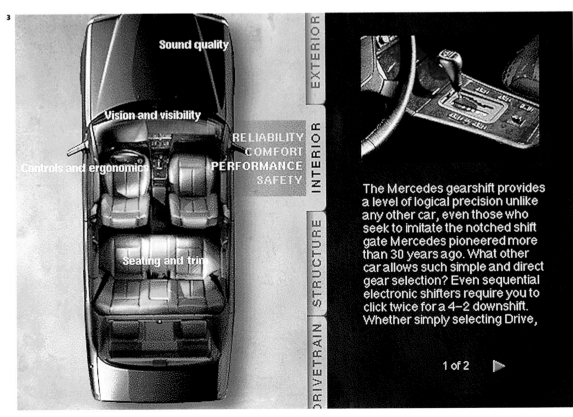

1 TITLE **A6 Book** DESIGN FIRM **MetaDesign, San Francisco, CA** CREATIVE DIRECTOR **Terry Irwin** GRAPHIC DESIGNERS **Various** PHOTOGRAPHERS **Kevin Ng, Edric Alunan, Jym Warhol** TYPEFACE **FF Metaplus, FF Dingbats** PRINTER **Bofors Lithography** PAPER **Gilbert Esse Smooth White Cover and Text** CLIENTS **MetaDesign and Gilbert Paper** 2 TITLE **Is It a Word Or Not?** DESIGN FIRM **Shapiro Design Associates Inc., New York, NY** ART DIRECTOR/GRAPHIC DESIGNER **Ellen Shapiro** ILLUSTRATORS **Martin Haggland and David Marchisotto** WRITER **Ellen Shapiro** TYPEFACES **Century Expanded and Futura** PRINTER/FABRICATOR **Speed Graphics** PAPER **S.D. Warren Lustro** 3 TITLE **Ask Adlab** DESIGN FIRM **The Seaton Corporation, Chicago, IL** CREATIVE DIRECTOR **Hugh Farrington** ART DIRECTOR **Kirsten Goede** GRAPHIC DESIGNER **Carissa Andi** TYPEFACES **Helvetica Extra Compressed, Gill Sans** PAPER **Repap Matte 80# Cover, White Matte Finish** CLIENT **Adlab**

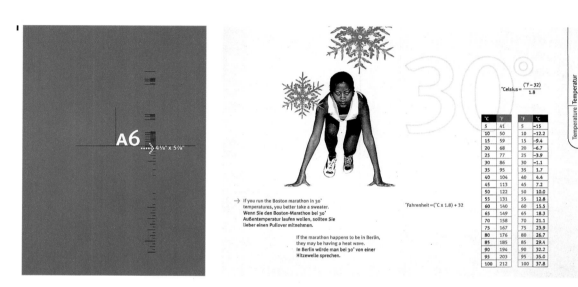

$$^{\circ}Celsius = \frac{(^{\circ}F - 32)}{1.8}$$

°C	°F	°F	°C
5	41	5	-15
10	50	10	-12.2
15	59	15	-9.4
20	68	20	-6.7
25	77	25	-3.9
30	86	30	-1.1
35	95	35	1.7
40	104	40	4.4
45	113	45	7.2
50	122	50	10.0
55	131	55	12.8
60	140	60	15.5
65	149	65	18.3
70	158	70	21.1
75	167	75	23.9
80	176	80	26.7
85	185	85	29.4
90	194	90	32.2
95	203	95	35.0
100	212	100	37.8

→ If you run the Boston marathon in 30° temperatures, you better take a sweater. Wenn Sie den Boston-Marathon bei 30° Außentemperatur laufen wollen, sollten Sie lieber einen Pullover mitnehmen.

If the marathon happens to be in Berlin, they may be having a heat wave. In Berlin würde man bei 30° von einer Hitzewelle sprechen.

$$^{\circ}Fahrenheit = (^{\circ}C \times 1.8) + 32$$

Temperature Temperatur

A6 4⅛" x 5⅛"

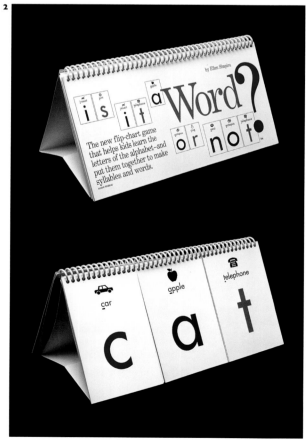

Important & Useful Numbers

312-915-0739	To check your schedule, report an absence, or report a late arrival. Your call may be automatically forwarded to voicemail.
800-966-4809	To recommend a friend for potential employment with Adlab, have them call this number and ask for extension 099-086.
312-915-0505	To recommend a potential client for Adlab (ask for an Adlab Sales Representative).
312-915-0009	For employment verification, references or correspondance, fax a request to the accounting department.
312-915-0505	To inquire about payroll questions or errors, call Monday-Friday, 8:00am-4:00pm (ask for the Adlab HR Manager).
312-915-0900	SeatonCorp main number
312-836-7000	Chicago public transportation CTA, RTA, Metra
Check Pick Up	Checks may be picked up from the Control Center from Friday 12:00 noon until Monday 11:00pm. After this time, all checks will be mailed to your home address.

062696

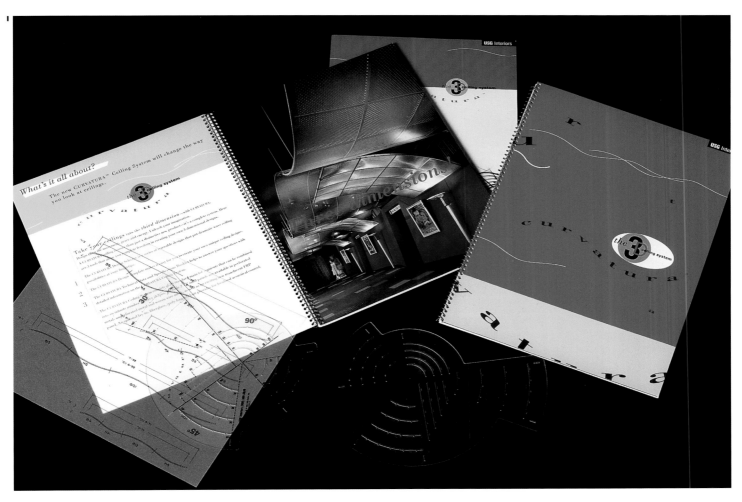

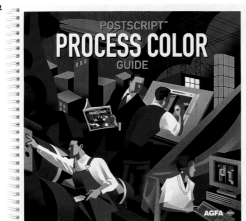

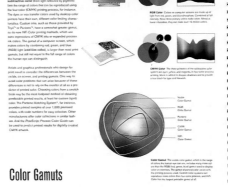

Color Gamuts

Monitor Calibration & Color Management

1 TITLE **Curvatura Program** DESIGN FIRM **USG Corporation, Marketing Communication, Chicago, IL** ART DIRECTORS **Julia Archier and Eric Nash** GRAPHIC DESIGNER **Eric Nash** ILLUSTRATORS **Eric Nash and Steve Kalter** PHOTOGRAPHER **Barbara Karant** WRITERS **Greg Ahren and Eric Nash** TYPEFACE **Bodoni** PRINTER **Argus** PAPER **Centura Gloss Cover + Text, Canson Satin** 2 TITLE **Postscript Process Color Guide** DESIGN FIRM **Yo, San Francisco, CA** CREATIVE DIRECTORS **Maria Guidice and Lynne Stiles** ILLUSTRATORS **Steve McGuire, Arne Hurty, and Ben Seibel** COPYWRITER **Linnea Dayton** TYPEFACE **Akzidenz Grotesk family** PRINTER **Fong & Fong** PAPER **80# Lithofect Dull Book and 80# Simpson Opaque Vellum Book** CLIENT/PUBLISHER **AGFA Prepress Education Resources**

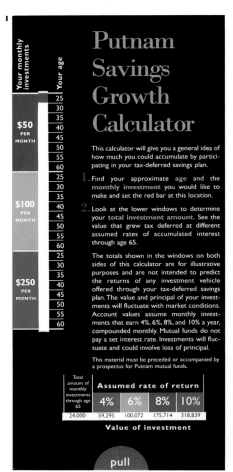
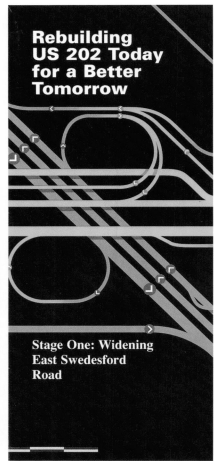

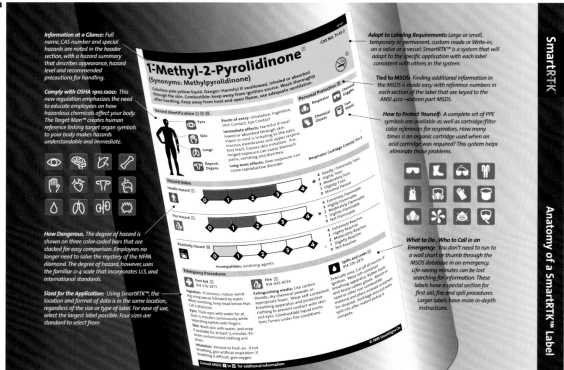

1 TITLE **Putnam Savings Growth Calculator** FIRM **Putnam Investments Corporate Communications, Boston, MA** GRAPHIC DESIGNER **Sean Mahoney** WRITER **Gina Picone** TYPEFACES **Bodoni, Gill Sans** PRINTER **The Flexi Group** PAPER **Warren Lustro Dull 100# Cover** CLIENT **Putnam Investments** 2 TITLE **Rebuilding US 202** DESIGN FIRM/PRODUCERS **Joel Katz Design Associates, Philadelphia, PA** CREATIVE DIRECTOR/GRAPHIC DESIGNER **Joel Katz** COPYWRITER **Gene Blaum** TYPEFACES **Times, Univers** PRINTER **Baum Printing Co.** PAPER **Westvaco Sterling Gloss 60# Text** CLIENT **Pennsylvania Dept. of Transportation, District 6-0** 3 TITLE **SmartRTK Labeling System** DESIGN FIRM **Meeker & Associates, Larchmont, NY** ART DIRECTOR **Donald T. Meeker** GRAPHIC DESIGNERS **Donald T. Meeker, Chris O'Hara, Harriet Spear** PHOTOGRAPHER **Alan Orling** TYPEFACE **Thesis Sans** FABRICATOR **Elecromark, Inc./Smart Signs Co.** CLIENT/PUBLISHER **Smart Signs Co.**

1 TITLE **Crane's "What Does It Cost to Send a Letter?"** DESIGN FIRM **Chermayeff & Geismar Inc., New York, NY** DESIGN DIRECTOR **Steff Geissbuhler** GRAPHIC DESIGNER **James McKibben** COPYWRITER **Paul Rosenthal** TYPEFACES **Univers Thin and Light Ultra Condensed, Garamond Expanded, Regular and Semi** PRINTER **Milocraft** PAPER **Crane's Cover, Crane's Crest** CLIENT **Crane & Co.** 2 TITLE **Morningstar Investor Newsletter** FIRM **Morningstar, Chicago, IL** ART DIRECTORS **Philip Burton, Angela Diebold, and David Williams** GRAPHIC DESIGNERS **Nathaniel Burgos, Philip Burton, Angela Diebolt, and Joy Gadrinab** WRITERS **Various** TYPEFACES **Adobe Garamond, Futura** PRINTER **Berlin Industries** PAPER **Husky Offset, 70# and 50#** PROGRAMMERS **Linda Gu and Bobbie Wlordarczyk** CLIENT/PUBLISHER **Morningstar** 3 TITLE **The Putnam Shareholder Guide** FIRM **Putnam Investments Corporate Communications, Boston, MA** GRAPHIC DESIGNER **Robert Santosuosso** ILLUSTRATOR **Midnight Oil** WRITER **David Lifsitz** TYPEFACES **Bodoni, Gill Sans** PRINTER **Acme Printing Company** PAPER **Westvaco Sterling 105# Matte Postcard Text and 70# Web Matte Text** CLIENT **Putnam Investments**

1

2

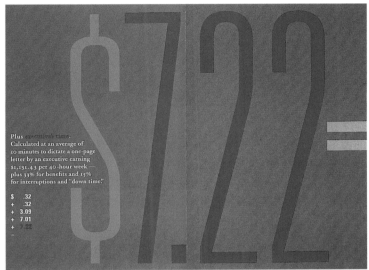

3

1 Title **Benetton "Faces" Bag** Design Firm **Axo Design Studio, San Francisco, CA** Art Director **Chris Dangtran (Benetton)** Graphic Designer **Brian Collentine** Photographer **Oliviero Toscani** Typeface **Gill Sans Regular** Fabricator **Brilliant Bags & Boxes** Client **Benetton** 2 Title **3M Coping Kit** Design Firm **Rapp Collins Communications, Minneapolis, MN** Creative Director **Brad Ray** Art Director/Graphic Designer **Amy Usdin** Illustrator **Alex Bois** Writer **Brad Ray** Typeface **Times Roman** Printer **Maximum Graphics** Paper **Neenah Environment** Client **3M** 3 Title **Choices** Design Firm **Essex Two, Chicago, IL** Creative Directors/Designers **Joseph Michael Essex and Nancy Denney Essex** Illustrators **Joseph Michael Essex and Joseph Michael Fiedler** Photographers **Mark Joseph, Marc Norberg, Sandro Miller, and Tom Vack** Writers **Joseph Michael Essex and Nancy Denney Essex** Typefaces **Sabon, Futura, Rockwell, Our Bodoni** Printer **Unique Printers and Lithographers** Paper **S.D. Warren Lustro Dull, Potlatch Quintessence Gloss, Strathmore Elements Solid**

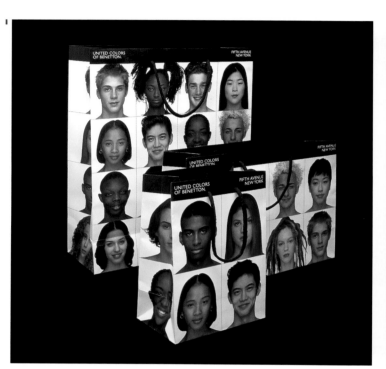

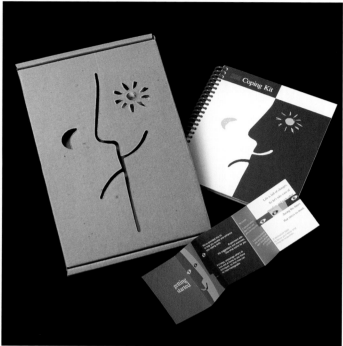

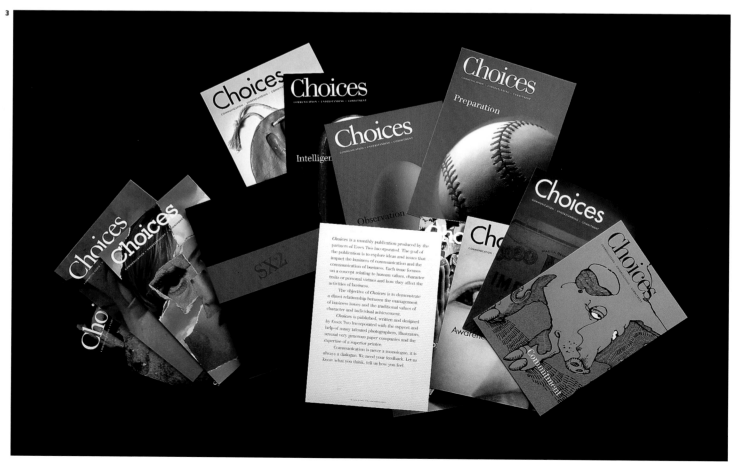

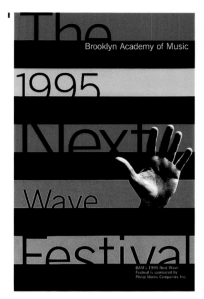

Brooklyn Academy of Music

1995

Next

Wave

Festival

BAM's 1995 Next Wave Festival is sponsored by Philip Morris Companies Inc.

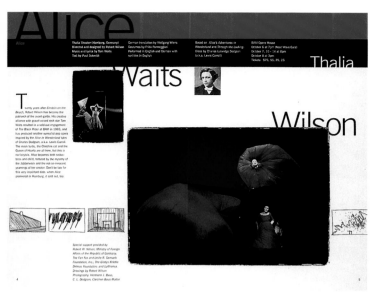

Alice

Waits

Wilson

Thalia

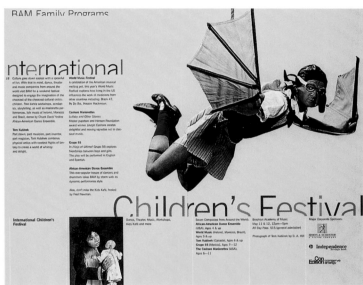

BAM
Spring

Brooklyn
Academy
of
Music

1996 Spring Season

BAM Family Programs

international

Children's Festival

1 TITLE **Brooklyn Academy of Music 1995 Next Wave Festival Brochure** DESIGN FIRM **Pentagram Design, New York, NY** ART DIRECTOR **Michael Bierut** GRAPHIC DESIGNERS **Michael Bierut and Emily Hayes** PHOTOGRAPHERS **Timothy Greenfield-Sanders (cover) and Various** TYPEFACE **News Gothic** PRINTER **Finlay Brothers** PAPER **Mohawk Satin** CLIENT **The Brooklyn Academy of Music** 2 TITLE **Brooklyn Academy of Music Spring 1996 Brochure** DESIGN FIRM **Pentagram Design, New York, NY** ART DIRECTOR **Michael Bierut** GRAPHIC DESIGNERS **Michael Bierut and Emily Hayes** PHOTOGRAPHERS **Various** TYPEFACE **News Gothic** PRINTER **Finlay Brothers** PAPER **Mohawk Opaque** CLIENT **The Brooklyn Academy of Music** 3 TITLE **CAT Limited 1996 Annual Report** DESIGN FIRM **Pentagram Design, New York, NY** ART DIRECTOR **Michael Gericke** GRAPHIC DESIGNERS **Edward Chiquitucto, Tom Kenzie, and Liz Lyons** PRINTER **Finlay Brothers** CLIENT **CAT Limited**

The greening of design should be confidently moving on to Phase II. While we've made significant strides in the use of earth-friendly materials and the reduction of natural resources in our design, the real challenge to our creativity is now upon us.

As professional communicators, we have the opportunity and responsibility to influence our society in ways that will benefit our environment for generations to come.

The Greening of Design competition picked up where other competitions focused on the environment left off. We judged designs that use recycled and renewable resources in new ways — a commitment we've promoted for years and one that needs reinforcing. And we judged something perhaps more important.

For the first time, we have a competition to reward designers for the impact their work has on how others use natural resources. After all, an inventive message that can influence a new generation of designers and the world at large can make a much greater difference in our future.

Joe Duffy

CHAIRMAN

CALL FOR ENTRY

Design Neil Powell, Duffy Design

Typeface Helvetica

Printer Williamson Printing

Paper Beckett Concept Glacier 70# Text

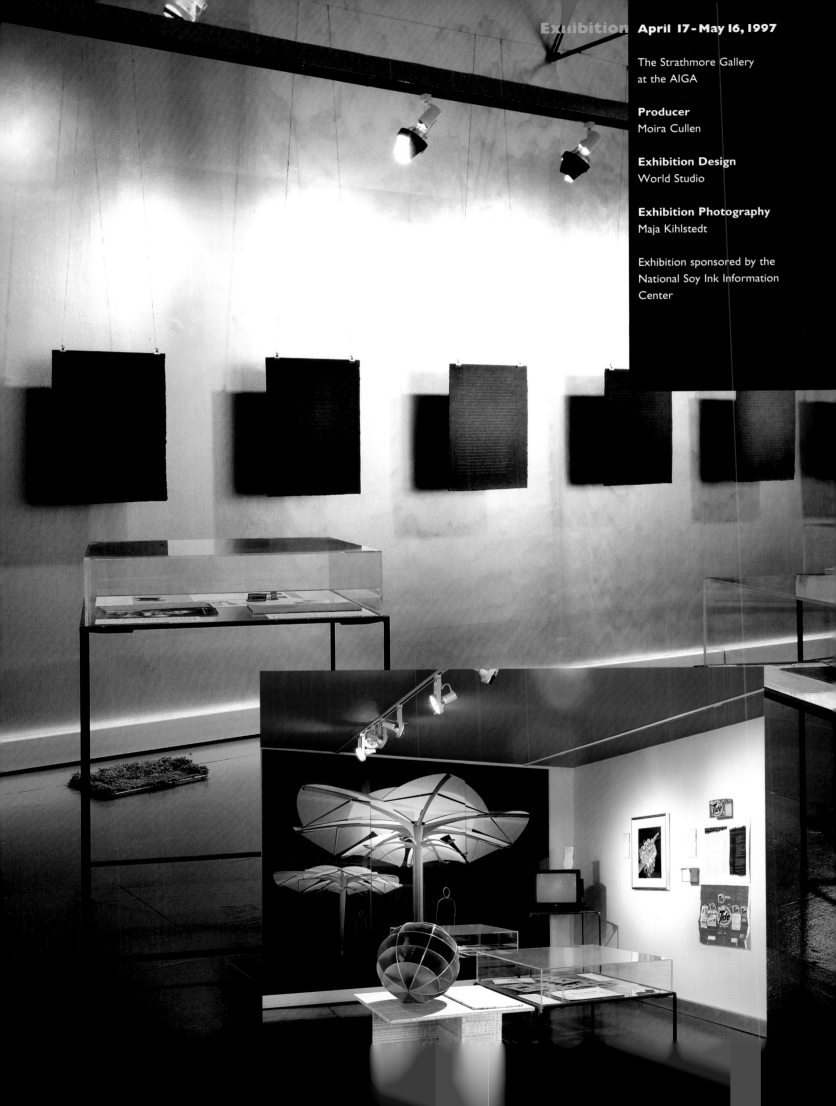

Exhibition April 17 - May 16, 1997

The Strathmore Gallery
at the AIGA

Producer
Moira Cullen

Exhibition Design
World Studio

Exhibition Photography
Maja Kihlstedt

Exhibition sponsored by the
National Soy Ink Information
Center

Joe Duffy (Chair), is president and creative director of Joe Duffy Design in Minneapolis. His work — which has received numerous awards from leading national and international design forums — includes brand and corporate identity development, literature, and packaging design for such clients as Ralph Lauren, Porsche, Timex, Lee Jeans, Coca-Cola, and Black & Decker. He chaired the AIGA national board's Environmental Committee and has lectured on design and the environment throughout the U.S., Europe, and Australia.

Eva Anderson, principal of Eva Anderson Design (founded in 1989), serves a range of businesses, primarily in New England. She is also founder, designer, and editor of ECO, a newsletter published by *Communication Arts* that is dedicated to environmental issues in graphic design, for which she received a 1991 EPA Environmental Award and a grant from the NEA.

Totally PC?
Assessing Computer Impacts

The Next Generation
(of Printing Papers)

Pulp Friction
The Great Chlorine

THE GREEN IMPERATIVE

NATURAL DESIGN
FOR THE REAL WORLD

VICTOR PAPANEK

Sheila Levrant de Bretteville began working in print graphics — books, posters, newspapers, and billboards — which have won awards and have been placed in special collections of public libraries and private art museums. The pieces that best express her personal vision give voice in public spaces to people not generally heard in public life. Her current projects include etching the railings of a new Boston highway with quotes and images from displaced residents and carving titles of immigrant stories into the risers of granite stairs of a new Flushing library. In 1991 she became the first tenured woman at the Yale University School of Art.

Victor Papanek is an educator and designer with a background in anthropology, whose seminal book *Design for the Real World: Human Ecology & Social Change* was the first to combine design and environmental concerns. His subsequent books include *Nomadic Furniture, How Things Don't Work, Design for Human Scale,* and *The Green Imperative* (Thames & Hudson, 1995). Since 1982, Papanek has been the J.L. Constant Professor of Architecture and Design at the University of Kansas.

Lana Rigsby is principal of Houston-based Rigsby Design. Her firm's work is included in the permanent collection of the Library of Congress and is consistently honored by *Graphis, Communication Arts,* the AIGA, the New York Art Directors Club, the Mead Annual Report Show, and the AR100. Named *Adweek*'s Southwest Creative All-Star Designer for 1995, Rigsby is a past officer and founding member of AIGA/Texas and was chair of the 1996 Mead Annual Report Conference.

1 TITLE **Friends of the Washington Park Zoo Annual Report** DESIGN FIRM **Thom Smith Associates, Portland, OR** ART DIRECTOR **Thom Smith** GRAPHIC DESIGNERS **Michael Reardon, Thom Smith, and Michael Hoeye** ILLUSTRATOR **Michael Reardon** WRITER **Michael Hoeye** TYPEFACES **Phaistos/Hand Lettering** PRINTER **Dynagraphics** PAPER **French Speckletone True White** CLIENT **Friends of the Washington Park Zoo** **2** TITLE **Earth Day '91** DESIGN FIRM **The Pushpin Group, New York, NY** ART DIRECTOR/GRAPHIC DESIGNER **Seymour Chwast** ILLUSTRATOR **Seymour Chwast** TYPEFACE **Hand Lettering** PRINTERS **Eco Support Graphic/Haff & Daugherty** PAPER **Fox River Circa Select 80# Cover "Burlap"** CLIENT **Earth Day New York** **3** TITLE **SEED Newsletter** DESIGN FIRM **Swanke Hayden Connell Architects, New York, NY** CREATIVE DIRECTOR **Donald L. Kiel** GRAPHIC DESIGNERS **Donald L. Kiel and Kyung Hui Lee** ILLUSTRATIONS **Clip Art from "Animals: A Pictorial Archive from 19th-Century Sources"** PRINTERS **PCW 100 Incorporated and Plowshares Press** PAPER **Domtar Sandpiper Text, Oat, Vellum Finish** PUBLISHER/CLIENT **New York Chapter of the Institute of Business Designers' Council on the Environment**

1 TITLE **Refuse — Good Everyday Design from Reused and Recycled Material Catalogue** DESIGN FIRM **Tom Graboski Associates, Miami, FL** ART DIRECTOR/GRAPHIC DESIGNER **Kerry J. Meier** COVER COLLAGE ARTIST **Kerry J. Meier** TYPEFACES **Harting, Kabel, and Futura** PRINTER **Graphic Connection of Miami** PAPER **Simpson Quest Bright White 100% Post-Consumer Waste Recycled** CLIENT **Arango Design Foundation** 2 TITLE **Refuse — Good Everyday Design from Reused and Recycled Material (Invitation)** DESIGN FIRM **Tom Graboski, Miami, FL** ART DIRECTOR **Charlie Calderin** GRAPHIC DESIGNER **Charlie Calderin** TYPEFACES **Harting and Futura** PRINTER **Graphic Connection of Miami** PAPER **Simpson Quest Bright White 100% Post-Consumer Waste Recycled** CLIENT **Arango Design Foundation** 3 TITLE **GVO Brochure Series** DESIGN FIRM **Cahan & Associates, San Francisco, CA** SERIES ART DIRECTOR **Bill Cahan** GRAPHIC DESIGNERS **Bob Dinetz and Kevin Roberson** ILLUSTRATORS **Tom Barlow, Gary Baseman, John Craig, Bob Dinetz, Nick Dewar, and Mark Todd** PHOTOGRAPHERS **Ken Probst, Holly Stewart, and Others** TYPEFACES **Caslon, Hand Lettering, IBM Selectric, News Gothic** COPYWRITERS **Danny Altman and Stefanie Marlis** PAPER **Simpson Opaque 50# Smooth Book** PRINTER **Graphic Arts Center** CLIENT **GVO**

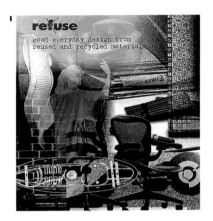

1 Title **Casa de San Pedro Brochure** Design Firm **After Hours Creative, Phoenix, AZ** Art Director/Graphic Designer/Writer **After Hours Creative** Printer **O'Neil Printing** Paper **Catherine's Rare Papers (Hand Made)** 2 Title **The Ecology of Design: The AIGA Handbook on Environmental Responsibility in Graphic Design** Design Firm **Brian Collins Studio** Creative Director/Graphic Designer **Brian Collins** Editor **Marie Finamore** Illustrators **Various** Typeface **Garamond #3** Printer **Diversified Graphics** Paper **Weyerhaeuser Jaguar** Client/Publisher **The American Institute of Graphic Arts** 3 Title **Alcan Architecture 1992** Design Firm **plus design inc., Boston, MA** Art/Creative Director **Anita Meyer** Graphic Designers **Nicole Juen, Anita Meyer, and Matthew Monk** Typefaces **Antique Typewriter and Stencils** Printers **Alpha Press and Arabesque Studio Ltd.** Poster Assembly **Daniels Printing Company** Materials **Cardboard, Recycled Alcan Posters, Aluminium** Client **Alcan Aluminium Ltd.**

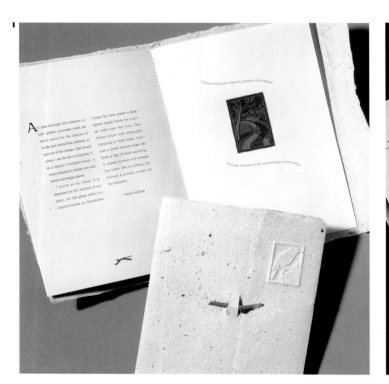

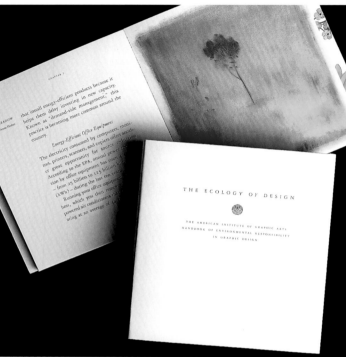

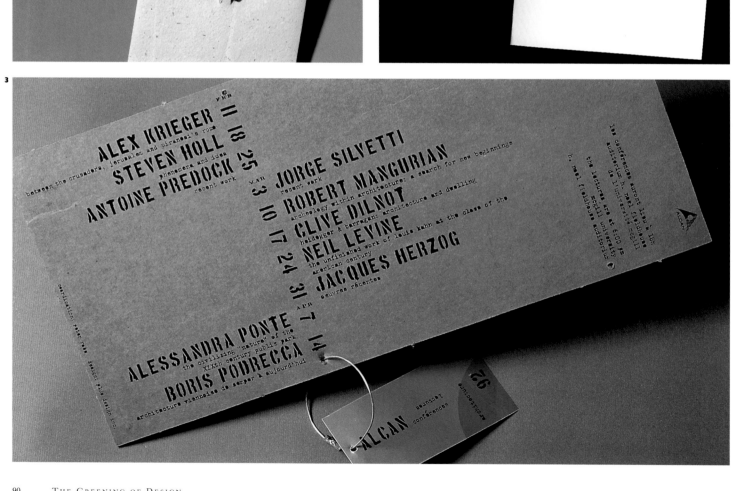

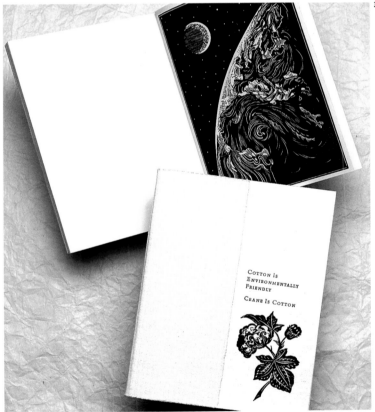

1 TITLE **Call-to-Action Boundry Waters Brochure** DESIGN FIRM **Eaton & Associates, Minneapolis, MN** CREATIVE DIRECTOR **Timothy Eaton** GRAPHIC DESIGNER **Carolyn Porter Gross** PHOTOGRAPHER **Jim Gindorff** TYPEFACE **Garamond** PRINTER **Litho, Inc.** PAPER **French Construction Recycled 70# Text** CLIENT **Quetico Superior Foundation** 2 TITLE **Extinctions** DESIGN FIRM **Kondrup Design, Pasadena, CA** CREATIVE DIRECTOR **Gloria Kondrup** TYPEFACES **Sabon, Sabon Italic, Centaur Expanded** PRINTER **Vandercook Tabloid Press at Archetype Press, Pasadena** PAPER **Mouchette Hand-Molded Cotton** 3 TITLE **Cotton Is Environmentally Friendly: Crane Is Cotton** DESIGN FIRM **Chermayeff & Geismar Inc., New York, NY** DESIGN DIRECTOR **Steff Geissbuhler** GRAPHIC DESIGNER **Bill Anton** ILLUSTRATOR **Stephen Alcorn** WRITER **Rose DeNeve** TYPESETTING **A. Colish, Inc.** PRINTER **Milocraft** BINDING **Advanced Graphic Service** PAPER **Crane's Parchment Cover and Crane's Distaff Linen Text** CLIENT **Crane & Co.**

1

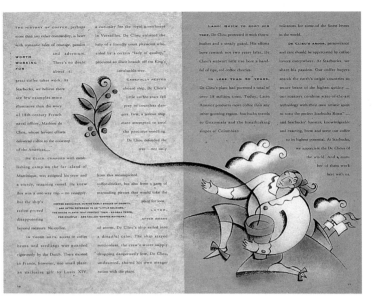

2

Greening

The City

Is it important to provide habitat for **wildlife** in our urban areas? Why? What kinds of animals live in different areas, and how can we improve the quality of natural wildlife habitat in our neighborhoods and cities? Like people, animals need food, water, and shelter to survive. These essentials of life can be difficult for animals to find in urban areas.

In Baltimore, the City is trying to improve the wildlife habitat available in the 6,500 acres of parkland. Many people enjoy sharing their parks, backyards, and other open spaces with certain kinds of animals.

In this booklet, there is information about how you can manage your open spaces to improve or create habitat for various kinds of animals. Depending upon the size of the site, the amount and types of vegetation growing there, the availability of water, and the ability of animals to get to the site, you may enjoy the company of any number of birds, reptiles, amphibians, and small mammals.

3

Our Environment

1 TITLE **Starbucks 1993 Annual Report** DESIGN FIRM **Hornall Anderson Design Works, Inc., Seattle, WA** ART DIRECTOR **Jack Anderson** GRAPHIC DESIGNERS **Jack Anderson, Bruce Branson-Meyer, Mary Chin Hutchison, and Julie Lock** ILLUSTRATOR **Julia LaPine** COPYWRITER **Julie Huffaker** TYPEFACES **Eras and Sabon** PRINTER **Graphic Arts Center** PAPER **Champion Carnival Groove White Cover, Kraft Vellum Text** CLIENT **Starbucks Coffee Company** 2 TITLE **Revitalizing Baltimore Training Manuals** DESIGN FIRM **Greaney Design, Baltimore, MD** GRAPHIC DESIGNER **Gerry Greaney** ILLUSTRATOR **Sandy Glover** PHOTOGRAPHER **Steffi Graham** WRITER **Shawn Dalton** TYPEFACES **Memphis, Century** PRINTER **Collins Litho** PAPER **Mohawk Options** CLIENT **Revitalizing Baltimore** 3 TITLE **Our Environment: Silicon Graphics Environmental Policy** DESIGN FIRM **Silicon Graphics Creative Dept., Mountain View, CA** ART DIRECTOR **Amy Gregg** GRAPHIC DESIGNER/ILLUSTRATOR **Jennifer Sonderby** WRITER **Mark Adams** TYPEFACES **Gill Sans and Sabon** PRINTER **Express Quality Printing** PAPER **French Dur-O-Tone Packing Carton (Cover) and Fox River Tree-Free Text** CLIENT **Silicon Graphics Facilities Management**

1 TITLE **Toulouse Campaign** DESIGN FIRM **Duffy Design, Minneapolis, MN** CREATIVE DIRECTOR **Joe Duffy** GRAPHIC DESIGNER/ILLUSTRATOR **Todd Waterbury** CLIENT **D'Amico & Partners** 2 TITLE **Nike Corporate Packaging** DESIGN FIRM **Nike Design, Beaverton, OR** ART DIRECTOR **Jeff Weithman** GRAPHIC DESIGNERS **Chris McCullick and Jeff Weithman** WRITER **Bob Lambie** TYPEFACE **Futura** PRINTER/FABRICATOR **Seattle Packaging** MATERIAL **Corrugated E-Flute** CLIENT **Nike, Inc.** 3 TITLE **Bloch Shoeboxes** DESIGN FIRM **Ph.D., Santa Monica, CA** ART DIRECTORS **Michael Hodgson and Clive Piercy** GRAPHIC DESIGNER **Carol Kono** PHOTOGRAPHERS **Victoria Pearson and Ty Allison** TYPEFACES **Gill Sans, Gill Sans Extra Condensed Bold** PRINTER/FABRICATOR **Rose City Paper Box** PAPER **White Lined 70#, Minimum 35% post-consumer/65% recycled fiber** CLIENT **Bloch, Inc.** 4 TITLE **Bloch Tights Packaging** DESIGN FIRM **Ph.D., Santa Monica, CA** ART DIRECTORS **Michael Hodgson and Clive Piercy** GRAPHIC DESIGNERS **Michael Hodgson and Carol Kono** TYPEFACES **Gill Sans, Gill Sans Extra Condensed Bold, Meta** PRINTER/FABRICATOR **Color Craft** PAPER **French Construction Recycled White, 20% certified post-consumer/80% recycled fiber** CLIENT **Bloch, Inc.**

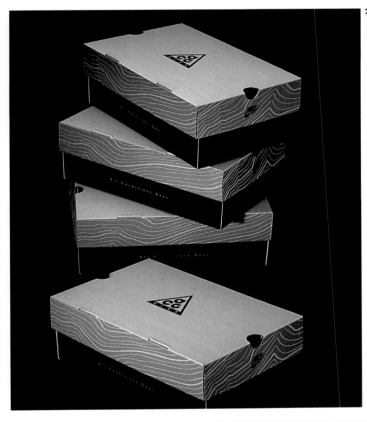

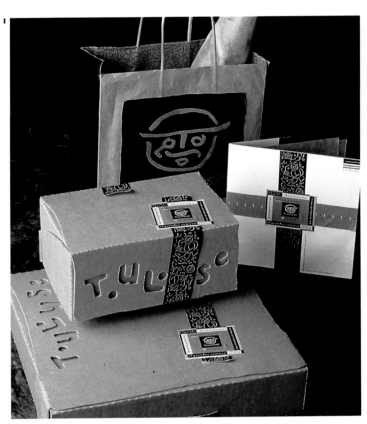

1 TITLE **Hornall Anderson "Open House" Drywall Invitation** DESIGN FIRM **Hornall Anderson Design Works, Inc., Seattle, WA** ART DIRECTORS **Jack Anderson and John Hornall** GRAPHIC DESIGNERS **Jack Anderson and John Hornall** ILLUSTRATOR **Greg Walters** COPYWRITER **John Hornall** PRINTING (Rubber Stamping) **Hornall Anderson Design Works, Inc.** MATERIAL **Drywall** CLIENT **Hornall Anderson Design Works, Inc.** 2 TITLE **Studio Flux Business Cards** DESIGN FIRM **Studio Flux, Minneapolis, MN** CREATIVE DIRECTORS **John J. Moes and Holly A. Utech** GRAPHIC DESIGNERS **John J. Moes and Holly A. Utech** PHOTOGRAPHER **John J. Moes** TYPEFACES **Monotype Script, Engraver's** PRINTER **Fast Print** PAPER **French Dur-O-Tone Newsprint Aged, 100% Recycled, 25% Post-Consumer Waste** CLIENT **Studio Flux** 3 TITLE **Green City Business Card** DESIGN FIRM **Sagmeister Inc., New York, NY** ART DIRECTOR **Stefan Sagmeister** GRAPHIC DESIGNER **Veronica Oh** TYPEFACE **Letter Gothic** PRINTER **Dependable Printing** PAPER **Strathmore Writing Recycled** CLIENT **Alexander Groger, Green City** 4 TITLE **The Modern Way Kenaf Paper Kit** DESIGN FIRM **Studio Flux, Minneapolis, MN** CREATIVE DIRECTORS **John J. Moes and Holly A. Utech** GRAPHIC DESIGNERS **John J. Moes and Holly A. Utech** WRITERS **John J. Moes and Holly A. Utech** TYPEFACES **Huxley, Engraver's, Franklin Gothic, and Rockwell** PRINTER **Fast Print** PAPER **Vision Paper Trailblazer Tree-Free Kanaf** CLIENT **Studio Flux**

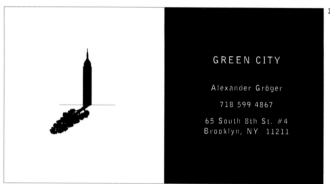

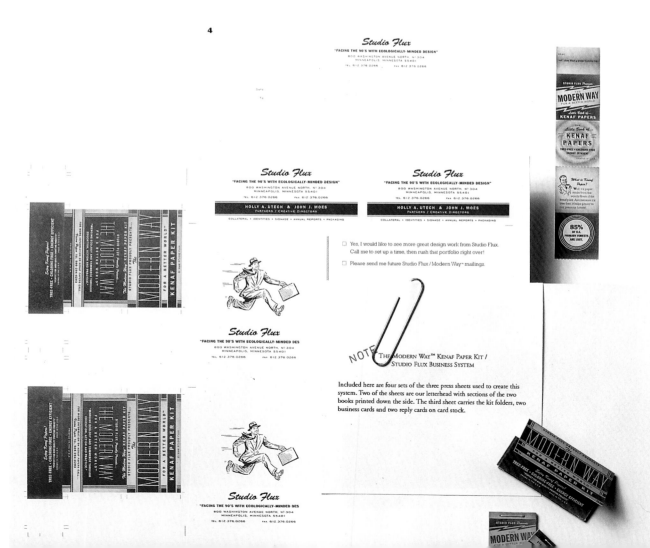

Basic

approach

to the

inclusion

A of *sustainable*
 environmental *process*

criteria

in the

assessment

of

design

and

communication

?

?

ASSESSMENT:
HAVE AN OPINION ABOUT THE PRODUCT YOU ARE
BEING ASKED TO EITHER REDESIGN OR CREATE.

What is the historical context and development of
the product or service?

How is the product or service presently perceived?

What is the value of its function?

How do we utilize or interact with the product or
service?

ESTABLISH A HIERARCHY:
AVOID USING TOXIC MATERIALS OR PROCESSES.
CREATE AN INTELLIGENT PRODUCT SYSTEM.

Is the product a <u>consumable</u>?
Does the waste degrade entirely and become another
species' food with no harm to the environment? Most
pesticides and heavy metals used in the production of
food and other natural crops remain as toxic waste
residues after decomposition.

Is it a product of <u>service</u>?
Products that fall into this category include durable
consumer items such as cars, and computers, and
non-durables such as packaging. As a service, the
product is only licensed by the customer. Ownership
and the responsibility of the disposal or reuse of the
product would be maintained by the manufacturer.

Is the product a <u>toxin</u>?
Products that cannot be integrated into the environ-
ment without causing harm. They include PCBs, heavy
metals, radiation and toxic chemicals. Use of these
products should be designed out of all consumables
and all products of service. Manufacturers of toxins
should be required to pay for the perpetual safe stor-
age of these materials until new technologies of
detoxification can be developed.

As proposed by Dr. Michael Braungart and Justus Englefried,
of the Environmental Protection Encouragement Agency and
illuminated by Paul Hawken in *The Ecology of Commerce*.

Natural Selection Foods

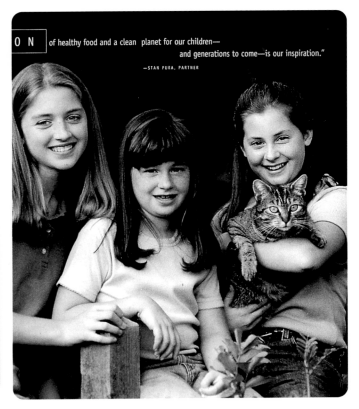

O N of healthy food and a clean planet for our children—
and generations to come—is our inspiration."

—STAN PURA, PARTNER

1 TITLE **A Sustainable Process** DESIGN FIRM **Kondrup Design, Pasadena, CA** CREATIVE DIRECTOR/WRITER **Gloria Kondrup** TYPEFACES **Minion and Gill Sans** PAPER
Neenah Environment Text, Birch; Neenah Environment Cover, Desert Storm PUBLISHER **Jero Press** 2 TITLE **Natural Selection Foods Brochure** DESIGN FIRM **Jerry
Takigawa Design, Monterey, CA** ART DIRECTOR **Jerry Takigawa** GRAPHIC DESIGNER **Glenn Johnson** PHOTOGRAPHERS **Tom O'Neal and Jerry Takigawa** WRITER **Gay
Machado** TYPEFACES **Oficina Sans Book, Oficina Sans Bold** PRINTER **Bayshore Press** PAPER **Simpson Evergreen 80# Kraft Cover, Evergreen 70# Fiber Text, Quest 80#
Beige Text** CLIENT **Natural Selection Foods**

To Our Trasholders:

1995 was a profitable year for everyone served by the people and facilities of Metro Waste Authority (MWA). In partnership with area residents and businesses, we significantly reduced the waste volume entering the landfill. We changed attitudes, created new paradigms, and clearly made our children's future more environmentally secure. Along the way, we demonstrated abiding respect for both our financial and natural resources.

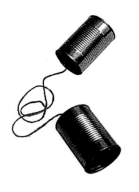

The more you **know** The more **you can do**

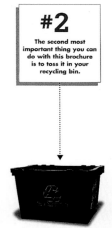

#2

The second most important thing you can do with this brochure is to toss it in your recycling bin.

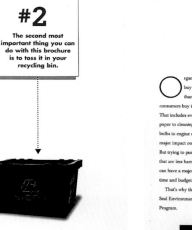

#1

The first is to fill this in and fax it back.

I TITLE **To Our Trasholders Annual Report** DESIGN FIRM **Pattee Design, Des Moines, IA** ART DIRECTOR **Steve Pattee** GRAPHIC DESIGNERS **Steve Pattee and Kelly Stiles** PHOTOGRAPHER **Pattee Design** COPYWRITER **Mike Condon** TYPEFACE **Courier** PRINTER **Holm Graphic** PAPER **French Dur-O-Tone** CLIENT **Metro Waste Authority**
2 TITLE **Environmental Partners Brochure** DESIGN FIRM **1050 A.D. Inc., Washington, D.C.** CREATIVE DIRECTOR **Jack Lanza** GRAPHIC DESIGNER **Jack Lanza** COPYWRITER **Cindy Cole** PAPER **Mohawk Satin Cool White Recycled 80# Cover** CLIENT **Green Seal** **3** TITLE **How to Manage Waste** DESIGN FIRM **Pattee Design, Des Moines, IA** ART DIRECTOR **Steve Pattee** GRAPHIC DESIGNERS **Steve Pattee, Cindy Poulton, and Kelly Stiles** PHOTOGRAPHER **Pattee Design** COPYWRITER **Mike Condon** TYPEFACES **Franklin Gothic and Times Roman** PRINTER **Seward Graphics** PAPER **French Construction, Champion Benefit**

1 TITLE **This Annual Report Is Trash** DESIGN FIRM **Pattee Design, Des Moines, IA** ART DIRECTOR **Steve Pattee** GRAPHIC DESIGNERS **Steve Pattee and Kelly Stiles** PHOTOGRAPHER **Pattee Design** COPYWRITER **Mike Condon** TYPEFACE **Franklin Gothic** PRINTER **Professional Offset** PAPER **Jerusalem Paperworks (Hand Made) and Simpson Quest** CLIENT **Metro Waste Authority** 2 TITLE **More Partners, Less Waste Annual Report** DESIGN FIRM **Pattee Design, Des Moines, IA** ART DIRECTOR **Steve Pattee** GRAPHIC DESIGNERS **Steve Pattee and Kelly Stiles** PHOTOGRAPHER **Pattee Design** COPYWRITER **Mike Condon** TYPEFACES **Univers and Bookman** PRINTER **Holm Graphic** PAPER **Chipboard, French Dur-O-Tone** CLIENT **Metro Waste Authority**

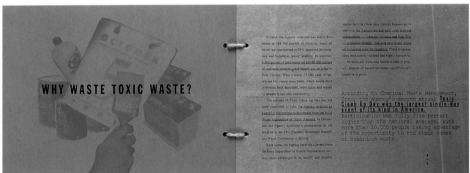

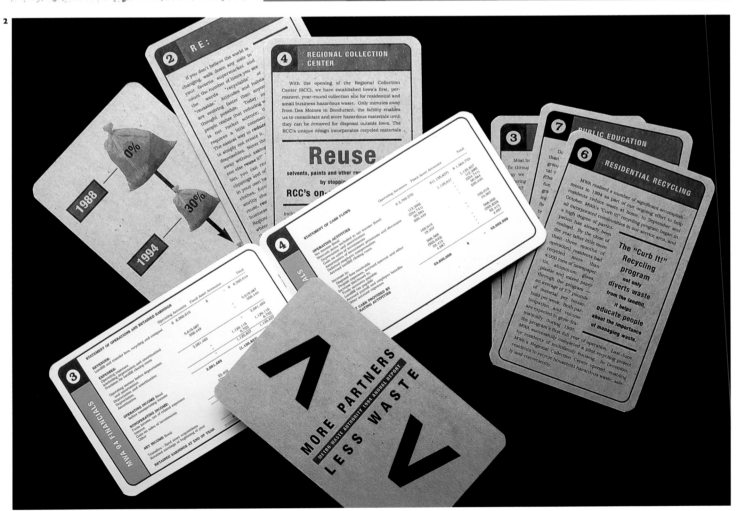

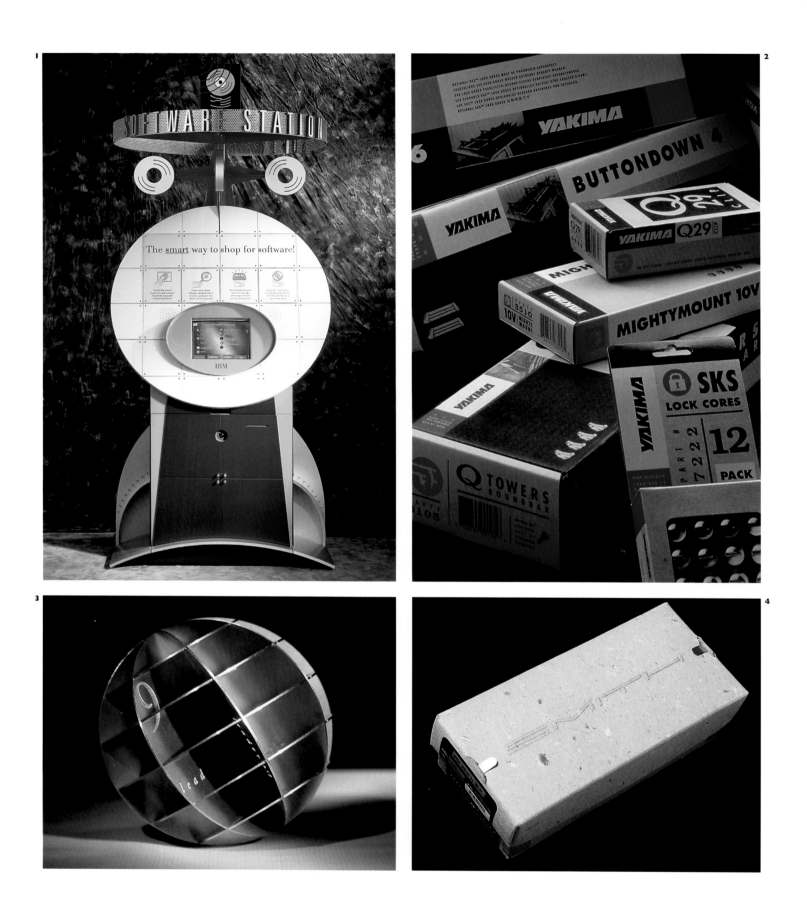

1 Title **IBM Software Station Kiosk** Design Firm **Gee + Chung Design, San Francisco, CA** Art Director/Graphic Designer **Earl Gee** Illustrator **Earl Gee** Photographer **Kirk Amyx** Writer **Susan Berman** Typefaces **Bodoni, Univers Ultracondensed Light** Fabricator **Hood Exhibits** Client **IBM Corporation** 2 Title **Yakima Packaging** Design Firm **Duffy Design, Minneapolis, MN** Creative Director **Joe Duffy** Art Director/Graphic Designer **Kobe** Client **Yakima** 3 Title **AIGA/San Francisco 1996 Environmental Award** Design Firm **Vanderbyl Design, San Francisco, CA** Art Director/Graphic Designer **Michael Vanderbyl** Fabricator **Thomas Swan Sign Company** Client **AIGA/San Francisco** 4 Title **Smith Sport Optics Sunglasses Packaging** Design Firm **Hornall Anderson Design Works, Inc., Seattle, WA** Art Director **Jack Anderson** Graphic Designers **Jack Anderson and David Bates** Typefaces **Futura Condensed and Square Slab 711A** Label Printer **Union Bay Label** Paper **French Dur-O-Tone Speckletone, Standard Box Stock** Client **Smith Sport Optics, Inc.**

1 TITLE **Chronicle Books GiftWorks Display** DESIGN FIRM **Gee + Chung Design, San Francisco, CA** ART DIRECTOR/GRAPHIC DESIGNER **Earl Gee** PHOTOGRAPHER **Alan Shortall** TYPEFACE **Copperplate 33/BC** FABRICATOR **Barr Exhibits** CLIENT **Chronicle Books** 2 TITLE **"Green October" Exhibition Signage** DESIGN FIRM **Swanke Hayden Connell Architects, New York, NY** GRAPHIC DESIGNER **Donald L. Kiel** PHOTOGRAPHER **Steve Friedman** TYPEFACE **Helvetica Bold Italic** FABRICATOR **Mary A. Kelly** CLIENT **One Voice** 3 TITLE **Apple Trade Show Exhibit Reuse Program** DESIGN FIRM **Mauk Design, San Francisco, CA** ART DIRECTOR **Mitchell Mauk** GRAPHIC DESIGNERS **Adam Brodsley, Mitchell Mauk, and Tim Mautz** PHOTOGRAPHER **Julie Chase** TYPEFACES **Apple Garamond and Helvetica Black** FABRICATOR **General Exhibits and Displays** CLIENT **Apple Computer**

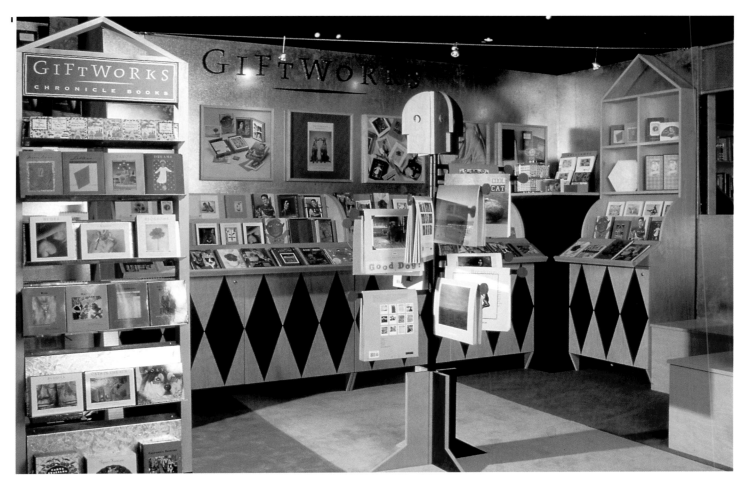

1 Title **The Getty Center Object** Design Firm **plus design inc., Boston, MA** Art/Creative Director **Anita Meyer** Graphic Designers **Jan Baker and Anita Meyer** Typefaces **Emigre Eight and Frutiger Roman** Hand Lettering **Jan Baker** Printer **Aldus Press** Paper **Curtis Parchtext Riblaid and Various Reused/Found Paper** Client **The Getty Center for the History of Art and the Humanities** 2 Title **Wieland Catalogue Binder** Design Firm **Duffy Design, Minneapolis, MN** Creative Director **Joe Duffy** Art Director/Graphic Designer **Neil Powell** Illustrator **Neil Powell** Photographer **Mark LaFavor-Parallel** Client **Wieland Furniture**

1 TITLE **Jane Addams Memorial Signage** DESIGN FIRM **studio blue, Chicago, IL** ART DIRECTORS **Cheryl and Dan Towler Weese, Kathy Fredrickson** DESIGNERS **Cheryl and Dan Towler Weese, Joellen Kames** PHOTOGRAPHER **Hull House Museum Archives, Bettmann Archives** WRITERS **Mary Ann Johnson and Terry Neff Zimmerman** TYPEFACE **Scala Sans** FABRICATOR **Doty and Associates** CLIENTS **Chicago Park District and The Art Institute of Chicago** **2** TITLE **Mohawk Paper Mills Trade Show Desk** DESIGN FIRM **Pentagram Design, New York, NY** ARCHITECTS **James Biber and Michael Zweck-Bronner** ART DIRECTOR **Michael Bierut** DESIGNER **Lisa Cerveny** ILLUSTRATOR **Michael Bull** PHOTOGRAPHER **Reven T. C. Wurman** CLIENT **Mohawk Paper Mills** **3** TITLE **Maryland Institute College of Art Undergraduate/Graduate Catalogue** DESIGN FIRM **Franek Design Associates, Washington, D.C.** ART DIRECTOR **David Franek** GRAPHIC DESIGNERS **David Franek, Max McNeil, and Jeff Wilt** PHOTOGRAPHER **Joe Rubino** WRITER **Debra Rubino** TYPEFACES **Various** PRINTER **Strine Printing Company, Inc.** PAPER **Mohawk Opaque Smooth White 80# Cover and 70# Text; Fridaflack Gray 18 pt. (Slipcase)** CLIENT **MICA**

1 TITLE **After Hours Creative Holiday Invitation** DESIGN FIRM **After Hours Creative, Phoenix, AZ** CREATIVE DIRECTOR/GRAPHIC DESIGNER **After Hours Creative** ILLUSTRATION/WRITING **After Hours Creative** TYPEFACES **Helvetica Neue Extended Bold and Helvetica Neue Condensed Bold** PRINTER **Metro Screen Print** FABRICATORS **After Hours Creative/Helms Industries** CLIENT **After Hours Creative** 2 TITLE **Tide & Cheer Detergents: Reduce, Reuse, Recycle & Refill Campaign** DESIGN FIRM **Burson-Marsteller, Chicago, IL** ART DIRECTOR/GRAPHIC DESIGNER **Karen Kotowicz** ILLUSTRATOR **Karen Kotowicz** WRITERS **Linda Lichter and Chris George** TYPEFACES **Oficina, Orator, and Garamond** PRINTERS **Accurate Silkscreen, Nutone Printing, Victor Envelope** FULFILLMENT **Graphic Finishing** CLIENT **Procter & Gamble** 3 TITLE **Trail Mark Campaign** DESIGN FIRM **Duffy Design, Minneapolis, MN** CREATIVE DIRECTOR **Joe Duffy** GRAPHIC DESIGNERS **Joe Duffy and Jeff Johnson** ILLUSTRATOR **Jeff Johnson** PHOTOGRAPHER **Paul Irmiter** CLIENT **Trail Mark**

1 TITLE **"RE: Formations" Exhibition Invitation** DESIGN FIRM **plus design, inc., Boston, MA** ART/CREATIVE DIRECTOR **Anita Meyer** GRAPHIC DESIGNERS **Anita Meyer and Dina Zaccagnini** WRITER **Judith Hoos Fox** TYPEFACES **Trixie, Dynamoe, Franklin Gothic Demi-Condensed, Gill Sans** PRINTER **Alpha Press** PAPER **Smead Manila Folders** CLIENT **Davis Museum and Cultural Center** **2** TITLE **"RE: Formations/Design Directions at the End of a Century"** DESIGN FIRM **plus design, inc., Boston, MA** ART/CREATIVE DIRECTOR **Anita Meyer** GRAPHIC DESIGNERS **Anita Meyer and Dina Zaccagnini** PHOTOGRAPHERS **Various** WRITERS **Judith Hoos Fox, Steven Skov Holt, and Others** TYPEFACES **Trixie, Dynamoe, Franklin Gothic Book, Franklin Gothic Demi-Condensed** PRINTER **Alpha Press** COLLATION **Center House Enterprises** BINDING **Bay State Bindery, Inc.** PAPER **Oxford Index Cards** CLIENT **Davis Museum and Cultural Center** **3** TITLE **Closing the Loop Annual Report** DESIGN FIRM **Pattee Design, Des Moines, IA** ART DIRECTOR **Steve Pattee** GRAPHIC DESIGNERS **Steve Pattee and Kelly Stiles** PHOTOGRAPHER **Pattee Design** COPYWRITER **Mike Condon** TYPEFACES **Courier and Univers** PRINTER **Professional Offset** PAPER **Fox River Confetti, French Dur-O-Tone** CLIENT **Metro Waste Authority**

There are days when I feel like a kid in a record store or at home wearing headphones, staring at album covers, asking myself: What's inside this box? Why am I drawn to one cover more than another? Then, as now, the answer remains the same — the design communicated a good idea. Music is an emotional experience, an exchange between an artist and an audience. Music is also an industry where annual production, distribution, and consumption exceed $12 billion. Though LPs have morphed into CDs and discus-sized covers shrank to 5x5-inch jewel boxes and cassettes the size of credit cards, the best of these still visually capture and convey the musician's mood, magic, and motivations while meeting the industry's marketing needs.

With this competition, the AIGA singles out design excellence, choosing 100 CD covers from the last five years, plus the best examples from a media stream that includes packaging, print, and advertising, retail merchandising, music videos and websites. In this business, competition for the listener's eyes and ears is fierce. What is being sold, however, are not man-made products, but visual representations of human messages. Design gives form to that experience, framing an imaginative response to the question "what's inside the box?"

Robin Sloane
CHAIRMAN

CALL FOR ENTRY
Design Patrick Raske, Barbis & Raske
Typefaces Trixie, Chicago
Printing AGI, Inc.
Paper Potlatch Vintage Velvet 80# Text

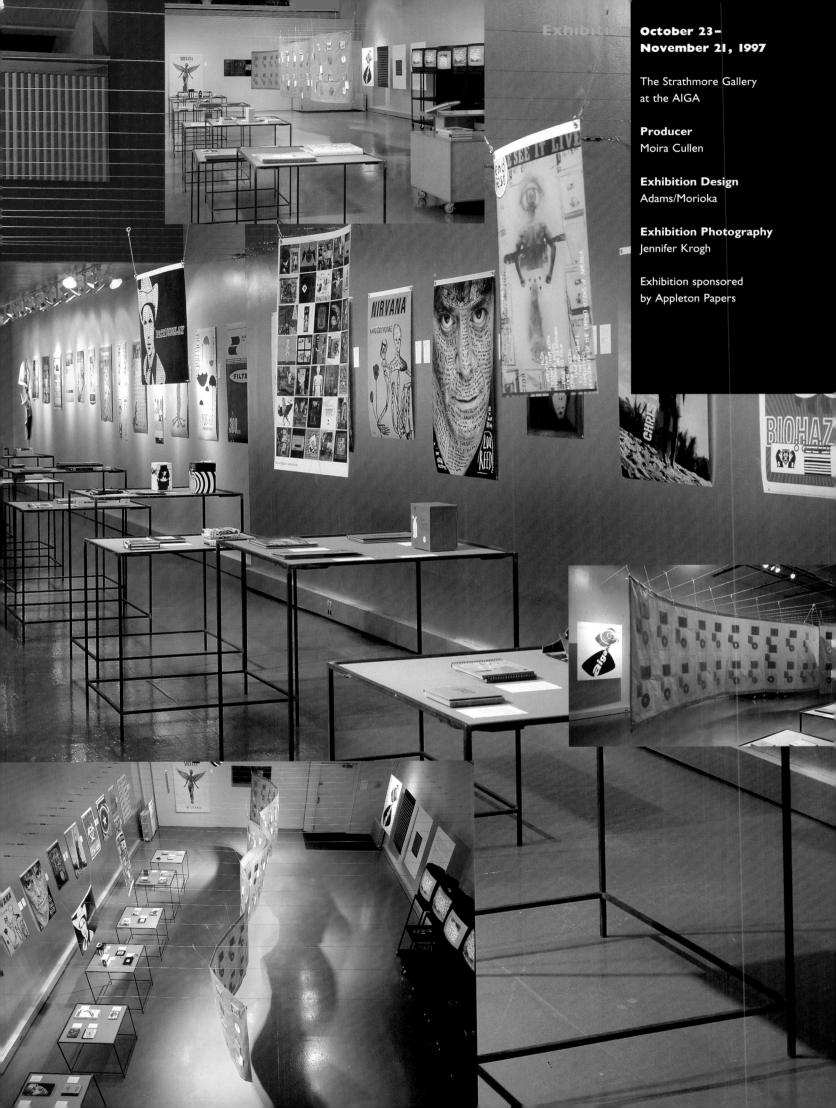

Exhibition

**October 23–
November 21, 1997**

The Strathmore Gallery
at the AIGA

Producer
Moira Cullen

Exhibition Design
Adams/Morioka

Exhibition Photography
Jennifer Krogh

Exhibition sponsored
by Appleton Papers

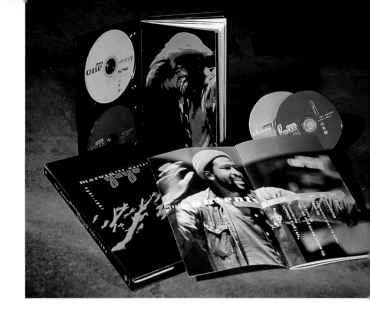

Robin Sloane is creative director at Dreamworks Records. Formerly creative director at Geffen Records, Sloane worked and lunched with David Geffen and Eddie Rosenblatt. Bob Krasnow was her mentor at Elektra. Straight out of college, she moved from an office in a barn at Philo Records in Vermont to Epic Records and has never had to buy an album since. Best of all, she has a corporate card to buy art books.

With a degree in biology and medical illustration, Margo Chase never expected to become the designer of choice for such musical artists as Madonna, Prince, Bonnie Raitt, and Melissa Etheridge. Her experimental style, complex layering, and innovative use of lettering have garnered her music industry acclaim while allowing her to expand into designing consumer packaging, corporate identity, movie poster campaigns, environmental graphics, and interactive multimedia design. She works out of her two-story fully Macintosh networked studio in the hills of Los Angeles with her staff of six, two cats, and a Sailfin lizard.

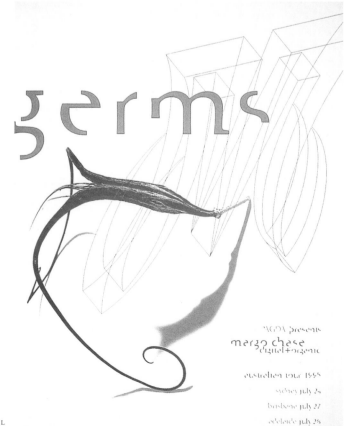

Jeri Heiden is senior vice president of creative services for A&M Records, supervising the development of all of A&M's packaging, videos, advertising, merchandising, and new media. Formerly vice president of creative services at Warner Bros., Heiden has received three Grammy nominations for album package design. Her work has won recognition from the AIGA, American Center for Design, Type Director's Club, *Print, Communication Arts, I.D.* Magazine, and the Art Directors Clubs of Los Angeles and New York.

Drew Hodges is the principal and creative director of Spot Design, an award-winning design studio specializing in entertainment graphics. Spot's extensive client list includes: AMC, AOL Greenhouse, Archive Films & Photo, Barnes & Noble, Calvin Klein, Comedy Central, ESPN, Frito-Lay, Geffen Records, HarperCollins, MTV, Nickelodeon, Pace Entertainment, Random House, Rémi-Martin, KG Dreamworks, Sony Music, Swatch Watch, *The Oprah Winfrey Show,* and USA Networks. Drew recently launched Spotco, a full-service advertising agency to work in tandem with Spot Design. Spotco's client list includes the Broadway production and touring companies of the musicals *Rent* and *Chicago,* as well as *The Diary of Anne Frank.*

Abby Terkuhle is executive vice-president/ creative director of MTV, where he spearheads the creative activities of MTV's in-house advertising and oversees on-air promotion and animation. He is also creative director of MTV Productions, an off-channel production unit that develops and produces feature films and other projects for syndication, including the original animated series *Beavis and Butt-head.* Before moving to MTV in 1986, he was a film segment producer for *Saturday Night Live* and a producer for Showtime/The Movie Channel.

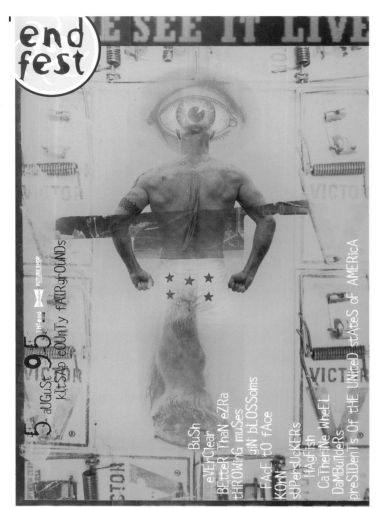

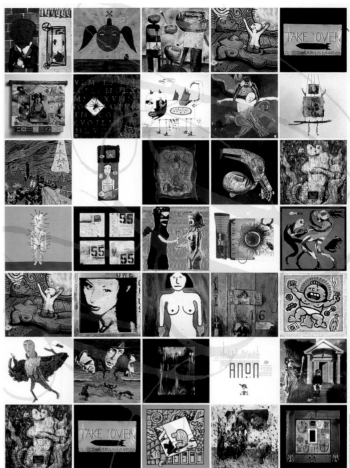

An art/music compilation

1 TITLE **End Fest Poster '95** DESIGN FIRM **MTV Networks Creative Services, New York, NY** ART DIRECTOR **Scott Wadler** GRAPHIC DESIGNER **Tim Morse** PHOTOGRAPHER **Exum** WRITER **Ken Saij** TYPEFACES **Escalido Streak, Gothico** PRINTER **Atwater Press Litho Corp.** PAPER **Lithofect Plus #80 Text** CLIENT **KNDD "The End" 107.7** **2** TITLE **Anon Poster** DESIGN FIRM **Stoltze Design, Boston, MA** ART DIRECTOR/GRAPHIC DESIGNER **Clifford Stoltze** ILLUSTRATORS **Various** TYPEFACES **Calvino, Gangly** PRINTER **Pride Printers** PAPER **Repap Matte** CLIENT **Castle von Buhler Records**

1 TITLE **Les Baxter "The Exotic Moods of Les Baxter"** DESIGN FIRM **Capitol Records, Hollywood, CA** ART DIRECTORS **Jeff Fey and Tommy Steele** GRAPHIC DESIGNER **Jeff Fey** ILLUSTRATOR **Mark Ryden** PHOTOGRAPHER **Capitol Archives** 2 TITLE **The Smashing Pumpkins "Mellon Collie and the Infinite Sadness"** DESIGN FIRM **Frank Olinsky, Brooklyn, NY** ART DIRECTORS **Billy Corgan and Frank Olinsky** GRAPHIC DESIGNER **Frank Olinsky** ILLUSTRATOR **John Craig** PHOTOGRAPHER **Andrea Giacobbe** TYPEFACES **Gill Sans, Glorietta, Le Petit Trottin** PRINTER/FABRICATOR **AGI** CLIENT **Virgin Records America** 3 TITLE **Anon** DESIGN FIRM **Stoltze Design, Boston, MA** ART DIRECTOR/GRAPHIC DESIGNER **Clifford Stoltze** ILLUSTRATORS **Various** PHOTOGRAPHER **Craig MacCormack** TYPEFACES **Calvino, Gangly** PRINTERS **Calumet and Pride Printers** PAPER **Kraft board, Repap Matte** CLIENT **Castle von Buhler Records**

1 TITLE **Miles Davis "The Complete Live at the Plugged Nickel 1965"** DESIGN FIRM **Sony Music Creative Services, New York, NY** ART DIRECTOR/GRAPHIC DESIGNER **Julian Peploe** PHOTOGRAPHER **Dora Handel** TYPEFACE **Futura** CLIENT **Columbia Records** 2 TITLE **Sam Cooke's SAR Records Story** DESIGN FIRM **ABKCO, New York, NY** ART DIRECTOR **Iris Keitel** ASSISTANT ART DIRECTOR **Alisa Ritz** GRAPHIC DESIGNERS **Diana Graham and Cody Rasmussen** ILLUSTRATOR **Angelo Tillery** CONCEPT **Lenne Allik** PRINTER **Queens Group** CLIENT **ABKCO Records**

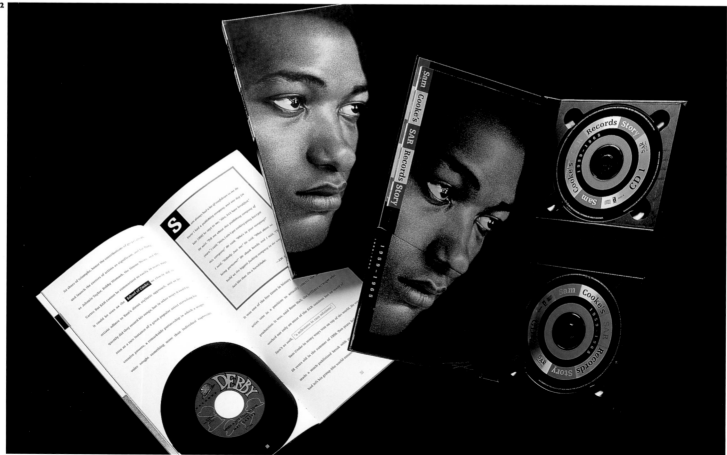

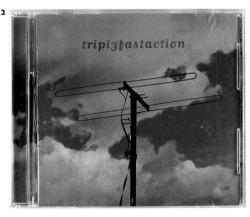
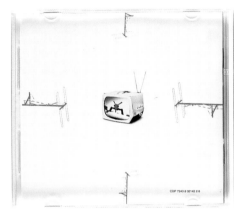
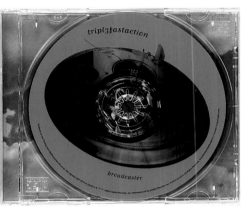

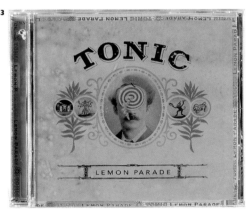
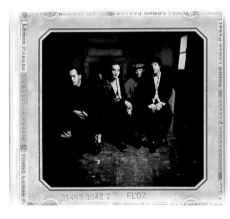

1 TITLE **Toad the Wet Sprocket "In Light Syrup"** DESIGN FIRM **Sony Music Creative Services, Santa Monica, CA** ART DIRECTOR **Mary Maurer** GRAPHIC DESIGNER **Hooshik** ILLUSTRATOR **Bill Barminski** PHOTOGRAPHERS **Dana Tynan and Various** CLIENT **Columbia Records** 2 TITLE **Tripl3FastAction "Broadcaster"** DESIGN FIRM **Capitol Records In-House Art Dept., Hollywood, CA** ART DIRECTOR **Tommy Steele** GRAPHIC DESIGNER **George Mimnaugh** PHOTOGRAPHER **Unknown (Archival)** PRINTER **Erica Records** 3 TITLE **Tonic "Lemon Parade"** ART DIRECTOR **Jeri Heiden** GRAPHIC DESIGNER **Jean Krikorian** ILLUSTRATORS **Jonathon Rosen and Malcolm Tarlofsky** WRITERS **Danny Clinch and Holly Lindem** CLIENT **A&M Records, Inc.**

1 TITLE **Alice in Chains "Jar of Flies"** DESIGN FIRM **Sony Music Creative Services, Santa Monica, CA** CREATIVE DIRECTOR **Mary Maurer** PHOTOGRAPHERS **Pete Cronin and Rocky Schenck** ELECTRON MICROSCOPE PHOTOGRAPHY **Alicia K. Thompson** CLIENT **Columbia Records** 2 TITLE **Sparklehorse "VivaDixieSubmarineTransmission Plot"** DESIGN FIRM **Capitol Records, Hollywood, CA** ART DIRECTOR **Mark Linkous** GRAPHIC DESIGNER **Paul Brown** PHOTOGRAPHER **Mark Linkous** 3 TITLE **Acid/Base** DESIGN FIRM **Hollywood Records Creative, Burbank, CA** ART DIRECTORS/GRAPHIC DESIGNERS **Todd Gallopo and Tim Stedman** TYPEFACES **Helvetica, New Century Schoolbook, Palatino** PRINTER **Westland Graphics** FABRICATOR **Distrionics**

1 TITLE **1993 MTV Video Music Awards Program** DESIGN FIRM **MTV Off-Air Creative, New York, NY** CREATIVE DIRECTOR **Jeffrey Keyton** ART DIRECTORS **Steve Byram, Stacy Drummond, and Jeffrey Keyton** GRAPHIC DESIGNERS/ILLUSTRATORS **Various** COPYWRITER **Karin Henderson** 2 TITLE **1994 MTV Video Music Awards Program** DESIGN FIRM **MTV Off-Air Creative, New York, NY** CREATIVE DIRECTOR **Jeffrey Keyton** ART DIRECTORS **Tracy Boychuk, Stacy Drummond, and Jeffrey Keyton** GRAPHIC DESIGNERS **Tracy Boychuk, Stacy Drummond, and Johan Vipper** COPYWRITER **David Felton** 3 TITLE **1995 MTV Video Music Awards Program** DESIGN FIRM **MTV Off-Air Creative, New York, NY** CREATIVE DIRECTORS **Stacy Drummond and Jeffrey Keaton** GRAPHIC DESIGNER/ILLUSTRATOR **David Sandlin** WRITER **David Sandlin**

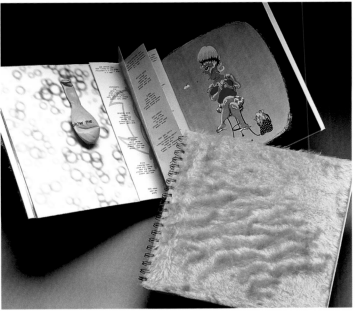

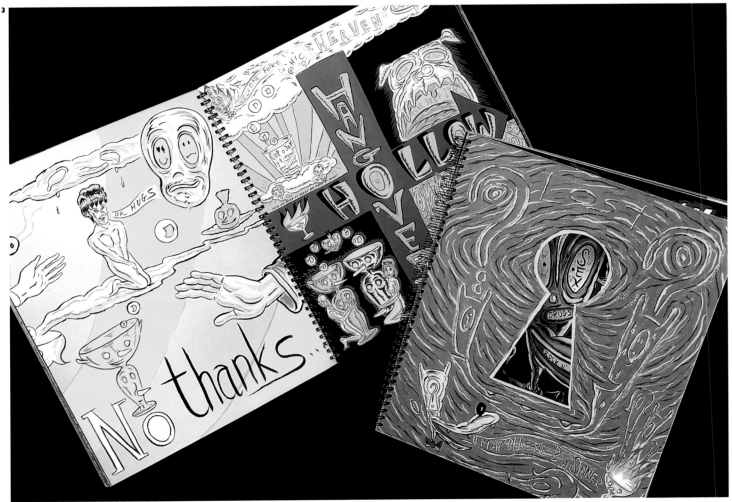

1 TITLE **"Crossroads: Southern Routes"** DESIGN FIRM **Scott Stowell Design, Brooklyn, NY** ART DIRECTOR/GRAPHIC DESIGNER **Scott Stowell** WRITERS **Anthony Seeger and Kip Lornell** TYPEFACES **Interstate Bold Condensed, Ionic No. 5** PRINTER **Queens Group** PAPER **Mead Coated 2-Side Cover and Text** CLIENT **Smithsonian Folkways Recordings** 2 TITLE **Roseanne Cash "Ten Song Demo"** DESIGN FIRM **Capitol Records, Hollywood, CA** ART DIRECTORS **Tommy Steele and Paul Brown** GRAPHIC DESIGNER **Paul Brown** 3 TITLE **Beck "Odelay"** DESIGN FIRM **Geffen Records, Los Angeles, CA** ART DIRECTORS **Robert Fisher and Beck Hansen** ILLUSTRATORS **Robert Fisher, Al Hansen, Manuel Ocampo, and Zarim Osborn** PHOTOGRAPHERS **Nitin Vadukul and Ludwig** TYPEFACES **Antique Tuscan Outline, Bauhaus Medium, Davida**

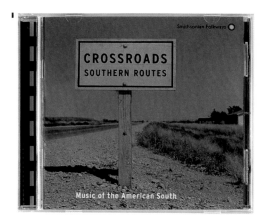

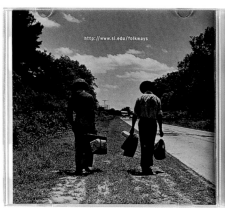

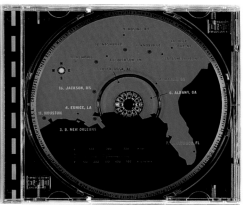

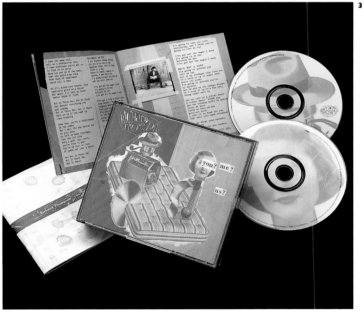

1 TITLE **Beck "Odelay" Poster** DESIGN FIRM **Geffen Records, Los Angeles, CA** ART DIRECTOR **Robert Fisher** PHOTOGRAPHER **Nitin Vadukul** PRINTER **Westland Graphics** 2 TITLE **"Elvis 56"** DESIGN FIRM **Design/Art Inc., Los Angeles, CA** ART DIRECTORS **Ria Lewerke and Norman Moore** GRAPHIC DESIGNERS **Dayna Fredrickson, Norman Moore, and Andrew Sutton** PHOTOGRAPHER **Alfred Wertheimer** TYPEFACE **Helvetica** PRINTER **Queens Litho** CLIENT **RCA Records** 3 TITLE **Richard Thompson "You? Me? Us?"** DESIGN FIRM **Capitol Records, Hollywood, CA** ART DIRECTORS **Jeff Fey and Tommy Steele** ILLUSTRATOR **David Plunkert** PHOTOGRAPHER **Michael Wilson**

1 TITLE "The Trocadero Presents: Wilco and September 67" DESIGN FIRM Urban Outfitters, Philadelphia, PA ART DIRECTOR/GRAPHIC DESIGNER Howard Brown
TYPEFACE Banner Stars PRINTER Royal Press PAPER Chipboard PUBLISHER Urban Outfitters CLIENT The Trocadero 2 TITLE Bonepony "Stomp Revival" Ad/Poster
DESIGN FIRM Capitol Records, Hollywood, CA ART DIRECTOR Jeff Fey GRAPHIC DESIGNER Jim Sherraden (Hatch Show Print)

1 TITLE **Bonepony "Stomp Revival"** DESIGN FIRM **Capitol Records, Hollywood, CA** ART DIRECTORS **Jeff Fey and Tommy Steele** GRAPHIC DESIGNER **Jeff Fey**
PHOTOGRAPHER **Michael Wilson** 2 TITLE **Ultra Lounge Leopard Skin Sampler** DESIGN FIRM **Capitol Records, Hollywood, CA** ART DIRECTORS **Tommy Steele and Andy**
Engel GRAPHIC DESIGNER **Andy Engel** PHOTOGRAPHER **Don Miller** PRINTER/FABRICATOR **AGI, Inc.** 3 TITLE **That Dog "Totally Crushed Out"** DESIGN FIRM **Geffen**
Records, Los Angeles, CA ART DIRECTOR **Robert Fisher** ILLUSTRATOR **Jason Dowd** PHOTOGRAPHER **Photobooth 2000** TYPEFACES **Brody, New Century Schoolbook,**
Spumoni

1 TITLE **Ella Fitzgerald "The Complete Ella Fitzgerald Songbook"** DESIGN FIRM **Verve Records, New York, NY** ART DIRECTOR/GRAPHIC DESIGNER **Chris Thompson** ILLUSTRATOR **Jeffrey Fulvimani** PHOTOGRAPHER **Various** PRINTER **AGI** CLIENT/PUBLISHER **Verve Records** 2 TITLE **Blues, Boogie & Bop: The 1940s Mercury Sessions** DESIGN FIRM **Verve Records, New York, NY** ART DIRECTORS **Michael Kaye, David Lau, and Giulio Turturro** GRAPHIC DESIGNER **Giulio Turturro** PHOTOGRAPHERS **Various** TYPEFACE **Trade Gothic Family** PRINTER **Enterprise Press** PAPER **French Speckletone** CLIENTS/PUBLISHERS **Verve Records, Polygram Records**

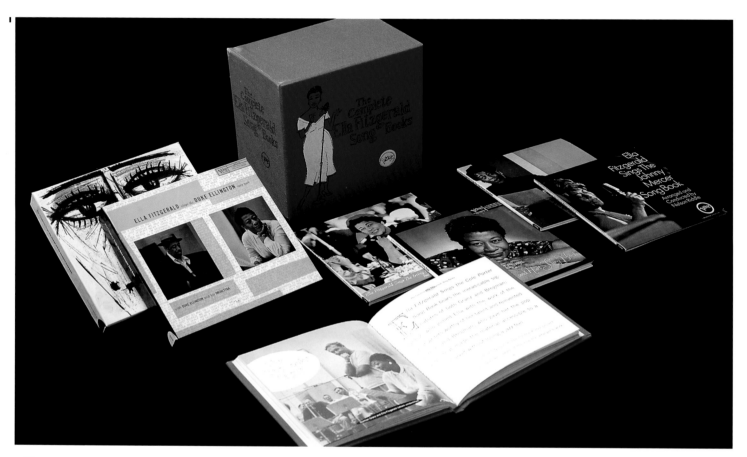

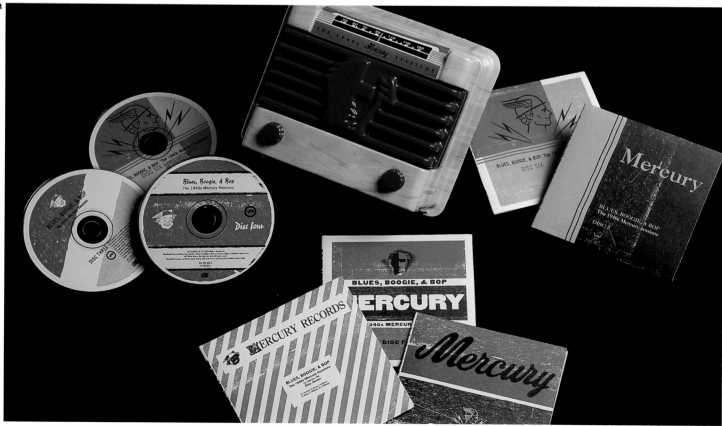

1 TITLE **Cuban Blues "The Chico O'Farrill Sessions"** DESIGN FIRM **Verve Records, New York, NY** ART DIRECTOR/GRAPHIC DESIGNER **Lisa Po-Ying Huang** PHOTOGRAPHS **Courtesy of Lupe and Chico O'Farrill** PRINTER **Shorewood** PAPER **Cougar Uncoated** 2 TITLE **White Zombie Presents Supersexy Swingin' Sounds** DESIGN FIRM **Art Slave, Santa Monica, CA** ART DIRECTORS/GRAPHIC DESIGNERS **Rob Zombie and Wendy Sherman** PHOTOGRAPHER **Peter Gowland** 3 TITLE **Joe Henderson "Big Band"** DESIGN FIRM **Verve Records, New York, NY** ART DIRECTOR/GRAPHIC DESIGNER **Patricia Lie** ILLUSTRATOR **Ed Fotheringham**

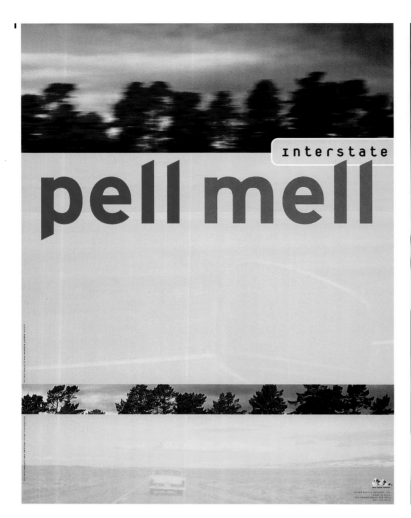

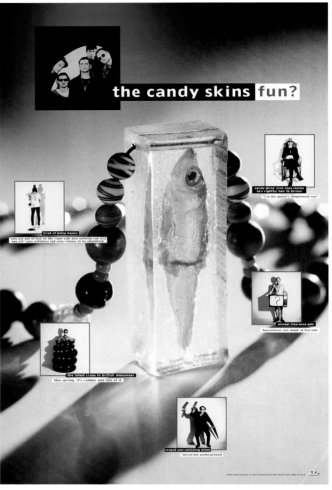

1 TITLE **Pell Mell Poster** DESIGN FIRM **Stoltze Design, Boston, MA** ART DIRECTOR **Clifford Stoltze** GRAPHIC DESIGNERS **Bob Beerman and Clifford Stoltze** PHOTOGRAPHERS **Kelly Spalding and Clifford Stoltze** TYPEFACES **Interstate, Platelet** PRINTER **Westland Graphics** CLIENT **David Geffen Company** 2 TITLE **The Candy Skins "Oxford Times" Poster** DESIGN FIRM **Geffen Records, Los Angeles, CA** ART DIRECTOR **Bill Merryfield** PHOTOGRAPHER **Walter Wick** WRITER **Maria Morin** PRINTER **Westland Graphics**

1 TITLE **Blind Melon "Soup"** DESIGN FIRM **Capitol Records, Hollywood, CA** ART DIRECTORS **Jeff Fey and Tommy Steele** GRAPHIC DESIGNER **Jeff Fey** PHOTOGRAPHER **Danny Clinch** 2 TITLE **Drill Team "In Bloom"** DESIGN FIRM **Warner Bros. Records, Burbank, CA** ART DIRECTORS/GRAPHIC DESIGNERS **Deborah Norcross and Jim Mills** PHOTOGRAPHER **Victor Bracke** CLIENT/PUBLISHER **Warner Bros. Records** 3 TITLE **Buy Product** DESIGN FIRM **Cornynshen Advertising, San Francisco, CA** ART DIRECTORS **Chris Cornyn and Billy Shen** GRAPHIC DESIGNER **Billy Shen** PHOTOGRAPHER **Rick Der** WRITER **Chris Cornyn** CLIENT **Geffen Records**

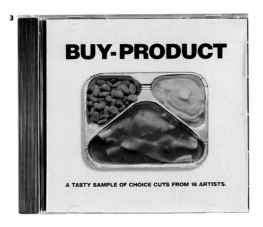

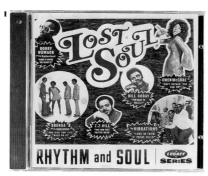

TITLE **Baboon, Bikini Kill, Jawbreaker, Voodoo Glow Skulls Flyer** DESIGN FIRM **Toast, Portland, OR** ILLUSTRATOR **Toast** PRINTER **Photocopied**

1 Title **Mike Watt "Ball-Hog or Tugboat" CD Package** Design Firm **Sony Music Creative Services, Santa Monica, CA** Art Director/Graphic Designer **Doug Erb** Illustrators **Doug Erb, Kira, and Raymond Pettibon** Client **Columbia Records** 2 Title **Mike Watt "Ball-Hog or Tugboat" Poster** Design Firm **Sony Music Creative Services, Santa Monica, CA** Art Director/Graphic Designer **Doug Erb** Client **Columbia Records** 3 Title **Rage Against the Machine "Evil Empire"** Design Firm **Sony Music Entertainment, New York, NY** Art Directors **Rage Against the Machine and Aimee Macauley** Graphic Designer **Aimee Macauley** Illustrator **Mel Ramos** Typeface **Helvetica** 4 Title **Kansas City** Design Firm **Verve Records, New York, NY** Art Director/Graphic Designer **Patricia Lie** Photogarpher **Eli Reed** Typeface **Lemiesz** Client **Verve Records**

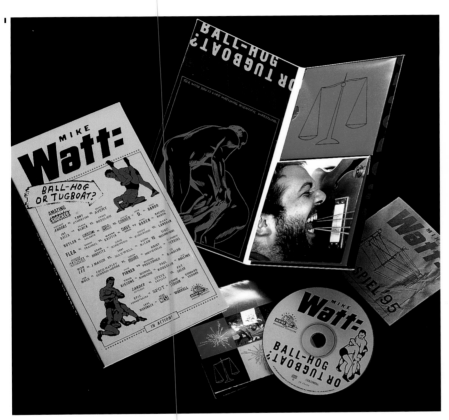

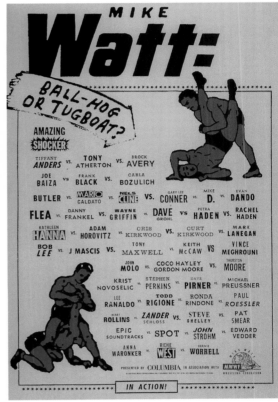

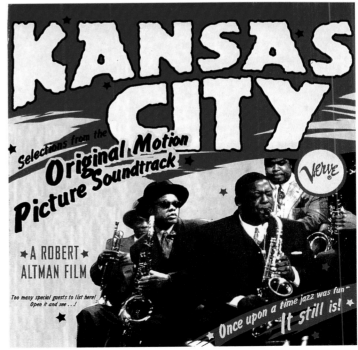

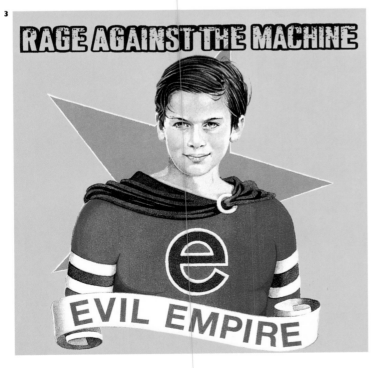

1 TITLE **Ween "Chocolate and Cheese"** DESIGN FIRM **Reiner Design, New York, NY** ART DIRECTOR **Roger Gorman** GRAPHIC DESIGNER **Rick Patrick** PHOTOGRAPHER **John Kuczala** CLIENT **Elektra Entertainment** 2 TITLE **Too Much Joy "...Finally"** DESIGN FIRM **Greenberg Kingsley, New York, NY** ART DIRECTORS **Karen L. Greenberg and D. Mark Kingsley** GRAPHIC DESIGNER **D. Mark Kingsley** ILLUSTRATOR **Doug Allen** PHOTOGRAPHER **Robert Lewis** PRINTER **Westland Graphics** CLIENT **Discovery Records** 3 TITLE **Hole "Live Through This"** DESIGN FIRM **Geffen Records, Los Angeles** CREATIVE DIRECTOR **Robin Sloane** ART DIRECTOR **Janet Wolsbout** PHOTOGRAPHER **Ellen Von Unworth** CUSTOM LOGO **Bill Money**

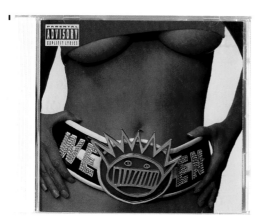

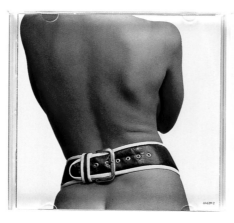

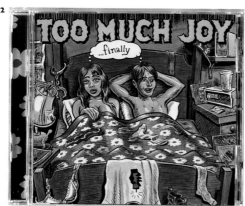

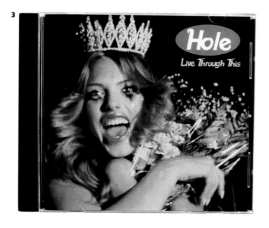

1 TITLE **Eels "Beautiful Freak" Poster** DESIGN FIRM **Geffen Records, Los Angeles, CA** ART DIRECTOR **Francesca Restrepo** PHOTOGRAPHER **Ann Giordano** PRINTER **Westland Graphics** 2 TITLE **Porno for Pyros "Good God's Urge" Poster** DESIGN FIRM **Warner Bros. Records, Burbank, CA** ART DIRECTORS **Deborah Norcross and Perry Farrell** GRAPHIC DESIGNER **Deborah Norcross** PHOTOGRAPHER **John Eder** CLIENT/PUBLISHER **Warner Bros. Records**

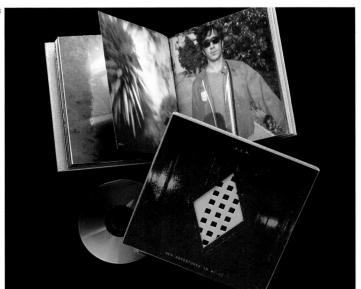

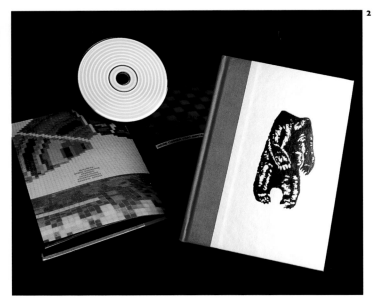

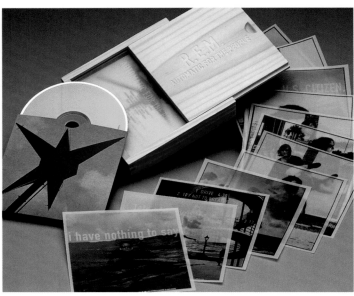

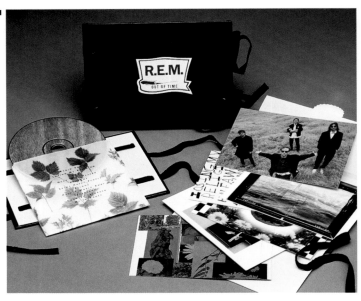

1 TITLE **R.E.M. "Out of Time"** DESIGN FIRM **Warner Bros. Records, Burbank, CA** ART DIRECTORS/GRAPHIC DESIGNERS **Tom Recchion and Michael Stipe** PHOTOGRAPHERS **Ben Katchor, Frank Ockenfels, Ed Rogers, Doug & Mike Stam** CLIENT/PUBLISHER **Warner Bros. Records** 2 TITLE **R.E.M. "Monster"** DESIGN FIRM **Warner Bros. Records, Burbank, CA** ART DIRECTORS/GRAPHIC DESIGNERS **Chris Bilheimer, Tom Reccion, and Michael Stipe** PHOTOGRAPHERS **Chris Bilheimer, Christy Bush, Jem Cohen, Brooks Dillon, Michael Meister, and Michael Stipe** CLIENT/PUBLISHER **Warner Bros. Records** 3 TITLE **R.E.M. "New Adventures in Hi-Fi"** DESIGN FIRM **Warner Bros. Records, Burbank, CA** CLIENT/PUBLISHER **Warner Bros. Records** CREATIVE DIRECTORS/GRAPHIC DESIGNERS **Chris Bilheimer and Michael Stipe** PHOTOGRAPHERS **Chris Bilheimer, Jem Cohen, and Michael Stipe** CLIENT/PUBLISHER **Warner Bros. Records** 4 TITLE **R.E.M. "Automatic for the People"** DESIGN FIRM **Warner Bros. Records, Burbank, CA** ART DIRECTORS **Jim Ladwig, Tom Recchion, and Michael Stipe** GRAPHIC DESIGNER **Tom Recchion** PHOTOGRAPHER **Anton Corbijn** CLIENT/PUBLISHER **Warner Bros. Records**

1 TITLE **Alice in Chains "Alice in Chains"** DESIGN FIRM **Sony Music Creative Services, Santa Monica, CA** ART DIRECTOR **Mary Maurer** GRAPHIC DESIGNER **Doug Erb** ILLUSTRATOR **Grandville** PHOTOGRAPHERS **Rob Bloch and Rocky Schenck** CLIENT **Columbia Records** **2** TITLE **Balloon Guy "The West Coast Shakes"** DESIGN FIRM **Warner Bros. Records, Burbank, CA** ART DIRECTOR/GRAPHIC DESIGNER **Christine Cano** ILLUSTRATOR **Mark Todd** CLIENT/PUBLISHER **Warner Bros. Records** **3** TITLE **Butthole Surfers "Pepper"** DESIGN FIRM **Capitol Records, Hollywood, CA** ART DIRECTOR **Tommy Steele** GRAPHIC DESIGNER **Wendy Dougan**

1 TITLE **Boss Hog** DESIGN FIRM **Mike Mills Diversified, New York, NY** ART DIRECTOR/GRAPHIC DESIGNER **Mike Mills** ILLUSTRATORS **Mike Mills and Beth Bartholomew,** based on photos by **Michael Lavine** 2 TITLE **Velvet Crush "Teenage Symphonies to God"** DESIGN FIRM **Sony Music, Santa Monica, CA** ART DIRECTOR/GRAPHIC DESIGNER **Francesca Restrepo** ILLUSTRATOR **Ed Fotheringham** 3 TITLE **Sponge "Rotting Piñata"** DESIGN FIRM **Sony Music, Santa Monica, CA** ART DIRECTOR/GRAPHIC DESIGNER **David Coleman** PHOTOGRAPHER **Michael Halsband** CLIENT **Work Records**

1 TITLE **Boss Hogg "New Album October 10th" Snipe Poster** DESIGN FIRM **Geffen Records, Los Angeles, CA** ART DIRECTOR/GRAPHIC DESIGNER **Mike Mills** ILLUSTRATOR **Mike Mills** 2 TITLE **Filter "Short Bus" Poster** DESIGN FIRM **Warner Bros. Records, Burbank, CA** ART DIRECTOR/GRAPHIC DESIGNER **Deborah Norcross** PHOTOGRAPHER **Paul McMenamin**

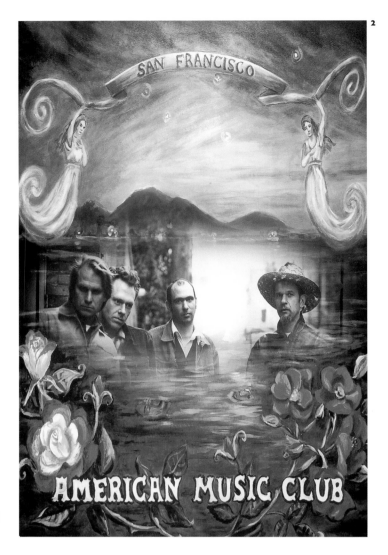

1 TITLE **Los Lobos "Colossal Head" Poster** DESIGN FIRM **Warner Bros. Records, Burbank, CA** ART DIRECTOR/GRAPHIC DESIGNER **Tom Recchion** PHOTOGRAPHER **Jim Douglas** 2 TITLE **American Music Club "San Francisco" Poster** DESIGN FIRM **Warner Bros. Records, Burbank, CA** ART DIRECTOR/GRAPHIC DESIGNER **Tom Recchion** ILLUSTRATOR **Dan Kalal** PHOTOGRAPHER **Bill Phelps** CLIENT/PUBLISHER **Warner Bros. Records**

1 TITLE **Los Lobos "Colossal Head"** DESIGN FIRM **Warner Bros. Records, Burbank, CA** ART DIRECTOR/GRAPHIC DESIGNER **Tom Recchion** PHOTOGRAPHER **Jim Douglas** CLIENT/PUBLISHER **Warner Bros. Records** **2** TITLE **Los Lobos "Just Another Band from East L.A."** DESIGN FIRM **Warner Bros. Records, Burbank, CA** ART DIRECTORS/GRAPHIC DESIGNERS **Louie Perez and Tom Recchion** PHOTOGRAPHERS **Keith Carter and Fredrik Nilsen** CLIENT/PUBLISHER **Warner Bros. Records** **3** TITLE **Los Angeles Free Music Society "The Lowest Form of Music"** DESIGN FIRM **Warner Bros. Records, Burbank, CA** ART DIRECTOR/GRAPHIC DESIGNER **Tom Recchion** PHOTOGRAPHERS **David Arnoff, Chip Chapman, Susan Chapman, Dennis Ducks, Kevin Laffey, Don Lewis, Alison Lloyd, Fredrik Nilsen, Carla Rajnus, Tom Recchion, Sears Photo Studio, Annike Soderholm, Mark Takeuchi, and Bill Woland** CLIENT/PUBLISHER **Warner Bros. Records**

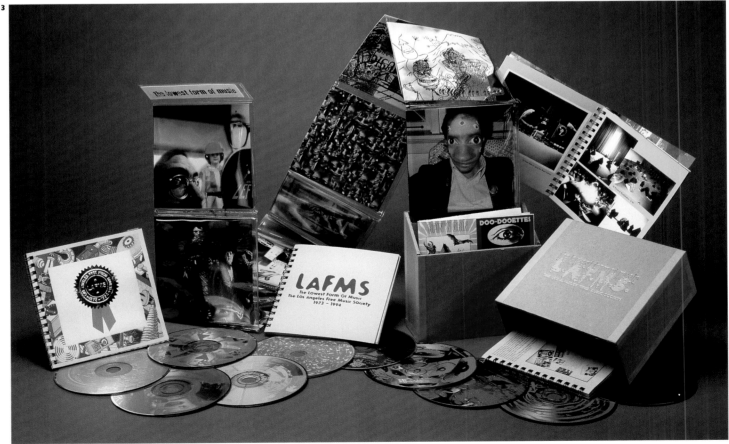

1 TITLE **"The Pipes of Pan at Jajouka"** DESIGN FIRM **Polygram Classics & Jazz, New York, NY** ART DIRECTORS **Margery Greenspan and Gordon H. Jee** GRAPHIC DESIGNER **Gordon H. Jee** PRINTER **AGI** CLIENT **Point Music** 2 TITLE **This Is Fort Apache** DESIGN FIRM **MCA Records Creative, Universal City, CA** ART DIRECTOR **Tim Stedman** GRAPHIC DESIGNERS **Robin Cottle, Todd Gallopo, Pia Koskella, and Tim Stedman** PHOTOGRAPHER **Michael Wilson** COPYWRITER **Karen Schoemer** TYPEFACE **Franklin Gothic** PRINTER **AGI** PAPER **Chipboard** 3 TITLE **Onobox** DESIGN FIRM **Reiner Design, New York, NY** ART DIRECTOR **Roger Gorman** PHOTOGRAPHER **Raenne Rubenstein (Box Cover)** WRITER **Robert Palmer** CLIENT **Rykodisc**

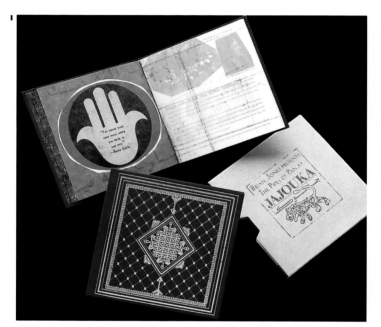

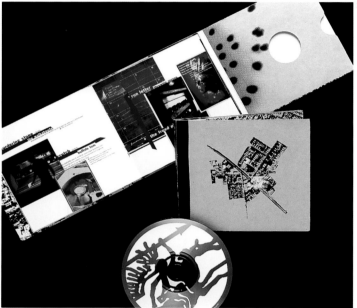

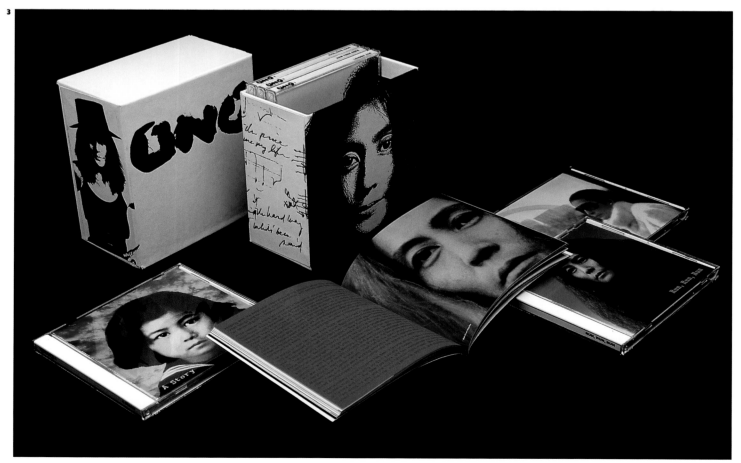

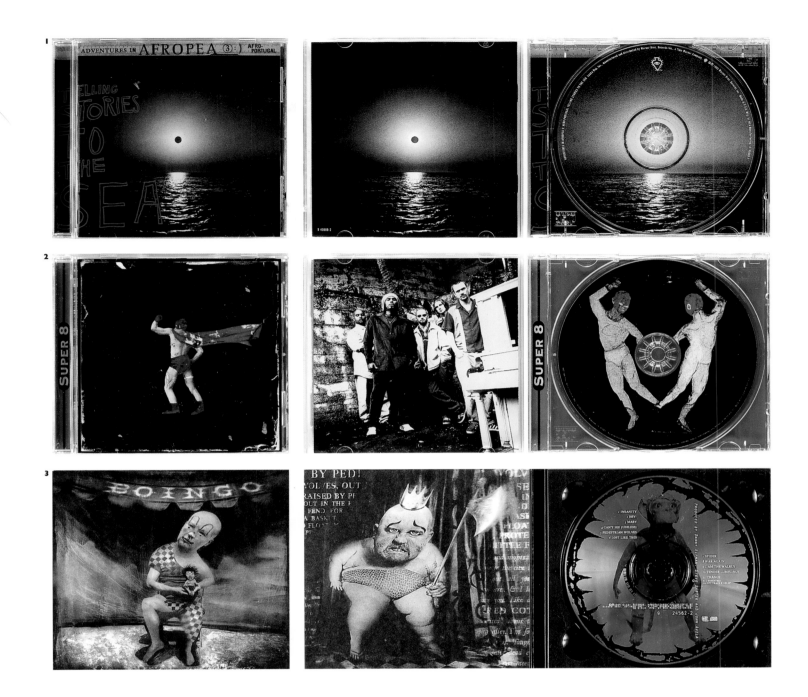

1 TITLE **Afropea 3 "Telling Stories to the Sea"** DESIGN FIRM **Sagmeister, Inc., New York, NY** ART DIRECTOR/GRAPHIC DESIGNER **Stefan Sagmeister** ILLUSTRATOR **Indigo Arts** PHOTOGRAPHER **Tom Schierlitz** TYPEFACES **Baskerville, Bembo, Bodoni, Garamond, Mrs. Eaves, News Gothic, Times, Trade Gothic, Spartan** PRINTER **Warner Media Services** CLIENT/PUBLISHER **Warner Bros. Records Inc.** 2 TITLE **Super 8** DESIGN FIRM **Hollywood Records Creative, Burbank, CA** ART DIRECTOR **Ted Stedman** GRAPHIC DESIGNERS **Ted Stedman and Todd Gallopo** ILLUSTRATOR **Jason Holley** PHOTOGRAPHER **Michael Wilson** CALLIGRAPHY **Nicole Eckenrode** TYPEFACE **Copperplate Gothic** PRINTER **Queens** 3 TITLE **Boingo "Boingo"** DESIGN FIRM **Warner Bros. Records, Burbank, CA** ART DIRECTOR/GRAPHIC DESIGNER **Deborah Norcross** PHOTOGRAPHERS **Anthony Artiaga and Melodie McDaniel** TYPEFACES **Ideoque, Oration, Ditigally Altered/Created Type** CLIENT **Giant Records**

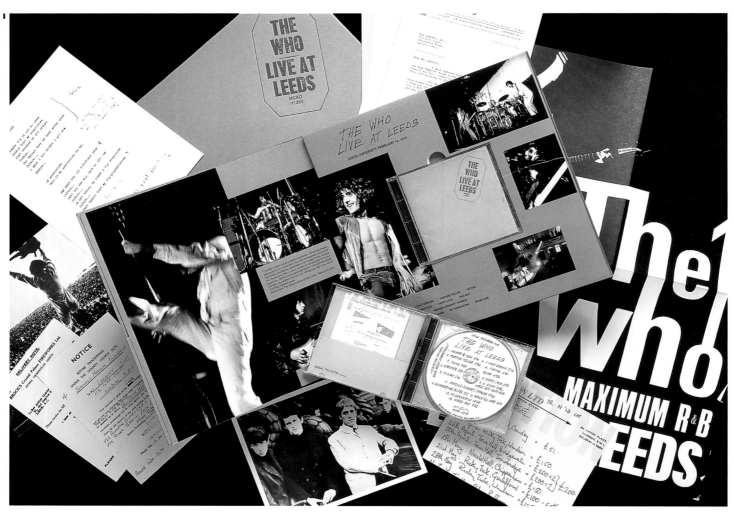

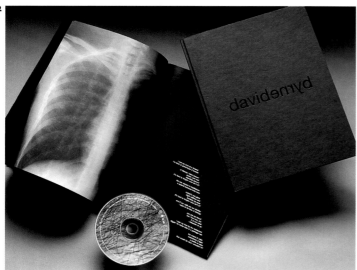

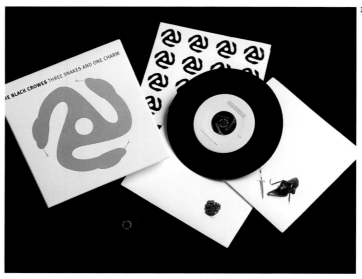

1 TITLE **The Who "Live at Leeds"** DESIGN FIRM **Richard Evans Design, Little Venice, London** ART DIRECTORS **Richard Evans and Vartan** GRAPHIC DESIGNERS **Graphreaks (original vinyl sleeve edition) and Richard Evans (CD)** PHOTOGRAPHER **Chris McCourt** TYPEFACE **Helvetica** PRINTER/FABRICATOR **Queens Group, Inc.** 2 TITLE **David Byrne "David Byrne"** DESIGN FIRM **Warner Bros. Records, Burbank, CA** ART DIRECTOR/GRAPHIC DESIGNER **Robert Bergman-Ungar** PHOTOGRAPHER **Jean Baptiste Mondino** CLIENT/PUBLISHER **Warner Bros. Records** 3 TITLE **The Black Crowes "Three Snakes and One Charm"** DESIGN FIRM **Warner Bros. Records, Burbank, CA** ART DIRECTOR **Janet Levinson** GRAPHIC DESIGNERS **Janet Levinson and Lyn Bradley** COVER ILLUSTRATOR **Larimie Garcia** PHOTOGRAPHERS **Fredrik Nilsen and Victor Bracke** CLIENT/PUBLISHER **Warner Bros. Records**

1 TITLE **Sponge "Wax Ecstatic"** DESIGN FIRM **Sony Music Creative Services, Santa Monica, CA** ART DIRECTOR **Mary Maurer** GRAPHIC DESIGNER **Matt Coonrod**
PHOTOGRAPHER **Melanie Nissen** 2 TITLE **Foo Fighters "UFO"** DESIGN FIRM **Capitol Records, Hollywood, CA** ART DIRECTOR/GRAPHIC DESIGNER **Tim Gabor**
PHOTOGRAPHER **Jennifer Youngblood** 3 TITLE **Floodgate "Penalty"** DESIGN FIRM **Smay Vision, Inc., New York, NY** ART DIRECTOR **John Wujcik** GRAPHIC DESIGNERS
Stan Stanski and Phil Yarnall ILLUSTRATOR **Dave McKean @ Hourglass** CLIENT **Roadrunner Records**

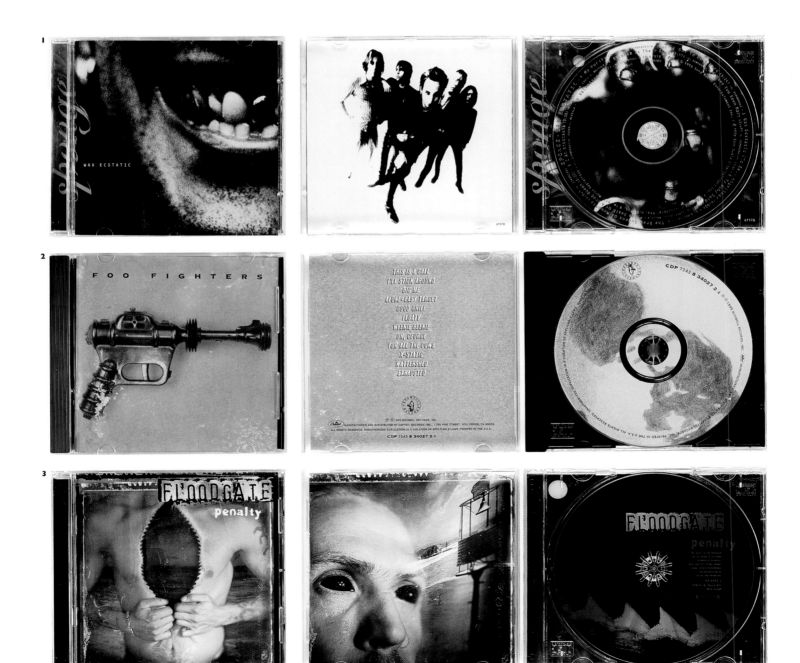

1 Title **Kronos Quartet "Howl USA"** Design Firm **Frank Olinsky, Brooklyn, NY** Art Director/Graphic Designer **Frank Olinsky** Photographers **Robert Mapplethorpe and Nitin Vadukul** Typefaces **Garage Gothic Black, Officina Sans, Zapf Dingbats** Printer **Ivy Hill** Fabricator **Specialty Records** Client **Nonesuch Records** 2 Title **The Devlins "Someone to Talk To"** Design Firm **Capitol Records, Hollywood, CA** Art Directors **Jeff Fey and Tommy Steele** Graphic Designer **Jeff Fey**

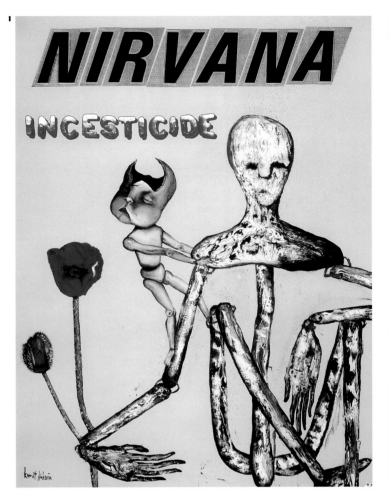

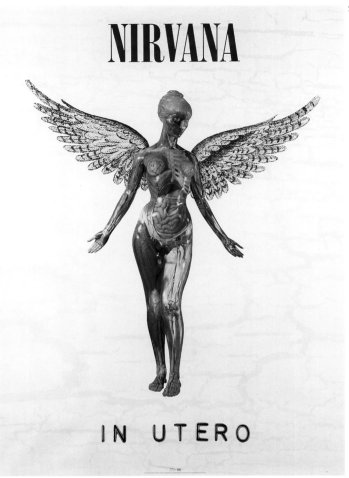

1 TITLE **Nirvana "Incesticide" Poster** DESIGN FIRM **Geffen Records, Los Angeles, CA** ART DIRECTOR **Robert Fisher** PRINTER **Westland Graphics** 2 TITLE **Nirvana "In Utero" Poster** DESIGN FIRM **Geffen Records, Los Angeles, CA** ART DIRECTOR **Robert Fisher** ILLUSTRATOR **Kurt Cobain** PRINTER **Westland Graphics**

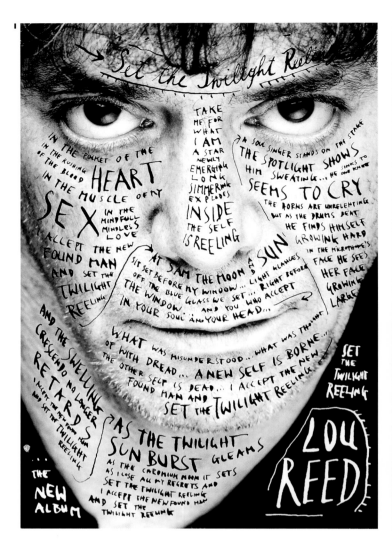

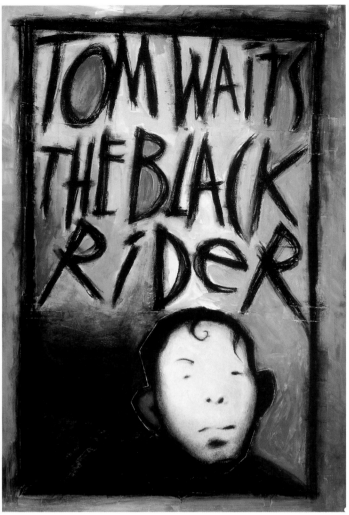

1 TITLE **Lou Reed "Set the Twilight Reeling" Poster** DESIGN FIRM **Sagmeister, Inc., New York, NY** ART DIRECTOR/GRAPHIC DESIGNER **Stefan Sagmeister**
PHOTOGRAPHER **Timothy Greenfield-Sanders** PRINTER **Warner Media Services** CLIENT **Warner Bros. Records Inc.** 2 TITLE **Tom Waits "The Black Rider" Poster**
DESIGN FIRM **Supernatural Design, San Francisco, CA** GRAPHIC DESIGNER/ILLUSTRATOR **Christie Rixford** CLIENT **Island Records**

1 Title **The Cars Anthology "Just What I Needed"** Design Firm **MCA Records, Universal City, CA** Art Directors **Monster X, David Robinson, Coco Shinomiya** Illustration/Cover Logo **Steve Stanford** Photographers **E.J. Camp, David Gahr, Lynn Goldsmith, B.C. Kagan, Brian McLaughlin, E. Roberts, and Mark Takeuchi** Printers **Local Graphics, Ivy Hill** **2** Title **Huey Lewis and the News "Four Chords and Several Years Ago"** Design Firm **Elektra Records** Art Directors **Robin Lynch and JoDee Stringham** Grpahc Designers **Craig Braun, Robin Lynch, and JoDee Stringham** Photographer **Keeley** Printers **Noblet Serigraphic, Darbert Offset** Fabricators **Warner Media Services, Walden/Lang** **3** Title **Velvet Underground "Peel Slowly and See"** Design Firm **Smay Vision, Inc., New York, NY** Art Directors/Graphic Designers **Stan Stanski and Phil Yarnall** Printer **AGI** Client **Chronicles/Polydor Records**

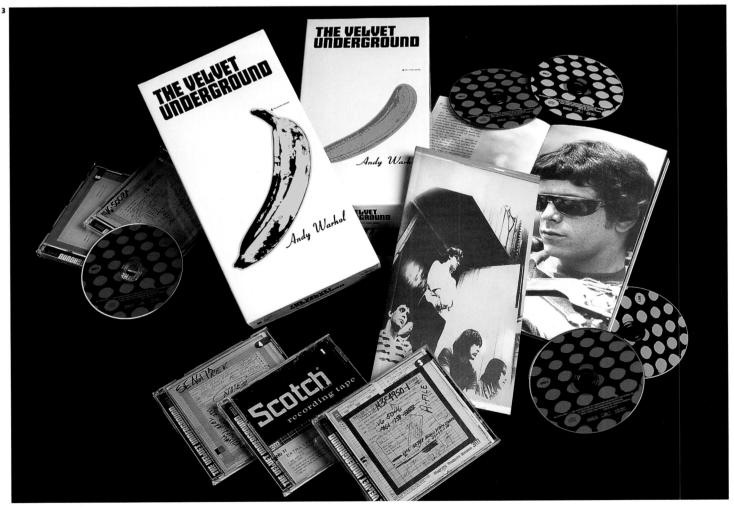

1 TITLE **Scarce "Dead Sexy" Special Package** ART DIRECTOR **Karen Walker** GRAPHIC DESIGNERS **Lyn Bradley, Caroline Devita, and Julia Kuskin** ILLUSTRATOR **Joyce Raskin** CLIENT **A&M Records, Inc.** **2** TITLE **Mr. Mirainga "Burnin' Rubber"** DESIGN FIRM **MCA Records, Universal City, CA** ART DIRECTOR/GRAPHIC DESIGNER **Kevin Reagan** PRINTER/FABRICATOR **Westland Graphics** PAPER/MATERIALS **Chipboard, Rubber** CLIENT **MCA Records** **3** TITLE **Lou Reed "Set the Twilight Reeling"** DESIGN FIRM **Sagmeister, Inc., New York, NY** ART DIRECTOR **Stefan Sagmeister** GRAPHIC DESIGNERS **Veronica Oh and Stefan Sagmeister** ILLUSTRATOR **Tony Fitzpatrick** TYPEFACES **Bembo, Franklin Gothic, Kabel, Trade Gothic** PRINTER **Warner Media Services, Ivy Hill** PUBLISHER **Warner Bros.**

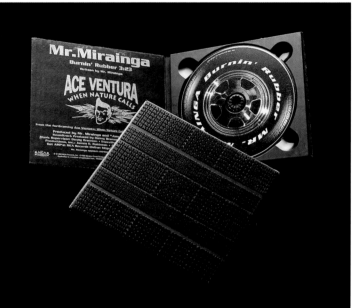

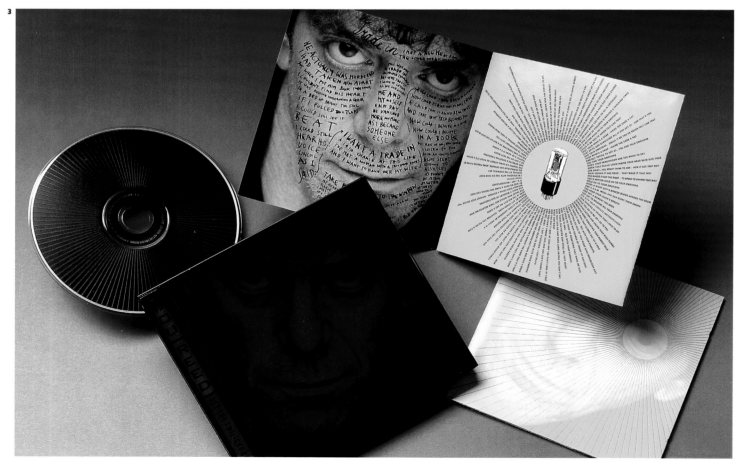

1

2

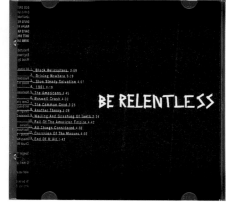

3

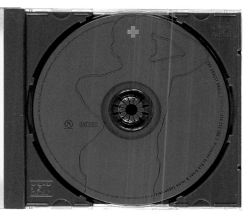

1 TITLE **Craig Carothers "Air Mail Blue"** ART DIRECTOR/GRAPHIC DESIGNER **Bob Smith** TYPEFACE **Bank Gothic** CLIENT **Craig Carothers** 2 TITLE **H.P. Zinker "Mountains of Madness"** DESIGN FIRM **Sagmeister, Inc., New York, NY** ART DIRECTOR **Stefan Sagmeister** GRAPHIC DESIGNERS **Veronica Oh and Stefan Sagmeister** PHOTOGRAPHER **Tom Schierlitz** TYPEFACES **Bembo, Peignot, Times, Typewriter** PRINTER **Disc Graphics** PUBLISHER **Energy Records** 3 TITLE **The Grassy Knoll "Positive"** DESIGN FIRM **Verve Records, New York, NY** ART DIRECTORS **Chika Azuma and Patricia Lie** GRAPHIC DESIGNER **Chika Azuma** PHOTOGRAPHER **Larry Sultan** TYPEFACES **OCRB, Orator, Trade Gothic** PRINTER **Shorewood Packaging** PAPER/MATERIALS **Weyerhaeuser Cougar Opaque and PVC Puffy Sticker**

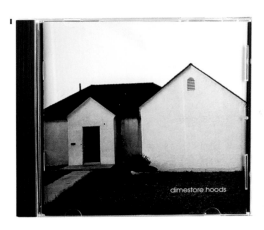 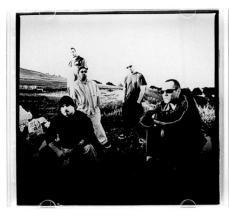

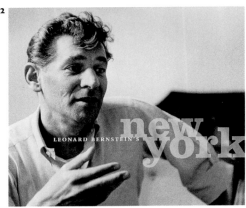 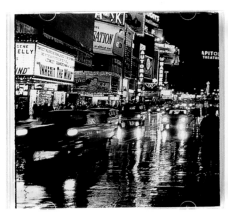

1 TITLE **Dimestore Hoods** DESIGN FIRM **MCA Records, Universal City, CA** ART DIRECTOR **Kevin Reagan** GRAPHIC DESIGNERS **Kevin Reagan and Anabel Sinn** PHOTOGRAPHER **Dennis Keeley** TYPEFACES **Avant Garde, Futura** PRINTER **Queens** PAPER **Karma** CLIENT **MCA Records** **2** TITLE **Leonard Bernstein's New York** DESIGN FIRM **Carbone Smolan Associates, New York, NY** ART DIRECTOR **Ken Carbone** GRAPHIC DESIGNERS **John Nishimoto and Karla Henrick** PHOTOGRAPHERS **Tony Vaccaro and Various** TYPEFACES **Bell Gothic, Clarendon, Minion** PRINTER/FABRICATOR **Ivy Hill Graphics** PAPER **Westvaco** **3** TITLE **Bill Evans "The Best of Bill Evans on Verve"** DESIGN FIRM **Verve Records, New York, NY** ART DIRECTOR/GRAPHIC DESIGNER **Patricia Lie** PHOTOGRAPHER **Chuck Stewart** PRINTER **Shorewood** CLIENT/PUBLISHER **Verve Records**

1 TITLE **Billy Mann Special Package** ART DIRECTOR **Jeri Heiden** GRAPHIC DESIGNER **Karen Walker** PHOTOGRAPHER **Frank Ockenfels** PRINTER **Westland** CLIENT **A&M Records, Inc.** 2 TITLE **Paul Westerberg "14 Songs"** DESIGN FIRM **Warner Bros. Records Inc., Burbank, CA** CREATIVE DIRECTORS **Kim Champagne and Paul Westerberg** ART DIRECTORS **Kim Champagne and Jeff Gold** GRAPHIC DESIGNERS **Kim Champagne and Jean Krikorian** PHOTOGRAPHERS **Frank Ockenfels** FABRICATOR **Ivy Hill** PAPER **Chipboard, Williamsburg Hi-Bulk, Kraft Grandee** CLIENT **Reprise/Sire Records** 3 TITLE **Skeleton Key EP** DESIGN FIRM **Sagmeister, Inc., New York, NY** ART DIRECTOR **Stefan Sagmeister** GRAPHIC DESIGNERS **Veronica Oh and Stefan Sagmeister** ILLUSTRATORS **Veronica Oh, Stefan Sagmeister, and Eric Sanko** TYPEFACES **Bembo, Bodoni, Franklin, Sabon** PRINTER **Ross Ellis** PUBLISHER **Motel Records** CLIENT **Skeleton Key**

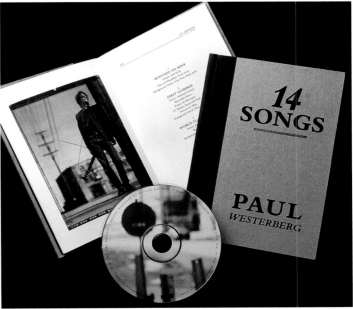

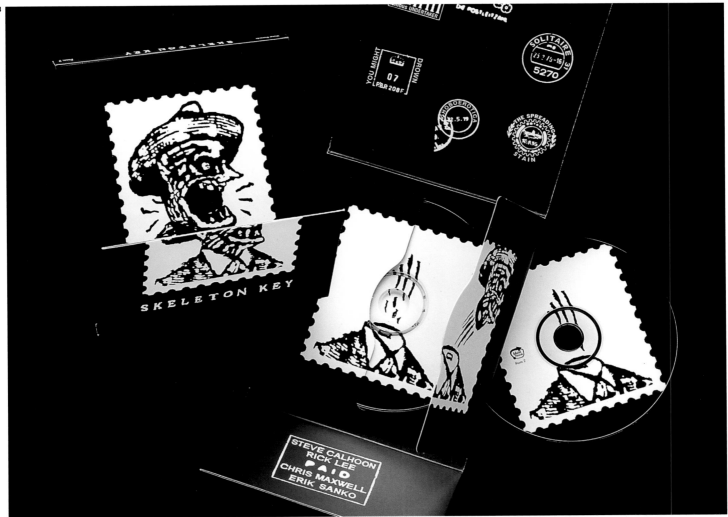

1 TITLE **Floor Jack "Transistor"** DESIGN FIRM **Maggadee, New York, NY** ART DIRECTORS **Mike Joyce and Bill Dolan** GRAPHIC DESIGNER **Mike Joyce** PHOTOGRAPHER **Dirk Herrmann** TYPEFACE **Univers** PRINTER **Nimbus Press** CLIENT **Maggadee Records** 2 TITLE **Fiona Apple "Tidal"** DESIGN FIRM **Fred Woodward, New York, NY** ART DIRECTOR **Fred Woodward** PHOTOGRAPHER **Nathaniel Goldberg** 3 TITLE **Chick Corea "Return to Forever: The Anthology"** DESIGN FIRM **Verve Records, New York, NY** ART DIRECTOR/GRAPHIC DESIGNER **Patricia Lie** PHOTOGRAPHERS **Harvey Grynbaum, Hiro Ho, Dennis Keim, Joe E. Mullens** TYPEFACE **Blind Date** PRINTER **Klearfold/Shorewood** CLIENT **Verve/Chronicles**

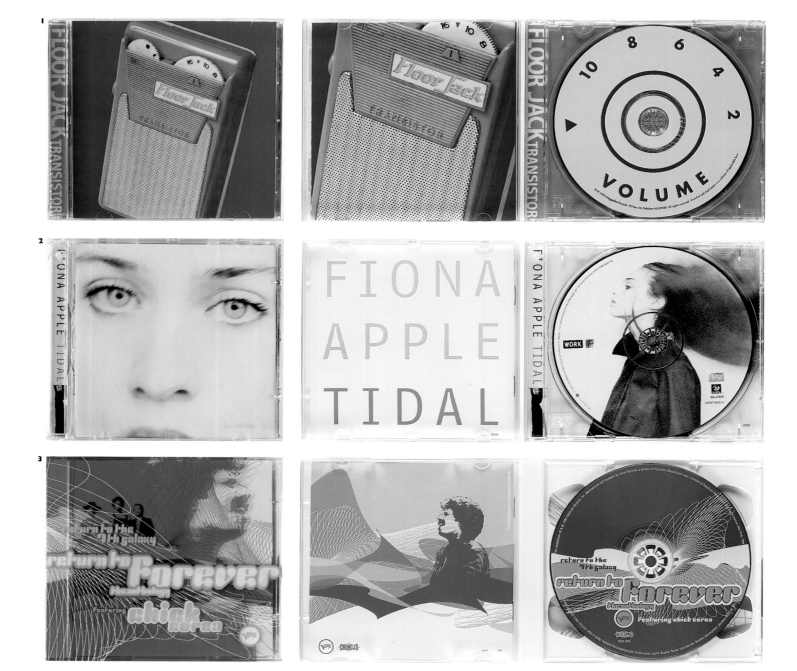

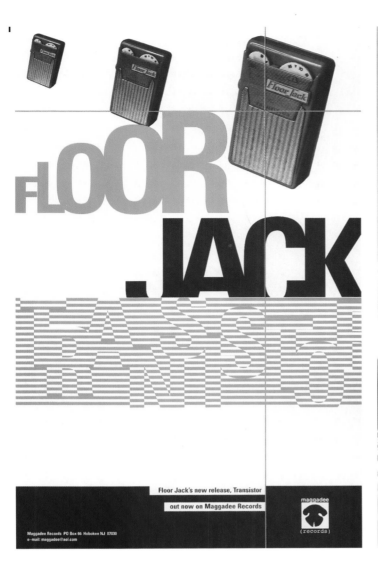

1 TITLE **Floor Jack "Transistor" Announcement** DESIGN FIRM **Maggadee, New York, NY** ART DIRECTORS **Mike Joyce and Bill Dolan** GRAPHIC DESIGNER **Mike Joyce** PHOTOGRAPHER **Dirk Herrmann** TYPEFACE **Univers** PRINTER **Minisink Press** CLIENT **Maggadee Records** 2 TITLE **Chris Isaak "Baja Sessions" Poster** DESIGN FIRM **Warner Bros. Records, Burbank, CA** ART DIRECTOR/GRAPHIC DESIGNER **Linda Cobb-Stalker** PHOTOGRAPHER **Aaron Chang**

1 TITLE **Biohazard "Mata Leão" Poster** DESIGN FIRM **Warner Bros. Records, Burbank, CA** ART DIRECTOR/GRAPHIC DESIGNER **Deborah Norcross** PHOTOGRAPHER **Amy Guip** CLIENT/PUBLISHER **Warner Bros. Records** 2 TITLE **1996 MTV Video Music Awards Poster** DESIGN FIRM **MTV Off-Air Creative, New York, NY** CREATIVE DIRECTOR **Jeffrey Keaton** ART DIRECTOR/GRAPHIC DESIGNER **Christopher Davis**

1 TITLE **Biohazard "Mata Leão"** DESIGN FIRM **Warner Bros. Records, Burbank, CA** ART DIRECTOR/GRAPHIC DESIGNER **Deborah Norcross** PHOTOGRAPHER **Amy Guip** CLIENT/PUBLISHER **Warner Bros. Records 2** TITLE **Boukan Ginen "Rèv an Nou"** DESIGN FIRM **Greenberg Kingsley, New York, NY** ART DIRECTORS **Karen L. Greenberg and D. Mark Kingsley** GRAPHIC DESIGNER **D. Mark Kingsley** ILLUSTRATOR **Calef Brown** PRINTER **CRT** CLIENT **Xenophile 3** TITLE **Menthol** DESIGN FIRM **Capitol Records, Hollywood, CA** ART DIRECTOR/GRAPHIC DESIGNER **Andy Mueller** PHOTOGRAPHERS **Michele Martin and Andy Mueller 4** TITLE **Verve New Releases (April 1996)** DESIGN FIRM **Verve Records, New York, NY** ART DIRECTOR/GRAPHIC DESIGNER **Patricia Lie** CLIENT/PUBLISHER **Verve Records**

1 TITLE **Gino Vannelli** DESIGN FIRM **Verve Records, New York, NY** ART DIRECTOR/GRAPHIC DESIGNER **Patricia Lie** WRITER **Gino Vannelli** TYPEFACE **Sassoon** PRINTER **Shorewood** CLIENT/PUBLISHER **Verve Records** 2 TITLE **Christian McBride "[Is] Gettin' to It"** DESIGN FIRM **Verve Records, New York, NY** ART DIRECTOR/GRAPHIC DESIGNER **Patricia Lie** PHOTOGRAPHER **James R. Minchin III** PRINTER **Prestone** CLIENT **Verve Records**

ALBUM JULY 4

1 TITLE **Richard Thompson "You? Me? Us?" Ad/Poster** DESIGN FIRM **Capitol Records, Hollywood, CA** ART DIRECTOR/GRAPHIC DESIGNER **Jeff Fey** PHOTOGRAPHER
Michael Wilson 2 TITLE **Smoking Popes "Need You Around" Ad/Poster** DESIGN FIRM **Capitol Records, Hollywood, CA** ART DIRECTORS **Paul Brown and Tommy Steele**
GRAPHIC DESIGNER **Paul Brown**

1 TITLE **Oscar Peterson Trio "The London House Sessions"** DESIGN FIRM **Verve Records, New York, NY** ART DIRECTORS/GRAPHIC DESIGNERS **Lisa Po-Ying Huang and David Lau** PHOTOGRAPHERS **Various** PRINTER **Enterprise Press** PAPER **French Speckletone** CLIENT/PUBLISHER **Verve Records** 2 TITLE **Indigo Girls "1,200 Curfews"** DESIGN FIRM **Franke Design Co., Minneapolis, MN** GRAPHIC DESIGNERS **Jeff Franke and Linda Franke** ILLUSTRATOR **Linda Franke** PHOTOGRAPHERS **Lance Mercer and Kelly Shields** TYPEFACES **Bauer Bodoni, Frutiger, Typewriter** PRINTER **Heartland Graphics** PAPER **French Dur-O-Tone and Speckletone** CLIENT **Epic Records** 3 TITLE **Blues Classics** DESIGN FIRM **I-Level, Clarksville, TN** ART DIRECTOR **Vartan** GRAPHIC DESIGNERS **Mike Fink, Meire Murakami, and Vartan** PHOTOGRAPHER **Michael Wilson** WRITER **Mary Katherine Aldin** TYPEFACE **News Gothic** PRINTER/FABRICATOR **Queens Group, Inc.** PAPER **French Dur-O-Tone Aged Newsprint, Karma, Gilclear**

1

2

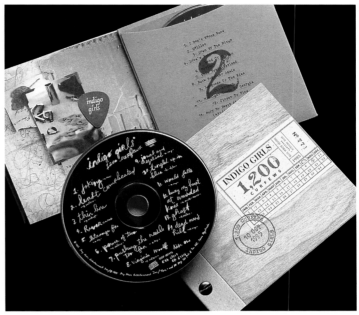

3

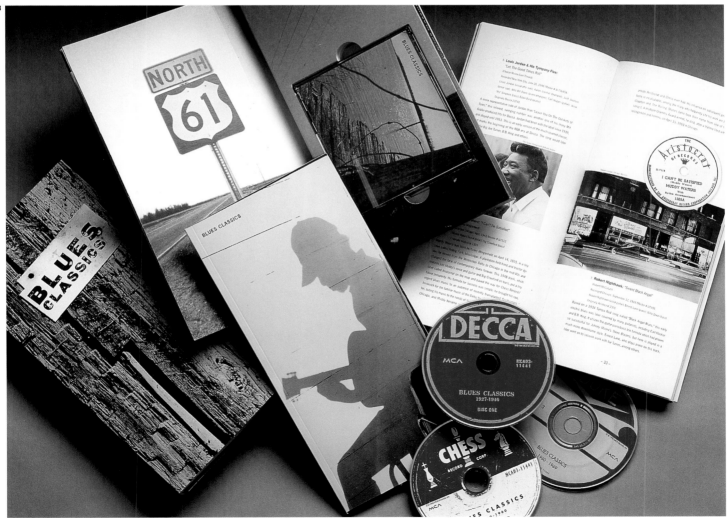

1 TITLE **Antonio Carlos Jobim "The Man from Ipanema"** DESIGN FIRM **Verve Records, New York, NY** ART DIRECTOR/GRAPHIC DESIGNER **Giulio Turturro** PHOTOGRAPHER **Ana Lontra-Jobim** TYPEFACES **Matrix, Triplex** PRINTER **Enterprise Press** PAPER **Mohawk Satin** CLIENT/PUBLISHER **Verve Records** 2 TITLE **MTV Unplugged Book** DESIGN FIRM **MTV Off-Air Creative, New York, NY** CREATIVE DIRECTORS **Jeffrey Keaton** ART DIRECTOR/GRAPHIC DESIGNER **Christopher Davis**

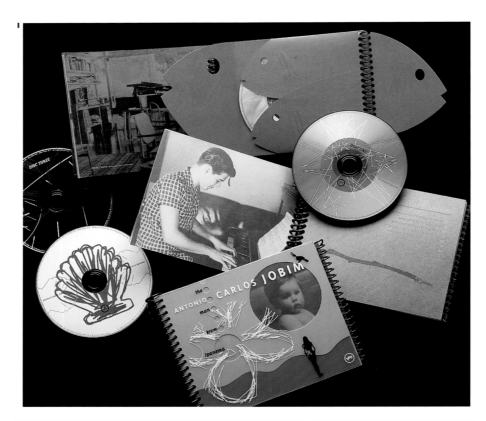

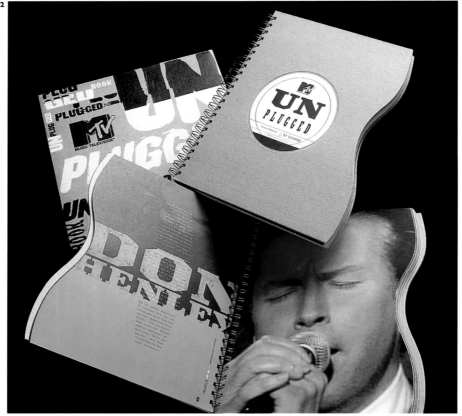

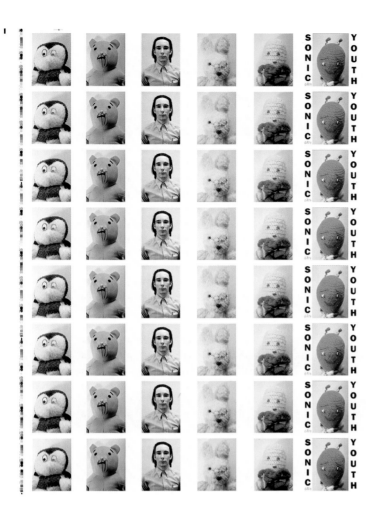

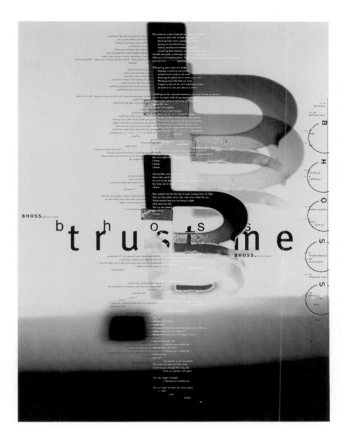

1 TITLE **Sonic Youth "Dirty" Poster** DESIGN FIRM **Geffen Records, Los Angeles, CA** ART DIRECTOR **Kevin Reagan** PHOTOGRAPHER/ARTIST **Mike Kelley** PRINTER **Westland Graphics** 2 TITLE **Bhoss "Trust Me"** DESIGN FIRM **Jennifer Sterling Design, San Francisco, CA** ART DIRECTOR/GRAPHIC DESIGNER **Jennifer Sterling** PHOTOGRAPHER **Tony Stromberg** PRINTER **Logos/Graphics** CLIENT **Bhoss**

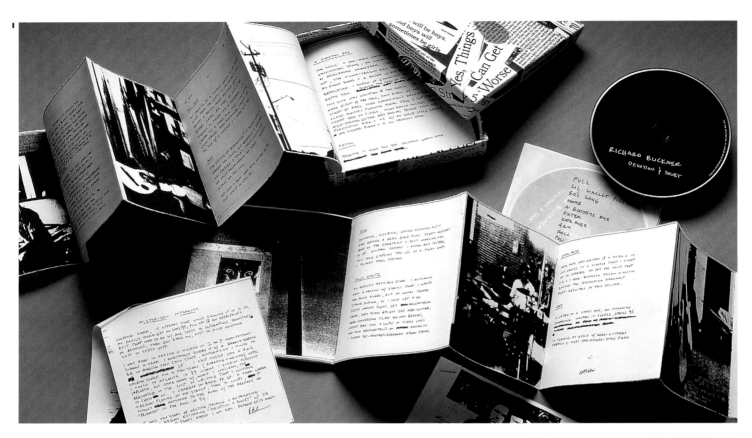

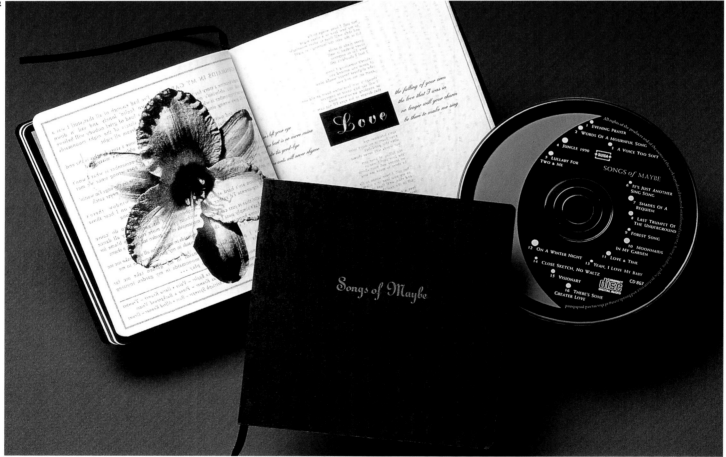

1 TITLE **Richard Buckner "Devotion and Doubt"** DESIGN FIRM **MCA Records Creative, Universal City, CA** ART DIRECTORS **Todd Gallopo and Tim Stedman** GRAPHIC DESIGNERS **Richard Buckner, Todd Gallopo, and Tim Stedman** PHOTOGRAPHER **Darcy Hemley** WRITER **Richard Buckner** TYPEFACES **Helvetica, Sabon** PRINTER **Continental Graphics** FABRICATOR **Westland Graphics** 2 TITLE **Songs of Maybe — Moonmaids in My Garden** DESIGN FIRM **Sagmeister, Inc., New York, NY** ART DIRECTOR **Stefan Sagmeister** GRAPHIC DESIGNERS **Stefan Sagmeister and Mike Chan** ILLUSTRATORS **Stefan Sagmeister and Stock** PHOTOGRAPHER **Bela Borsodi** TYPEFACES **Baskerville, Bembo, Garamond, Times** PRINTER **Eric Cheng** PAPER **Bible Print** PUBLISHER **Uru Records**

1 TITLE **"The Jazz Scene"** DESIGN FIRM **Verve Records, New York, NY** ART DIRECTOR **David Lau** GRAPHIC DESIGNER **Lisa Po-Ying Huang** PHOTOGRAPHERS **Various** PRINTER **Enterprise Press** CLIENT/PUBLISHER **Verve Records** 2 TITLE **The Smashing Pumpkins "The Aeroplane Flies High"** DESIGN FIRM **Frank Olinsky, Brooklyn, NY** ART DIRECTORS **Billy Corgan and Frank Olinsky** GRAPHIC DESIGNER **Frank Olinsky** ILLUSTRATORS **Billy Corgan and John Craig** PHOTOGRAPHERS **Paul Elledge and Yelena Yemchuk** TYPEFACES **TF Avian, Bank Gothic, Bell Gothic Bold, Cochin Italic, Constructivist, Gill Sans, Glorietta, Le Petit Trottin, Meta Condensed Bold, Platelet Heavy, Romeo Medium Condensed** PRINTER/FABRICATOR **AGI** PAPER **70# Presidential III Litho, Chipboard, 90# Cordwain Cover, 60# Cougar Opaque Smooth, 100# LOE Gloss Text** CLIENT **Virgin Records America** 3 TITLE **Leadbelly's Last Sessions** DESIGN FIRM **Visual Dialogue, Boston, MA** ART DIRECTOR/GRAPHIC DESIGNER **Fritz Klaetke** PHOTOGRAPHERS **James Chapelle and Tiny Robinson** PRINTER **Ross-Ellis** CLIENT **Smithsonian Folkways Recordings**

1 TITLE **Slant Holiday 1995 Issue #5: Roots Music** DESIGN FIRM **Urban Outfitters, Philadelphia, PA** DESIGN DIRECTOR **Howard Brown** ART DIRECTORS **Howard Brown and Mike Calkins** COVER DESIGN/ILLUSTRATION **Gary Panter** GRAPHIC DESIGNERS **Various** PRINTER **Step Ladder Press** PAPER **Newsprint** CLIENT/PUBLISHER **Urban Outfitters, Inc. 2** TITLE **Slant Holiday 1995 Issue #3: Punk Rock** DESIGN FIRM **Urban Outfitters, Philadelphia, PA** DESIGN DIRECTOR **Howard Brown** ART DIRECTORS **Howard Brown and Mike Calkins** COVER DESIGN/ILLUSTRATION **Michael Mabry** GRAPHIC DESIGNERS **Various** PRINTER **Step Ladder Press** PAPER **Newsprint** CLIENT/PUBLISHER **Urban Outfitters, Inc. 3** TITLE **"Invisible Roots: A Queer History of Rock"** DESIGN FIRM **Urban Outfitters, Philadelphia, PA** DESIGN DIRECTOR **Howard Brown** ART DIRECTORS **Howard Brown and Mike Calkins** GRAPHIC DESIGNER/ILLUSTRATOR **Howard Brown** WRITER **Adam Block** PRINTER **Step Ladder Press** PAPER **Newsprint** CLIENT/PUBLISHER **Urban Outfitters, Inc.**

1

2

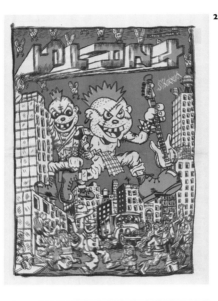

3

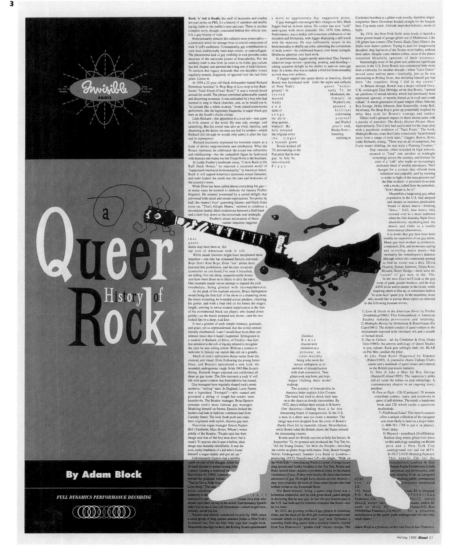

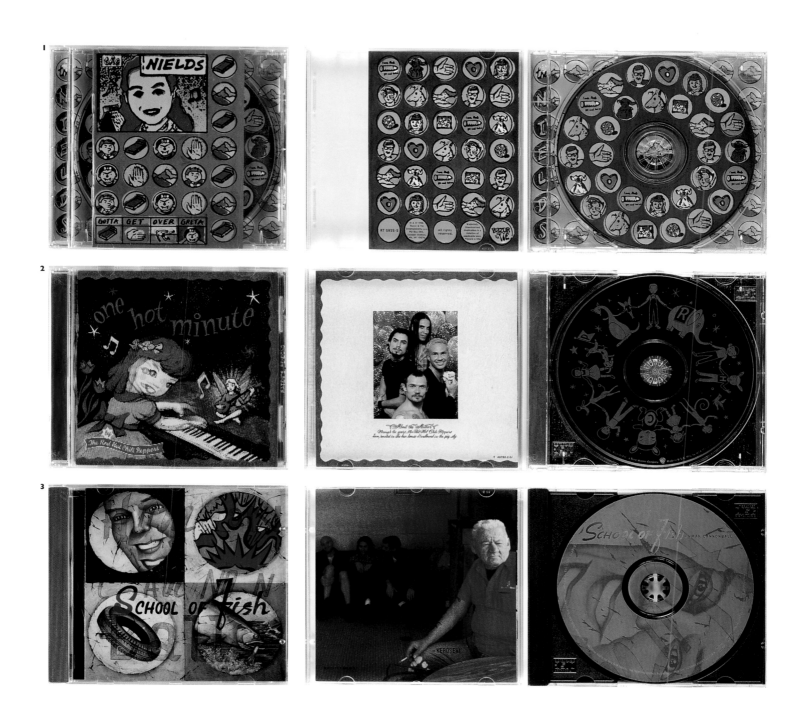

1 TITLE **The Nields "Gotta Get Over Greta"** DESIGN FIRM **Sagmeister, Inc., New York, NY** ART DIRECTOR **Stefan Sagmeister** GRAPHIC DESIGNERS **Veronica Oh and Stefan Sagmeister** ILLUSTRATORS **Carola Preifer and Stefan Sagmeister** PHOTOGRAPHER **Tom Schierlitz** TYPEFACES **Bembo, Caslon** PRINTER **Queens Group** PUBLISHER **Razor & Tie** 2 TITLE **The Red Hot Chili Peppers "One Hot Minute"** DESIGN FIRM **Warner Bros. Records, Burbank, CA** ART DIRECTORS **Anthony Kiedis, Flea, and Dirk Walter** ILLUSTRATOR **Mark Ryden** CLIENT/PUBLISHER **Warner Bros. Records** 3 TITLE **School of Fish "Human Cannonball"** DESIGN FIRM **Capitol Records, Hollywood, CA** ART DIRECTORS **Tommy Steele and Stephen Walker** GRAPHIC DESIGNER **Stephen Walker** ILLUSTRATOR **Bill Barminski** PHOTOGRAPHER **Melodie McDaniel**

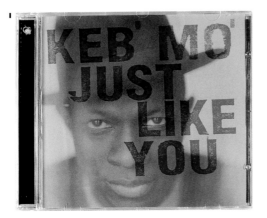

1 TITLE **Keb' Mo' "Just Like You"** DESIGN FIRM **Sony Music Creative Services, New York, NY** ART DIRECTOR **Mark Burdett** GRAPHIC DESIGNER **Jean Carbain** PHOTOGRAPHER **Frank W. Ockenfels 2** TITLE **Ol' Dirty Bastard "Return to the 36 Chambers: The Dirty Version"** DESIGN FIRM **Elektra Art Department, New York, NY** ART DIRECTOR **Alli Truch** GRAPHIC DESIGNER **Brett Kilroe** PHOTOGRAPHER **Danny Clinch** PRINTER/FABRICATOR **Ivy Hill** CLIENT **Elektra Entertainment Group**

160 SOUND OFF: THE TOP 100 CDS, MUSIC VIDEOS, AND PRINT COLLATERAL

1 TITLE **Navel Ring Ad/Geffen/DGC Generic Ad** DESIGN FIRM **Cornynshen, San Francisco, CA** ART DIRECTORS **Chris Cornyn and Billy Shen** CLIENT **Geffen Records** 2 TITLE **"Rent" Poster** DESIGN FIRMS **Geffen Records and Spot Design** CREATIVE DIRECTORS **Robin Sloane and Drew Hodges** GRAPHIC DESIGNER **Bill Merryfield** PHOTOGRAPHERS **Amy Guip and Joan Marcus** PRINTER **Westland Graphics** 3 TITLE **"This Is My Home Page Advertisement"** DESIGN FIRM **Tommy Boy Music, New York, NY** ART DIRECTOR **Stacy Drummond and Michelle Willems** PHOTOGRAPHER **Mai Lucas** COPYWRITER **Stacy Drummond** 4 TITLE **Paper Magazine (October 1996)** DESIGN FIRM **Socio X, New York, NY** ART DIRECTOR **Bridget deSocio** GRAPHIC DESIGNERS **Bridget deSocio and Albert Lin** DIGITAL IMAGING **Bridget deSocio and Malcolm Turk** PHOTOGRAPHER **Dah Len** WRITER **David Herschkovitz** TYPEFACE **LCD** PRINTER **Accurate Web** CLIENT **Paper Magazine**

▌TITLE **Legends of Country Music** DESIGN FIRM **Rolling Stone, New York, NY** ART DIRECTOR **Fred Woodward** GRAPHIC DESIGNERS **Gail Anderson and Fred Woodward** PHOTOGRAPHER **Mark Seliger** PHOTO EDITOR **Jodi Peckman** PUBLISHER **Wenner Media** CLIENT **Rolling Stone**

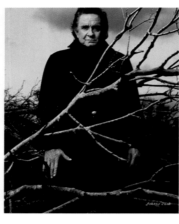

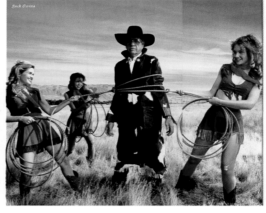

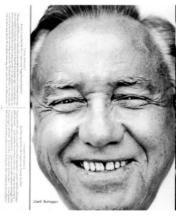

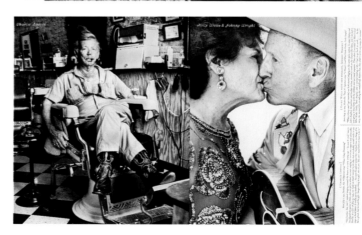

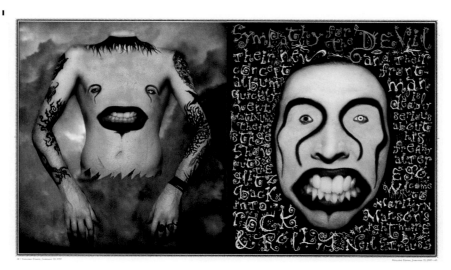

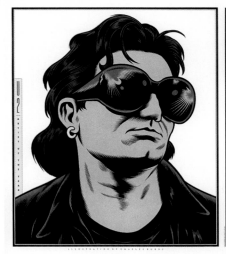
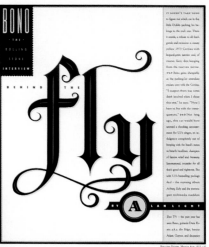

1 TITLE **Marilyn Manson** DESIGN FIRM **Rolling Stone, New York, NY** ART DIRECTOR **Fred Woodward** GRAPHIC DESIGNERS **Gail Anderson and Fred Woodward** PHOTOGRAPHER **Matt Mahurin** PHOTO EDITOR **Jodi Peckman** PUBLISHER **Wenner Media** CLIENT **Rolling Stone** 2 TITLE **Vic Chesnutt** DESIGN FIRM **Rolling Stone, New York, NY** ART DIRECTOR **Fred Woodward** GRAPHIC DESIGNERS **Lee Bearson and Fred Woodward** PHOTOGRAPHER **Mary Ellen Mark** PHOTO EDITOR **Jodi Peckman** PUBLISHER **Wenner Media** CLIENT **Rolling Stone** 3 TITLE **Bono "The Fly"** DESIGN FIRM **Rolling Stone, New York, NY** ART DIRECTOR **Fred Woodward** GRAPHIC DESIGNER **Debra Bishop** ILLUSTRATOR **Charles Burns** PUBLISHER **Wenner Media** CLIENT **Rolling Stone**

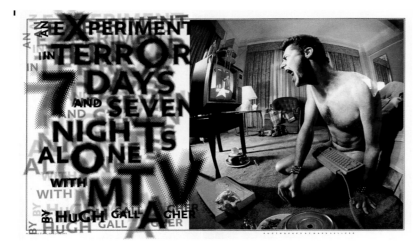

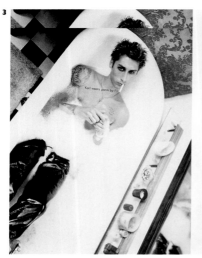

1 TITLE **MTV—7 Days & 7 Nights** DESIGN FIRM **Rolling Stone, New York, NY** ART DIRECTOR **Fred Woodward** GRAPHIC DESIGNER **Angela Skouras** PHOTOGRAPHER **Mark Selinger** PHOTO EDITOR **Laurie Kratochvil** PUBLISHER **Wenner Media** CLIENT **Rolling Stone** **2** TITLE **Phish** DESIGN FIRM **Rolling Stone, New York, NY** ART DIRECTOR **Fred Woodward** GRAPHIC DESIGNERS **Geraldine Hessler and Fred Woodward** PHOTOGRAPHER **Mark Seliger** PHOTO EDITOR **Jodi Peckman** PUBLISHER **Wenner Media** CLIENT **Rolling Stone** **3** TITLE **"I'm With the Band"** DESIGN FIRM **Socio X, New York, NY** ART DIRECTOR **Bridget de Socio** GRAPHIC DESIGNER **Albert Lin** PHOTOGRAPHER **Judson Baker** TYPEFACE **Trajan** PRINTER **Accuweb** PAPER **Repap** CLIENT **Paper Magazine**

1 TITLE **Rusty "Sophomoric" Poster** DESIGN FIRM **Wing Group, Toronto, Ontario** ART DIRECTOR/GRAPHIC DESIGNER **Kathi Prosser** PHOTOGRAPHER **Chris Buck**
2 TITLE **Flipp Poster** DESIGN FIRM **Hollywood Records Creative, Burbank, CA** ART DIRECTORS/GRAPHIC DESIGNERS **Todd Gallopo and Tim Stedman** PHOTOGRAPHER **David Jensen** PRINTER **Westland Graphics**

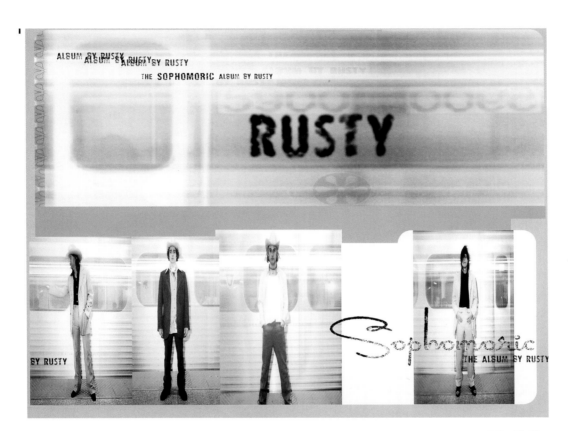

1 Title **Cobain** Design Firm **Rolling Stone, New York, NY** Art Director/Graphic Designer **Fred Woodward** Illustrators/Photographers **Various** Publisher **Little, Brown & Company** Client **Rolling Stone Press** **2** Title **Images of Rock & Roll** Design Firm **Rolling Stone, New York, NY** Art Director/Graphic Designer **Fred Woodward** Photographers **Various** Photo Editors **Julie Claire Derscheid and Denise Sfraga** Printer **Dai Nippon** Paper **NPI Matte Art 157 gsm** Publisher **Little, Brown & Company** Client **Rolling Stone Press** **3** Title **Garcia** Design Firm **Rolling Stone, New York, NY** Art Director **Fred Woodward** Graphic Designers **Gail Anderson, Lee Bearson, Geraldine Hessler, Eric Siry, and Fred Woodward** Photo Editor **Jodi Peckman** Jacket Photographer **Herbi Greene** Publisher **Little, Brown & Company** Client **Rolling Stone Press**

1

2

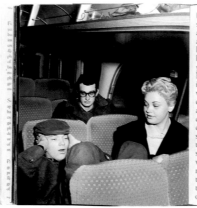

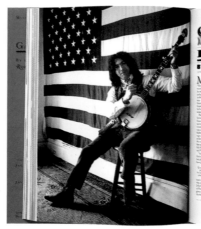

3

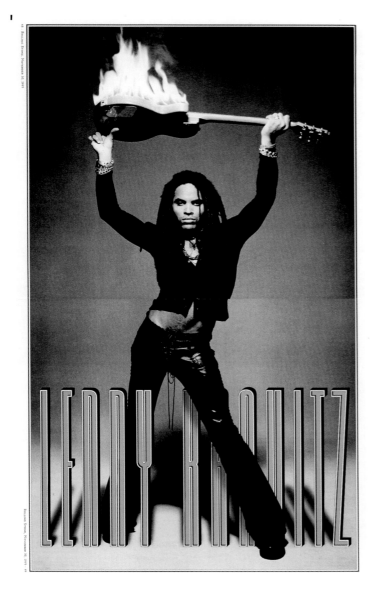

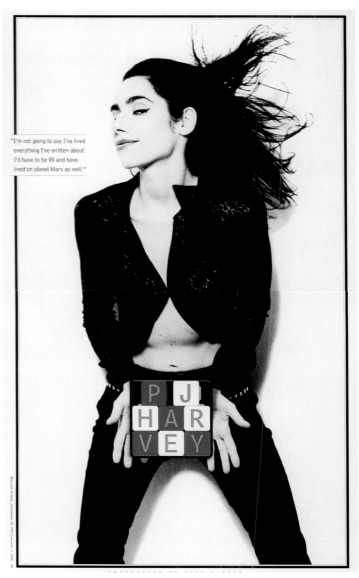

"I'm not going to say I've lived everything I've written about. I'd have to be 90 and have lived on planet Mars as well."

1 TITLE **Lenny Kravitz** DESIGN FIRM **Rolling Stone, New York, NY** ART DIRECTOR **Fred Woodward** GRAPHIC DESIGNERS **Geraldine Hessler and Fred Woodward** PHOTOGRAPHER **Matthew Rolston** PUBLISHER **Wenner Media** CLIENT **Rolling Stone** 2 TITLE **P.J. Harvey** DESIGN FIRM **Rolling Stone, New York, NY** ART DIRECTOR **Fred Woodward** GRAPHIC DESIGNERS **Gail Anderson and Fred Woodward** PHOTOGRAPHER **Kate Garner** PHOTO EDITOR **Jodi Peckman** PUBLISHER **Wenner Media** CLIENT **Rolling Stone**

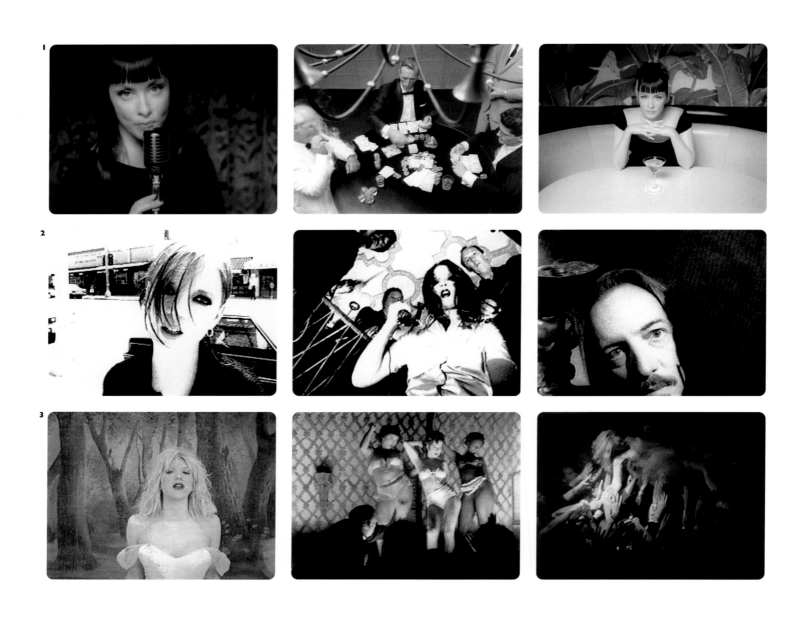

1 TITLE **Suzanne Vega "No Cheap Thrill"** DIRECTOR **David Cameron** DIGITAL VIDEO PRODUCER **Brian Kilcullen** CLIENT **A&M Records, Inc.** 2 TITLE **Garbage "Queer" Video** PRODUCTION COMPANY **Propaganda Films, Hollywood, CA** DIRECTOR **Stephanie Sednaoui** ART DIRECTOR **Kiki Giet** DIRECTORY OF PHOTOGRAPHY **Sal Tortino** PRODUCER **Stephanie Malkin** RECORD COMPANY **Almo Sounds** 3 TITLE **Hole "Violet" Video** PRODUCTION COMPANY **Woo Art International, New York, NY** RECORD COMPANY **DGC Records**

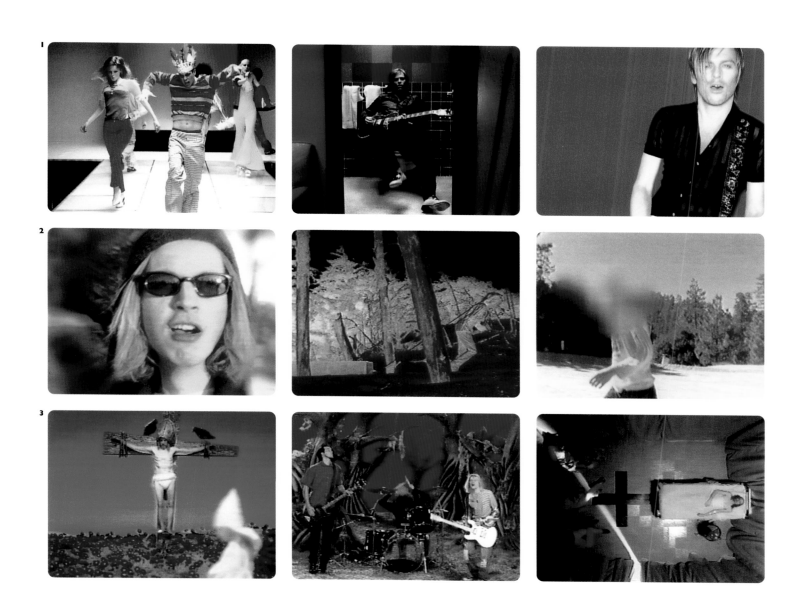

1 TITLE **Bryan Adams "The Only Thing That Looks Good on Me Is You"** DIRECTOR **Matthew Rolson** DIGITAL VIDEO PRODUCER **Lynn Zekanis** CLIENT **A&M Records, Inc.** 2 TITLE **Beck "Loser" Video** ART DIRECTOR/GRAPHIC DESIGNER **Steven Hanft** DIRECTOR OF PHOTOGRAPHY **Steven Hanft** ILLUSTRATOR/ANIMATOR **Steven Hanft** RECORD COMPANY **DGC Records** 3 TITLE **Nirvana "Heart-Shaped Box" Video** PRODUCTION COMPANY **State, London** CREATIVE DIRECTOR **Anton Corbijn** ART DIRECTOR **Bernadette Disanto** DIRECTOR OF PHOTOGRAPHY **John Mathieson** PRODUCER **Richard Bell** RECORD COMPANY **DGC Record Co.**

1 TITLE **Weezer "Buddy Holly" Video** PRODUCTION COMPANY **Satellite Films, Hollywood, CA** DIRECTOR OF PHOTOGRAPHY **Scott Henricksen** PRODUCER **Larry Pevel** RECORD COMPANY **DGC Records** 2 TITLE **Nirvana "In Bloom" Video** PRODUCTION COMPANY **Silvey & CO., Beverly Hills, CA** DIRECTOR **Kevin Kerslake** ART DIRECTOR **Jim Reva** DIRECTOR OF PHOTOGRAPHY **Kevin Kerslake** PRODUCERS **Tina Silvey and Line Postmyr** RECORD COMPANY **DGC Records** 3 TITLE **Peter Gabriel "Diggin' in the Dirt" Video** FIRM **Real World Productions, England** DIRECTOR/PRODUCER **John Downer** DIRECTOR OF PHOTOGRAPHY **Martin Dohrn and Rod Clarke** CLIENT **Geffen/Virgin Records**

1 TITLE **The Roots "What They Do" Video** PRODUCTION COMPANY **Woo Art International, New York, NY** DIRECTOR **Charles S. Stone III** ART DIRECTOR **Carol Wells** DIRECTOR OF PHOTOGRAPHY **Russel Swanson** PRODUCER **Nicola Doring** RECORD COMPANY **DGC Records** 2 TITLE **Beck "Where It's At" Video** PRODUCTION COMPANY **Propaganda Films, Hollywood, CA** DIRECTOR **Steve Hanft** ART DIRECTOR **Jonathan Stearnes** ILLUSTRATOR **Chris Cooper** DIRECTOR OF PHOTOGRAPHY **Lance Accord** PRODUCER **Raub Shapiro** RECORD COMPANY **DGC Records** 3 TITLE **Eels "Novocaine for the Soul" Video** PRODUCTION COMPANY **Satellite Films, Hollywood, CA** DIRECTOR **Mark Romanek** DIRECTOR OF PHOTOGRAPHY **Harris Sevides** PRODUCER **Allan Wachs** RECORD COMPANY **DreamWorks Records**

1 TITLE **Crash Test Dummies "My Own Sunrise" Enhanced CD** DESIGN FIRM **Wing Group, Toronto, Ontario** ART DIRECTOR **Rick Hoffart** INTERFACE DESIGNER **Kathi Prosser** ILUSTRATOR **Barry Blitt** PHOTOGRAPHER **Kathi Prosser** DIGITAL VIDEO PRODUCERS **Kathi Prosser and Christiane Smith** PROGRAMMERS **Winston Mar and Allan Shum** SOUND EDITOR **Wing Group** CLIENT **B.M.G. Music** 2 TITLE **R.E.M. "Monster" Interactive Press Kit** DESIGN FIRM **Warner Bros. Records, Burbank, CA** ART DIRECTORS/GRAPHIC DESIGNERS **Chris Bilheimer, Cecil Juanarena, Tom Recchion, and Michael Stipe** CLIENT/PUBLISHER **Warner Bros. Records** 3 TITLE **Handsome CD Extra** DESIGN FIRM **Sony Music Entertainment, New York, NY** GRAPHIC DESIGNERS/ANIMATORS **Galo Morales and Robert Sagerman** DIGITAL VIDEO PRODUCER **Jennifer Frommer** PROGRAMMER/SOUND EDITOR **Ian Frommer** TITLE COORDINATOR **Paul Giordano** PUBLISHER **Sony Music Entertainment** CLIENT **Epic Records**

1 Title **Alice in Chains "Dog's Breath" Website** Design Firm **Sony Music Creative Services, Santa Monica, CA** Producers **Peter Anton and Mary Maurer** Art Director **Mary Maurer** Graphic/Interface Designer **Mary Maurer** Photographers **Rocky Schenck and Various** Writers **Peter Fletcher and Todd Shuss** Programmer **Peter Anton** Client **Columbia Records**

Design eludes categories. It plays betweens spheres of influence. It is informative and expressive, persuasive and provocative. As designers, we work in the spaces between the conditions of our commission and our own sensibility and style. Our work may be bold and original, graced with irony and wit, but we answer to the client. This is a paradox for designers, as is the brief transit of our work in the world. Much of design has a very brief life. How do we deal concretely and intelligently with the stated objectives of the moment in a way that will have meaning after that moment? How do we balance personal vision, the demands of the problem, and grander issues such as the ecological balance or social residue of design? The answers are made visible in this competition, which features designers' images, products, and environments in their highest forms. Not as a "best-dressed" list with the short rack life of fashion, but as a forceful, skillful means of shaping the world and our culture.

Michael Vanderbyl

CHAIRMAN

CALL FOR ENTRY

Design Vanderbyl Design

Typefaces Franklin Gothic Extra Condensed, Kunstler Script, Mrs Eaves, OCR-B

Photography Photodisc

Printing Anderson Lithograph

Paper Potlatch Vintage Remarque Velvet 80# Text

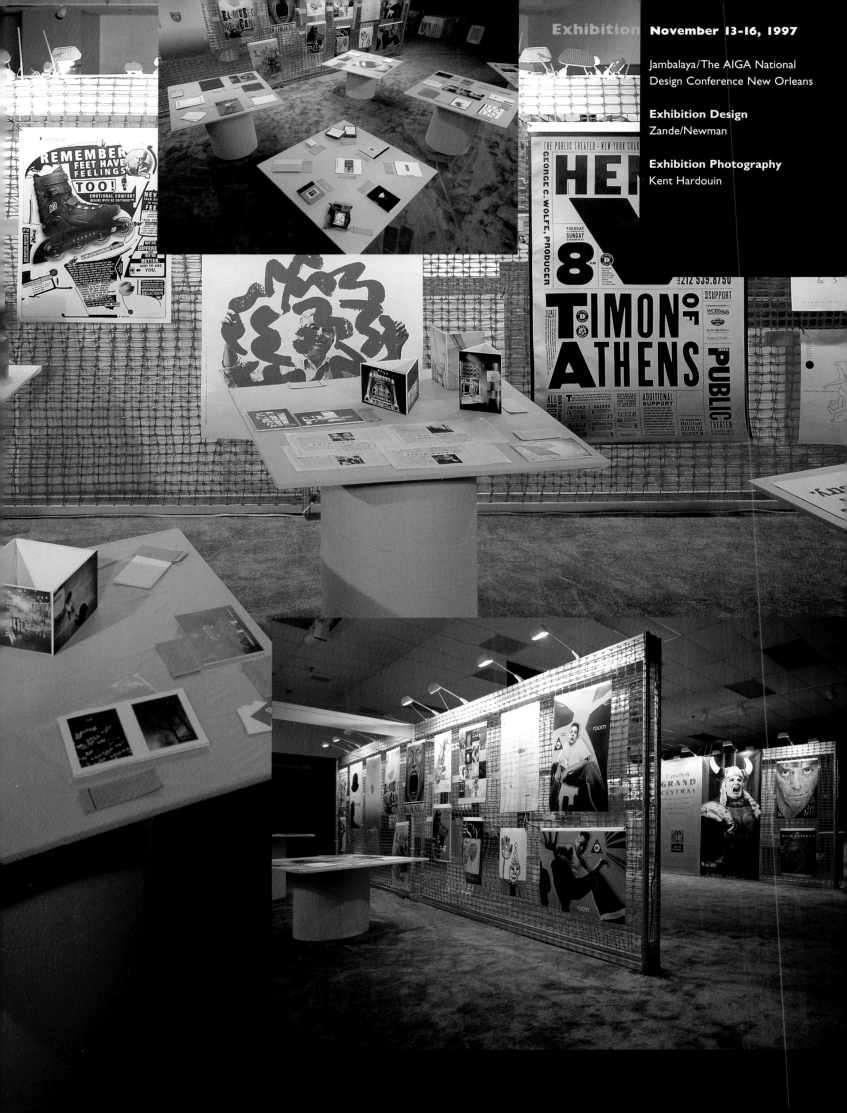

November 13-16, 1997

Jambalaya/The AIGA National
Design Conference New Orleans

Exhibition Design
Zande/Newman

Exhibition Photography
Kent Hardouin

John Bielenberg is principal of Bielenberg Design, a graphic design studio in Boulder and San Francisco. He has taught graphic design at California College of Arts and Crafts in San Francisco, judged several national design competitions, served on the events and environmental committees of AIGA/San Francisco as well as the board of directors of AIGA/Colorado, and has contributed articles on graphic design to *Communication Arts* and the American Center for Design.

John has received more than 200 national and international design awards from the AIGA, Communication *Arts, Graphis, Print, I.D. Magazine, Art Direction,* the American Center for Design, and the Los Angeles, New York, San Francisco, and Western Art Directors Clubs, among others. His work has been featured in numerous book on graphic design and is part of the Library of Congress permanent collection, the Chicago Athenaeum "Good Design" exhibition, and the San Francisco MOMA, which is currently planning an exhibition of his virtual Telemetrix projects.

Noreen Morioka is principal, with Sean Adams, of the firm Adams/Morioka in Beverly Hills. Noreen was also the creative director at Buz Design Group, M Squared Design, and was a senior designer at April Greiman Inc.

While she was an art director at Landor Associates, Tokyo, her clients included Japan Air Lines, Coca-Cola, Hyundai, Toyota, Nissan, Honda, Aldus Software, and Time-Warner New Media. She has also worked extensively with prominent architectural firms on environmental signage and interiors/materials programs, and is an acknowledged expert in digital design-related technology. Specific examples of her work have been published in Macintosh Designers Network, AXIS Japan, and *Designers on Mac.*

Noreen has a BFA from the California Institute of the Arts and has received honors from the AIGA, the Art Director's Club of Los Angeles, and the Society of Publication Designers. Her work is included in the collections of the Library of Congress, UCLA, and Columbia University, and has been exhibited in galleries and institutions in the United States, Japan, Australia, and Europe.

Steve Pattee is a principal of Pattee Design Inc. in Des Moines. Founded in 1985, Pattee Design, Inc. is an internationally recognized full-service graphic design firm specializing in strategic annual report development and business-to-business collateral communications. The firm's work has been regularly published and recognized worldwide by the AIGA, *Communication Arts, Graphis,* AR 100, *Print,* the ACD 100 Show, the Type Directors Club, and the Art Directors Club of New York, as well as design publications of North America and Europe. In addition, two of the firm's annual reports are included in an environmental exhibition at the Smithsonian Institution in Washington, D.C.

Steve is currently president of AIGA/Iowa and is past president of the Art Directors Association of Iowa. He has judged the *Communication Arts* Design Annual and the Dallas Society of Visual Communications Annual Exhibition.

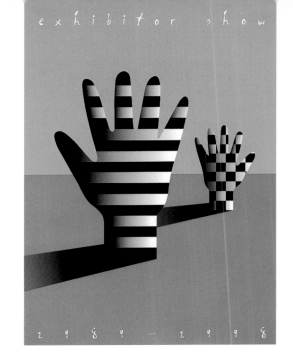

Since 1973, **Christopher Pullman** has served as vice president of design at WGBH, the Boston public television station. He and his staff are responsible for the complete visual personality (broadcast, print, and interactive media) of WGBH, which in 1986 received the AIGA's Design Leadership Award in recognition of its "advancement of design by application of the highest standards, as a matter of policy, to all visual communications."

He received a BA from Princeton and an MFA from Yale, where he has taught graduate and undergraduate studies and is still a senior critic. Before joining WGBH, he was also a member of the original design faculty at SUNY Purchase, ran a freelance design practice, and was a design consultant to the office of George Nelson in New York. He has served on the national boards of the Design Management Institute, the AIGA, the ACD, and the Corporate Design Foundation. He was named to the first list of the I.D. 40, has lectured widely to schools and organizations, and has published articles on design for television.

Jennifer Sterling is principal of Sterling Design in San Francisco, a firm specializing in annual reports, packaging, product design, book and major collateral communications, corporate and product identity, web services, and multimedia.

Her work has received recognition from the AIGA, *Graphis,* the ACD 100 Show, the Mead Annual Report Show, *Communication Arts,* the Type Directors Club, the Society of Typographic Arts, the I.D. Design Review, AR 100, Society of Illustrators, *Print,* Adobe, and *How.* The work of Sterling Design is also included in the AIGA/Library of Congress book tour and is in the permanent collection in the Museum of Illustration in New York. Jennifer has worked on a wide range of consumer and corporate products and is best known for creating the design promotional concept and materials for Fox Rivers Confetti papers. With three other designers, she also created the paper itself for the Fox River Circa Select paper line. Before opening her own firm, she was the art director for Tolleson Design.

Michael Vanderbyl, chair, is dean of the School of Design at the California College of Arts and Crafts, his alma mater. He has gained international prominence in the design field as a practitioner, educator, critic, and advocate.

Since 1973, Vanderbyl Design in San Francisco has evolved into a multi-discipline design firm specializing in graphics, packaging, signage, interiors, showrooms, furniture, textile, and fashion apparel. A shortened client list includes Amoco, AIA, Disney, Esprit, Hickory Business Furniture, IBM, Polaroid, San Francisco Design Center, San Francisco Museum of Modern Art, and Sun Microsystems. Michael's showroom, furniture, and lighting designs have received many prestigious awards, while his printed work has been recognized in every major design competition in the United States and Europe and is part of the permanent collections of the Cooper-Hewitt, National Design Museum, the San Francisco MOMA, and Die Neu Sammlung in Munich.

Tek nion abil ity

1 TITLE **Tupperware Corporation 1996 Annual Report** DESIGN FIRM **SamataMason, Chicago, IL** ART DIRECTOR **Greg Samata** GRAPHIC DESIGNER **Joe Baran** PHOTOGRAPHER **Mark Joseph** WRITER **Frank Greene** TYPEFACE **Bell Gothic** PRINTER **H. MacDonald Printing** PAPER **Monadnock Astrolite Vellum, Appleton Utopia Premium Gloss, Champion Carnival Vellum** 2 TITLE **Smithfield Foods 1996 Annual Report** DESIGN FIRM **VSA Partners, Chicago, IL** ART DIRECTOR **Jamie Koval** GRAPHIC DESIGNER **Dan Kraemer** PHOTOGRAPHERS **James Schnepf and Michael Deuson** WRITER **Steve Weiner** TYPEFACES **Trade Gothic, Garamond 3** PRINTER **Bruce Offset Company** PAPER **Simpson Evergreen** CLIENT **Smithfield Foods, Inc.**

MTV NETWORKS www.hotlink.mtvn.com

1 TITLE **MTV Networks Mouse Trap Mouse Pad** DESIGN FIRM **MTV Networks Creative Services, New York, NY** ART DIRECTOR **Scott Wadler** GRAPHIC DESIGNER **Nok Acharee** TYPEFACE **DIN Engschrift Alternate, Woodblock** CLIENT **MTV Networks** 2 TITLE **Knoll Website Announcement Card** DESIGN FIRM **Boxer Design, Brooklyn, NY** CREATIVE DIRECTOR/GRAPHIC DESIGNER **Eileen Boxer** TYPEFACES **Helvetica, Bodoni** PRINTER **Intervisual Communications, Inc.**

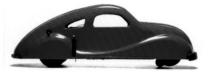

50

1946 A TOY · A DREAM 1996

THANK YOU FOR MAKING THIS TRIP AN ENJOYABLE ONE.
MERRY CHRISTMAS FROM YOUR FRIENDS AT NYLINT.

THE FIRST NYLINT TOY MANUFACTURED IN 1946

I TITLE **"The Master: Jordan" Poster** DESIGN FIRM **Nike, Inc., Beaverton, OR** ART DIRECTOR/GRAPHIC DEISGNER **Jeff Weithman** PHOTOGRAPHER **Christopher Griffith** PRINTERS **Irwin Hodson, Colorscan** PAPER **Kromekote** CLIENT **Nike, Inc.** 2 TITLE **Nylint Toys 50th Anniversary Poster** DESIGN FIRM **The Larson Group, Rockford, IL** ART DIRECTOR/GRAPHIC DESIGNER **Jeff Larson** PHOTOGRAPHER **Bob Cholke** WRITER **Jeff Larson** TYPEFACES **Helvetica Condensed, Sabon** PRINTER **The Printery** PAPER **Mohawk Superfine** CLIENT **Nylint Toys**

1 TITLE **Hockey Owner's Manual** DESIGN FIRM **Nike, Inc., Beaverton, OR** ART DIRECTORS **Dan Richards, Webb Blevins** GRAPHIC DESIGNER **Webb Blevins** COPYWRITER **Neil Webster** TYPEFACES **OCRA, Meta Caps** PAPER **Incentive 100** 2 TITLE **Teen Fact Book (1996)** DESIGN FIRM **High Design, New York, NY** ART DIRECTOR **Cheri Dorr** GRAPHIC DESIGNER/ILLUSTRATOR **David High** TYPEFACES **Trade Gothic and Platelet** PRINTER **Atwater** PAPER **Skivertex Cover, Finch Opaque Text 80#** CLIENT **Channel One Network**

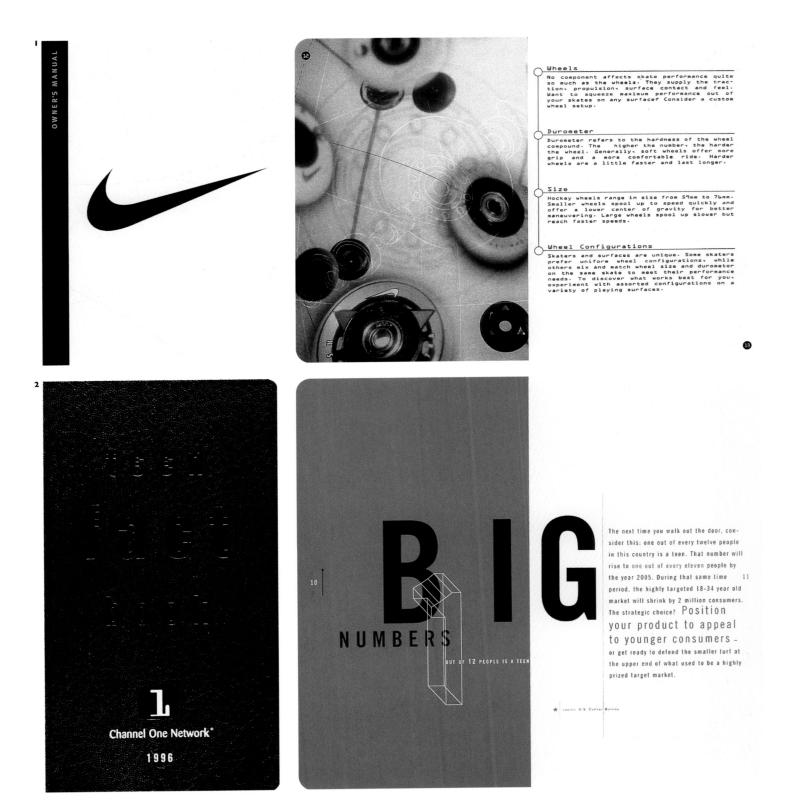

1 TITLE **1996 Video Music Awards Book** DESIGN FIRM **MTV Off-Air Creative, New York, NY** ART DIRECTORS **Tracy Boychuck, Stacy Drummond, and Jeffrey Keyton** GRAPHIC DESIGNERS **Tracy Boychuck and Stacy Drummond** WRITER **David Felton** TYPEFACE **Helvetica** 2 TITLE **Yunker '97 Brochure** DESIGN FIRM **Terrelonge, Inc., Toronto, Ontario** CREATIVE DIRECTOR **Del Terrelonge** GRAPHIC DESIGNERS **Del Terrelonge and Karen Oikonen** PHOTOGRAPHER **Annabel Reyes** PRINTER **Cheyenne Yulo Press** CLIENT **Yunker** 3 TITLE **1998 Mercedes-Benz SLK Brochure** DESIGN FIRM **The Designory, Inc., Long Beach, CA** CREATIVE DIRECTORS **Tim Meraz and David Tanimoto** ART DIRECTOR/GRAPHIC DESIGNER **Andrea Schindler** PHOTOGRAPHERS **Vic Huber and Michael Rausch** TYPEFACE **Mercedes-Benz Corporate Family** PRINTER **Williamson Printing Corporation** CLIENT **Mercedes-Benz North America**

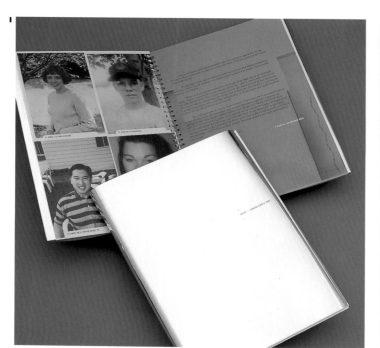

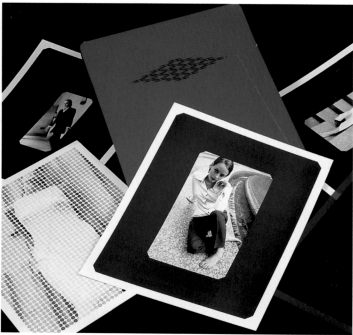

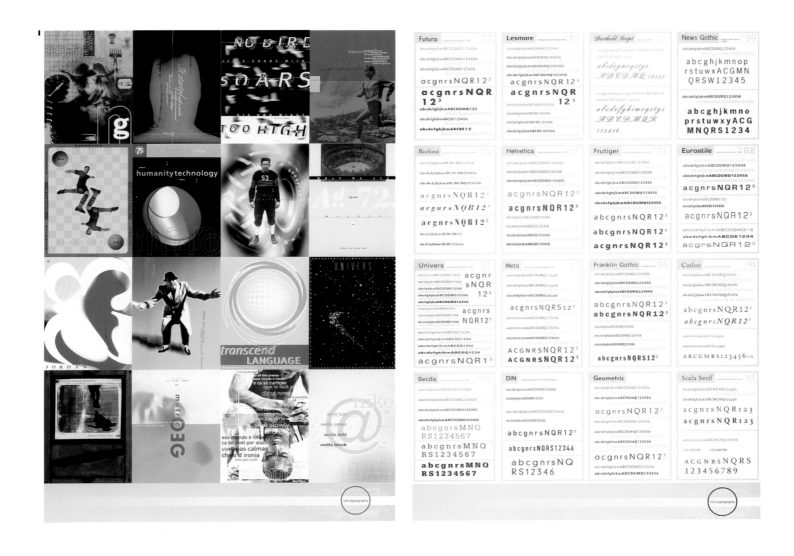

I TITLE **Nike Typography Poster** DESIGN FIRM **Nike Inc., Beaverton, OR** CREATIVE DIRECTOR **Val Taylor-Smith** GRAPHIC DESIGNER **Dan Sharp** ILLUSTRATORS **Various**
WRITER **Stanley Hainsworth** TYPEFACES **Various** PRINTER **Irwin Hodson** PAPER **Potlatch Vintage Velvet** CLIENT **Nike, Inc.**

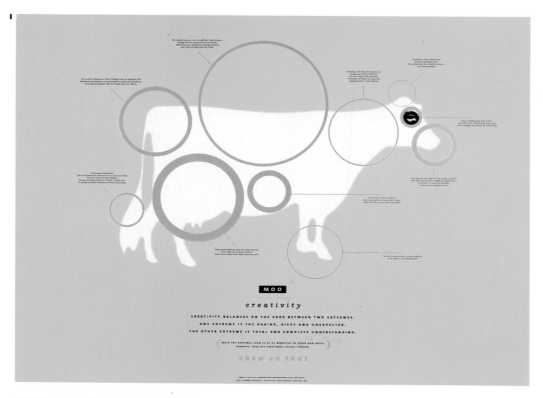

I TITLE **"Moo" Poster** DESIGN FIRM **Mark Oldach Design, Ltd., Chicago, IL** CREATIVE DIRECTOR **Don Emery** ART DIRECTOR **Mark Oldach** GRAPHIC DESIGNER **Guido Mendez** COPYWRITER **Mark Oldach** TYPEFACES **Matrix Inline Script, Syntax** PRINTER **Holm Graphic Services, Inc.** PAPER **Potlatch Quintessence** CLIENT **Art Directors Club of Iowa**

1 TITLE **Literary Objects: Flaubert** DESIGN FIRM **studio blue, Chicago, IL** ART DIRECTORS **Kathy Fredrickson and Cheryl Towler Weese** GRAPHIC DESIGNERS **Joellen Kames and Cheryl Towler Weese** PHOTOGRAPHS **Courtesy of the David and Alfred Smart Museum of Art** TYPEFACES **ITC Bodoni, Democratica, Sackers Gothic, Commercial Script** PRINTER **Hull Printing** PAPER **Mohawk Satin, Strathmore Beau Brilliant, Weyerhaeuser Cougar Opaque** CLIENT **The David and Alfred Smart Museum of Art, University of Chicago 2** TITLE **Speaking Volumes: The World of the Book (Rethinking Design #3)** DESIGN FIRM **Pentagram Design, New York, NY** ART DIRECTOR **Michael Bierut** GRAPHIC DESIGNERS **Michael Bierut and Lisa Anderson** PAPER **Mohawk Options** CLIENT **Mohawk Paper Mills**

1 TITLE **Brøderbund 1996 Annual Report** DESIGN FIRM **SamataMason, Chicago, IL** ART DIRECTOR **Dave Mason** GRAPHIC DESIGNERS **Pamela Lee, Joe Baran, and Dave Mason** ILLUSTRATOR **Joe Baran** PHOTOGRAPHER **Howard Fry** WRITER **Tura Cottingham** TYPEFACES **Centaur, Officina, and OCRB** PRINTER **H. MacDonald Printing** PAPER **Simpson Coronado SST Smooth, Repap Lithofect Dull Text** 2 TITLE **Corporation for Public Broadcasting 1995 Annual Report** DESIGN FIRM **Michael Gunselman Incorporated, Wilmington, DE** ART DIRECTOR/GRAPHIC DESIGNER **Michael Gunselman** PHOTOGRAPHER **Ira Wexler** TYPEFACES **Bembo, Univers** PRINTER **GraphTec** PAPER **Fox River Confetti, Mohawk Superfine** CLIENT **Corporation for Public Broadcasting**

1

2

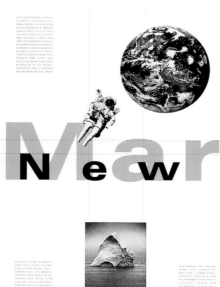

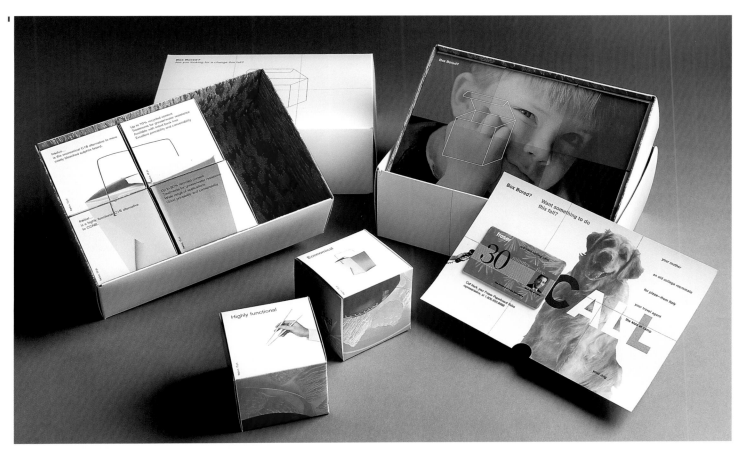

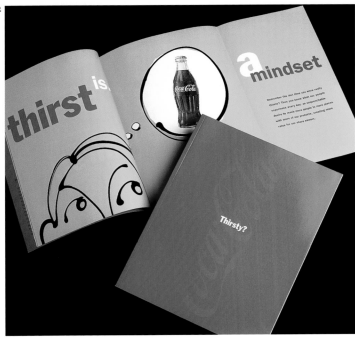

1 TITLE **Box Bored?** DESIGN FIRM **ViA, Columbus, OH** GRAPHIC DESIGNER **Oscar Fernández** WRITER **Wendie Wulff** TYPEFACES **Frutiger and Sabon** PRINTER **GAC Shepard Poorman** PAPER **Fraser Papers FraDuo** 2 TITLE **The Coca-Cola Company 1996 Annual Report** DESIGN FIRM **Executive Arts, Atlanta, GA** ART DIRECTOR/GRAPHIC DESIGNER **Phil Hamlett** ILLUSTRATOR **Laurie Rosenwald** PHOTOGRAPHER **Jeff Corwin** TYPEFACE **Franklin Gothic** PRINTER **Anderson Lithograph** CLIENT **Coca-Cola** 3 TITLE **Archive 1997 Calendar** DESIGN FIRM **Spot Design, New York, NY** ART DIRECTOR **Drew Hodges** GRAPHIC DESIGNER **Kevin Brainard** TYPEFACES **Bank Gothic, Brush Script, Clarendon, Futura** PRINTER **Red Ink Productions** FABRICATOR **Mandarin Offset** PAPER **Riegel Leatherette, Chipboard** CLIENT **Archive Films/Archive Photos**

187

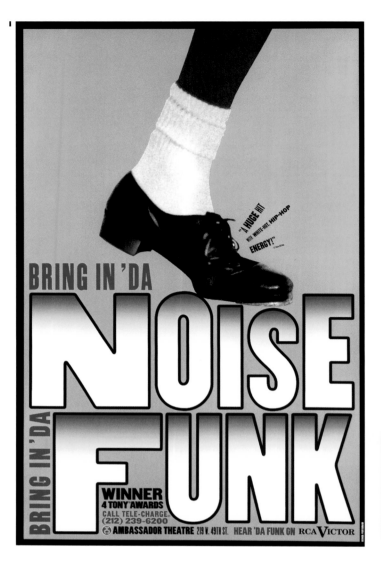

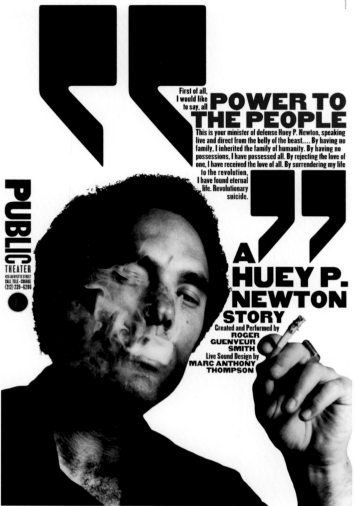

1 TITLE **"Bring in 'Da Noise, Bring in 'Da Funk" Poster** DESIGN FIRM **Pentagram, New York, NY** ART DIRECTOR **Paula Scher** GRAPHIC DESIGNERS **Paula Scher, Lisa Mazur** TYPEFACE **American Wood Type** CLIENT **The Joseph Papp Public Theater** 2 TITLE **"A Huey P. Newton Story" Poster** DESIGN FIRM **Pentagram, New York, NY** ART DIRECTOR **Paula Scher** GRAPHIC DESIGNERS **Paula Scher, Lisa Mazur, and Anke Stohlmann** TYPEFACE **American Wood Type** CLIENT **The Joseph Papp Public Theater**

188 COMMUNICATION GRAPHICS 18

1 TITLE **"Bring in 'Da Noise, Bring in 'Da Funk" Souvenir Brochure** DESIGN FIRM **Pentagram, New York, NY** ART DIRECTOR **Paula Scher** GRAPHIC DESIGNERS **Paula Scher and Lisa Mazur** PHOTOGRAPHERS **Michael Daniel and Richard Avedon** TYPEFACE **American Wood Type** PRINTER **Finlay Brothers** PAPER **Georgia-Pacific** CLIENT **The Joseph Papp Public Theater** 2 TITLE **"Rent" Souvenir Book** DESIGN FIRM **Spot Design, New York, NY** ART DIRECTOR **Drew Hodges** GRAPHIC DESIGNER **Naomi Nizusaki** ILLUSTRATOR/PHOTOGRAPHER **Amy Guip** WRITER **David Lipsky** TYPEFACES **Bell Centennial, ITC Century** PRINTER **Brodock Press** PAPER **French Butcher, Packing Carton** CLIENT **Rent, LLC**

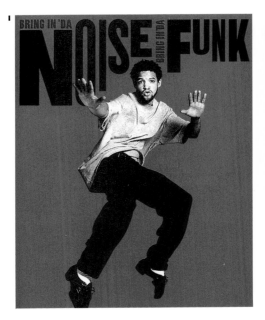

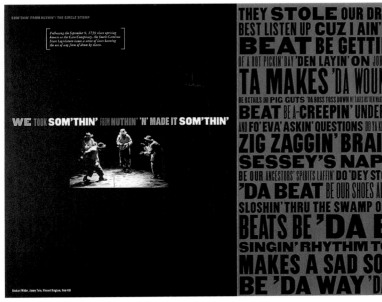

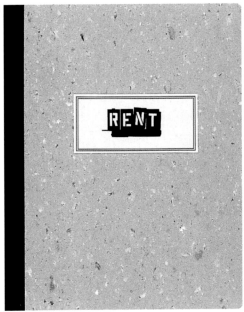

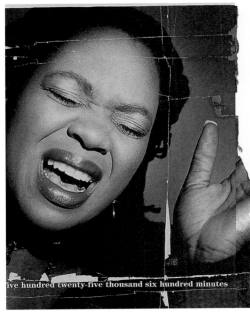

1 Title **First Reserve Sell Book** Design Firm **Duffy Design, Minneapolis, MN** Creative Director **Joe Duffy** Art Director/Graphic Designer **Dan Olson** Photographer **Leo Tushhaus** Copywriter **Riley Kane** Printer **Heartland Graphics** Client **Flagstone Brewery** 2 Title **Computer Donor Luncheon Invitation** Design Firm **Art Center College of Design, Pasadena, CA** Creative Director **Stuart I. Frolick** Art Director **Darin Beaman** Graphic Designers **Darin Beaman and John Choe** Typefaces **Meta, OCRB** Paper **Mylar Brushed Silver, 100# Matrix Matte Book, 80# Leatherette Regal Jersey Cover** 3 Title **Terry Vine Abroad** Design Firm **Rigsby Design, Inc., Houston, TX** Art Director **Lana Rigsby** Graphic Designers **Trisha Rausch and Lana Rigsby** Photographer **Terry Vine** Typeface **Poppl-Residenz** Printer **International Printing & Publishing** Paper **Simpson Starwhite Vicksburg Archiva** Client **Terry Vine Photography**

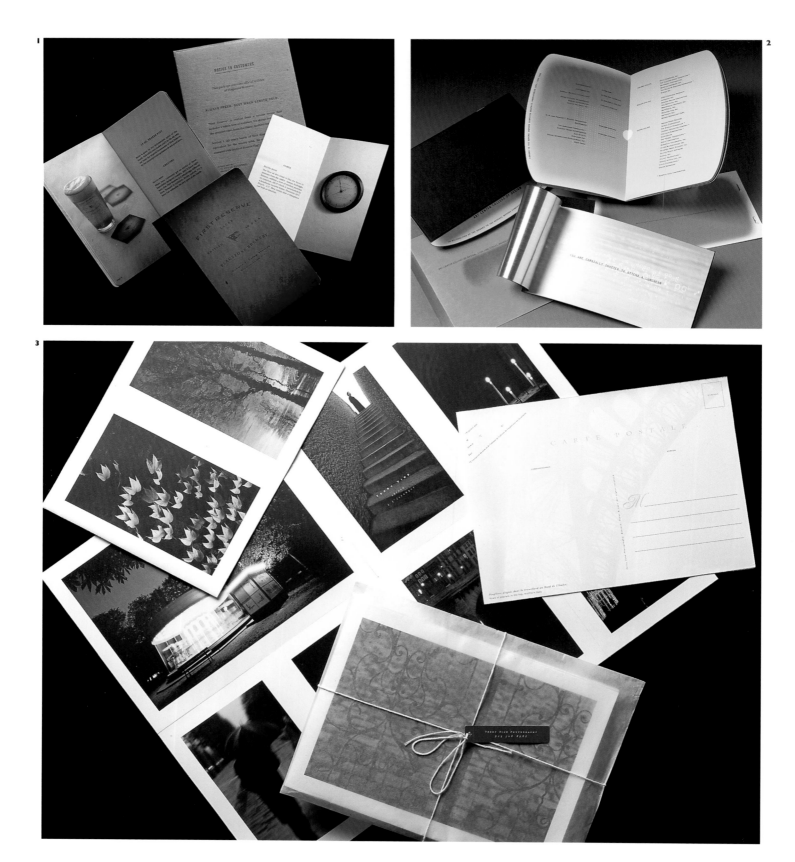

sundance

sundance

PREMIERING THE BEST IN NEW INDEPENDENT FILM.
UNCUT AND COMMERCIAL-FREE.
UNDER THE CREATIVE DIRECTION OF ROBERT REDFORD.

www.sundancechannel.com

PREMIERING THE BEST IN NEW INDEPENDENT FILM.
UNCUT AND COMMERCIAL-FREE.
UNDER THE CREATIVE DIRECTION OF ROBERT REDFORD.

www.sundancechannel.com

TITLE **Sundance Channel Poster Series** DESIGN FIRM **Young & Rubicam, New York, NY** CREATIVE DIRECTORS **Jeff Streeper and Lyle Owerko** DESIGNER **Jeff Streeper**
LOGO DESIGN **Lyle Owerko** PHOTOGRAPHERS **Leonard Freed and Ken Regan** TYPEFACE **Frutiger** CLIENT **Sundance Channel**

1 TITLE **"Having Our Say" Poster** DESIGN FIRM **Cyclone, Seattle, WA** GRAPHIC DESIGNERS/ILLUSTRATORS **Dennis Clouse and Traci Daberko** TYPEFACE **Felix Titling** PRINTER **Icon** PAPER **Cougar** CLIENT **Intiman Theatre** 2 TITLE **French Paper Company 125th Anniversary Poster** DESIGN FIRM **Charles S. Anderson Design Company, Minneapolis, MN** ART DIRECTOR **Charles S. Anderson** GRAPHIC DESIGNER/ILLUSTRATOR **Erik Johnson** PRINTER **Pilot Prints** PAPER **French Speckletone** CLIENT **French Paper Company** 3 TITLE **Third Annual Rainy States Film Festival Poster** DESIGN FIRM **Modern Dog, Seattle, WA** ART DIRECTOR/GRAPHIC DESIGNER **Vittorio Costarella** ILLUSTRATOR **Vittorio Costarella** TYPEFACE **Sharpie** PRINTER **Two Dimensions** PAPER **Gilbert "Special Brown"** CLIENT **The Rainy States Film Festival**

1 TITLE **"Think Brink" Catalogue** DESIGN FIRM **Willoughby Design, Kansas City, MO** ART DIRECTORS/GRAPHIC DESIGNERS **Ingred Sidie and Michelle Sonderegger** ILLUSTRATORS **Various** PHOTOGRAPHER **Tim Pott** COPYWRITER **Mara Friedman** PRINTER **Austin American Chronical** PAPER **Newsprint** 2 TITLE **Nozone #8 "Extremism" Issue** DESIGN FIRM **Nozone, New York, NY** ART DIRECTOR/GRAPHIC DESIGNER **Knickerbocker** ILLUSTRATORS **Various** TYPEFACES **Garamond, Franklin Gothic** PRINTER **The Studley Press** PUBLISHER **Nozone**

1
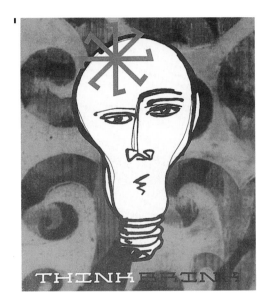
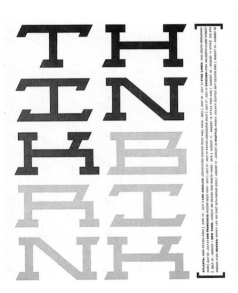
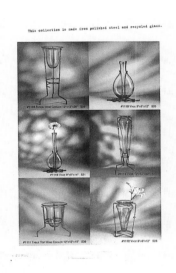

2
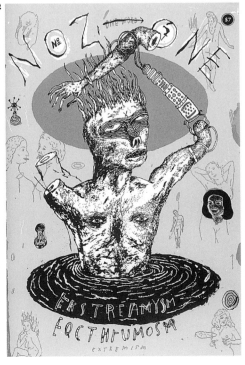
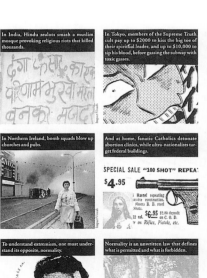
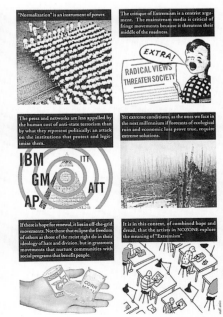

1 TITLE **Penwest 1996 Annual Report** DESIGN FIRM **Leimer Cross Design Corporation, Seattle, WA** ART DIRECTOR/GRAPHIC DESIGNER **Kerry Leimer** ILLUSTRATOR **Peter Kramer** PHOTOGRAPHER **Jeff Corwin** TYPEFACE **Didot** PRINTER **Lithographix, Inc.** PAPER **Monadnock Astrolite** 2 TITLE **MacMillan Bloedel 1996 Annual Report** DESIGN FIRM **SamataMason, Chicago, IL** ART DIRECTOR **Dave Mason** GRAPHIC DESIGNERS **Pamela Lee and Dave Mason** ILLUSTRATOR **Pamela Lee** PHOTOGRAPHER **James LaBounty** WRITER **Deirdre Holmes** TYPEFACE **Bembo** PRINTER **H. MacDonald Printing** PAPER **MacMillan Bloedel Linerboard and Pacifica Gloss, Simpson Coronado**

1

PROFIT POTENTIAL DEMAND

select global markets

The acceptance and demand for our science and products continues to grow in North America. But we are discovering the great potential in international markets. Fifty percent of our pharmaceutical excipients were sold in Europe last year. In our paper business, we are aggressively pursuing joint venture opportunities in Asia – a part of the world that is projected to grow paper production and consumption significantly in the next decade. Trials demonstrated to this new market what we already know at home, that our starches improve strength and finish, speed up production and increase consistency, efficiency and profitability.

If our paper products are successful in penetrating this huge Asian market, not only would our volumes and sales increase but, just as importantly, the effects of a low growth North American paper industry would be mitigated. And no matter where we go, no matter what the language, we are learning that the value, efficiency and effectiveness our products offer are in demand.

2

Building Materials is the largest part of our company and we're working towards increased growth and profitability. Our Solid Wood business continues to pursue its value added approach. Our Composite Wood business is successfully competing in expanding North American markets and our Distribution business has the people, operations and systems to continue its growth. Together these businesses have the fibre resources, know-how, technology and marketing network to deliver a broad and complementary range of building products to customers throughout the world.

Building Materials

SOLID WOOD We at MacMillan Bloedel have access to a unique and special forest resource in coastal British Columbia. As the largest holder of forest tenure in BC we have a responsibility to ensure proper forest management. Our primary objective is to get full value from every tree harvested. MacMillan Bloedel began producing lumber more than eighty years ago, but our current products bear little resemblance to those of early years. We've shifted from large, rough products to finished specialty products in many sizes and end uses, such as decking, siding, windows and doors.

Increasing margins – adding value and reducing costs – begins in the forest, extends to the mills and manufacturing plants and ends with finished products and satisfied customers. We have higher manufacturing costs than commodity producers but these are offset by increased value in the marketplace. In fact the average sales value of our solid wood products has increased 68% – more than $430 per thousand board feet – since 1990. Our product value is going up – but our costs are rising more dramatically. MB's logging costs

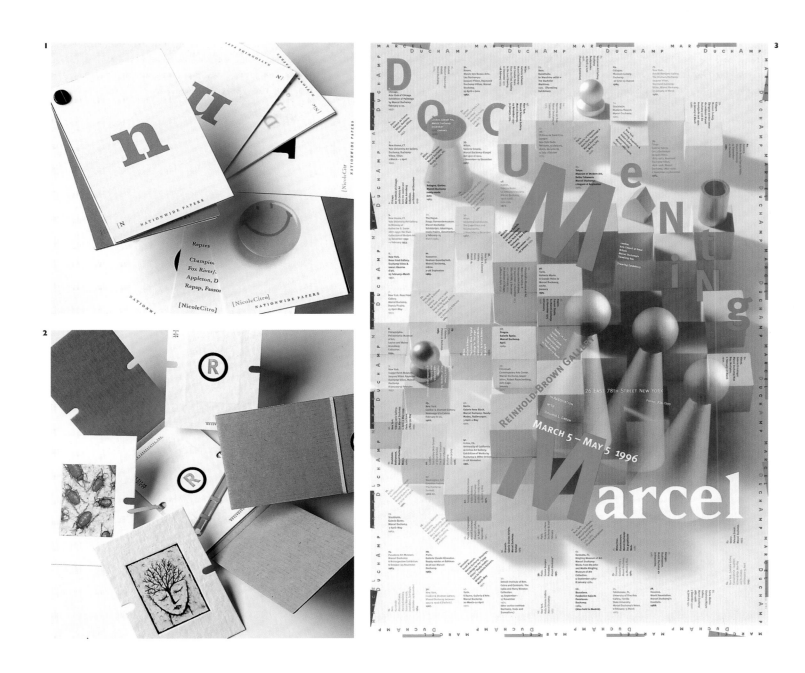

1 TITLE **Nicole Citro Promotion Brochure** DESIGN FIRM **Grady Campbell, Inc., Chicago, IL** CREATIVE DIRECTOR **Kerry Grady** ART DIRECTOR **Jeff Clift** WRITERS **Jeff Clift and Kerry Grady** TYPEFACES **Bulmer, Clarendon, Ponderosa, DIN** PRINTER **Active Graphics** FABRICATOR **Slam Lam** PAPER **Simpson Starwhite Vicksburg** CLIENT **Nation Wide Papers/Nicole Citro 2** TITLE **Dan Richards Illustration Self-Promotion** DESIGN FIRM **Dan Richards, Hillsboro, OR** ART DIRECTOR/GRAPHIC DESIGNER **Dan Richards** ILLUSTRATOR **Dan Richards** TYPEFACE **OCRB** PRINTER **Good Egg Press** PAPER **Reliance 190# Blotter Paper** CLIENT **Dan Richards 3** TITLE **"Documenting Marcel" Poster** DESIGN FIRM **Skolos/Wedell, Charlestown, MA** ART DIRECTORS **Nancy Skolos and Thomas Wedell** GRAPHIC DESIGNER **Nancy Skolos** TYPEFACES **Meta, Matrix, Keedy Sans** PRINTER **Daniels Printing** PAPER **Neenah UV/Ultra II Translucent Printing Paper Columns** CLIENT **Reinhold-Brown Gallery and Virginia L. Green**

195

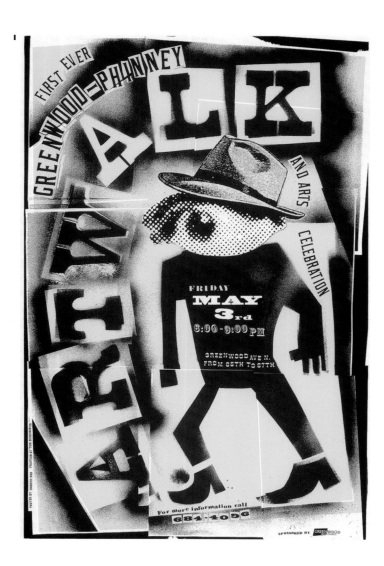

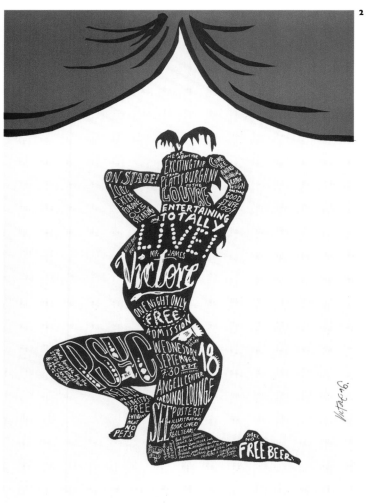

1 TITLE **Artwalk Poster** DESIGN FIRM **Modern Dog, Seattle, WA** ART DIRECTOR/GRAPHIC DESIGNER **Robynne Raye** ILLUSTRATOR **Robynne Raye** TYPEFACE **Franklin Gothic and Hand Lettering** CLIENT **Greenwood Arts Council** 2 TITLE **Plattsburgh State University College Poster** DESIGN FIRM **James Victore, Inc., New York, NY** CREATIVE DIRECTOR **Diane Fine** GRAPHIC DESIGNER/WRITER **James Victore** PRINTER **Royal Offset** PAPER **Champion Carnival**

1 TITLE **Restart Issue #1 (Cover)** DESIGN FIRM **Restart, New York, NY** CREATIVE DIRECTORS/GRAPHIC DESIGNERS **Thomas Noller , G. K. Van Patter** PHOTOGRAPHER **David Golden** TYPEFACE **Tema Cantante** PRINTER **Katz Digital Technologies** PAPER **Monadnock** CLIENT/PUBLISHER **Restart Publishing 2** TITLE **Restart Issue #1** DESIGN FIRM **Restart, New York, NY** CREATIVE DIRECTORS/GRAPHIC DESIGNERS **Thomas Noller, G. K. Van Patter** PHOTOGRAPHER **David Golden** TYPEFACES **Cothral, Entropy, Flexture, Fragment, Freedom, Indelible Victorian, Lomba, Missive, Osprey, Roppongi, Tema Cantante** PRINTERS **Katz Digital Technologies, Medallion Associates** PAPER **Monadnock** CLIENT/PUBLISHER **Restart Publishing 3** TITLE **Jacor Communications Inc. 1995 Annual Report** DESIGN FIRM **Petrick Design, Chicago, IL** ART DIRECTOR **Robert Petrick** GRAPHIC DESIGNERS **Robert Petrick, Laura Ress** ILLUSTRATORS **Mark Heckman, Various** PHOTOGRAPHERS **Paul Ellidge, Various** TYPEFACE **News Gothic** PRINTER **The Hennegan Company** PAPER **Fine Finch VHF Text** CLIENT **Jacor Communications Inc.**

1

2

3

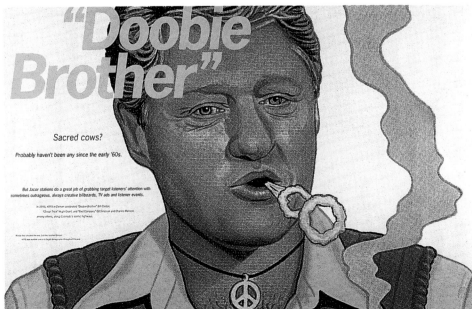

1 TITLE **Shakespeare's Unruly Women Exhibition Catalogue** DESIGN FIRM **Studio A, Alexandria, VA** JACKET/COVER DESIGNER **Antonio Alcalá** ILLUSTRATORS **Kenny Meadows, W. H. Mote** TYPEFACES **Adobe Minion, Kunstler** PRINTER **Hagerstown Bookbinding and Printing Company** PAPER **Mohawk Options** PUBLISHER **The Folger Shakespeare Library** 2 TITLE **Nicolas Africano "Two Sisters" Catalogue** DESIGN FIRM **Leimer Cross Design Corporation, Seattle, WA** ART DIRECTOR/GRAPHIC DESIGNER **Kerry Leimer** PHOTOGRAPHERS **Spike Mafford, Arthur Aubrey, Eduardo Calderon** WRITER **Lisa Lyons** TYPEFACE **Garamond #3** PRINTER **H. MacDonald Printing** PAPER **Potlatch Karma, Mohawk Molino**

1

Shakespeare's *Unruly* Women

Olivia and Viola

TWELFTH NIGHT 1601–02

This play shows us the processes by which two women work through their grief over the deaths of their brothers: the Countess Olivia for a brother who has actually died, and Viola for a twin brother whom she fears may have perished in the same storm that threw her on the coast of Illyria. Olivia hides behind the veils of mourning and refuses to hear the entreaties of Duke Orsino for her hand, while Viola dresses as the boy Sebastian and offers her service to the Duke in order to make her way in the world. When she comes to court Olivia on behalf of Orsino, Olivia falls in love with Viola/Sebastian, while Viola has fallen in love with Orsino. The gender-bending plot rights itself with the eventual appearance of Viola's lost twin brother who happily marries Olivia, leaving the Duke for Viola. The waiting-gentle-woman Maria adds humor and warmth to the play through her witty dealings with Malvolio and Sir Toby Belch, Olivia's kinsman.

* Artist Unknown, *Twelfth Night*, Act III, scene i. (n.d., c.1850), colored engraving. The artist here shows one of the most intimate moments between Viola and Olivia. Viola, dressed as the young courtier, Sebastian, has come to woo Olivia on behalf of her master, Orsino, but Olivia falls in love with the disguised Viola instead, and reaches her hand towards her pouch to give him some money.

* Artist Unknown, *Twelfth Night*, Act III, scene iv (n.d., c.1880), colored lithograph. The artist captures the pleasure on the faces of Olivia and her gentlewoman, Maria, as they wait to see Malvolio in his yellow stockings with crossed garters.

* Kenny Meadows (1790–1874), *Viola*, (original c.1836), colored engraving.

* Kenny Meadows (1790–1874), *Olivia*, (original c.1836), colored engraving.

These two engravings were part of the original "beauties" sets depicting Shakespeare's heroines, published in 1836–37 by Charles Heath. They were reproduced widely throughout the nineteenth century and are here presented as finely-colored

White, Julia Marlowe as Viola in Twelfth Night (n.d.), photograph. Julia Marlowe (1866–1950) first played Viola in 1887.

65

2

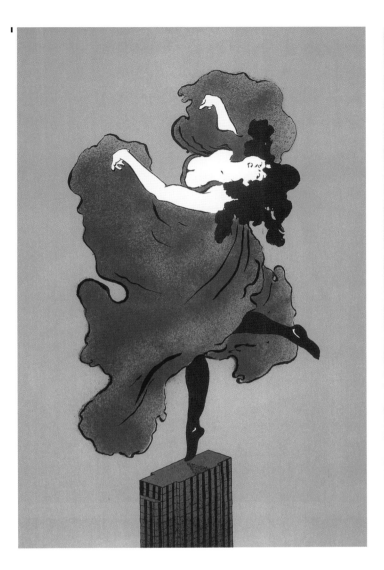

THE FOUR BROKERS WHO SIGN THE LARGEST LEASES AT
135 SOUTH LA SALLE
CAN WATCH THE SUNSET FROM ATOP THE
EIFFEL TOWER,
EXPERIENCE A PARISIAN EVENING AT THE
MOULIN ROUGE,
OR SAVOR FRANCE'S CUISINE AND WINES.
PARIS

100,000 CONTIGUOUS SQUARE FEET OF TOWER SPACE IS NOW AVAILABLE IN A CHICAGO LANDMARK, 135 SOUTH LA SALLE. WITH FLOORPLATES OF 12,000 SQUARE FEET, THIS IS AN EXCELLENT OPPORTUNITY FOR TENANTS TO HAVE FULL-FLOOR IDENTITY IN ONE OF THE CITY'S MOST PRESTIGIOUS ADDRESSES.

FOUR TRIPS FOR TWO WILL BE OFFERED
TO THE FOUR BROKERS WHO SIGN THE LARGEST LEASES IN THE TOWER AT 135 SOUTH LA SALLE
FROM JANUARY 1, 1997 TO DECEMBER 31, 1997.
THE WINNERS WILL SPEND
5 EXCITING DAYS & 4 ROMANTIC NIGHTS
THE TRIP INCLUDES AIRFARE, ACCOMODATIONS IN A FINE HOTEL, DINNERS FOR TWO & EXPENSES.
ALL TRIPS WILL BE BOOKED BETWEEN JANUARY 1, 1998 AND FEBRUARY 28, 1998. TRAVEL MAY OCCUR FROM JANUARY 1, 1998 THROUGH OCTOBER 31, 1998.
Restrictions: New tenant floor deals only (no renewals) with a minimum of 10,000 square feet per deal; minimum term of five years; multiple deals will be counted together for total square footage; one broker per deal; no substitutions.

TITLE **LaSalle Incentives Poster** DESIGN FIRM **Froeter Design Co., Chicago, IL** ART DIRECTOR/GRAPHIC DESIGNER **Chris Froeter** ILLUSTRATOR **Chris Froeter** WRITER **Ted Stoik** TYPEFACE **Clarendon** PRINTER **Rider Dickerson** PAPER **Mohawk Superfine** CLIENT **Marketing Communications Consortium**

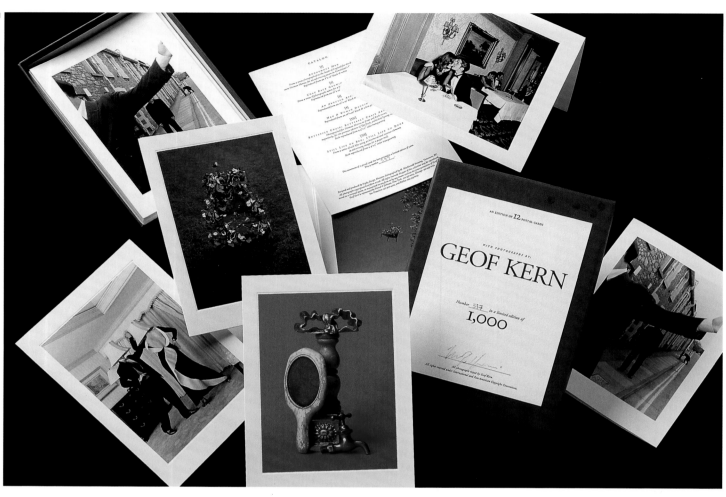

1 TITLE **Geof Kern Limited-Edition Postal Cards** DESIGN FIRM **Rigsby Design, Inc., Houston, TX** ART DIRECTOR **Lana Rigsby** GRAPHIC DESIGNERS **Lana Rigsby and Michael Thede** PHOTOGRAPHER **Geof Kern** TYPEFACE **Adobe Garamond** PRINTER **Julie Holcomb Printers** PAPER **Rives BFK** CLIENT **Geof Kern Photography** 2 TITLE **"Parched" French Parchtone Promotion** DESIGN FIRM **Studio D Design, Minneapolis, MN** ART DIRECTOR/GRAPHIC DESIGNER **Laurie DeMartino** PHOTOGRAPHER **Steve Belkowitz** WRITER **Lisa Pemrick** TYPEFACES **New Baskerville, News Gothic** PRINTER **The Etheridge Company** PAPER **French Parchtone** CLIENT **French Paper Company** 3 TITLE **American Crew 01 Book** DESIGN FIRM **Liska and Associates, Chicago, IL** ART DIRECTOR **Steven Liska** GRAPHIC DESIGNER **Marcos Chavez** PHOTOGRAPHER **Mark Havriliak** WRITER **Jack Sichterman** TYPEFACES **Bell Gothic, Garamond, Highway Gothic, OCRB, Letter Gothic** PAPER **Gleneagle Dull** CLIENT **American Crew**

1 TITLE **Daniel Proctor Photography** DESIGN FIRM **Michael Mabry Design, San Francisco, CA** GRAPHIC DESIGNERS **Michael Mabry and Kristen Malan** PHOTOGRAPHER **Daniel Proctor** TYPEFACE **Engravers Roman** PRINTER **Forman Lithograph** PAPER **Arches Cover, Mohawk Superfine Text** CLIENT **Daniel Proctor** 2 TITLE **Open House Exhibition Catalogue** DESIGN FIRM **Art Center College of Design, Pasadena, CA** CREATIVE DIRECTOR **Stuart I. Frolick** ART DIRECTOR **Darin Beaman** GRAPHIC DESIGNERS **Darin Beaman and Carla Figueroa** PHOTOGRAPHER **Steven A. Heller** TYPEFACE **Citizen** PAPER **100# Matrix Dull Book, Pajco Woodgrain Cover, Mohawk Natural Parchment**

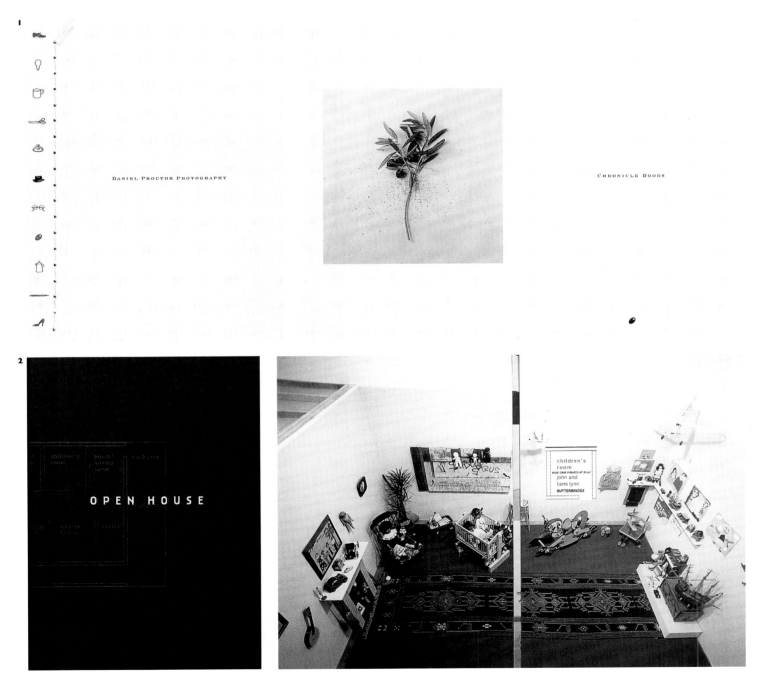

1 TITLE **Massachusetts College of Art 1995/97 Catalogue** DESIGN FIRM **Stoltze Design, Boston, MA** GRAPHIC DESIGNERS **Resa Blatman, Peter Farrell, Heather Kramer, Tracy Schroder, and Clifford Stoltze** PHOTOGRAPHERS **Jon Baring-Gould and Cecilia Hirsch** WRITER **Elizabeth Mackie** TYPEFACES **Meta, New Baskerville, Trixie** PRINTER **W. E. Andrews** CLIENT **Massachusetts College of Art** 2 TITLE **MICA Catalogue "The Future Is Yours to Create"** DESIGN FIRM **Grafik Communications, Ltd., Alexandria, VA** CREATIVE DIRECTOR **Judy Kirpich** ART DIRECTOR **Gregg Glaviano** GRAPHIC DESIGNERS **Gregg Glaviano and Lynn Umemoto** PHOTOGRAPHER **Joe Rubino** COPYWRITER **Debra Rubino** TYPEFACES **Garamond 3, Officina Sans, Trixie** PRINTER **Schneidereith & Sons** PAPER **Gilbert Esse Textured Text, Mead Moistrite Matte** CLIENT **Maryland Institute College of Art**

1

2

1 TITLE **"Art Is..." 1996 School of Visual Arts Poster** DESIGN FIRM **Milton Glaser, Inc., New York, NY** ART DIRECTOR/GRAPHIC DESIGNER **Milton Glaser** ILLUSTRATOR **Milton Glaser** WRITER **Milton Glaser** CLIENT **School of Visual Arts** 2 TITLE **"Congratulations, School of Visual Arts" Poster** DESIGN FIRM **George Tscherny, Inc., New York, NY** CREATIVE DIRECTOR **Silas H. Rhodes** GRAPHIC DESIGNER/ILLUSTRATOR **George Tscherny** PHOTOGRAPHER **Oscar Villegas** COPYWRITER **Silas H. Rhodes** TYPEFACE **Bodoni** PRINTER **National Posters Inc.** PROGRAMMER **Lynn Buchman** CLIENT/PUBLISHER **School of Visual Arts**

Reproduction [fig. 1.5] Self-replication is known to exist among many simple life-forms, but the reproduction of a complex structure such as a book requires collaboration among many organisms. The generation of multiple volumes from a single alpha book involves such exotic and imperfectly understood processes as imprinting, binding, and shrink-wrapping. (The process for determining how many copies of a given book are reproduced is known as "market research" and is described in an equation too complex to reproduce here.)

Adaptability [fig. 1.6] A book is created when matter, shaped by the energy of organisms, is transformed into an ordered structure that acts on the environment. Its strength lies in its adaptability: As the environment changes, the form of the book can evolve as well. As an adaptable, essentially stable product, books represent the most advanced means to transfer text [T] and image [I] among organisms. This dynamic can be described by the equation

$$(T + I)^3 = (I \times \infty)$$

the **graphic design** handbook for **business**

American Institute of Graphic Arts/Chicago Chapter

" What these managers need to begin realizing, is that by employing the right design talent, your company will

IMPROVE its *competitive* position.

5

What more proof " do they need?

Gordon Segal, President, Owner, CEO, Crate & Barrel

SECTION **5:** Profiles of success.

The design work we present in this handbook comes from some of the most successful companies in their respective industries. What did they do differently from companies who don't use design well? They chose to believe that design matters. And for each one, that belief led to soaring sales and profits.

Some people would cite the chicken-and-the-egg argument when looking at these examples, saying that the good design happened because of the success. But the fact is, the people directly involved know which came first, and they passionately describe how their design programs paved their way to the success they enjoy today.

As these examples illustrate, design requires a solid commitment and teamwork. Where possible, we've cited the people directly involved in case you want to contact them about the decisions they faced and how they resisted settling for compromised work. The point is, you can follow these examples to achieve success for your company.

Great design has achieved outstanding results time after time and will continue to do so into the future. It's a proven model with recognized methods and predictable results. Design more than matters; it makes a huge difference in terms of brand equity and a company's ability to grow.

21

1 TITLE **Bibliology 101** DESIGN FIRM **studio blue, Chicago, IL** ART DIRECTORS **Kathy Fredrickson and Cheryl Towler Weese** ILLUSTRATOR **Cheryl Towler Weese** TYPEFACE **Interstate** PRINTER **Dupli-Graphics** PAPER **French Dur-o-Tone Butcher and Packing Gray Liner** CLIENT **studio blue** 2 TITLE **The Graphic Design Handbook for Business** DESIGN FIRM **Hartford Design, Chicago, IL** ART DIRECTOR/GRAPHIC DESIGNER **Tim Hartford** PHOTOGRAPHER **Kipling Swehla** WRITER **Chuck Carlson** TYPEFACE **Officina Sans** PRINTER **Columbia Graphics** FABRICATOR **Graphic Packaging Resources** PAPER **Strathmore Writing** PUBLISHER **AIGA/Chicago**

1 TITLE **Sit Brochure** DESIGN FIRM **Lee Hunt Associates, New York, NY** ART DIRECTOR/GRAPHIC DESIGNER **Susanna Ko** ILLUSTRATORS **Gary Baseman and Various** WRITER **Sharon Glassman** TYPEFACES **New Century Schoolbook and Liberty** PRINTER **Innovisions** CLIENT **USA Network** 2 TITLE **A to Z** DESIGN FIRM **Slover and Company, New York, NY** CREATIVE DIRECTOR **Susan Slover** GRAPHIC DESIGNER **Christina Hsiao** ILLUSTRATOR **Laura Ljungkvist** WRITER **Rosemary Kuropat** PRINTER **Masterpiece Printers** PAPER **Mohawk Tomahawk** CLIENT **Mohawk Paper Mills** 3 TITLE **Rough Magazine, November 1996** DESIGN FIRM **Brainstorm, Dallas, TX** ART DIRECTORS/GRAPHIC DESIGNERS **Chuck Johnson, Wayne Geyer, Jeff Dey** ILLUSTRATORS **Wayne Geyser, Artman, Chuck Johnson, and Others** PHOTOGRAPHERS **Phil Hollenbeck, Doug Davis, Steve McAlister** TYPEFACES **Trade Gothic, Century** PRINTER **Brodnax Printing** PAPER **Ris Paper Sandpiper Fern, Domtar Plainfield Plus Homespun Finish** CLIENT **Dallas Society of Visual Communications**

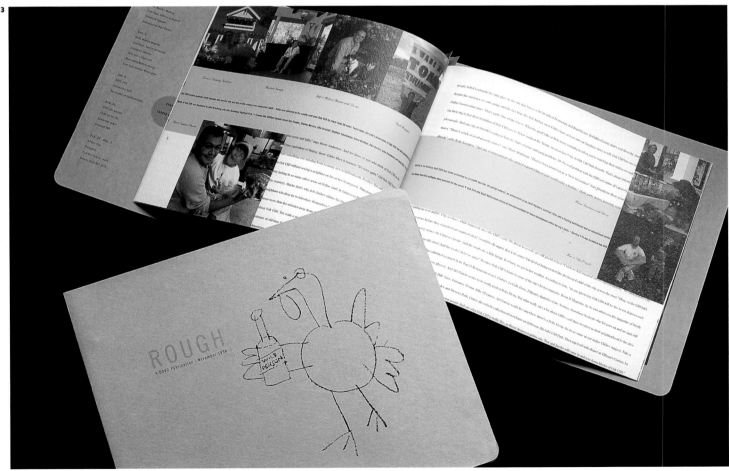

1 TITLE **Critique Magazine, Summer 1996 "Curiosity" Issue** DESIGN FIRM **Neumeier Design Team, Palo Alto, CA** CREATIVE DIRECTOR **Christopher Chu** GRAPHIC DESIGNERS **Kellie Barnbach, Vinh Chung, Aimee Dale, Heather McDonald** PHOTOGRAPHER **Jeanne Carley** TYPEFACES **Vectora and Times Roman** PRINTER **Graphic Center** PAPER **Mead Signature Dull Cover, Strathmore Writing Text, Mohawk Innovation II Text** PUBLISHER **Neumeier Design Team** 2 TITLE **Critique Magazine Fall 1996 "Rebellion" Issue** DESIGN FIRM **Neumeier Design Team, Palo Alto, CA** CREATIVE DIRECTOR **Christopher Chu** GRAPHIC DESIGNERS **Kellie Barnbach, Vinh Chung, Aimee Dale, Heather McDonald** PHOTOGRAPHER **Jeanne Carley** TYPEFACES **Vectora and Times Roman** PRINTER **Graphic Center** PAPER **Mead Signature Dull Cover and Text, Gilbert Esse Text** PUBLISHER **Neumeier Design Team** 3 TITLE **Critique Magazine Winter 1997 "Relevance" Issue** DESIGN FIRM **Neumeier Design Team, Palo Alto, CA** CREATIVE DIRECTOR **Christopher Chu** GRAPHIC DESIGNERS **Kellie Barnbach, Vinh Chung, Aimee Dale, Heather McDonald** PHOTOGRAPHER **Jeanne Carley** TYPEFACES **Vectora and Times Roman** PRINTER **Graphic Center** PAPER **Mohawk 50/10 Plus, Mohawk Superfine Eggshell** PUBLISHER **Neumeier Design Team**

1 TITLE **"Golden Child" Poster** DESIGN FIRM **Pentagram, New York, NY** ART DIRECTOR **Paula Scher** GRAPHIC DESIGNERS **Paula Scher and Lisa Mazur** TYPEFACE **American Wood Type** CLIENT **The Joseph Papp Public Theater** 2 TITLE **"Henry VI" Poster** DESIGN FIRM **Pentagram, New York, NY** ART DIRECTOR **Paula Scher** GRAPHIC DESIGNERS **Paula Scher, Lisa Mazur, and Anke Stohlmann** TYPEFACE **American Wood Type** CLIENT **The Joseph Papp Public Theater**

1 TITLE **Pentagram Papers #25: Souvenir Albums** DESIGN FIRM **Pentagram Design, Inc., San Francisco, CA** ART DIRECTOR **Kit Hinrichs** GRAPHIC DESIGNERS **Karen Berndt, Kashka Pregowska-Czerw** PHOTOGRAPHER **Bob Esparza** WRITER **Delphine Hirasuna** TYPEFACE **Cheltenham** PRINTER **H. MacDonald Printing** PAPER **Potlatch Vintage Velvet, Vintage Gloss** CLIENT/PUBLISHER **Pentagram Design Inc.** 2 TITLE **Baskin: The Human Condition: Selected Works by Leonard Baskin** DESIGN FIRM **Summerford Design, Dallas, TX** GRAPHIC DESIGNER **Jack Summerford** ILLUSTRATOR **Leonard Baskin** TYPEFACE **Bembo** PRINTER **Monarch Press** PAPER **Mohawk Superfine** CLIENT **Stephen F. Austin University**

[PROMOTING INDUSTRY]

A forerunner of today's corporate capabilities books, albums were produced by companies and industries to promote their business. Like their contemporary counterparts, early industrial albums showcased modern facilities, thriving businesses and state-of-the-art machinery.

The brewing industry is credited for giving rise to some of the first American souvenir albums via the Wittemann Brothers of New York City. Emigrants from Germany, the Wittemanns initially imported stone-lithographed beer labels produced in Leipzig, a 19th century printing and publishing center, and adapted the process to produce more than 400 souvenir albums.

Proud of their thriving economies, states and regions touted their leading industries. In the late

19th century, Michigan produced this viewbook to demonstrate that its abundant timber resources and

manufacturing capabilities could keep pace with the nation's increasing demand for lumber products.

I TITLE **The Golden Gate National Park Poster Series** DESIGN FIRM **Michael Schwab Studio, San Anselmo, CA** ILLUSTRATOR **Michael Schwab** TYPEFACE **Schwab Poster** PRINTER **B+R Screen Graphics** CLIENT **The Golden Gate National Park**

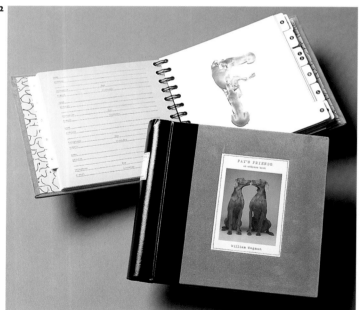

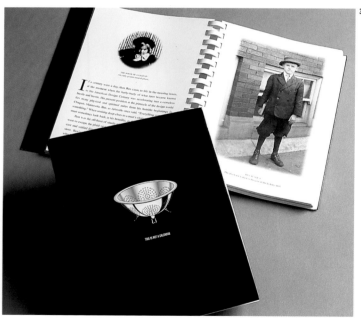

1 TITLE **Elixir Design Inc. Self-Promotion Brochure** DESIGN FIRM **Elixir Design Inc., San Francisco, CA** ART DIRECTORS **Jennifer Jerde and Jennifer Huff Breeze** GRAPHIC DESIGNERS **Michael Braley, Julie Cristello, Jennifer Huff Breeze, and Jennifer Jerde** PHOTOGRAPHERS **Deborah Jones, Tony Stromberg** TYPEFACES **Adobe Garamond, DIN Mittelschrift, Trade Gothic 18 Condensed** PRINTERS **Linotext, Premier, APS** FABRICATOR **Premier Diecutting and Mounting** PAPER **Crane's** CLIENT **Elixir Design Inc.** 2 TITLE **Fay's Friends Address Book** DESIGN FIRM **Michael Mabry, San Francisco, CA** ART DIRECTORS **Michael Mabry and Liz Miranda Roberts** GRAPHIC DESIGNERS **Michael Mabry and Kristen Malan** ILLUSTRATOR/PHOTOGRAPHER **William Wegman** TYPEFACE **Typewriter** CLIENT/PUBLISHER **Chronicle Books/Giftworks** 3 TITLE **365 Ben Days Calendar** DESIGN FIRM **VSA Partners, Chicago, IL** ART DIRECTOR **Dana Arnett** GRAPHIC DESIGNERS **Ken Fox, Fletcher Martin** PHOTOGRAPHER **Scott Shigley** WRITER **John Naresky** TYPEFACE **Franklin Gothic** PRINTER **Woods Litho** PAPER **Potlatch Karma Bright White 80# Text**

1 TITLE **First Reserve Print Ads** DESIGN FIRM **Duffy Design, Minneapolis, MN** CREATIVE DIRECTOR **Joe Duffy** ART DIRECTOR/GRAPHIC DESIGNER **Dan Olson** ILLUSTRATOR **Elizabeth Traynor** PHOTOGRAPHER **Leo Tushhaus** COPYWRITER **John Jarvis** CLIENT **Flagstone Brewery** **2** TITLE **French Paper White Ad Series** DESIGN FIRM **Charles S. Anderson Design Company, Minneapolis, MN** ART DIRECTOR **Charles S. Anderson** GRAPHIC DESIGNERS **Jason Schulte and Charles S. Anderson** PHOTOGRAPHER **CSA Archive Plastock** COPYWRITER **Lisa Pemrick** TYPEFACE **Garamond Expert** PRINTER **The Etheridge Company** PAPER **French Speckletone** CLIENT **French Paper**

1

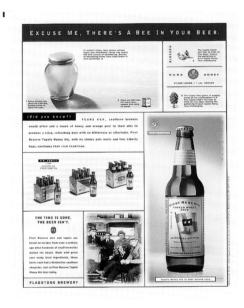

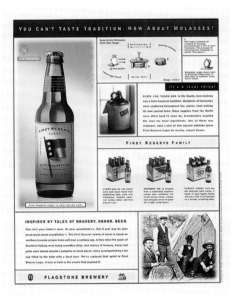

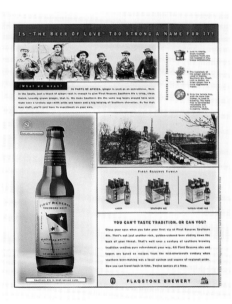

2

1 TITLE **Wired Stock Certificate** DESIGN FIRM **M.A.D., Sausalito, CA** GRAPHIC DESIGNERS **Erik Adigard and John Plunkett** CLIENT **Wired Ventures 2** TITLE **Benefit Map of America** DESIGN FIRM **Drenttel Doyle Partners, New York, NY** CREATIVE DIRECTOR **Stephen Doyle** GRAPHIC DESIGNERS **Cary Murnion, Dan Drenger** PRINTER **Red Ink Productions** PAPER **Champion Benefit 70# White Text** TYPEFACE **Custom** CLIENT **Champion International Corporation**

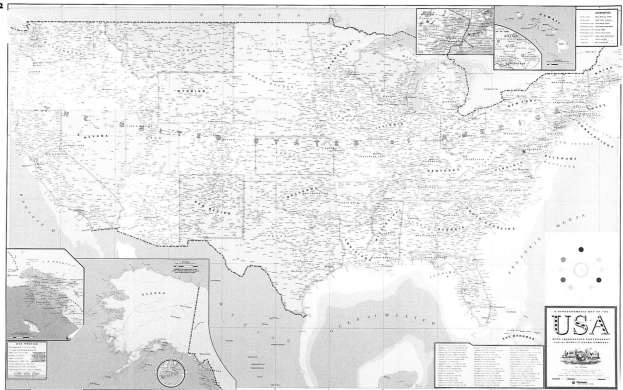

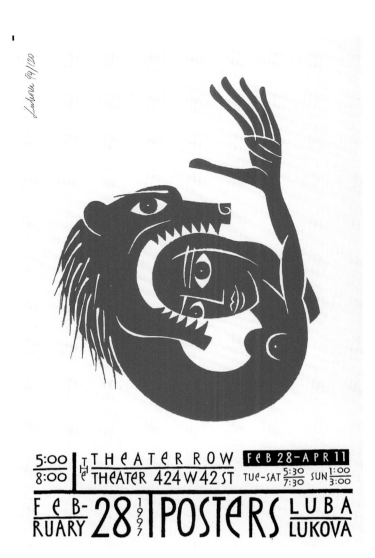

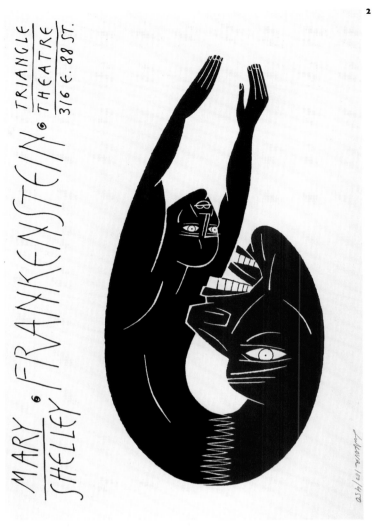

1 Title **Luba Lukova Posters** Design Firm **Luba Lukova, New York, NY** Graphic Designer/Illustrator **Luba Lukova** Printer **Janus Screen Graphics Studio** Paper **Fabriano Tiziano** Client **Theater Row Theater** 2 Title **Frankenstein Poster** Design Firm **Luba Lukova, New York, NY** Graphic Designer/Illustrator **Luba Lukova** Printer **Janus Screen Graphics Studio** Paper **Fabriano Tiziano** Client **Triangle Theater**

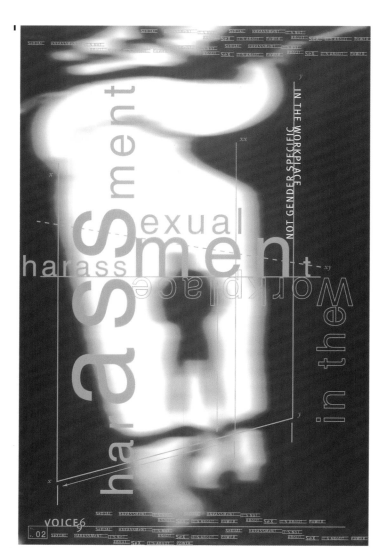

1 TITLE **Art in Public Places Forum "Voice" Poster** DESIGN FIRM **Jennifer Sterling Design, San Francisco, CA** ART DIRECTOR/GRAPHIC DESIGNER **Jennifer Sterling** PHOTOGRAPHER **Robert Lo** TYPEFACE **Meta** PRINTER **Oscar Printers** PAPER **Zellerbach Vellum** CLIENT **Art in Public Places** 2 TITLE **Sterling Design Poster** DESIGN FIRM **Sterling Design, San Francisco, CA** ART DIRECTOR/GRAPHIC DESIGNER **Jennifer Sterling** ILLUSTRATOR **Jennifer Sterling** TYPEFACE **Garamond** PRINTER **Oscar Printers** PAPER **Zellerbach Vellum** CLIENT **Sterling Design**

1 TITLE **Pina Zangaro 1996 Product Catalogue** DESIGN FIRM **Jennifer Sterling Design, San Francisco, CA** ART DIRECTOR/GRAPHIC DESIGNER **Jennifer Sterling** PHOTOGRAPHER **Dave Magnusson** WRITER **Tim Mullen** TYPEFACES **Garamond, Meta** PRINTER **Logos Graphics** PAPER **Zellerbach Vellum** CLIENT **Pina Zangaro** 2 TITLE **Quickturn Design Systems Annual Report** DESIGN FIRM **Jennifer Sterling Design, San Francisco, CA** ART DIRECTOR/GRAPHIC DESIGNER **Jennifer Sterling** ILLUSTRATOR **Jennifer Sterling** WRITER **Robert Pollie** TYPEFACE **Garamond** PRINTER **Active Graphics** PAPER **Fox River Circa Select, Howard Text** CLIENT **Quickturn Design Systems** 3 TITLE **Sterling Design Portfolio of Works** DESIGN FIRM **Jennifer Sterling Design, San Francisco, CA** ART DIRECTOR/GRAPHIC DESIGNER **Jennifer Sterling** ILLUSTRATOR **Jennifer Sterling** PHOTOGRAPHERS **Various** TYPEFACE **Garamond** PRINTER **Logos Graphics** PAPER **Fox River Winstead** CLIENT **Jennifer Sterling Design**

1 TITLE **Kaufman and Broad 1995 Annual Report** DESIGN FIRM **Louey/Rubino Design Group, Santa Monica, CA** ART DIRECTOR/GRAPHIC DESIGNER **Robert Louey** PHOTOGRAPHER **Eric Tucker** PRINTER **Lithographix, Inc.** CLIENT **Kaufman and Broad Home Corporation** 2 TITLE **Sonus Pharmaceuticals 1995 Annual Report** DESIGN FIRM **The Leonhardt Group, Seattle, WA** CREATIVE DIRECTOR **Ray Ueno** GRAPHIC DESIGNERS **Ray Ueno, Renée Sullivan, Jeff Welsh** WRITER **Lynn Parker** TYPEFACE **Centaur** PRINTER **Lithocraft** PAPER **Hammermill** CLIENT **Sonus Pharmaceuticals, Inc.**

1

2

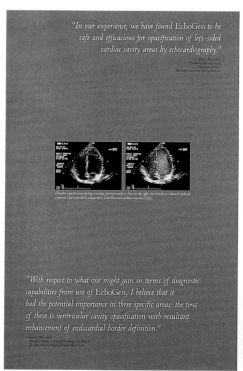

"In our experience, we have found EchoGen to be safe and efficacious for opacification of left-sided cardiac cavity areas by echocardiography."

"With respect to what one might gain in terms of diagnostic capabilities from use of EchoGen, I believe that it had the potential importance in three specific areas: the first of these is ventricular cavity opacification with resultant enhancement of endocardial border definition."

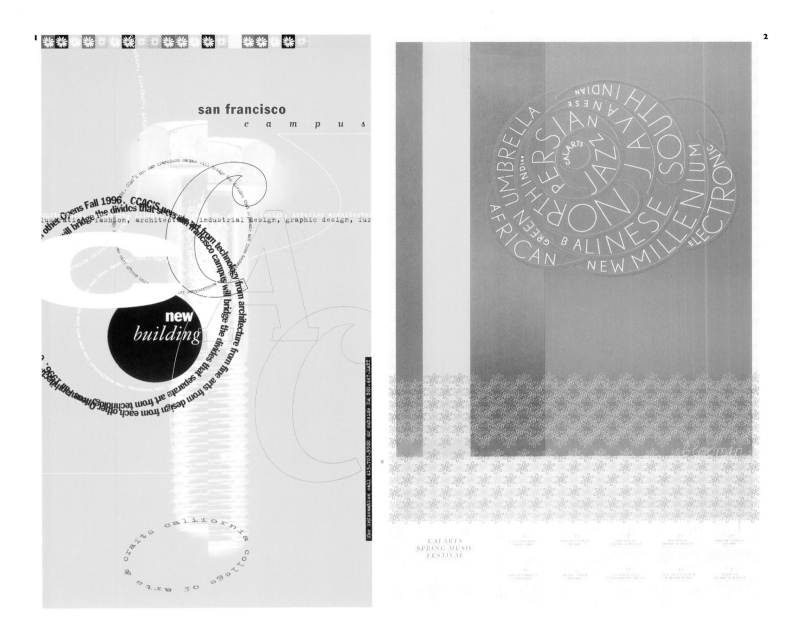

1 TITLE **California College of Arts and Crafts New Building Poster** DESIGN FIRM **Morla Design, San Francisco, CA** ART DIRECTOR **Jennifer Morla** GRAPHIC DESIGNERS **Jennifer Morla, Petra Geiger** PHOTOGRAPHER **Morla Design** WRITER **Mindpower Inc.** TYPEFACES **Stymie, Univers (Extended 230%), Matrix Script, Trixie, Franklin Gothic, Adobe Garamond** PAPER **Mead Signature Satin** CLIENT **California College of Arts and Crafts** **2** TITLE **CalArts Spring Music Festival Poster** DESIGN FIRM **California Institute of the Arts Public Affairs Office, Valencia, CA** GRAPHIC DESIGNER **Caryn Aono** PRINTER **Printing Consultants** PUBLISHER **California Institute of the Arts School of Music**

1 TITLE **Art Center College of Design Catalogue 1997–'98** DESIGN FIRM **Art Center College of Design, Pasadena, CA** CREATIVE DIRECTOR **Stuart I. Frolick** ART DIRECTOR **Darin Beaman** GRAPHIC DESIGNERS **Darin Beaman, John Choe, and Carla Figueroa** PHOTOGRAPHER **Steven A. Heller** TYPEFACES **Letter Gothic, Rose Queen, Tweeker, Univers** PAPER **Carolina C2S Cover, Champion Benefit Cover Swirl, Mill's Place Book, Porcelain Dull Book** **2** TITLE **Earth Tech Capabilities Brochure** DESIGN FIRM **Rigsby Design, Inc., Houston, TX** ART DIRECTOR **Lana Rigsby** GRAPHIC DESIGNERS **Lana Rigsby and Jerod Dame** ILLUSTRATOR **Jerod Dame** COPYWRITER **Joann Stone** TYPEFACE **Helvetica Neue** PRINTER/FABRICATOR **H. MacDonald Printing** PAPER **Champion Benefit, Simpson Evergreen** CLIENT **Earth Tech Corporation** **3** TITLE **OEL Text Issue #1: The Evolution of a Dying Species** DESIGN FIRM **Terrelonge, Inc., Toronto, Ontario** CREATIVE DIRECTOR **Del Terrelonge** PHOTOGRAPHERS **Shin Sugino, Annabel Reyes, Keith Ng, Christoff Strube** WRITERS **Terrelonge, Inc.** CLIENT/PUBLISHER **Cheyenne Yulo Publishing**

1 TITLE **BC Telecom Inc. 1996 Annual Report** DESIGN FIRM **SamataMason, Chicago, IL** ART DIRECTORS **Dave Mason and John Van Dyke** GRAPHIC DESIGNERS **Dave Mason and Pamela Lee** PHOTOGRAPHERS **Victor John Penner and John Kenny** WRITER **Dave Crowe** TYPEFACES **Bembo and AG Oldface** PRINTER **H. MacDonald Printing** PAPER **Island Resolve Matte** 2 TITLE **CAT Limited 1996 Annual Report** DESIGN FIRM **Pentagram, New York, NY** ART DIRECTOR **Michael Gericke** GRAPHIC DESIGNERS **Michael Gericke and Elizabeth Lyons** PHOTOGRAPHERS **Various** TYPEFACES **Caslon, Franklin Gothic Demi** PRINTER **Finlay Brothers** CLIENT **CAT Limited**

1

2

1 TITLE **Williams-Sonoma Wedding Registry Insert** DESIGN FIRM **Landor Associates, San Francisco, CA** ART DIRECTOR **Nancy Hoefig** GRAPHIC DESIGNER **Cinthia Wen** PHOTOGRAPHER **Michael Friel** COPYWRITER **Donata Maggipinto** TYPEFACE **Centaur** PAPER **80# Karma Natural Cover** CLIENT **Williams-Sonoma** 2 TITLE **LinoGraphics Official Price Guide** DESIGN FIRM **Kode Associates Inc., New York, NY** ART DIRECTOR/GRAPHIC DESIGNER **William T. Kochi** PHOTOGRAPHER **William T. Kochi** TYPEFACES **Rockwell, Stuyvesant, OCRB** PRINTER **Cyan, Inc.** FABRICATOR **Riverside Group** PAPER **Neenah Buckskin Cover, Zanders Ikonex Text** CLIENT **LinoGraphics Corporation**

1

SOMETHING OLD SOMETHING NEW SOMETHING BORROWED

WILLIAMS-SONOMA
The Wedding Registry
COMPUTER-NETWORKED TO 140 STORES IN 115 CITIES NATIONWIDE

WILLIAMS-SONOMA
The Wedding Registry
SAN FRANCISCO BEVERLY HILLS BOSTON CHICAGO DALLAS

WILLIAMS-SONOMA
The Wedding Registry
MIAMI MINNEAPOLIS NEW YORK SEATTLE WASHINGTON D.C.

2

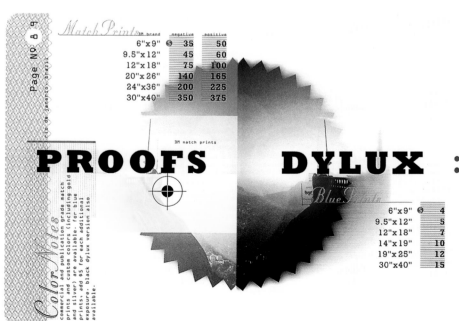

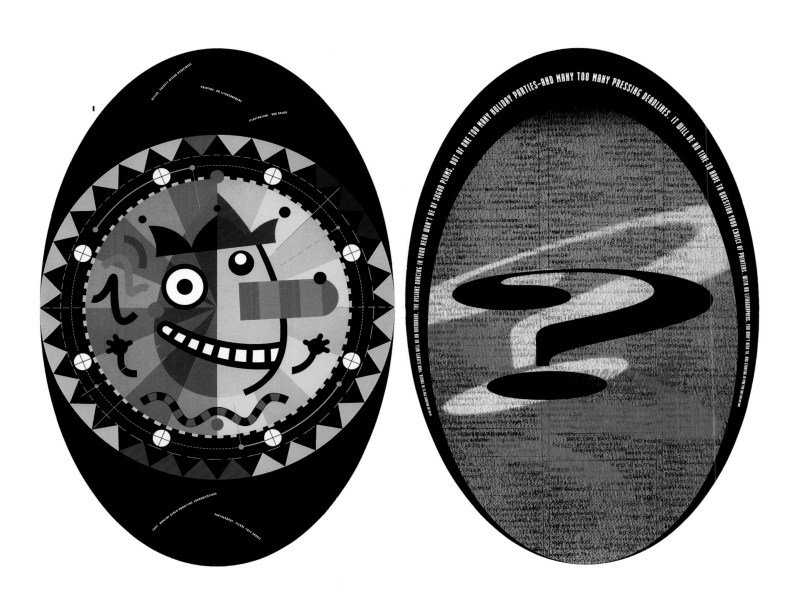

1 TITLE **AR Lithographers Poster** DESIGN FIRM **Sackett Design Associates, San Francisco, CA** CREATIVE DIRECTOR **Mark Sackett** GRAPHIC DESIGNERS **Wayne Sakamoto and James Sackamoto** ILLUSTRATOR **Bob Kolar** PHOTOGRAPHER **Pierre-Yves Goavec** PRINTER **AR Lithographers** PAPER **Potlatch Quintessence Gloss** CLIENT **AR Lithographers**

LAUNCHING MARCH 31.

TIG

I TITLE **Heart & Sole 1996 AIDS Walk Commemorative Poster** DESIGN FIRM **Vaughn Wedeen Creative, Albuquerque, NM** ART DIRECTOR **Steve Wedeen** GRAPHIC DESIGNERS **Adabel Kaskiewicz and Steve Wedeen** PHOTOGRAPHER **Julie Dean** PRINTER **Academy Printers** CLIENT **Santa Fe Cares** 2 TITLE **TIG Forum Poster** DESIGN FIRM **Eisenberg and Associates, Dallas, TX** CREATIVE DIRECTOR **Saul Torres** GRAPHIC DESIGNER/ILLUSTRATOR **Lauren DiRusso** COPYWRITER **Lauren DiRusso** TYPEFACE **OCRB** PRINTER **Typography Plus** PAPER **Mohawk Superfine** CLIENT **TIG Insurance Company**

1 TITLE **Herron School of Art Folder** DESIGN FIRM **Loft 219, Indianapolis, IN** GRAPHIC DESIGNERS **Elisabeth Charman, Brad Trost** PHOTOGRAPHER **Mary Schroeder** TYPEFACE **News Gothic** PRINTER **Design Printing** PAPER **Potlatch Vintage Velvet** CLIENT **Herron School of Art** 2 TITLE **Neo: A Journal of Innovation and Rediscovery** DESIGN FIRM **Carbone Smolan Associates, New York, NY** CREATIVE DIRECTORS **Ken Carbone and Leslie Smolan** GRAPHIC DESIGNERS **Jennifer Domer and Lesley Feldman** PHOTOGRAPHERS/ILLUSTRATORS **Various** WRITERS **Delphine Hirasura and Peggy Roalf** PRINTER **H. MacDonald Printing** PAPER **Simpson/Fox River Various Recycled Papers** CLIENT **Simpson/Fox River Company** 3 TITLE **Techno•Seduction** DESIGN FIRM **The Cooper Union Center for Design and Typography, New York, NY** GRAPHIC DESIGNER **Mindy Lang** LOGOTYPE (COVER) **Mike Essl** TYPEFACES **Emigre Suburban, Adobe Garamond** PRINTER **Rise Graphics** PAPER **Mohawk 50/10 Plus** CLIENT/PUBLISHER **The Cooper Union School of Art**

1 TITLE **DoubleTake Magazine (Summer 1996)** ART DIRECTOR **Molly Renda** PHOTOGRAPHERS/WRITERS **Various** TYPEFACES **Akzidenz Grotesk and Walbaum** PRINTER **Harperprints** PAPER **Repap Lithofect Plus Dull Coated Recycled** CLIENT **Center for Documentary Studies at Duke University** 2 TITLE **DoubleTake Magazine (Fall 1996)** ART DIRECTOR **Molly Renda** PHOTOGRAPHERS/WRITERS **Various** TYPEFACES **Akzidenz Grotesk and Walbaum** PRINTER **Harperprints** PAPER **Repap Lithofect Plus Dull Coated Recycled** CLIENT **Center for Documentary Studies at Duke University**

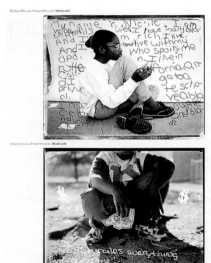

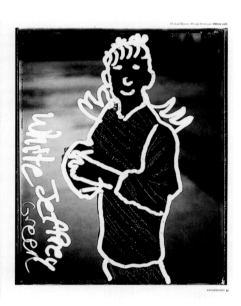

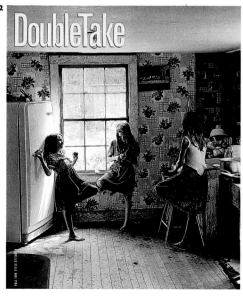

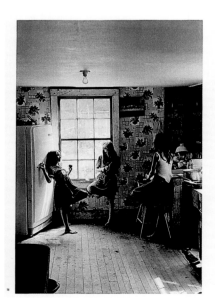

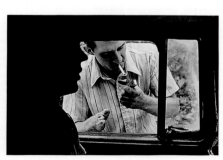

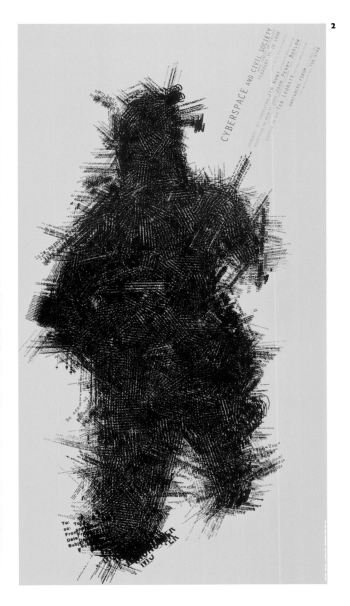

1 TITLE **Heritage Press Cow Poster** DESIGN FIRM **Peterson & Company, Dallas, TX** ART DIRECTORS/GRAPHIC DESIGNERS **Miler Hung and Scott Ray** ILLUSTRATOR **Rick Sealock** COPYWRITER **John Sealander** PRINTER **Heritage Press** PAPER **US Bristol 24#** CLIENT **Heritage Press 2** TITLE **Cyberspace Symposium Poster** DESIGN FIRM **Henderson Tyner Art Co., Winston-Salem, NC** ART DIRECTOR/GRAPHIC DESIGNER **Hayes Henderson** ILLUSTRATOR **Hayes Henderson** WRITER **Wayne King** TYPEFACE **Orator** PRINTER **Jostews Sprinting** PAPER **Strathmore Elements** CLIENT **Wake Forest University**

1 TITLE **French Paper Direct Packaging** DESIGN FIRM **Charles S. Anderson Design Company, Minneapolis, MN** ART DIRECTOR **Charles S. Anderson** GRAPHIC DESIGNER **Jason Schulte** COPYWRITER **Lisa Pemrick** TYPEFACES **Custom, 20th Century** PRINTER **Johnson Printing & Packaging Corporation** PAPER **Custom French Board Stock** CLIENT **French Paper Company** 2 TITLE **Modern Technology in the Classic Tradition** DESIGN FIRM **Adam Greiss Design, Inc., New York, NY** ART DIRECTOR/GRAPHIC DESIGNER **Adam Greiss** COPYWRITER **Allan Wahler** TYPEFACES **Monotype Centaur, Adobe Woodtype Ornaments** PRINTER **Noble Namark** PAPER **Strathmore White Wove** CLIENT **A to A Graphic Services, Inc.** 3 TITLE **Crane's Kid Finish Specification Binder** DESIGN FIRM **Design: M/W, New York, NY** CREATIVE DIRECTOR **J. Phillips Williams** GRAPHIC DESIGNERS **Allison Muench Williams and J. Phillips Williams** ILLUSTRATOR **Peter Phong** TYPEFACES **Engravers Gothic, Matrix Script** FABRICATOR **Dickard Widder** PAPER **Crane's Old Money and Kid Finish** CLIENT **Crane's Business Papers**

1 TITLE **Sterling Design Stationery** DESIGN FIRM **Jennifer Sterling Design, San Francisco, CA** ART DIRECTOR/GRAPHIC DESIGNER **Jennifer Sterling** TYPEFACE **Garamond** PRINTER **Logos Graphics** PAPER **Simpson Starwhite Vicksburg** CLIENT **Jennifer Sterling Design** 2 TITLE **Steve Belkowitz Identity System** DESIGN FIRM **Studio D Design, Minneapolis, MN** ART DIRECTOR/GRAPHIC DESIGNER **Laurie DeMartino** PHOTOGRAPHER **Steve Belkowitz** TYPEFACES **New Baskerville, News Gothic** PRINTER **The Etheridge Company** PAPER **French Dur-O-Tone Butcher** CLIENT **Belkowitz Photo + Film** 3 TITLE **Brain Reserve Stationery** DESIGN FIRM **Duffy Design, Minneapolis, MN** CREATIVE DIRECTOR **Joe Duffy** ART DIRECTOR **Neil Powell** GRAPHIC DESIGNERS/ILLUSTRATORS **Alan Leusink and Neil Powell** TYPEFACE **Franklin Gothic** PRINTER **Diversified Graphics** PAPER **Beckett Paper, Cambrick Arctic** CLIENT **Faith Popcorn's Brain Reserve**

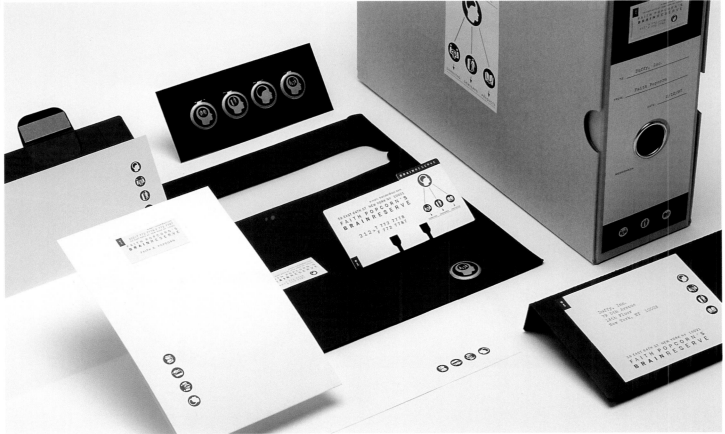

1 Title **Cigar Aficionado Magazine Logo** Design Firm **Dog Star, Birmingham, AL** Creative Director **Martin Leeds** Graphic Designer/Illustrator **Rodney Davidson** Client **Cigar Aficionado** 2 Title **Miller Lite Logo** Design Firm **Duffy Design, Minneapolis, MN** Creative Director **Joe Duffy** Art Directors **Jeff Johnson and Paul Malmstrom** Graphic Designer/Illustrator **Jeff Johnson** Photographer **Chris Sheehan** Client **Miller Brewing Co.** 3 Title **Birdland Logo** Design Firm **Daniel + Douglas + Norcross, Chattanooga, TN** Creative Director **Doug Cook** Graphic Designer **Michael Hendrix** Typeface **Carpenter (Modified)** Client **Birdland Restaurant and Lounge** 4 Title **The Strand Cybercafé** Design Firms **J. Cole Phillips Design and M Design, Baltimore MD** Art Director/Graphic Designer **Jennifer Phillips** Production Artist **Emily Goldstein** Client **The Strand**

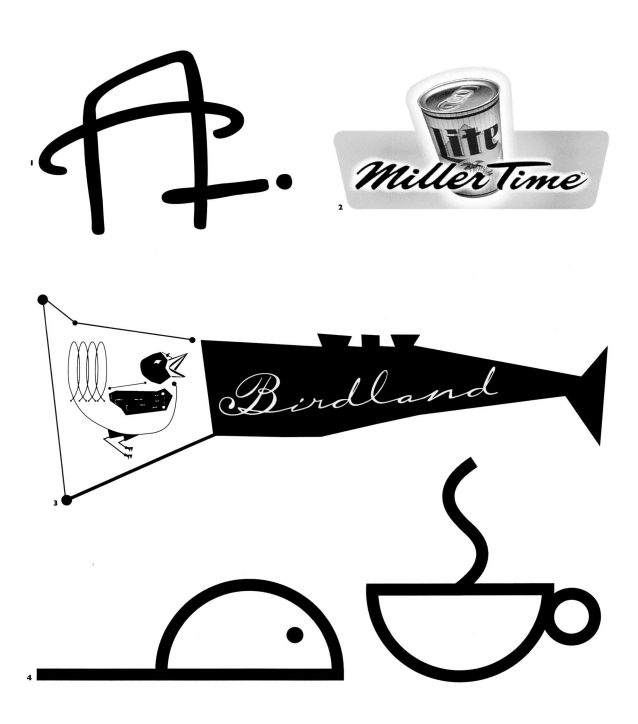

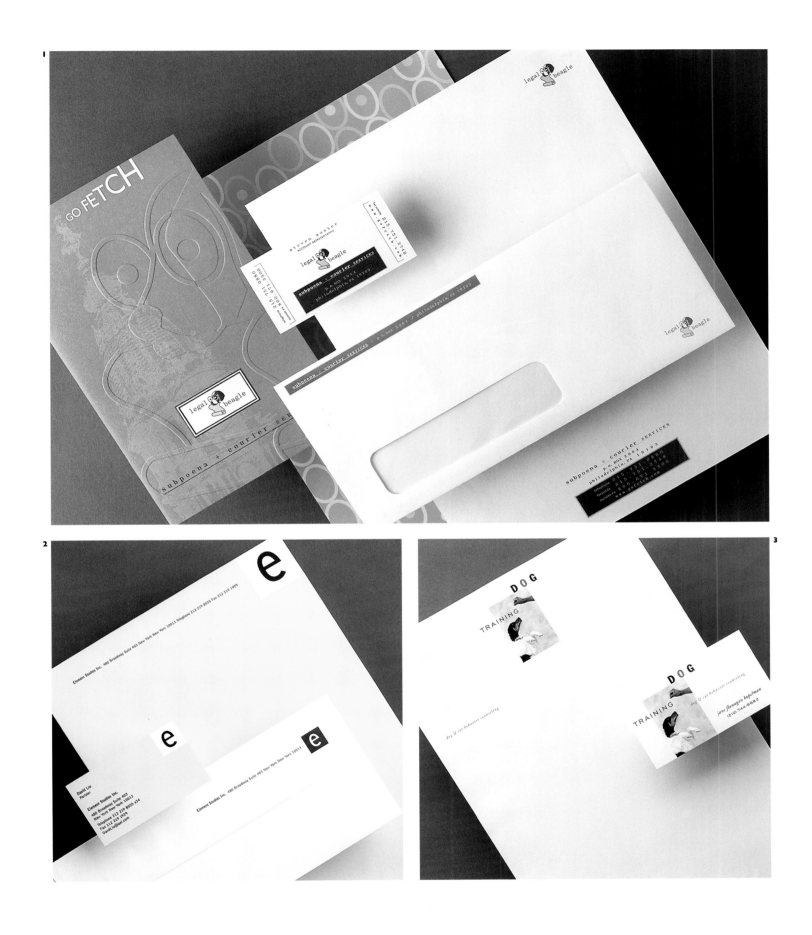

1 TITLE **Legal Beagle Stationery** DESIGN FIRM **Hansen Design, Philadelphia, PA** ART DIRECTOR/GRAPHIC DESIGNER **Jennifer Hansen** ILLUSTRATOR **Jennifer Hansen** TYPEFACES **New Baskerville, Helvetica** PRINTER **Citation Graphics** PAPER **Strathmore Writing** CLIENT **Legal Beagle Courier Services 2** TITLE **Element Studios Stationery/Identity** DESIGN FIRM **Tsang Seymour Design, New York, NY** GRAPHIC DESIGNER **Patrick Seymour** CLIENT **Element Studios Inc. 3** TITLE **Dog Training Stationery** DESIGN FIRM **Alan Hill Design, New York, NY** GRAPHIC DESIGNER **Alan Hill** PHOTOGRAPHER **Nita Winter** COPYWRITER **Jane Flanagan Kopelman** PRINTER **Bedwick & Jones Printing** PAPER **Strathmore Writing** CLIENT **Jane Flanagan Kopelman**

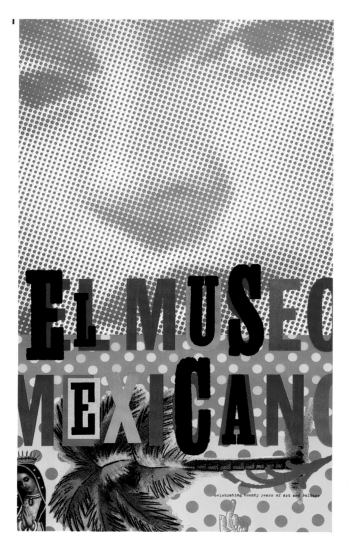

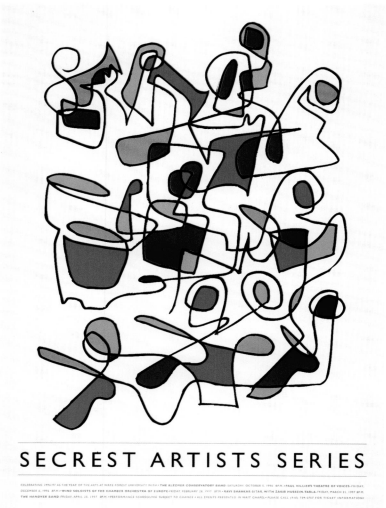

1 TITLE **The Mexican Museum 20th Anniversary Poster** DESIGN FIRM **Morla Design, San Francisco, CA** ART DIRECTOR **Jennifer Morla** GRAPHIC DESIGNERS **Jennifer Morla, Craig Bailey** PHOTOGRAPHS **Courtesy of International Museum of Photography at George Eastman House** TYPEFACES **Franklin Gothic Extra Condensed, Various Mexican Woodblock Faces** PRINTER **Bacchus Press** PAPER **Simpson Coronado SST Recycled** CLIENT **Bacchus Press** 2 TITLE **Secrest Poster** DESIGN FIRM **Henderson Tyner Art Co., Winston-Salem, NC** ART DIRECTOR/GRAPHIC DESIGNER **Hayes Henderson** ILLUSTRATOR **Hayes Henderson** TYPEFACE **Gill Sans** PRINTER **Meredith Webb Printing** PAPER **Mohawk Options** CLIENT **Wake Forest University**

1 TITLE **Global Village Annual 1996 Report** ART DIRECTOR **Kimberly Baer** ILLUSTRATOR **Marc Rosenthal** COPYWRITER **Lindsay Beaman** CLIENT **Global Village Communication, Inc.** 2 TITLE **One Year: Photographs by James Schnepf** DESIGN FIRM **VSA Partners, Chicago, IL** ART DIRECTOR **Jamie Koval** GRAPHIC DESIGNER **Dan Kraemer** PHOTOGRAPHER **James Schnepf** WRITER **Mike Noble** TYPEFACES **Various** PRINTER **H. MacDonald Printing** PAPER **Simpson Evergreen**

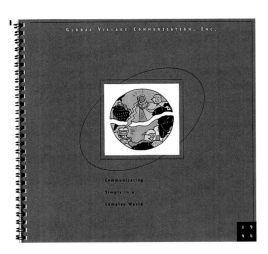

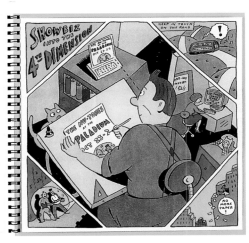

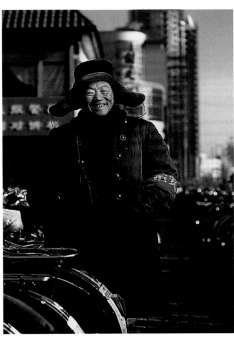

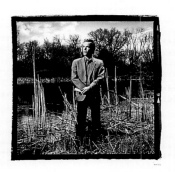

1 TITLE **Zurich Reinsurance 1995 Annual Report: "Do Not Open"** DESIGN FIRM **Leimer Cross Design, Seattle, WA** ART DIRECTOR/GRAPHIC DESIGNER **Kerry Leimer** PHOTOGRAPHER **Tyler Boley** WRITERS **Nicholas Carter, Kerry Leimer** TYPEFACES **Franklin Gothic, Garamond #3** PRINTER **Lithographix, Inc.** PAPER **Mead Signature Dull, Gilbert Oxford and Esse** **2** TITLE **A Guide to Digital Tools** DESIGN FIRM **Spangler Associates, Seattle, WA** CREATIVE DIRECTOR **Allen Woodard** GRAPHIC DESIGNERS **Allen Woodard, Jon Cannell, Kristin Easterbrook** ILLUSTRATOR **Allen Woodard** PHOTOGRAPHER **Rick Ells** TYPEFACE **Frutiger** PRINTER **Trojan Litho** PAPER **Neenah Classic Crest** CLIENT **University of Washington**

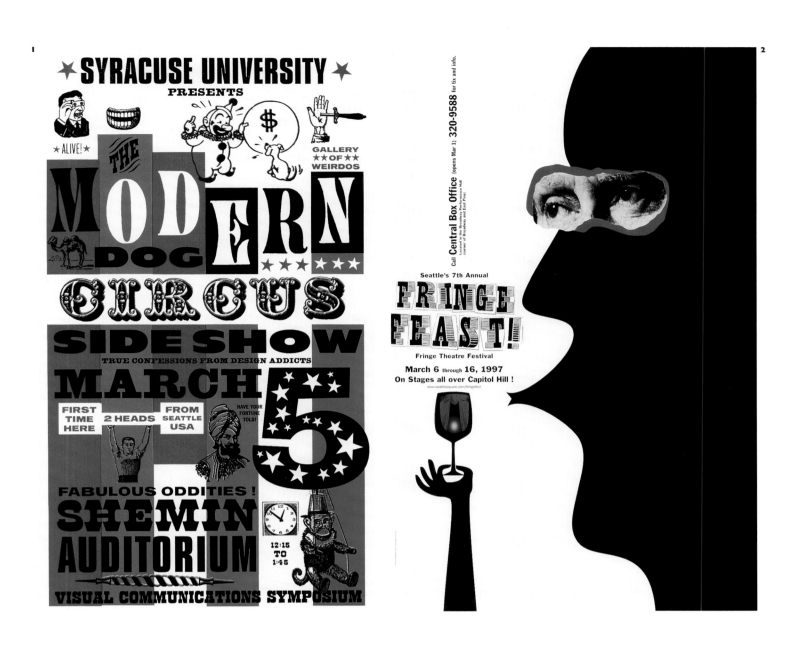

1 Title **The Modern Dog Circus Side Show Poster** Design Firm **Modern Dog, Seattle, WA** Art Director/Graphic Designer **Robynne Raye** Copywriter **Robynne Raye** Typefaces **Barnum Block, Rodding, and Assorted Woodblock Type** Printer **Two Dimensions** Client **Syracuse University** 2 Title **1997 Fringe Feast Poster** Design Firm **Modern Dog, Seattle, WA** Art Director/Graphic Designer **Michael Strassburger** Illustrator **Michael Strassburger** Typefaces **Broadcast and Franklin Gothic** Printer **The Copy Company** Paper **Simpson Evergreen Matte** Client **Seattle Fringe Theatre Festival**

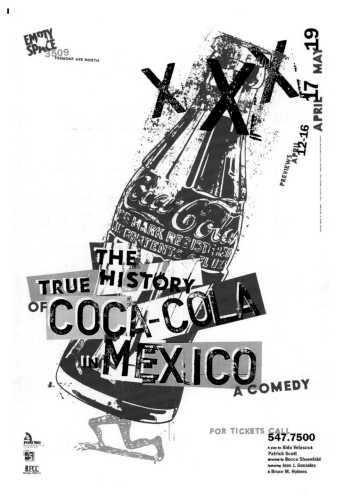

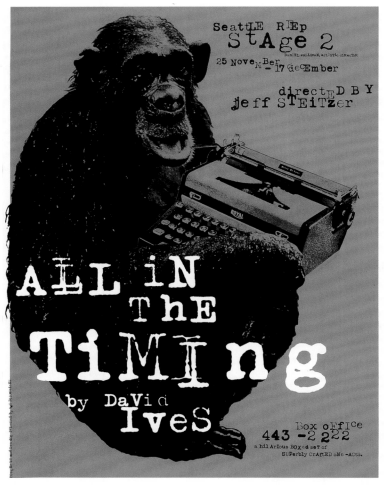

1 TITLE **The True History of Coca-Cola in Mexico** DESIGN FIRM **NBBJ, Seattle, WA** GRAPHIC DESIGNER **Daniel R. Smith** TYPEFACE **Found/Scanned Type and Franklin Gothic** PRINTER **Pacific Publishing Company** PAPER **Cheap Newsprint** CLIENT **Empty Space Theater** 2 TITLE **"All in the Timing" Poster** DESIGN FIRM **Modern Dog, Seattle, WA** ART DIRECTORS **Robynne Raye and Roxy Moffit** GRAPHIC DESIGNER/ILLUSTRATOR **Robynne Raye** TYPEFACE **Typeka (modified)** PRINTER **Two Dimensions** PAPER **Simpson Evergreen Matte** CLIENT **Seattle Repertory Theatre**

1 TITLE **Walking Man Legendary Shirt Ad** DESIGN FIRM **Cronan Design, San Francisco, CA** CREATIVE DIRECTOR **Michael Cronan** GRAPHIC DESIGNER **Anthony Yell** ILLUSTRATOR **Clifford Jew** COPYWRITER **Mary Coe** CLIENT **Cronan Artefact** 2 TITLE **Exhibition Invitation "Low Brow Gods: The Art of Boxing"** DESIGN FIRM **Lowbrowgods.com, Berkeley, CA** ART DIRECTOR/GRAPHIC DESIGNER **Cameron Woo** ILLUSTRATORS **Ted Carroll and Erwin L. Hess** LOGO FONT DESIGNER **Jim Lang** TYPEFACES **Sans Serif Wood Type, Adobe Poplar, Adobe Rockwell** PRINTER **Julie Holcolm Printer** PAPER **Strathmore Natural White** CLIENT **Center for the Arts, Yerba Buena Gardens**

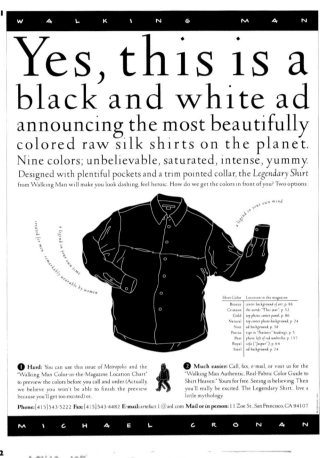

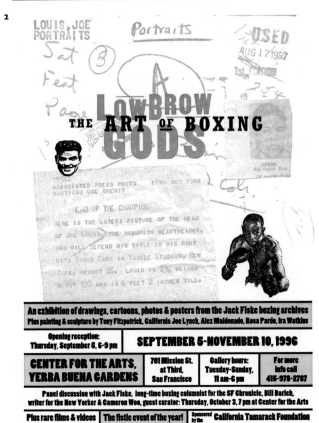

I TITLE **Design Quarterly Fifty Years: 1946–1996** DESIGN FIRM **Steven Guarnaccia, Montclair, NJ** ART DIRECTOR **Robert Jensen** ILLUSTRATOR (BACK COVER) **Steven Guarnaccia** CLIENT/PUBLISHER **Design Quarterly** 2 TITLE **Idea Magazine Cover** DESIGN FIRM **Charles S. Anderson Design Company, Minneapolis, MN** ART DIRECTOR **Charles S. Anderson** GRAPHIC DESIGNER **Jason Schulte** CLIENT **Idea Magazine, Japan**

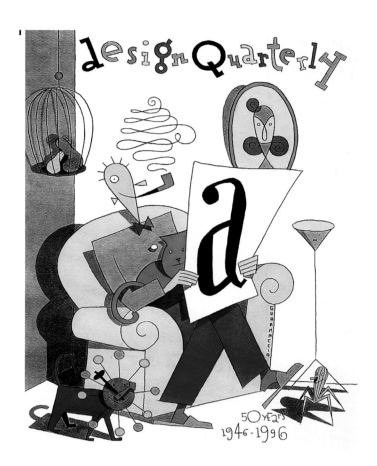

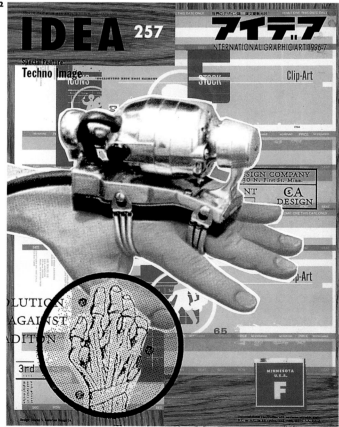

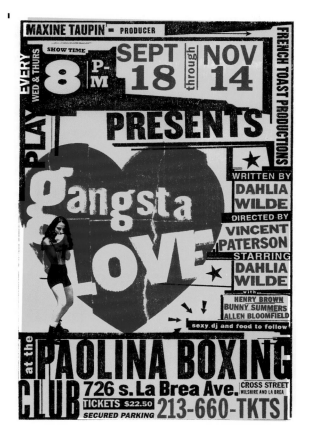

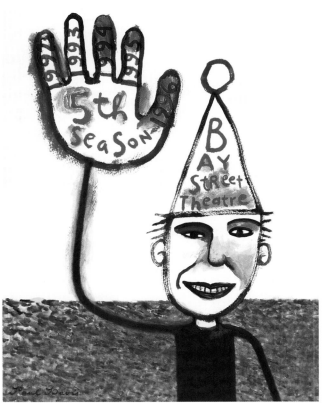

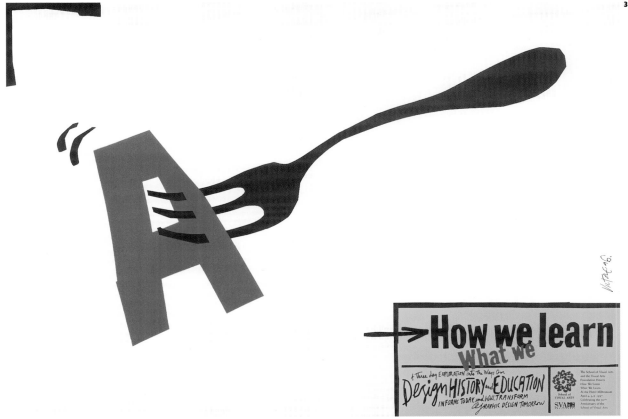

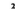

1 TITLE **Gangsta Love Poster** DESIGN FIRM **Spot Design, New York, NY** ART DIRECTOR **Drew Hodges** GRAPHIC DESIGNER **Kevin Brainard** TYPEFACES **Champion, Franklin Gothic** PRINTER **Brodock Press** PAPER **Finch 80# Cover** CLIENT **French Toast Productions** 2 TITLE **1996 Bay Street Theatre Poster** DESIGN FIRM **Paul Davis Studio, New York, NY** ART DIRECTOR/ILLUSTRATOR **Paul Davis** CLIENT **Bay Street Theater, Sag Harbor, NY** 3 TITLE **How We Learn What We Learn** DESIGN FIRM **James Victore, Inc., New York, NY** CREATIVE DIRECTOR **Silas Rhodes** GRAPHIC DESIGNER **James Victore** PRINTER **Royal Offset** PAPER **Champion Carnival** CLIENT **School of Visual Arts**

1

To Our Trasholders:

1995 was a profitable year for everyone served by the people and facilities of Metro Waste Authority (MWA). In partnership with area residents and businesses, we significantly reduced the waste volume entering the landfill. We changed attitudes, created new paradigms, and clearly made our children's future more environmentally secure. Along the way, we demonstrated abiding respect for both our financial and natural resources.

The more you
know
The more
you
can do

2

This is our first annual report.
It will tell you about our
$1.3 billion in sales,
our 63% increase in earnings,
our 32-year history
of unbroken profitability,
our market leadership,
and what's next.

Boise Cascade Office Products

Our 1995 sales were $1.3 billion.

That's 45% higher than 1994 sales.

Our sales growth strategy is working.

1 TITLE **"To Our Trasholders" Annual Report** DESIGN FIRM **Pattee Design, Des Moines, IA** ART DIRECTOR **Steve Pattee** GRAPHIC DESIGNERS **Steve Pattee and Kelly Stiles** PHOTOGRAPHER **Pattee Design** COPYWRITER **Mike Condon** TYPEFACE **Courier** PRINTER **Holm Graphic** PAPER **French Dur-O-Tone** CLIENT **Metro Waste Authority**
2 TITLE **Boise Cascade Office Products 1995 Annual Report** DESIGN FIRM **Petrick Design, Chicago, IL** ART DIRECTOR **Robert Petrick** GRAPHIC DESIGNERS **Robert Petrick and Laura Ress** PHOTOGRAPHER **Chuck Shotwell** TYPEFACE **Akzidenz Grotesque** PRINTER **The Hennegan Company** PAPER **Mohawk Superfine** CLIENT **Boise Cascade Office Products**

I Title **Flash Card Annual Report** Design Firm **Pattee Design, Des Moines, IA** Creative Director **Steve Pattee** Graphic Designers **Steve Pattee and Kelly Stiles** Writer **Mike Condon** Typefaces **Helvetica, Bookman** Printer **Holm Graphic** Paper **24 Pt. Recycled Chipboard**

1 TITLE **Paradise Cage: Kiki Smith and Coop Himmelblau** DESIGN FIRM **The Museum of Contemporary Art, Los Angeles, CA** ART DIRECTOR/GRAPHIC DESIGNER **Anna Boyiazis** PHOTOGRAPHER **Paula Goldman** WRITER **Stephanie Emerson** TYPEFACE **Univers** PRINTER **Delta Graphics** PAPER **Neenah Classic Crest, Neenah UV Ultra, French Dur-O-Tone Packing Gray Liner** CLIENT **The Museum of Contemporary Art, Los Angeles** **2** TITLE **Defining Moments: A.T. Kearney 70th Anniversary Book** DESIGN FIRM **VSA Partners, Chicago, IL** ART DIRECTOR **James Koval** GRAPHIC DESIGNER **Steve Ryan** PHOTOGRAPHER **Stock** TYPEFACES **Times Roman, Trajan** PRINTER **Active Graphics** PAPER **Mohawk Superfine** CLIENT **A. T. Kearney, Inc.**

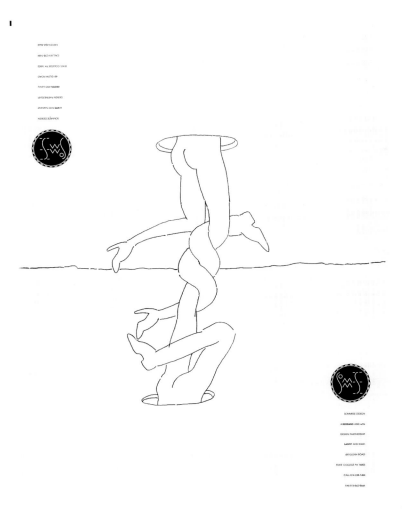

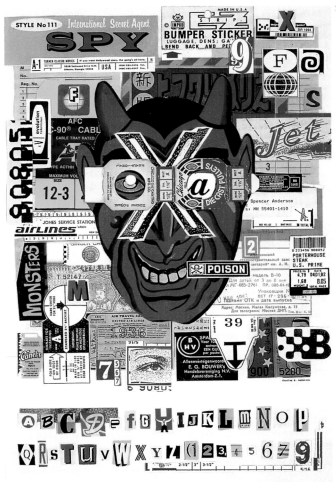

1 TITLE **Sommese Design Poster** DESIGN FIRM **Sommese Design, State College, PA** ART DIRECTORS **Lanny Sommese and Kristin Sommese** GRAPHIC DESIGNER **Kristin Sommese** ILLUSTRATOR **Lanny Sommese** PRINTER **Commercial Printing** PAPER **French Speckletone Cover** CLIENT **Sommese Design** 2 TITLE **AIGA Literacy Campaign Poster** DESIGN FIRM **Charles S. Anderson Design Company, Minneapolis, MN** ART DIRECTOR/GRAPHIC DESIGNER **Charles S. Anderson** ILLUSTRATOR **Charles S. Anderson** TYPEFACE **Found Type** PAPER **French Construction Pure White** CLIENT **AIGA/Colorado**

1 TITLE **1996 Mill Valley Film Festival Poster Series** DESIGN FIRM **BlackDog, San Anselmo, CA** GRAPHIC DESIGNER/PHOTOGRAPHER **Mark Fox** TYPEFACE **Akzidenz Grotesk** PRINTER **Acme Silk Screen** PAPER **Simpson Starwhite Vicksburg Cover** CLIENT **Mill Valley Film Festival** **2** TITLE **Wired Poster** DESIGN FIRM **Spur, Baltimore, MD** ART DIRECTOR/GRAPHIC DESIGNER **David Plunkert** PHOTOGRAPHER **David Plunkert** COPYWRITER **John Plunkert** TYPEFACE **Frutiger** PRINTER **Printing Corp. of America** PAPER **Champion Pageantry 80# Cover Silk** CLIENT **AIGA/Baltimore**

1 TITLE **Capsure Holdings Corporation 1995 Annual Report** DESIGN FIRM **Petrick Design, Chicago, IL** ART DIRECTOR **Robert Petrick** GRAPHIC DESIGNERS **Robert Petrick, Laura Ress** PHOTOGRAPHERS **Geof Kern, Scogin Mayo, Alan Shortall** WRITERS **Doreen Lubeck, Daphne Murray** TYPEFACE **Bodoni Berthold** PRINTER **The Hennegan Company** PAPER **Mohawk Superfine** CLIENT **Capsure Holdings Corp.** 2 TITLE **John Deere Credit 1996 Annual Report** DESIGN FIRM **SamataMason, Chicago, IL** ART DIRECTOR **Greg Samata** GRAPHIC DESIGNER **Joe Baran** PHOTOGRAPHER **Marc Norberg** WRITER **Bernie Napolski** TYPEFACES **Gill Sans, Courier** PRINTER **Bruce Offset** PAPER **International Green Hanging File Folder Stock (two sheets glued together), French Dur-O-Tone Butcher, Synergy Natural Imaging Laid, Appleton Utopia Premium Silk Text**

consumer
lending division

243

I TITLE **Wired Intro Spreads** DESIGN FIRM **Adams/Morioka, Beverly Hills, CA** ART DIRECTORS **John Plunkett, Sean Adams, Noreen Morioka** GRAPHIC DESIGNERS **Sean Adams and Noreen Morioka** PHOTOGRAPHERS **Various** TYPEFACES **Trade Gothic Condensed Italic** CLIENT/PUBLISHER **Wired Magazine**

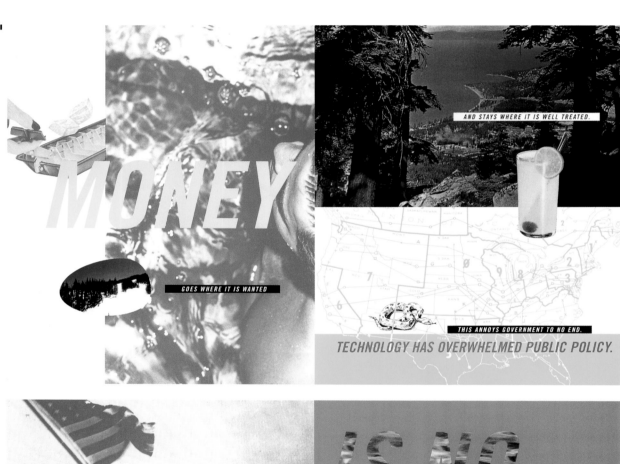

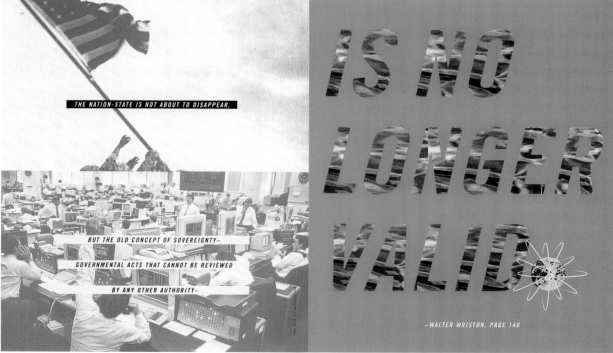

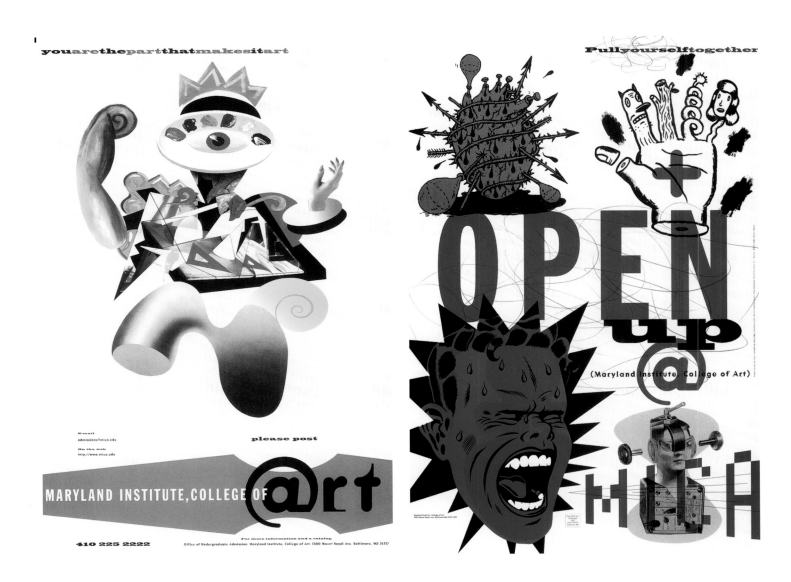

1 TITLE **"You Are the Part That Makes It Art" Poster** DESIGN FIRM **Spur, Baltimore, MD** ART DIRECTOR/GRAPHIC DESIGNER **David Plunkert** ILLUSTRATORS **Gary Baseman, A. J. Garces, Jayme Odgers, David Plunkert, Jonathon Rosen** COPYWRITER **David Plunkert** TYPEFACES **Blackoak, Dead History Bold, Franklin Gothic Condensed** PRINTER **French Bray** PAPER **Champion Benefit 70# Vertical Text**

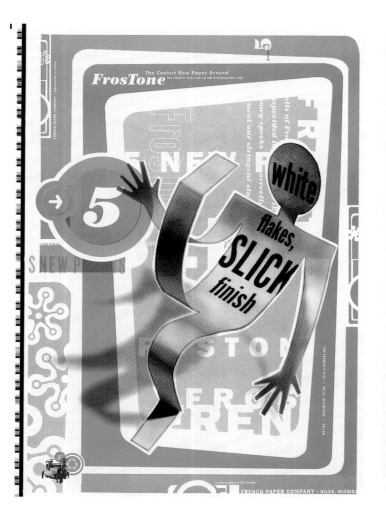

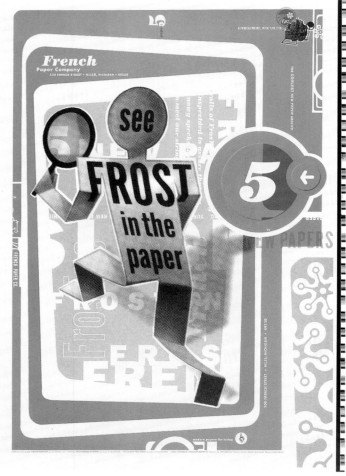

I TITLE **French FrosTone Poster** DESIGN FIRM **Charles S. Anderson Design Company, Minneapolis, MN** ART DIRECTOR **Charles S. Anderson** GRAPHIC DESIGNER **Jason Schulte** TYPEFACES **Century Ultra Italic, 20th Century** PRINTER **The Etheridge Company** PAPER **French FrosTone Iceberg** CLIENT **French Paper Company**

1 TITLE **1996 Autocam Annual Report** DESIGN FIRM **Leslie Black Design, Grand Rapids, MI** ART DIRECTOR/GRAPHIC DESIGNER **Leslie Black** ILLUSTRATOR **Jonathon Rosen** PHOTOGRAPHER **Brett Beimers** COPYWRITER **Polly Hewitt** TYPEFACE **Galliard** PRINTER **George Rice Sons** PAPER **Neenah Classic Crest** CLIENT **Autocam**
2 TITLE **Chicago Board of Trade 1995 Annual Report** DESIGN FIRM **VSA Partners, Chicago, IL** ART DIRECTOR **Dana Arnett** GRAPHIC DESIGNERS **Curtis Schreiber, Fletcher Martin** ILLUSTRATORS **Philip Burke and Robert Clyde Anderson** PHOTOGRAPHER **Eric Hausman** TYPEFACE **Futura** PRINTER **H. MacDonald Printing** PAPER **Simpson Starwhite Vicksburg** CLIENT **Chicago Board of Trade**

the news

Harold W. Lavender, Jr. Terrence M. Cullerton Michael A. Manning Michael J. O'Brien James F. Curley Not pictured

Donald G. Andrew
L. Thomas Baldwin III
Dr. Sanford J. Grossman
Dr. Henry G. Jarecki
Robert J. Pierce
Ralph H. Weems

meet an October 1995 deadline for compliance with the Futures Trading Practices Act of 1992.

We concentrated a great deal of time, resources and energy in 1995 communicating with the CFTC and the Congress on the need for regulation that keeps pace with market realities. We believe the Congress should conduct a comprehensive review of the Commodity Exchange Act with an eye toward identifying its excesses and streamlining its regulatory structure through the use of cost-benefit analysis. That review should be driven by our national need to have strong derivatives markets to provide affordable risk management services in competitive, honest, financially secure markets.

We will continue to urge the Congress and the CFTC to focus their resources and energy on making sure the U.S. futures industry remains on a level

federal policy formulation to shift more risk management from the government to the private sector.

As our future assumes physical shape through the construction of our new trading facility, the Chicago Board of Trade will continue to pioneer innovative concepts, relationships and strategies in order to provide additional trading opportunities for our members, member firms and customers. We also will work to ensure that our lowest-cost agricultural and financial markets maintain the unparalleled liquidity and integrity that make them the best in the world.

Patrick H. Arbor
Chairman of the Board

Thomas R. Donovan
President & Chief Executive Officer

1 TITLE **Heltzer Capabilities Brochure** DESIGN FIRM **Liska and Associates, Chicago, IL** ART DIRECTOR **Steven Liska** GRAPHIC DESIGNER **Susan Carlson** PHOTOGRAPHER **Steve Grubman** TYPEFACE **News Gothic** PRINTER **Columbia** PAPER **Mead Signature Dull** CLIENT **Helzer Incorporated** 2 TITLE **Fremont General 1995 Annual Report** DESIGN FIRM **Louey/Rubino Design Group, Santa Monica, CA** ART DIRECTOR/GRAPHIC DESIGNER **Robert Louey** ILLUSTRATOR **Robert Louey** PRINTER **Lithographix, Inc.** CLIENT **Fremont General**

1

2

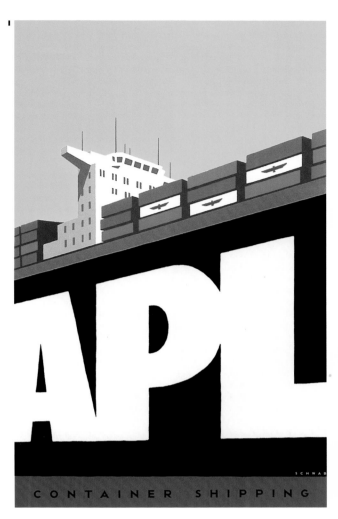

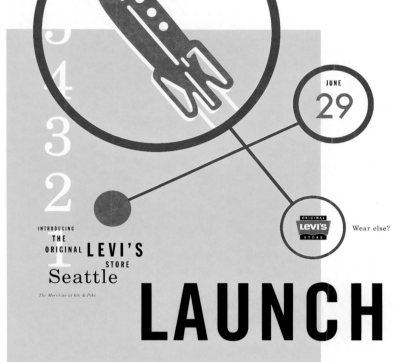

One day only. 3D theater, climbing wall, half pip[2] velcro wall, virtual world, bands, giveaways and more. Not to mention the Store. Launching Saturday, June 29 at Westlake Park, 12 to 6 p.m Free to anyone who's ever worn a pair of jean

1 TITLE **1996 APL Calendar Cover** DESIGN FIRM **Michael Schwab Studio, San Anselmo, CA** CREATIVE DIRECTOR **Andy Dreyfus** ILLUSTRATOR **Michael Schwab** PRINTER **H. MacDonald Printing** CLIENT **American Presidents Line** 2 TITLE **Original Levi's Store Seattle Launch Poster** DESIGN FIRM **Foote, Cone & Belding, San Francisco, CA** CREATIVE DIRECTOR/GRAPHIC DESIGNER **Brian Collins** WRITERS **Damon Allred and Brian Collins** TYPEFACE **Trade Gothic** CLIENT/PUBLISHER **Levi Strauss & Co.**

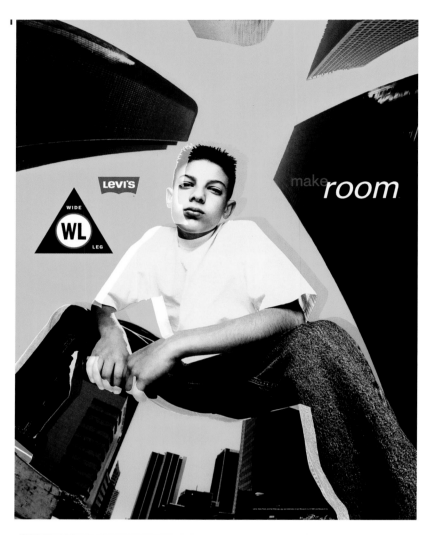

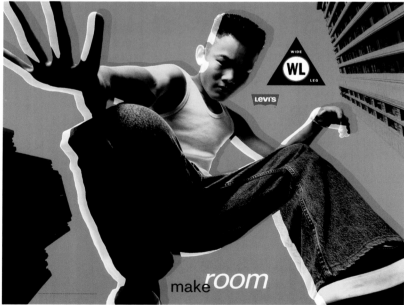

❙ TITLE **Levi's "Make Room" Campaign Posters** DESIGN FIRM **Foote, Cone & Belding, San Francisco, CA** CREATIVE DIRECTOR/GRAPHIC DESIGNER **Brian Collins** TYPEFACE **Trade Gothic** CLIENT/PUBLISHER **Levi Strauss & Co.**

I Title **Levi's "Real Good Jeans" Posters** Design Firm **Foote, Cone & Belding, San Francisco, CA** Creative Director **Brian Collins** Graphic Designer **Sharon Werner** Writers **Jeff Mueller and Brian Collins** Typeface **Trade Gothic** Client/Publisher **Levi Strauss & Co.**

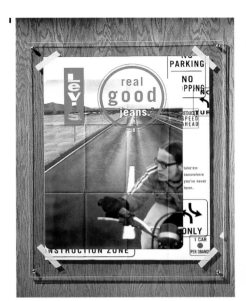

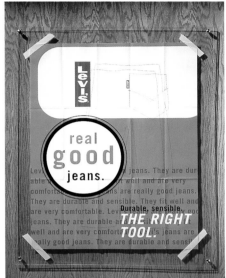

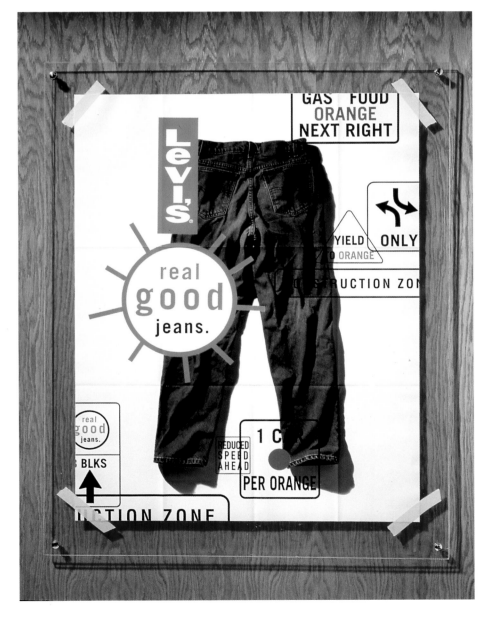

1 Title **Push Collaborative 1** Design Firm **Push, San Francisco, CA** Art Directors **Steve Barretto and Todd Foreman** Graphic Designers **John Barretto, Steve Barretto, and Todd Foreman** Photographers **Cesar Rubio, David Casteel, Jonathan Sprague** Printers **Color Copy Printing, Stamping Express** Paper **Karma 65# Cover** 2 Title **View on Colour** Design Firm **United Publishers S.A., New York, NY** Art Director **Li Edelkoort** Graphic Designer **Anthon Beeke** Styling Director **Graham Hollick** Printer **Royal Smeets, Nederland** Paper **Job Parilux Silk**

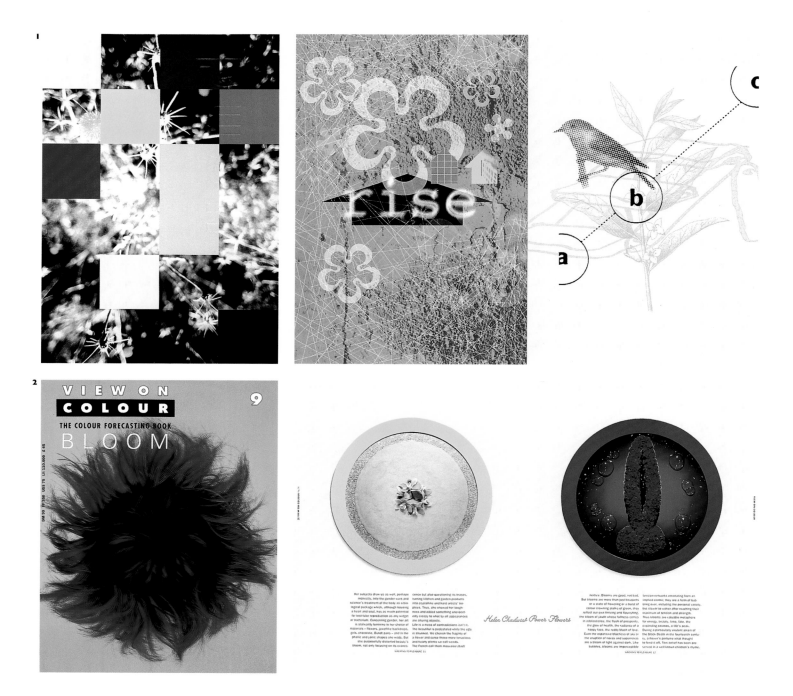

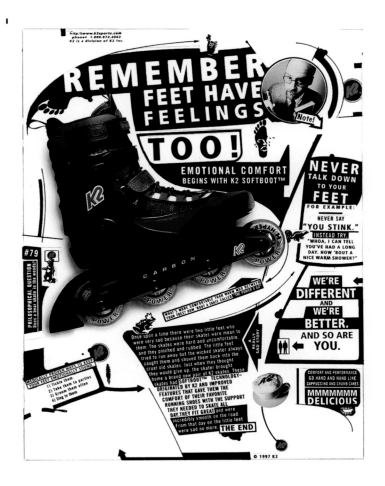

1 Title **Remember Poster** Design Firm **Initio, Minneapolis, MN** Art Directors **Paul Chapin and Dave Damman** Graphic Designer **Joe Monnens** Photographer **Curtis Johnson** Copywriter **Eddie Prentiss** Printer **Nordic Press** Paper **Northwest Gloss 100# Text** Client **K2 In-Line Skates** 2 Title **Cognizant Poster** Design Firm **CKS Partners, Washington, DC** Creative Director **Robert Wong** Graphic Designers **Robert Wong and Diddo Ramm** Printer **Screen Graphics** Client **Cognizant**

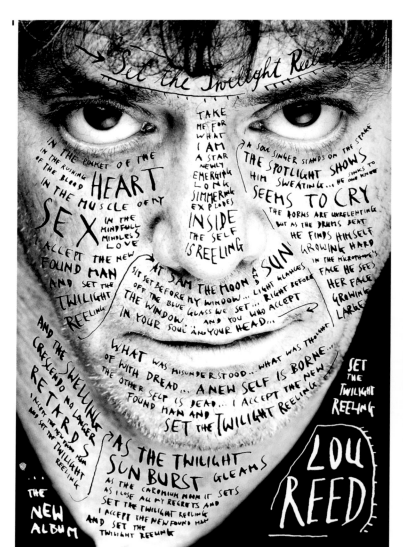

1 TITLE **Lou Reed Poster** DESIGN FIRM **Sagmeister Inc., New York, NY** ART DIRECTOR/GRAPHIC DESIGNER **Stefan Sagmeister** PHOTOGRAPHER **Timothy Greenfield Sanders** COPYWRITER **Lou Reed** PRINTER **Warner Media Services** PAPER **100 Pt. Matte Coated** CLIENT **Warner Bros. Records Inc.** 2 TITLE **Society of Illustrators Call for Entries Poster** ART DIRECTOR/GRAPHIC DESIGNER **D. J. Stout** ILLUSTRATOR **Anita Kunz** CLIENT **Society of Illustrators**

1 TITLE **Fresh Dialogue Poster** DESIGN FIRM **Sagmeister Inc., New York, NY** ART DIRECTOR/GRAPHIC DESIGNER **Stefan Sagmeister** PHOTOGRAPHER **Tom Schierlitz** COPYWRITER **Jim Anderson** PRINTER **L.P. Thebault Company** PAPER **S.D. Warren Lustro Dull** CLIENT **AIGA/New York** 2 TITLE **Wild About Science Poster** DESIGN FIRM **SamataMason, Chicago, IL** ART DIRECTOR **Pat Samata** GRAPHIC DESIGNER **Joe Baran** PHOTOGRAPHY **Stock** TYPEFACE **Gill Sans** PRINTER **Randolph Street Press** PAPER **Consolidated Centura Dull** 3 TITLE **Portfolio X-Hibition Poster** DESIGN FIRM **Spur, Baltimore, MD** ART DIRECTOR/GRAPHIC DESIGNER **David Plunkert** ILLUSTRATORS **Sirkis Hardware, David Plunkert** TYPEFACES **Serifa, Akzidenz Grotesk** PRINTER **Printech** PAPER **Mohawk Superfine**

1 TITLE **The New York Times Magazine: A Celebration of 100 Years/Pictures** DESIGN FIRM **The New York Times Magazine, New York, NY** ART DIRECTOR **Janet Froelich** GRAPHIC DESIGNER **Joel Cuyler** PHOTO EDITOR **Kathy Ryan** TYPEFACES **Stymie, Cheltenham** PRINTER **R.R. Donnelley Sons** PUBLISHER **The New York Times** 2 TITLE **The New York Times Magazine: A Celebration of 100 Years** DESIGN FIRM **The New York Times Magazine, New York, NY** ART DIRECTOR **Janet Froelich** GRAPHIC DESIGNER **Catherine Gilmore-Barnes** PHOTO EDITOR **Kathy Ryan** TYPEFACES **Stymie, Cheltenham** PRINTER **R.R. Donnelley Sons** PUBLISHER **The New York Times**

I TITLE **Hans Neleman CD-ROM** DESIGN FIRM **Neleman Studio, New York, NY** ART DIRECTOR/PHOTOGRAPHER **Hans Neleman** GRAPHIC DESIGNER/PRODUCER **Keith Seward**

1 TITLE **Prototype Font Specimen Kit** DESIGN FIRM **Automatic Art and Design, Columbus, OH** ART DIRECTOR/GRAPHIC DESIGNER **Charles Wilkin** ILLUSTRATOR **Charles Wilkin** WRITERS **Charles Wilkin, Megan Crawford** TYPEFACES **Space Boy, Phink, Velvet, Superchunk, Kink, Ghetto Prince** PRINTER **Odyssey Press** PAPER **Cross Pointe Synergy 80# Text** CLIENT **Prototype Experimental Foundry**

1 TITLE **Interactive Resplendence 1996** DESIGN FIRM **Inscape, Los Angeles, CA** ART DIRECTOR/GRAPHIC DESIGNER **Melissa Hertz** INTERFACE DESIGNER **Alicia Garcia** PROGRAMMER **Erik Loyer** SOUND EDITOR **David Javelosa** CLIENT **Inscape** 2 TITLE **Evenson Design Group Holiday "Fruitcake" Promotion** DESIGN FIRM **Evenson Design Group, Culver City, CA** ART DIRECTORS **Stan Evenson and Karen Barranco** GRAPHIC DESIGNER **Rose Hartano** COPYWRITER **Eric LaBrecque** PRINTER **Anderson Printing** DIGITAL VIDEO PRODUCER/SOUND EDITOR **Dave Chappel** CLIENT **Evenson Design Group**

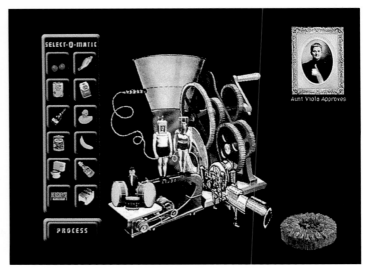

1 TITLE **The Mead Annual Report Show "Forty Years of Ideas" CD-ROM** DESIGN FIRM **Peponi, Seattle, WA** ART DIRECTOR **John Van Dyke** GRAPHIC DESIGNERS **John Van Dyke and Danny Yount** PRINTER **H. MacDonald Printing** PROGRAMMER **Danny Yount** CLIENT **Mead Paper Company**

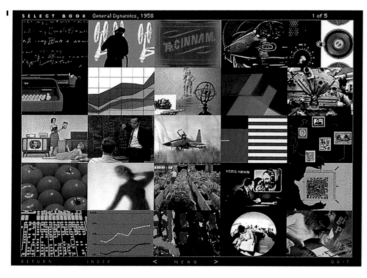

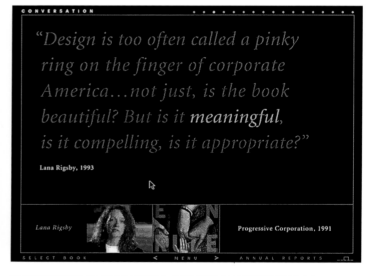

1 TITLE **Joe Machnik's No. 1 Soccer Camps** DESIGN FIRM **Temel Inc., Boonton, NJ** ART DIRECTOR **Carlos J. Alcala** GRAPHIC DESIGNER **João J. Nero** PHOTOGRAPHER **Maurice Harmon** DIGITAL VIDEO PRODUCER **Maurice Harmon** PROGRAMMER **Robert Butts** SOUND EDITOR **Smiling Pig Productions** CLIENT **Joe Machnik**

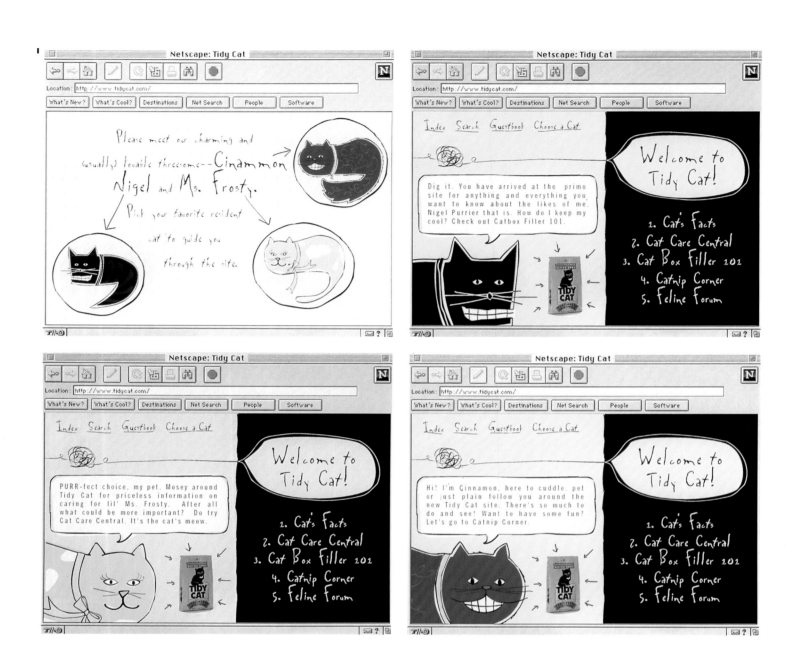

I TITLE **Tidy Cat Website** DESIGN FIRM **Duffy Design, Minneapolis, MN** CREATIVE DIRECTOR **Joe Duffy** ART DIRECTOR **Neil Powell** GRAPHIC DESIGNER/ILLUSTRATOR **Lourdes Banez** COPYWRITERS **Chuck Carlson and Deborah Gold** CLIENT **Ralston Purina**

I TITLE **Miller Lite Website** DESIGN FIRM **Duffy Design, Minneapolis, MN** CREATIVE DIRECTOR **Joe Duffy** GRAPHIC DESIGNER/ILLUSTRATOR **Jeff Johnson** COPYWRITER **Linus Karlsson** PROGRAMMER **Margaret Bossen** CLIENT **Miller Brewing Co.**

1 TITLE **BRNR Website** DESIGN FIRM **BRNR Graphics, Redondo Beach, CA** ART DIRECTOR/GRAPHIC DESIGNER **Michael French** ILLUSTRATOR/PHOTOGRAPHER **Michael French** PROGRAMMER **Michael French** CLIENT **BRNR Graphics**

1 Title **Reel NY** Design Firm **WNET/Channel 13, New York, NY** Art Director/Graphic Designer **David Chomowicz** Photographer **Glen Ribble** Digital Video Producer **David Chomowicz** Client **Channel 13/WNET 2** Title **World AIDS Day Public Service Announcement** Design Firm **Foote, Cone & Belding, San Francisco, CA** Creative Director **Brian Collins** Graphic Designer **Gaby Birnk** Photographer **Albert Watson** Writers **Steve Good and Chris Lissick** Digital Video Producer **Rock, Paper, Scissor** Clients **Levi Strauss & Co./The Magic Johnson Foundation 3** Title **Sundance Channel Broadcast Identity Program** Design Firm **Young & Rubicam, New York, NY** Creative Directors **Jeff Streeper and Lyle Owerko** Logo Design **Lyle Owerko** Producers **Sandy Breakstone and Ken Yagoda** Sound Design **Pink Noise** Animation **Ink Tank** Typeface **Frutiger** Client **Sundance Channel 4** Title **Showtime Original Movies "Critical Choices" Video** Design Firm **Paladino Design, New York, NY** Art Director/Graphic Designer **Nancy Paladino** Photographer **Cathy Hundt** Writer **Janusz Kawa** Typeface **Bell Gothic** Post Production **Video Works** Client **Showtime Networks**

1 TITLE **Show Open for MTV's "AMP"** DESIGN FIRM **Arce & Kwan Inc., New York, NY** CREATIVE DIRECTOR/GRAPHIC DESIGNER **Alejandro Arce** ANIMATOR **Alejandro Arce** PRODUCER **Todd Mueller** CLIENT **MTV/Viacom** 2 TITLE **"The Girl With Her Head Coming Off" Video** DESIGN FIRM **Nickelodeon, New York, NY** CREATIVE DIRECTOR/EXECUTIVE PRODUCER **Amy Friedman** ANIMATOR **Emily Hubley** PRODUCTION CO. **Hubbub, Inc.** WRITERS **Emily Hubley and Neena Beber** PRODUCER **Karen Fowler** CLIENT **Nickelodeon** 3 TITLE **Raw/Promo** DESIGN FIRM **MTV, New York, NY** CREATIVE DIRECTOR **David LaChapelle** DIRECTOR/PHOTOGRAPHER **David LaChapelle**

1 TITLE **Intensity by Dean Koontz** DESIGN FIRM **Arce & Kwan Inc., New York, NY** CREATIVE DIRECTOR/GRAPHIC DESIGNER **Ivy Kwan** ANIMATOR **Alejandro Arce** PRODUCER **Janice Goldklange** CLIENT **Knopf Pantheon/Random House** 2 TITLE **TV Land Retromercial Opens** DESIGN FIRM **MTV Networks, New York, NY** ART DIRECTORS **Jim Spegman and Matthew Duntemann** GRAPHIC DESIGNERS **Slatoff & Cohen** WRITER **Mark Sullivan** 3 TITLE **Nickelodeon Fish Identity** DESIGN FIRM **Nickelodeon On-Air Design, New York, NY** ART DIRECTOR/GRAPHIC DESIGNER **Linda Walsh** ANIMATOR **Douglass Grimmett/Primal Screen** SOUND EDITOR **Clack** CLIENT **Nickelodeon** 4 TITLE **Nick Jr. Pig Identity** DESIGN FIRM **Nickelodeon On-Air Design, New York, NY** ART DIRECTORS **George Guzman and Cathy Masinter** GRAPHIC DESIGNER **George Guzman** ANIMATOR **Manhattoons/Helena Vszac**

1 TITLE **K-Ration T-Shirt Packaging** DESIGN FIRM **Charles S. Anderson Design Company, Minneapolis, MN** ART DIRECTORS **Charles S. Anderson and Todd Piper-Hauswirth** GRAPHIC DESIGNER **Todd Piper-Hauswirth** TYPEFACE **Opti Alternate** CLIENT **K-Ration** 2 TITLE **Bracelet Tin Series 0008-0001** DESIGN FIRM **Fossil Design Studio, Richardson, TX** CREATIVE DIRECTOR **Jim Hale** GRAPHIC DESIGNER **Andrea Levitan** ILLUSTRATIONS **Archival** TYPEFACES **Various** PRINTER **U.S. Can/Dallas** CLIENT **Fossil, Inc.** 3 TITLE **Princeton University "With One Accord" Fundraising Campaign Print Collateral** DESIGN FIRM **Pentagram, New York, NY** ART DIRECTOR **Michael Bierut** GRAPHIC DESIGNERS **Michael Bierut and Emily Hayes** PHOTOGRAPHER **Dorothy Kresz** CLIENT **Princeton University**

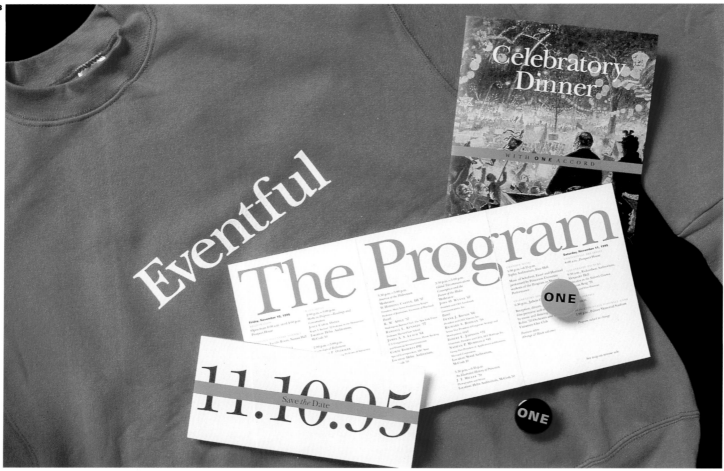

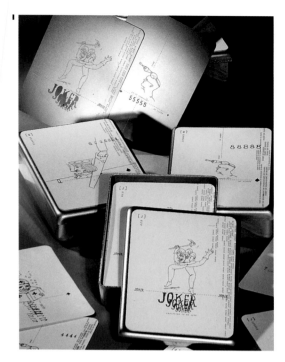

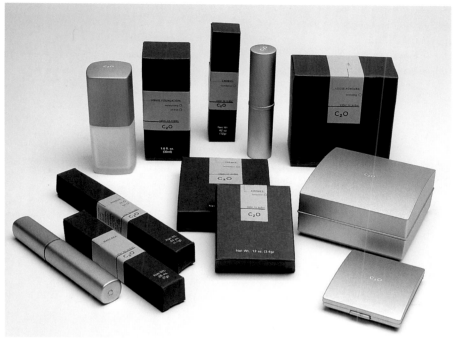

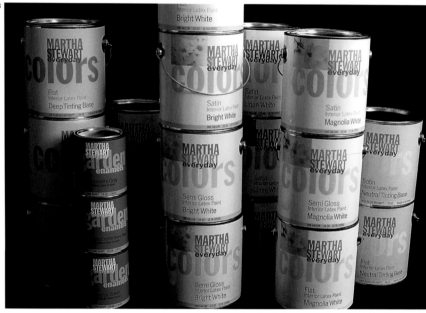

1 TITLE **Quickturn Giveaway at Design Automation Conference** DESIGN FIRM **Jennifer Sterling Design, San Francisco, CA** ART DIRECTOR/GRAPHIC DESIGNER **Jennifer Sterling** ILLUSTRATOR **Jonathon Rosen, Jennifer Sterling** WRITER **Robert Pollie** TYPEFACE **Garamond** PAPER **Fox River Winstead Ivory** CLIENT **Quickturn Design Systems Inc.** 2 TITLE **C2O Color to Order Packaging** DESIGN FIRM **Nordstrom In-House, Seattle, WA** CREATIVE DIRECTOR **Cheryl Zahniser** GRAPHIC DESIGNER **Åsa Sandlund** COPYWRITER **Gail Miller** TYPEFACES **Avenir and Gill Sans Condensed** PRINTER **FMC** PAPER **Custom Board Stock and MacTac Starliner** CLIENT **Nordstrom Corp.** 3 TITLE **Martha Stewart Everyday Paint Colors** DESIGN FIRM **Drenttel Doyle Partners, New York, NY** CREATIVE DIRECTOR **Stephen Doyle** GRAPHIC DESIGNERS **Rosemarie Turk, Tom Kluepfel** TYPEFACES **News Gothic, Franklin Gothic** PRINTER **Sherwin Williams Graphic Arts** PAPER **70# Kromekote, 70# Lustro Dull** CLIENTS **Martha Stewart Omnimedia Ltd., Sherwin Williams** 4 TITLE **Nike Vision Point of Purchase** DESIGN FIRM **Nike, Inc., Beaverton, OR** ART DIRECTOR **Jeff Weithman** GRAPHIC DESIGNERS **Jeff Weithman and Darrel Frier** PHOTOGRAPHER **David Emitte** FABRICATOR **Transworld Marketing** MATERIALS **Kraton, Aluminum, Plexiglas** CLIENT **Nike, Inc.**

1 TITLE **Labrot & Graham Woodford Reserve** DESIGN FIRM **SBG Partners, San Francisco, CA** CREATIVE DIRECTOR/GRAPHIC DESIGNER **Thomas Bond** 2 TITLE **Miller Lite 11:59 Campaign** DESIGN FIRM **Duffy Design, Minneapolis, MN** CREATIVE DIRECTOR **Joe Duffy** GRAPHIC DESIGNER **Kobe** WRITER **Bill Westbrook** CLIENT **Miller Brewing Co.** 3 TITLE **Dufflet Truffles** DESIGN FIRM **Concrete Design Communications Inc., Toronto, Ontario** ART DIRECTORS **Diti Katonah and John Pylypczak** GRAPHIC DESIGNER **Susan McIntee** TYPEFACES **Franklin Gothic and Kuenstler Script** PRINTER **C. J. Graphics** CLIENT **Dufflet Pastries** 4 TITLE **Magic Hat Jinx** DESIGN FIRM **Jager Di Paola Kemp, Burlington, VT** CREATIVE DIRECTOR **Michael Jager** ART DIRECTOR/GRAPHIC DESIGNER **David Covell** TYPEFACES **Minion, Xavier, Various Custom** CLIENT **Magic Hat Brewing Company**

1 TITLE **Levi's Wide Leg Display Fixture** DESIGN FIRM **Zimmermann Crowe Design, San Francisco, CA** CREATIVE DIRECTOR **Brian Collins** GRAPHIC DESIGNER **Dennis Crowe** FABRICATOR **Mobius, Inc.** CLIENT **Levi Strauss & Co.** 2 TITLE **Benetton "Faces" Bag** DESIGN FIRM **Axo Design Studio, San Francisco, CA** ART DIRECTOR **Chris Dangtran (Benetton)** GRAPHIC DESIGNER **Brian Collentine** PHOTOGRAPHER **Oliviero Toscani** TYPEFACE **Gill Sans Regular** FABRICATOR **Brilliant Bags & Boxes** CLIENT **Benetton** 3 TITLE **Nikepark Shopping Bag** DESIGN FIRM **Nike Image Design, Beaverton, OR** CREATIVE DIRECTOR **John Hoke III** ART DIRECTOR **Michael Tiedy** GRAPHIC DESIGNER **Derek Welch** PHOTOGRAPHER **Cliff Watts** PRINTER **Wright Packaging** PAPER **White Kraft** CLIENT **Nike, Inc.**

1 TITLE **Princeton University "With One Accord" Fundraising Campaign Banners** DESIGN FIRM **Pentagram, New York, NY** ART DIRECTOR **Michael Bierut** GRAPHIC DESIGNERS **Michael Bierut and Emily Hayes** PHOTOGRAPHER **Dorothy Kresz** CLIENT **Princeton University** 2 TITLE **Steelcase Worklife New York Environment** DESIGN FIRM **Ideo, San Francisco, CA** ENVIRONMENTAL GRAPHICS **David Reinfurt and Cheryn Flanagan** INTERACTION DESIGN **Gitta Salomon** PHOTOGRAPHER **Peter Aaron/Esto** TYPEFACES **Trade Gothic Condensed, Emigre Suburban** CLIENT **Steelcase, Inc.** 3 TITLE **"Drawn from the Source: The Travel Sketches of Louis I. Kahn"** DESIGN FIRM **Amy Reichert Architecture & Design, Williamstown, MA** EXHIBITION DESIGNER **Amy Reichert** PHOTOGRAPHER **Nick Whitman** TYPEFACE **Gill Sans** CLIENT **Williams College Museum of Art**

1 TITLE **Jane Addams Memorial Signage** DESIGN FIRM **studio blue, Chicago, IL** ART DIRECTORS **Kathy Fredrickson, Cheryl Towler Weese, Dan Towler Weese** GRAPHIC DESIGNERS **Joellen Kames, Cheryl Towler Weese, Dan Towler Weese** PHOTOGRAPHERS **Hull House Museum Archives, Bettmann Archives** TYPEFACE **Scala Sans** FABRICATOR **Doty & Associates** CLIENTS **Chicago Park District, The Art Institute of Chicago** 2 TITLE **"Sense of Government" Installation** DESIGN FIRM **BJ Krivanek Art + Design, Chicago, IL** DESIGN DIRECTOR **BJ Krivanek** ENVIRONMENTAL DESIGNER **Joel Breaux** PHOTOGRAPHER **Jeff Kurt Petersen** WRITERS **The Children of Riverside, California** TYPEFACE **Futura (digitally modified)** FABRICATOR **Fabrication Arts** CLIENT **The Riverside Arts Foundation** 3 TITLE **Chronicle Books GiftWorks Display** DESIGN FIRM **Gee + Chung Design, San Francisco, CA** ART DIRECTOR/GRAPHIC DESIGNER **Earl Gee** PHOTOGRAPHER **Alan Shortall** TYPEFACE **Copperplate 33 BC** FABRICATOR **Barr Exhibits** CLIENT **Chronicle Books**

1 TITLE **The Casinos at Buffington Harbor** DESIGN FIRM **PlanCom, Inc., Chicago, IL** GRAPHIC DESIGNER **PlanCom Design Team** PHOTOGRAPHER **Mark Segal** FABRICATOR **White Way Sign** CLIENTS **Donald Trump/Borden Development** 2 TITLE **Nickelodeon Mural** DESIGN FIRM **Nickelodeon Acme Creative Group, New York, NY** CREATIVE DIRECTOR **Kim Rosenblum** ART DIRECTOR **Kenna Kay** ILLUSTRATOR **Michael Bartalos** CLIENT **Nickelodeon** 3 TITLE **Dupont Corian Trade Show Exhibit** DESIGN FIRM **Pentagram, New York, NY** ARCHITECTS **James Biber and Michael Zweck-Bronner** GRAPHIC DESIGNER **Nikki Richardson** CLIENT **Dupont**

1 TITLE **Virgin Interactive Entertainment Exhibit Booth** DESIGN FIRM **Ph.D., Santa Monica, CA** CREATIVE DIRECTOR/GRAPHIC DESIGNER **Clive Piercy** FABRICATORS **Scenario, Exhibit Group** 2 TITLE **Sony Comdex '96 Graphics** DESIGN FIRM **Drive Communications, New York, NY** ART DIRECTOR/GRAPHIC DESIGNER **Michael Graziolo** TYPEFACES **Frutiger and Aachen** PRINTER **Duggal Color Projects** FABRICATOR **Design and Production, Inc.** ARCHITECT/EXHIBIT DESIGNER **Tom Hennes, Thinc Inc.** CLIENT **Sony Electronics, Inc.** 3 TITLE **The Public Theater New York Shakespeare Festival 1996 Poster** DESIGN FIRM **Pentagram Design, New York, NY** PARTNER/DESIGNER **Paula Scher** GRAPHIC DESIGNER **Lisa Mazur** CLIENT **The Joseph Papp Public Theater** 4 TITLE **Fashion Center Information Kiosk** DESIGN FIRM **Pentagram, NY** ARCHITECTS **James Biber, Michael Zweck-Bronner** GRAPHIC DESIGNERS **Michael Bierut, Esther Bridavsky** CLIENT **The Fashion Center**

1 Title **"Rent" Subway Campaign** Design Firm **Spot Design, New York, NY** Creative Director **Drew Hodges** Graphic Designer **Lia Chi** Photographer **Amy Guip** Copywriter **Drew Hodges** Typeface **Royal Typewriter Delux** Printer **Triumph Productions** Client **Rent, LLC** 2 Title **Grand Central Construction Walls** Design Firm **Frankfurt Balkind, New York, NY** Creative Director **Kent Hunter** Graphic Designers **Natalie Lam and Robert Wong** Photographers **Victor Schrager and Various** Fabricator **Applied Graphics** Paper **3M** Client **Metropolitan Transportation Authority** 3 Title **Barneys Windows** Design Firm **Mighty House of Pictures, New York, NY** Graphic Designer **Josh Gosfield** Client **Barneys New York**

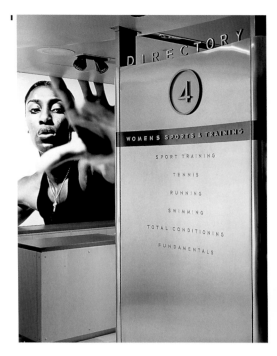

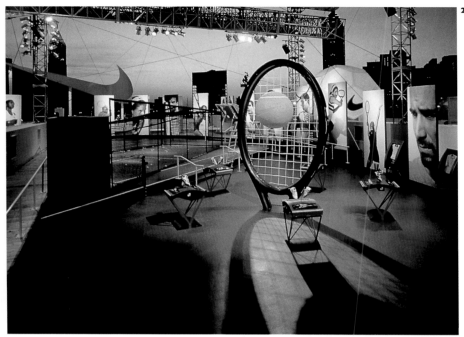

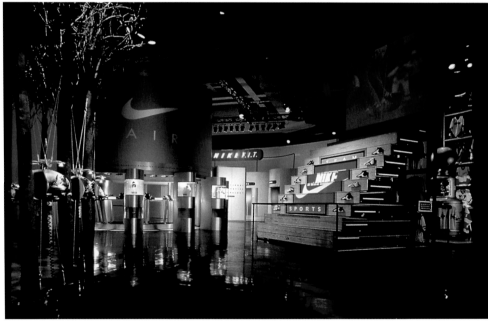

1 TITLE **Niketown NY Identity System** DESIGN FIRM **Nike, Inc., Beaverton, OR** CREATIVE DIRECTORS **Val Taylor-Smith, Jeff Weithman** GRAPHIC DESIGNERS **Clint Gorthy, Val Taylor-Smith, Michael Hernandes** WRITER **Bob Lambie** TYPEFACE **Custom Niketown NYC (NTNYC 5.0)** PRINTERS **Diversified Graphics, Setpoint** CLIENT **Nike, Inc.** 2 TITLE **NikePark** DESIGN FIRM **Nike Image Design, Beaverton, OR** CREATIVE DIRECTOR **John Hoke III** ART DIRECTOR **Michael Tiedy** DESIGNERS **Mike Ely, Ryan Gray, Stephanie Kraus, Sean O'Conner, Steve Thompson, John Trotter, Derek Welch, and Toki Wolf** PHOTOGRAPHER **Cliff Watts** CLIENT **Nike, Inc.** 3 TITLE **Nike Supershow 1996 Environment** DESIGN FIRM **Nike, Inc., Beaverton, OR** CREATIVE DIRECTOR **John Hoke** GRAPHIC DESIGNERS **Val Taylor-Smith, Ted Jacobs, Greg Hoffman, Richard Elder, Chuck Roth, David Poremba** WRITER **Bob Lambie** TYPEFACE **Custom Niketown NYC (NTNYC 5.0)** PRINTER **Premier Press** FABRICATOR **Ideas** DIGITAL VIDEO PRODUCER/SOUND EDITOR **David Poremba** PROGRAMMER **Danny Rosenburg** CLIENT **Nike, Inc.** 4 TITLE **Blank Opening Exhibit Artwork** DESIGN FIRM **Blank, Washington, DC** GRAPHIC DESIGNERS **Adam Cohn, Robert Kent Wilson, and Suzanne Ultman** ILLUSTRATOR **Suzanne Ultman** WRITER **Robert Kent Wilson** TYPEFACE **Letter Gothic** CLIENT **Blank**

A Revolution is coming in your industry.

1 TITLE **Strategos Brochure** DESIGN FIRM **Bielenberg Design, Boulder, CO** CREATIVE DIRECTOR **John Bielenberg** GRAPHIC DESIGNERS **John Bielenberg and Chuck Denison** PHOTOGRAPHER **Doug Menuez** WRITER **Rich Binell** TYPEFACES **Franklin Gothic Condensed, Garamond** PRINTER **Dharma Enterprises** PAPER **Strathmore Elements** CLIENT **Strategos** 2 TITLE **61 Ways of Looking at Poverty** DESIGN FIRM **Emerson, Wajdowicz Studios, New York, NY** CREATIVE DIRECTOR **Jurek Wajdowicz** GRAPHIC DESIGNERS **Lisa LaRochelle and Jurek Wajdowicz** PHOTOGRAPHERS **Various** PRINTER **Hoechstetter Printing** PAPER **Mohawk Options** CLIENT/PUBLISHER **United Nations Development Programme**

1 TITLE **Life Magazine 60th Anniversary** DESIGN FIRM **Life Magazine, New York, NY** CREATIVE DIRECTOR **Tom Bentkowski** ART DIRECTOR/GRAPHIC DESIGNER **Mimi Park** ILLUSTRATOR **Rob Silvers** PRINTER **Judds Inc.** PUBLISHER **Time Inc. Magazines** 2 TITLE **Apple Inc.** DESIGN FIRM **Rolling Stone, New York, NY** ART DIRECTOR **Fred Woodward** DESIGNERS **Lee Bearson and Fred Woodward** CLIENT/PUBLISHER **Rolling Stone**

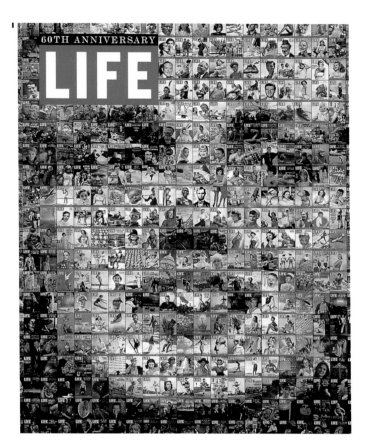

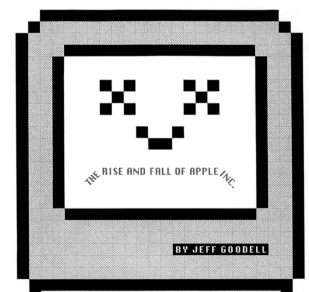

1 TITLE **Coolio** DESIGN FIRM **Us Magazine, New York, NY** ART DIRECTOR **Richard Baker** GRAPHIC DESIGNER **Daniel Stark** PHOTOGRAPHER **Albert Watson** PUBLISHER **Us Magazine** 2 TITLE **Nick Cave** DESIGN FIRM **Rolling Stone, New York, NY** ART DIRECTOR **Fred Woodward** DESIGNER **Geraldine Hessler** PHOTOGRAPHER **Richard Burbridge** CLIENT/PUBLISHER **Rolling Stone**

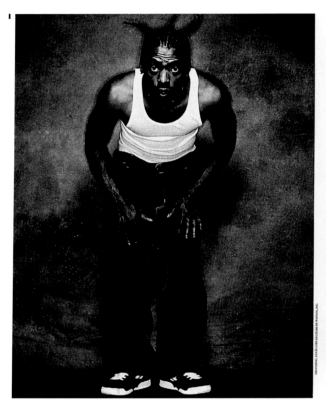

COOLIO

THE GANGSTA RAPPER WITH THE WAY-OUT HAIR MAKES HIS MAINSTREAM MARK BY JONATHAN GOLD

THE FIRST THING THAT STRIKES YOU WHEN YOU meet Coolio is how very much like Coolio he looks, or rather, like an action figure of Coolio: the oversize features, the ironed plaid shirt and the khakis that slouch mid-buttock, the sleepy eyes that glower from deep inside his skull, and the hair—the hair! —that shoots off in thin shafts at every possible angle, minibraids that look more like the result of an unfortunate encounter with a Tesla coil than anything you might describe as fashion.

"I'm never going to be Michael Jackson," Coolio says matter-of-factly. "If I want to be left alone, I can just put on a hat."

The man may underestimate himself. Coolio, 32, is probably the very first hard-core rapper you can imagine taking a seat on *The Hollywood Squares*—"I'll take Coolio to block, please"—and your mother probably knows who Coolio is, if only for the video he made with that nice Michelle Pfeiffer for last year's smoky, insinuating rap ballad "Gangsta's Paradise." Flavored with the atmospheric crooning of Coolio's friend L.V., "Gangsta's Paradise" stayed in the top five for almost half a year, selling more than two and a half million copies. It's widely considered the reason that the otherwise rote *Dangerous Minds* became a box-office hit; and it won Coolio this year's Grammy for solo rap performance.

Snoop Doggy Dogg may sell more albums, but at this point, Coolio is the consummate celebrity of California's rap scene, as notorious for his coif as for any song he happens to have written, famously willing to lounge in vintage suits for splashy magazine layouts or play charity softball games or pose for his record company's Christmas card with glass tree ornaments hanging off his braids as if they were so many twigs on a confit. Coolio is nothing if not a good sport.

"It's been a long, hard road," Coolio says, leaning on the hood of his sleek black Lexus. "That's why I don't sweat things so much. I know I'm living in a fantasy world, and one day it's going to be over."

Alone among the successful West Coast gangsta rappers, who tend to flee as far into gated suburbia as they can afford, Coolio lives with his fiancee, Los Angeles DJ Josefa

Salinas, and his six children (three daughters, two sons, a stepdaughter, and a baby on the way) in a predominantly African-American neighborhood, the green, graceful Ladera Heights district near LAX airport.

Geographically speaking, it's not terribly far by freeway from Compton, Calif., where Coolio grew up as Artis Ivey and made the not-so-uncommon transition from straight-A student to practicing gang member. He spent 10 months in jail for cashing a money order that a friend had stolen. "I'd gotten away with a lot of stuff, so I looked at it as if I got caught for something I did," he says). By the mid-'80s, he was hooked on the popular drug at the time, primos—marijuana cigarettes laced with crack cocaine.

"I was out of control... I can look back on those times and make myself cry," Coolio says, misting up, then catching himself in midsniff. "There were some days, man—you're smokin' rock all night until the sun come up the next morning."

During his drug-haze period, Coolio had

a series of jobs that ranged from running the cash register at Taco Bell to—scarily enough —screening luggage at LAX; he even joined a firefighting squad in San Jose, Calif. By the late '80s, though, he was ready to clean up his act, opting against rehab and instead slowly weaning himself off crack. He also struggled to make a name for himself in Compton's burgeoning underground rap scene. Surrounded by teen-age sensations and producers who went gold before they were old enough to shave, Coolio paid dues upon dues upon dues. He rapped as a sideman to the smoldering anger of his friend WC in the underrated rap combo WC and the Maad Circle; he emceed at skating rinks and house parties; he had a tiny hit on the local rap radio station KDAY.

Finally, Coolio caught a break, signing with Tommy Boy Records in 1993, the label of Naughty by Nature and Queen Latifah, on the strength of "County Line," a song written about what he considers the absolute nadir of his life, the day he was recognized picking up his welfare check.

"County Line," flavored with the humor

the ease, that had been missing from West Coast rap for years, became a regional hit. But it was "Fantastic Voyage," the bouncy utopian anthem powered into the public consciousness by a video showing Coolio's multiculti party on the beach, that sold more than a million copies. The song featured the line unusual for gangsta rap at the time "It don't matter if you're white or black" and became an instant family-safe MTV smash. Coolio was suddenly a star.

"I've been around the world in the last couple of years," he says, "and my view of life is much broader now. I can sit here and say that I've had a tough life. But I didn't miss that many meals. We had a Christmas tree and presents. We had Disneyland, sometimes two, three times a year. There wasn't a war going on in my neighborhood, with bombs dropping and tanks rolling by. I experienced racism, but not like they do in Croatia, where you could be put in jail just for speaking your own language."

Coolio gazes out at the skateboard kids who've gathered in the parking lot, circling the car hoping for his autograph. "I feel lucky now," he says, breaking into a wide smile. "I had a *cool* childhood." •

Jonathan Gold writes for 'Spin' and the 'Los Angeles Times.'

NICK CAVE *acquires a taste for murder*

DEATH
BECOMES HIM

FOR SOMEONE WHO HAS JUST RELEASED an album of songs devoted entirely to the dark art of murder, Nick Cave hasn't had much hands-on experience with firearms or dead folks. His one close encounter with a corpse, back when he was a schoolboy in his native Australia, didn't even give him much of a fright.

"I was riding my bicycle home from school, and I found this dead guy in an alley just by the river that went past the school," Cave recalls between swigs of milky tea in a Manhattan hotel room. "I had a few moments to poke around at the body before I raced back to tell the teachers about it."

As for guns, Cave briefly owned a pistol several years ago while he was living in Germany. "A drug dealer gave it to me – he owed me," he says flatly of the transaction. "It was kind of difficult to use, so I gave it to someone else. I hope he used it appropriately."

Cave has been on the wrong end of a beater – twice – and didn't like it much. "It was in L.A.," he explains. "I was stealing drugs both times, and it all sort of evened. I just had to give over my money, and then it was, 'All right, fuck off.' I

> "There are
> times when I
> feel I can
> go and murder
> somebody,"
> Cave admits.
> "Definitely."

found that deeply humiliating.

Still, that's small beer compared to the hard rain of blood and bullets on Cave's recent homicide suite, *Murder Ballads*, his 10th album with his longtime band, the Bad Seeds, and the compellingly grisly apex of his artistic obsession with the deadliest sin. The body count over the course of the record's seven new originals and two public-domain narratives, the dark lullaby "Henry Lee" (a duet with Polly Jean Harvey) and the venerable blues "Stagger Lee," is truly breathtaking. By the time he lapses into the niggering solemnity of the closing hymn, a cover of Bob Dylan's "Death Is Not the End," Cave has dispatched more than 60 men, women and children in violent, untimely ends – more than 20 just in the morbidly hilarious barn dance "The Curse of Millhaven." The long, lean, pistol-packing bastard in Cave's 14-minute epic "O'Malley's Bar" wipes out a dozen people before the song is two-thirds over.

Cave, who is 38, has been writing and singing vividly, enthusiastically, about murder and mayhem since his early-'80s tenure as the

cadaverous frontman and hellfire voice of the notorious Australian band the Birthday Party. His extensive solo work with the Bad Seeds, beginning with the blackhearted 1984 masterpiece *From Her to Eternity*, is a gripping catalog of base instincts and poisoned passions vivified by the dark, gnarly sound of the Bad Seeds (particularly the clawing, convulsive guitar of Blixa Bargeld) and the heated, eccentric intimacy of Cave's language. "I poisoned the blood under the choo'chad her feet looked raw and vicious," he sneers unabashe before pulling the trigger in "O'Malley's Bar." "Her head it landed in the sink/With all the dirty dishes."

"I have a certain way with words when it comes to violence," Cave says without apology, looking like a hip, Defenstion undertaker in a snazzy dark-blue pinstripe suit supplemented with a long, knitted scarf. "I just enjoy ruminating over the details."

What is remarkable about *Murder Ballads*, though, is the mad genius of its dynamic extremes. Cave avoids "Stagger Lee" with a bonesawblunt indignation that would make the Geto Boys blanch, then shifts unflappably into the sultry-villainy of "Where the Wild Roses Grow," a brilliant pairing of Cave's macabre crooning with the sweet-maiden sigh of the Australian pop thrush Kylie Minogue. And there is no mistaking the broad comic streak running through the confessions of Lottie, the serial murderer in "The Curse of Millhaven." They ask me if I feel remorse, and I answer, 'Why of course!/There is so much more I could have done if they'd let me.'"

"If my family had been murdered, I wouldn't be able to write as flippant a record as this," Cave admits. "In that respect, this record could offend a lot of

> "If my own
> family had been
> murdered, I
> wouldn't be able
> to write a record
> as flippant as
> this," Cave says.

people who have had direct experience with this sort of thing."

But he insists *Murder Ballads* was designed to offend, in be one of those records like Bob Dylan's *Self Portrait*, where people just go, 'What the fuck is this kind of crap?' In fact, it didn't work out that way." Much to Cave's chagrin, *Murder Ballads* is a major European smash. Cave doesn't have any false hopes about the album's prospects in the United States but figures, "Americans need a laugh, don't they? Well, buy my record. It's full of them."

Murder Ballads would have been a more serious, even spiritual affair had Cave made the record when the idea first came to him – more than 10 years ago, while he was working on his 1985 album *The Firstborn Is Dead*. He'd written an eerie, chantlike song of revenge called "Crow Jane" and envisioned what he describes as "a greatest-hits record, but it was only going to be murder songs. I'd write a few new ones, throw some old ones on as well." Grinning, he says, "Even back then there were enough murder songs for an album."

But by the time he'd started writing and recording in earnest ("O'Malley's

BY DAVID FRICKE

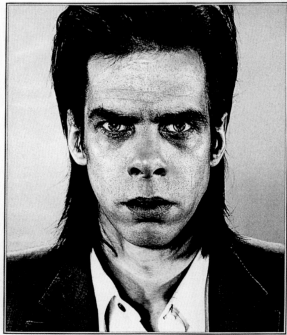

®EM

MORE SONGS about DEATH and ANXIETY... REMARKS Concerning BiLL CLINTON, psychedelic DRUGS And the SAD DECLINE oF the '60s GENERATION... the MYSTERIOUS CASE of the DISAPPEARING manager... and SOME PERTINENT FACTS about TODAY'S R.e.M. | by CHRIS HEATH |

[ROLLING STONE · 52 · October 17,1996]

TO MILLIONS of viewers a night, he's the host of *Larry King Live*. In my family, he's the crazy uncle

ILLUSTRATION BY AL HIRSCHFELD

The King &

I

A FEW TIMES EACH YEAR, Larry King puts everything aside and sets out for La Costa, a health spa in the hills north of San Diego. Nearly 10 years ago he had a heart attack, followed by quintuple-bypass surgery, and going to La Costa is his way of asking fate for a few more years. Each morning he takes a brisk walk around the golf course, checking his pulse along the way. Each afternoon he heads to the spa, pulls off his clothes and steps into a pool in a secluded courtyard. The pool is filled with naked men, ages 60 to 90, who pick sides and then play a rigorous game of nude volleyball. Many of these men have also had heart attacks, so every chest is marked by the jagged scar where the surgeon went in. They say this makes them members of the Zipper Club. • When Larry is behind a microphone in Washington, D.C., he's one of the most visible people on earth. Six nights a week he can be seen in more than 170 million households in 210 countries and territories. In recent years, the show has become a kind of inter-

By Rich Cohen

Rolling Stone, November 14, 1996 · 73

1 TITLE **REM** DESIGN FIRM **Rolling Stone, New York, NY** ART DIRECTOR **Fred Woodward** DESIGNERS **Geraldine Hessler and Fred Woodward** PHOTOGRAPHER **Anton Corbijn** CLIENT/PUBLISHER **Rolling Stone** 2 TITLE **Larry King** DESIGN FIRM **Rolling Stone, New York, NY** ART DIRECTOR **Fred Woodward** DESIGNERS **Gail Anderson and Fred Woodward** ILLUSTRATOR **Al Hirschfeld (Illustration © 1996 Al Hirschfeld. Drawing reproduced courtesy of the Margo Feiden Galleries Ltd., NY.)** CLIENT/PUBLISHER **Rolling Stone**

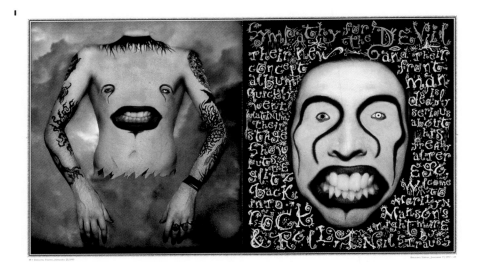

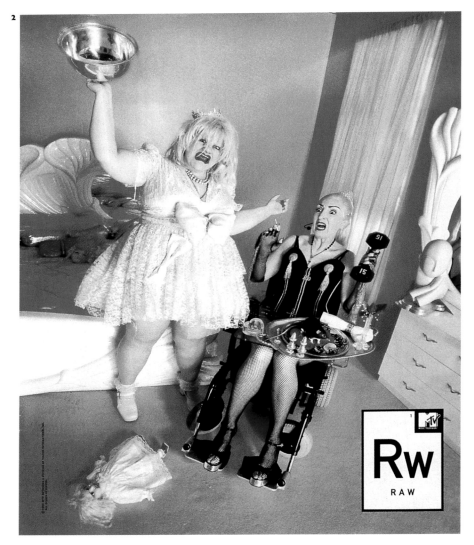

1 TITLE **Marilyn Manson** DESIGN FIRM **Rolling Stone, New York, NY** ART DIRECTOR **Fred Woodward** GRAPHIC DESIGNERS **Gail Anderson and Fred Woodward** PHOTOGRAPHER **Matt Mahurin** PHOTO EDITOR **Jodi Peckman** PUBLISHER **Wenner Media** CLIENT **Rolling Stone** 2 TITLE **Raw Advertisement** DESIGN FIRM **MTV, New York, NY** CREATIVE DIRECTOR/PHOTOGRAPHER **David LaChapelle** CLIENT **MTV: Music Television**

1 TITLE **Legends of Country Music** DESIGN FIRM **Rolling Stone, New York, NY** ART DIRECTOR **Fred Woodward** DESIGNERS **Gail Anderson and Fred Woodward** PHOTOGRAPHER **Mark Seliger** CLIENT/PUBLISHER **Rolling Stone**

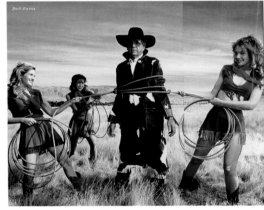

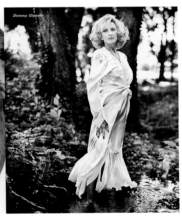

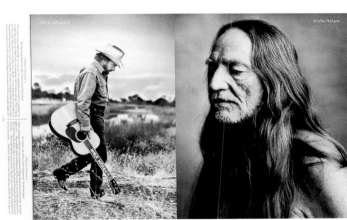

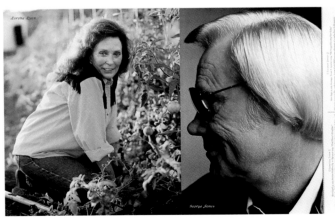

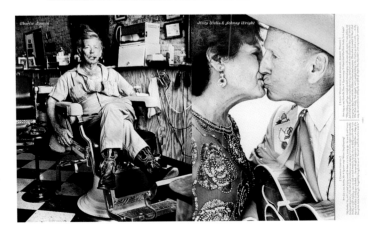

Traditionally, book design has been a rich, special territory for graphic designers. This does not mean that all books have been designed in a traditional manner, but rather that designers of all types have sought refuge in the art of the book. Books are to designers what buildings are to architects: we seek to build that worth building, to find information and stories worth preserving, and to create some vestige of permanence. Even as we seek to reinvent the book — as a relevant form and as a vehicle of communication — the impulse to design books is a valuable tradition within our profession.

This is the second year in which we have included book covers and jackets in this competition, making this the *Fifty Books/Fifty Covers* show. We're pleased with this evolution because it allows the AIGA to recognize excellence in design in this neglected area.

We also have expanded the jury from five to seven jurors, allowing us to include qualified professionals to represent other aspects of the book produciton and publishing industry: last year, a curator of rare books and an independend bookseller; this year, a university press editor and a leader from the publishing software industry.

The goal of these efforts, and our hope, is that this competition will acquire greater credibility among designers, relevance among publishers, and awareness among the general public.

William Drenttel
CHAIRMAN

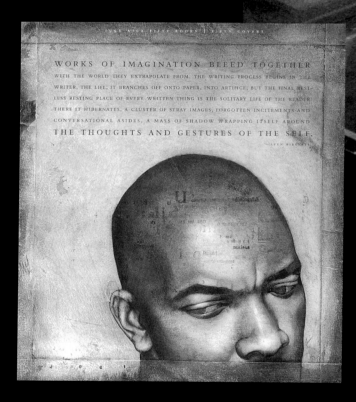

CALL FOR ENTRY
Design Jessica Helfand/William Drenttel
Illustration Joel Peter Johnson
Digital Photography and Printing Cedar Graphics
Paper Mohawk Options Bright White Text

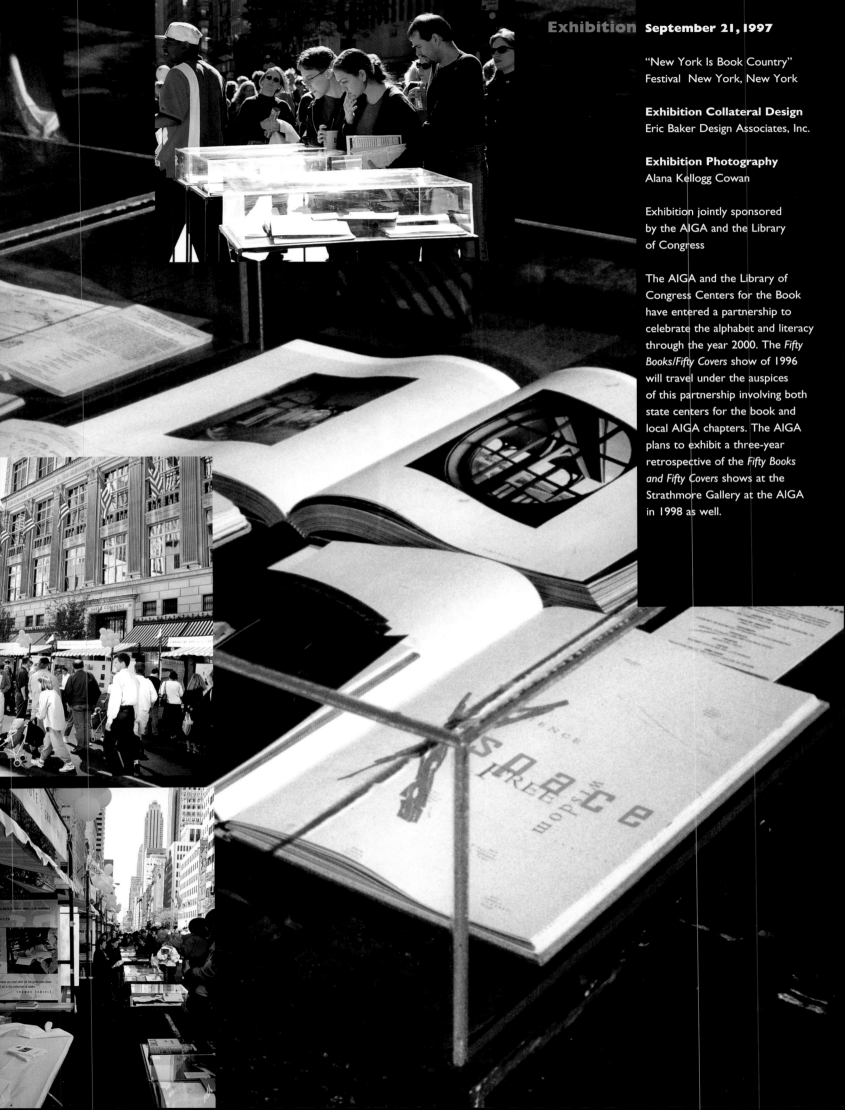

"New York Is Book Country"
Festival New York, New York

Exhibition Collateral Design
Eric Baker Design Associates, Inc.

Exhibition Photography
Alana Kellogg Cowan

Exhibition jointly sponsored
by the AIGA and the Library
of Congress

The AIGA and the Library of
Congress Centers for the Book
have entered a partnership to
celebrate the alphabet and literacy
through the year 2000. The *Fifty
Books/Fifty Covers* show of 1996
will travel under the auspices
of this partnership involving both
state centers for the book and
local AIGA chapters. The AIGA
plans to exhibit a three-year
retrospective of the *Fifty Books
and Fifty Covers* shows at the
Strathmore Gallery at the AIGA
in 1998 as well.

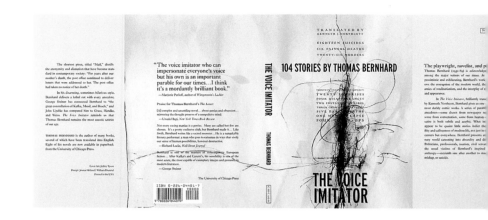

Irma Boom is a Dutch graphic designer specializing in printed matter, particularly books, stamps, and posters. Before opening her own design studio in Amsterdam in 1990, she was a senior designer at the Government Printing Office, The Hague. She lectures at several international schools of art and graduated from the Art School in Enschede in 1984.

Barbara deWilde is a graphic designer functioning primarily in the worlds of book jacket design and music packaging. Her work for Alfred A. Knopf and other publishers (including Farrar, Straus & Giroux, W. W. Norton, HarperCollins, and Random House) has been featured in *Eye, Print, Graphis, Vanity Fair, Time* and *I.D.* magazines. The latter chose her as part of its first *I.D.* 40 group of the nation's top designers. Her work has been included in various exhibitions by the AIGA, American Center for Design, Art Directors' Club, and the Cooper-Hewitt, National Design Museum, Smithsonian Institution.

William Drenttel (chairman) is a designer and publisher who works in partnership with Jessica Helfand in New York City. He is president emeritus of the AIGA, and chairman of both the AIGA's Literacy Initiative and the *Fifty Books/Fifty Covers of 1996* competition and exhibition. He is actively involved in literacy projects around the country and is a board member of the Poetry Society of America.

Jerry Kelly is a book designer and the New York City representative for the Stinehour Press, as well as a typographer and calligrapher. He is also a partner at the Kelly/Winterton Press, producers of fine printing. He has lectured, taught, and written widely on typography and calligraphy, and has designed twelve AIGA Book Show selections over the past decade.

Ellen Lupton is an author, designer, publisher, and reader of books. With J. Abbott Miller, she is co-chair of visual communications at the Maryland Institute College of Art in Baltimore. She is adjunct curator of contemporary design at the Cooper-Hewitt, National Design Museum in New York, where she has organized a series of major exhibitions, including: *Mechanical Brides: Women and Machines from Home to Office* (1993), *The Avant-Garde Letterhead* (1996), and *Mixing Messages: Graphic Design in Contemporary Culture* (1996). In 1996 she published the book *Design Writing Research: Writing on Graphic Design* with J. Abbott Miller.

Alan Thomas is a senior editor at the University of Chicago Press, where he has acquired books in the humanities since 1985. His recent and forthcoming projects include books by J. M. Coetzee, John Hollander, Norman Maclean, Thomas Bernhard, Christa Wolf, and Lawrence Weschler. He was educated at Princeton and Oxford and has worked as a photography critic for several Midwest publications.

John E. Warnock, a co-founder of Adobe Systems in 1982, is now the firm's chairman and CEO. For three decades, he has been a respected innovator in computer software. He holds three patents, has contributed many articles to technical and industry publications, and is a frequent speaker on industry issues. The recipient of numerous awards for technical and managerial achievement, he has been honored by the Software Publishers Association, the Association for Computing Machinery (ACM), *MacUser, Macworld, PC Magazine,* and the Rochester Institute of Technology. Dr. Warnock is a member of the National Academy of Engineering and sits on the boards of Netscape Communications Corporation, Redbrick Systems, and Evans & Sutherland.

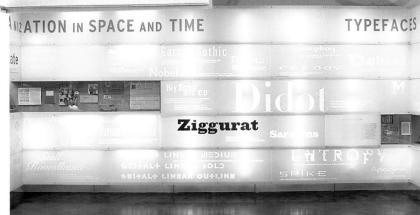

1 Title **Stanley Saitowitz** Author **Stanley Saitowitz** Art Director/Designer **Sze Tsung Leong** Photographers **Stanley Saitowitz, Sze Tsung Leong, Christopher Irion, Richard Barnes, Tim Street-Potter** Typeface **Gill Sans** Printer **Friesen Printers** Paper **Bravo Dull 100# Text, Benefit 70# Text (Endsheets)** Publisher **Princeton Architectural Press/Rice University School of Architecture** **2** Title **Goldens Bridge** Author **Louis Dreyfus Property Group** Design Firm **Wood Design, New York, NY** Art Directors **Tom Wood and Alyssa Weinstein** Designer **Tom Wood** Illustrator **Clint Bottoni** Photographer **Todd Flashner** Typefaces **Scala, Din** Printer **Hennegan** Paper **Monadnock Astrolite** Publisher **Louis Dreyfus**

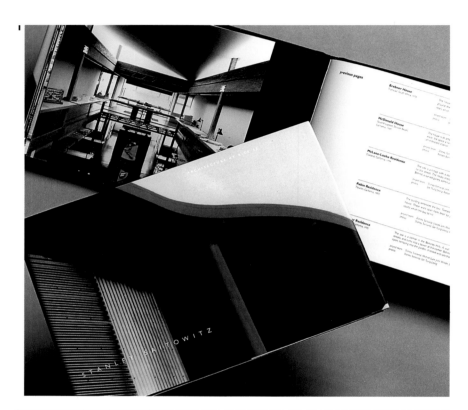

1 TITLE **Awestruck by the Majesty of the Heavens** AUTHOR **Anna Felicity Friedman** DESIGN FIRM **studio blue, Chicago, IL** DESIGNERS **Cheryl Towler Weese, JoEllen Kames, Gail Wiener** ART DIRECTORS **Kathy Fredrickson and Cheryl Towler Weese** PHOTOGRAPHER **Garry Henderson** TYPEFACE **Poliphilus, Blado, OCR-A** PRINTER **Multiple Images, Chicago** PAPER **King James Folding Board, Potlatch Northwest Dull** PUBLISHER **Adler Planetarium and Astronomy Museum** 2 TITLE **Painted Sun Trails** AUTHOR **Merrill Wagner** DESIGN FIRM **The Traver Company, Seattle, WA** CREATIVE DIRECTOR/DEISGNER **Anne Traver** PHOTOGRAPHER **Merrill Wagner** TYPEFACE **AT Officina Sans** PRINTER **C & C Offset Printing Co., Ltd.** PUBLISHER **Merrill Wagner**

1 TITLE **The God of Small Things** AUTHOR **Arundhati Roy** DESIGN FIRM **Random House Art Dept., New York, NY** ART DIRECTOR **Robbin Schiff** DESIGNER **Victoria Wong** TYPEFACES **Janson Monotype, Bernhard Modern Berthold** PRINTER **Phoenix Color** PAPER **Glatfelter 50# Sebago Antique** PUBLISHER **Random House** 2 TITLE **Making a Landscape of Continuity: The Practice of Innocenti and Webel** AUTHOR **Gary R. Hilderbrand** DESIGN FIRM **Hecht Design, Arlington, MA** ART DIRECTOR **Alice Hecht** DESIGNERS **Alice Hecht and Sarah Smith** PHOTOGRAPHERS **Samuel Gottscho, Frank Kluber, Tori Butt** TYPEFACES **Monotype Bembo and Adobe Bembo** PRINTER **The Stinehour Press** PAPER **Mohawk Superfine White 80# Text** PUBLISHER **Harvard University Graduate School of Design/Princeton Architectural Press**

1 TITLE **Transforming the Common/Place: Selections from Laurie Olin's Sketchbooks** AUTHORS **Brook Hodge, Peter Rowe, John Dixon Hunt, and Laurie Olin** DESIGN FIRM **Hecht Design, Arlington, MA** ART DIRECTOR **Alice Hecht** DESIGNERS **Alice Hecht and Sarah Smith** PHOTOGRAPHERS **Various** TYPEFACES **Meta, Monotype Perpetua** PRINTER **Bolger Publications** PAPER **Weyerhaeuser Cougar Opaque** PUBLISHER **Harvard University Graduate School of Design/Princeton Architectural Press** **2** TITLE **Mires Design Case Study Series** AUTHOR **Mires Design** DESIGN FIRM **Mires Design, CA** ART DIRECTOR **Jose Serrano** DESIGNERS **Jose Serrano and Jeff Samaripa** TYPEFACE **Futura** PRINTERS **Rush Press and Continental Graphics** PAPER **Chipboard (cover), Simpson Starwhite Vicksburg 80# Vellum**

1 TITLE **Mythopoeia** AUTHOR **Steve Tomasula** DESIGN FIRM **Slip Studios, Chicago, IL** CREATIVE DIRECTORS **Stephen Farrell, Don Pollack, Steve Tomasula**
DESIGNER/ILLUSTRATOR **Stephen Farrell** TYPEFACES **Perpetua, Volgare, Spartan Classified, Caslon 3** PRINTER **Advance Reproductions, Graphic Image Corporation**
PAPER **Potlatch Quintessence** PUBLISHER **Don Pollack (self-published)** 2 TITLE **The Captain from Nantucket and the Mutiny on the Bounty** AUTHOR **Walter Hayes**
DESIGN FIRM **The Stinehour Press, Lunenberg, VT** DESIGNER **Paul Hoffmann** ILLUSTRATOR **Amanda Newman** TYPEFACE **Bembo** PRINTER **The Stinehour Press** PAPER
Mohawk Superfine Text, Softwhite, Smooth 80# PUBLISHER **The William L. Clements Library**

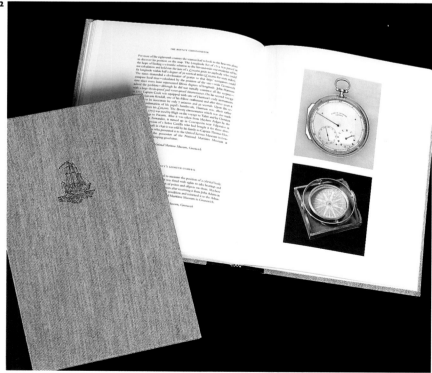

The Fragility Of Heavy Machinery
Caroline Fraser

View From The Cloisters
Gabriella Mirollo

WHAT would a grown woman do?
She'd tug off an earring, drop it to the desk
when the phone rang. You'd hear
for the clatter and roll. You'd hear
in this the ice, tangling in the glass;
in her voice, low on the line, the drink

being poured. All night awake,
I heard its fruity murmur of disease
and cure. I heard the sweet word 'sleep,'

which made me thirstier. Did I say it,
or did you? And will I learn
to wave the drink with a goodbye wrist

in conversation, toss it off all bracelet-bare
like more small talk about a small affair?
To begin, I'll claim what I want

is small: the childish hand

Primrose
Cynthia Zarin

David W

POEMS FOR THE
NEW CENTURY

NEW YORK PUBLIC LIBRARY
ARALIA PRESS 1996

I TITLE **Poems for the New Century** CURATOR **Rodney Phillips** DESIGN FIRM **Aralia Press, West Chester, PA** DESIGNER/PRINTER **Michael Peich** TYPEFACE **Romulus Open, Lutetia, Lutetia Italic** PAPER **Zerkall Mouldmade (printed damp)** PUBLISHER **Aralia Press, West Chester University**

1 TITLE **International Encounters: The Carnegie International and Contemporary Art, 1896–1996** AUTHORS **Vicky A. Clark, Bruce Altshuler, Lois Marie Fink, Kay Larson, Kenneth Neal, Susan Platt** DESIGN FIRM **Salsgiver Coveney Associates, Westport, CT** ART DIRECTOR **Karen Salsgiver** DESIGNERS **Karen Salsgiver and Laura Howell** TYPEFACES **Centaur, Scala** PRINTER **Innovation Printing and Lithography, Inc.** PAPER **Scheufelen PhenoStar Dull 80# Text and Cover** PUBLISHER **The Carnegie Musuem of Art** 2 TITLE **Metalwork in Early America** AUTHOR **Donald L. Fennimore** DESIGN FIRM **studio blue, Chicago, IL** DESIGNERS **Cheryl Towler Weese, JoEllen Kames, Gail Wiener** ART DIRECTORS **Kathy Fredrickson and Cheryl Towler Weese** PHOTOGRAPHER **George Fistrovich** TYPEFACES **ITC Bodoni, Monotype Grotesque** PRINTER **Balding & Mansell** PAPER **Job Parilux Dull Cream** PUBLISHERS **Antique Collectors' Club, The Winterthur Museum**

1 TITLE **The Road That Is Not a Road and the Open City, Ritoque, Chile** AUTHOR **Ann Pendleton-Jullian** DESIGN FIRM **The MIT Press, Cambridge, MA** DESIGNER **Ori Kometani** TYPEFACE **Gill Sans** PRINTER **Henry N. Sawyer Co.** PAPER **Domtar Plainfield Plus 80# Cover Smooth** PUBLISHER **The MIT Press** 2 TITLE **Orbiting the Giant Hairball** AUTHOR **Gordon MacKenzie** DESIGN FIRM **Willoughby Design Group, Kansas City, MO** ART DIRECTOR **Gordon MacKenzie** DESIGNER **Michelle Sonderegger** ILLUSTRATORS **Meg Cundiff, Suzi Vanztos, Ann Willoughby, Wendie Collins, Gordon MacKenzie** PRINTER **The Stinehour Press** PAPER **Simpson Starwhite Vicksburg Archiva Text** PUBLISHER **OpusPocus Publishing**

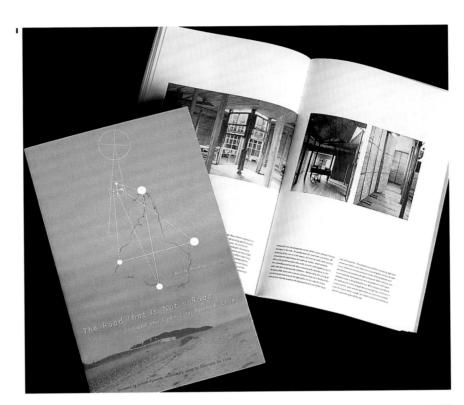

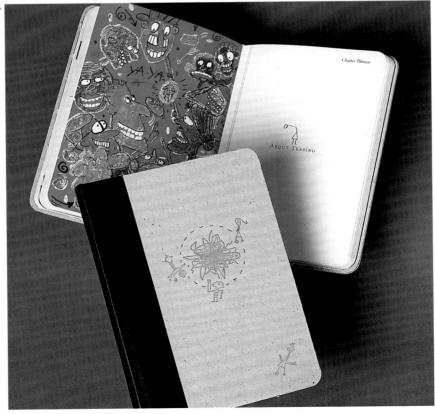

1 TITLE **Ellsworth Kelly** AUTHOR **Diane Waldman** DESIGN FIRM **Matsumoto Inc., New York, NY** ART DIRECTOR/DESIGNER **Takaaki Matsumoto** PHOTOGRAPHERS **Various** TYPEFACES **Univer and Sabon** PRINTER **Cantz** PUBLISHER **Solomon R. Guggenheim Museum** 2 TITLE **American Windsor Chairs** AUTHOR **Nancy Goyne Evans** DESIGN FIRM **Howard I. Gralla, New Haven, CT** ART DIRECTOR **Paul Anbinder** DESIGNER **Howard I. Gralla** MAPS **Gary Tong** PHOTOGRAPHERS **George Eistrovich and Various** TYPEFACE **Galliard** PRINTER **Toppan Printing Company** PAPER **New Age Matte-Coated Alkaline 128 gsm** PUBLISHER **Hudson Hills Press**

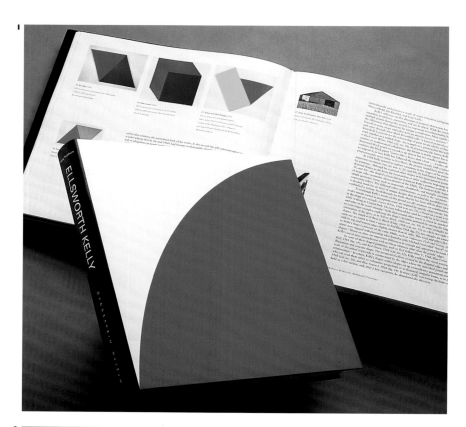

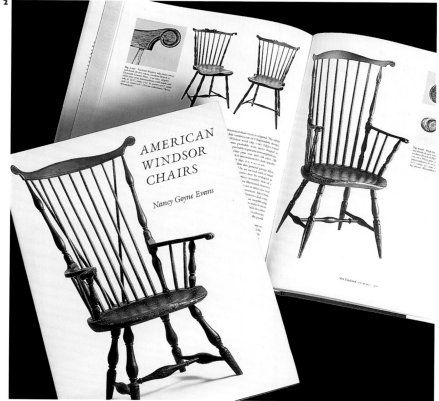

1 TITLE **Robert A. M. Stern: Buildings** AUTHOR **Robert A. M. Stern** DESIGN FIRM **Pentagram, New York, NY** ART DIRECTOR **Michael Beirut** DESIGNERS **Michael Bierut, Emily Hayes, Esther Bridavsky** PHOTOGRAPHERS **Various** PUBLISHER **The Monacelli Press** 2 TITLE **Eric Owen Moss: The Box** AUTHORS **Mack Scogin, Peter G. Rowe, Preston Scott Cohen, Herbert Muschamp, and Brooke Hodge** DESIGN FIRM **plus design inc., Boston, MA** ART DIRECTOR/DESIGNER **Anita Meyer** PHOTOGRAPHERS **Paul Aroh, Todd Conversano, Frank Jackson** TYPEFACE **Corporate Font Family** PRINTER **Mercantile Printing Company** PAPER **Monadnock Dulcet Smooth, Domtar Natural** PUBLISHER **Harvard University Graduate School of Design**

1 Title **Art in Chicago, 1945–1995** Authors **Lynne Warren, et al.** Design Firm **studio blue, Chicago, IL** Designers **Cheryl Towler Weese, JoEllen Kames, Gail Wiener** Art Directors **Kathy Fredrickson and Cheryl Towler Weese** Typefaces **Bell Gothic, Dogma, Gothic 13** Printer **Everbest Printing Company** Publishers **Thames and Hudson, The Museum of Contemporary Art, Chicago** 2 Title **Making Mischief: Dada Invades New York** Authors **Francis M. Naumann, Beth Venn, et al.** Design Firm **Lorraine Wild, Los Angeles, CA** Art Director **Lorraine Wild** Designers **Lorraine Wild with Amanda Washburn** Typefaces **Bank Gothic, Mrs Eaves, News Gothic, Square Slab Serif, Windsor** Printer **Dr. Cantz'sche Druckerei** Publishers **Whitney Museum of American Art and Harry N. Abrams**

1 TITLE **Christian Dior** AUTHORS **Richard Martin and Harold Koda** DESIGN FIRM **Matsumoto Inc., New York, NY** ART DIRECTOR/DESIGNER **Takaaki Matsumoto** PHOTOGRAPHER **Karin L. Willis** TYPEFACE **Bodoni** PRINTER **Meridan Printing** PUBLISHER **Metropolitan Museum of Art** 2 TITLE **The Best of Flair** AUTHOR **Fleur Cowles** DESIGN FIRM **Joel Avirom, New York, NY** CREATIVE DIRECTOR **Joseph Montebello** DESIGNER **Joel Avirom** PRINTER **Palace Press** PAPER **157 gsm Matte Art Paper** PUBLISHER **HarperCollins Publishers**

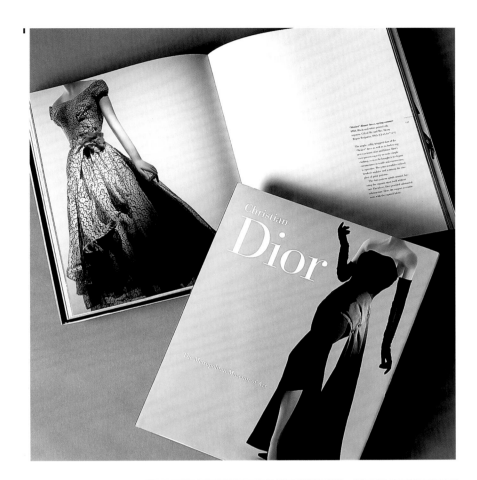

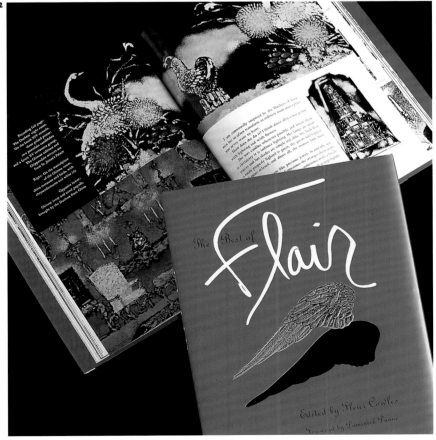

I TITLE **First Impressions: A China Diary** AUTHORS **James Avent and Mayna Avent Nance** DESIGN FIRM **Buchanan Design, Richmond, VA** ART DIRECTOR/DESIGNER **Margaret Buchanan** ILLUSTRATORS **Margaret Buchanan and Deh Chun** PHOTOGRAPHER **James Avent, Frederick Clapp, Upton Close (additional archival photos from the Bettmann Archive and World Wide Photos)** TYPEFACE **Weiss** PRINTER **Richmond Engraving** PAPER **Mohawk Superfine, Mohawk 50/10 (Frontispiece: French marble)** PUBLISHER **Mayna Avent Nance (hand-built, limited edition of 30)**

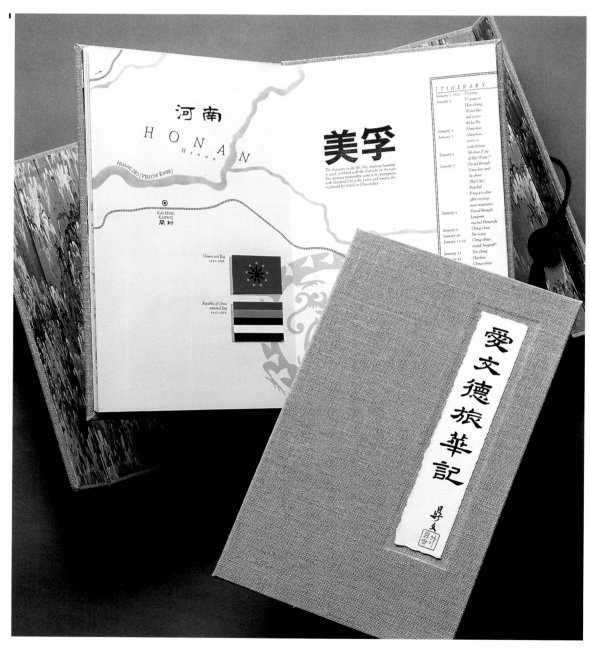

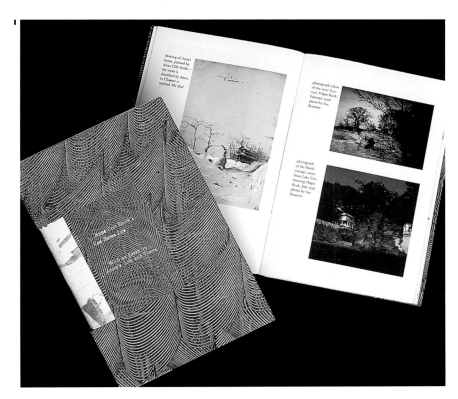

1 TITLE **Anna Clift Smith's Van Buren Life** AUTHORS **Anna Clift Smith and Wendy Woodury Straight** DESIGN FIRM **Fairbairn & Company, Fredonia, NY** ART DIRECTOR/GRAPHIC DESIGNER **Jan Fairbairn** PHOTOGRAPHER **Sue Besemer** TYPEFACES **Adobe Garamond, Adobe Garamond Expert** PRINTER **Thorner Press** FABRICATOR **Lynne McElhaney-Kirk/Dun Bindery** PAPER **Mohawk Superfine Text, Soft White Eggshell; Cover, Mideggen, Paste Paper Surface Treatment** PUBLISHER **Friends of Reed Library, State University of New York College at Fredonia** 2 TITLE **Typography and the Synthesis of Musical Form** PROJECT INSTRUCTOR **Vance Studley** DESIGN FIRM **Archetype Press, Art Center College of Design, Pasadena, CA** CREATIVE DIRECTOR **Vance Studley** DESIGNERS **Students in Advanced Typographic Studies Workshop** TYPEFACES **Various Foundry Type and Polymer Plates** PRINTER **Archetype Press** PAPER **Mohawk Superfine 80# Letterpress** PUBLISHER **Archetype Press, Art Center College of Design**

1 TITLE **From Cape Cod to the Bay of Fundy** AUTHOR **Philip W. Conkling** DESIGN FIRM **The MIT Press, Cambridge, MA** ART DIRECTOR/DESIGNER **Yasuyo Iguchi** TYPEFACES **Stone Sans, Garamond 3** PRINTER **Quebecor, Kingsport** PAPER **80# Tahoe Dull** PUBLISHER **The MIT Press** **2** TITLE **The Knowledge Exchange Business Encyclopedia** AUTHOR **Lorraine Spurge** DESIGN FIRM **Sussman/Prejza & Company, Inc., Culver City, CA** CREATIVE DIRECTORS **Debra Valencia and Deborah Sussman** DESIGNERS **Paula Loh, Armena Jehanian, Yuki Nishinaka, Christina Brenner, Hsin Hsien Tsai, Angela Leung, Silvia Park** TYPEFACE **Sabon, Univers, Trajan** PRINTER **Quebecor Printing** PAPER **50# Utopia Matte** PUBLISHER **Knowledge Exchange**

1 TITLE **Mingei Japanese Folk Art** AUTHOR **Robert Moes** ART DIRECTORS/DESIGNERS **Don Komai and Lynne Komai** TYPEFACE **Adobe Minion** PRINTER **Balding & Mansell** PUBLISHER **Art Services International 2** TITLE **A Visit to the Gallery** EDITORS **Richard Tillinghast and Leslie Stainton** DESIGN FIRM **Beth Hay/Graphic Design, Ann Arbor, MI** ART DIRECTOR **Beth Keillor Hay** DESIGNERS **Beth Keillor Hay and Margaret Ann Re** PHOTOGRAPHER **Pat Young** TYPEFACE **Sabon** PRINTER **University Lithoprinters, Inc.** PAPER **Monadnock Dulcet** PUBLISHER **University of Michigan Museum of Art**

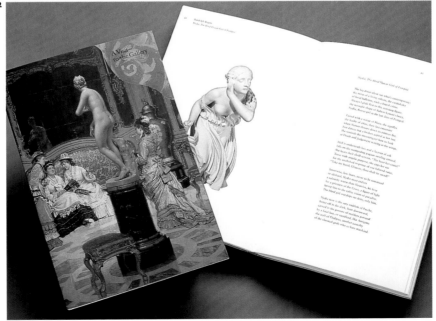

1 TITLE **The Ecology of Design: The AIGA Handbook of Environmental Responsibility in Graphic Design** AUTHORS **John Ortbal, Mike Lange, and Michael S. Carroll** CREATIVE DIRECTOR/GRAPHIC DESIGNER **Brian Collins** EDITOR **Marie Finamore** ILLUSTRATORS **Various** TYPEFACE **Garamond #3** PRINTER **Diversified Graphics** PAPER **Weyerhaeuser Jaguar** PUBLISHER **The American Institute of Graphic Arts** 2 TITLE **Graphis Annual Reports 5** EDITOR **Lana Rigsby** DESIGN FIRM **Rigsby Design, Houston, TX** ART DIRECTOR **Lana Rigsby** DEISGNERS **Lana Rigsby, Michael Thede, Alvin Ho Young** ILLUSTRATOR **Alvin Ho Young** PHOTOGRAPHERS **Terry Vine, Alfredo Parraga** TYPEFACES **Helvetica Neue, Adobe Garamond** PRINTER **Dai Nippon** PAPER **Mead** PUBLISHER **Graphis Press**

1 TITLE **1996 Seasonal Specialties LLC Tree Catalogue** AUTHOR **Seasonal Specialties LLC** DESIGN FIRM **Seasonal Specialties LLC, Eden Prairie, MN** CREATIVE DIRECTOR **Jennifer Sheeler** ART DIRECTOR **Barbara Roth** DESIGN PRODUCTION **Deborah Lee** PHOTOGRAPHER **Drew Trampe Photographics** TYPEFACES **Vintage Typewriter Two, Fur Extra Rounded** PRINTER **Daily Printing, Inc.** PAPER **Genesis, French Dur-O-Tone** 2 TITLE **Earth Tech Capabilities Brochure** AUTHOR **Earth Tech Corporation, with Joann Stone** DESIGN FIRM **Rigsby Design, Houston, TX** ART DIRECTOR **Lana Rigsby** DESIGNERS **Lana Rigsby, Jerod Dame** ILLUSTRATOR **Jerod Dame** PHOTOGRAPHER **Chriss Shinn** TYPEFACE **Helvetica Neue** PRINTER **H. MacDonald Printing** PAPER **Champion Benefit, Simpson Evergreen** PUBLISHER **Earth Tech**

1 TITLE **Disfarmer** AUTHOR **Julia Scully** DESIGN FIRM **Twin Palms Publishers, Santa Fe, NM** ART DIRECTOR/DESIGNER **Jack Woody** PHOTOGRAPHER **Disfarmer** TYPEFACE **Monotype Bulmer** PRINTER **Nissha** PUBLISHER **Twin Palms Publishers** **2** TITLE **Aftermath** AUTHOR **Rebecca Blissell** DESIGN FIRM **Rolling Bones Letterpress, Seattle, WA** DESIGNER **Rebecca Blissell** PHOTOGRAPHER **Rebecca Blissell** TYPEFACES **Stymie, Spartan, Typo Script, and Century, All Hand-Set** PRINTING/BINDING **Rebecca Blissell, Rolling Bones Letterpess** PAPER **Mohawk Vellum, Arches Cover** PUBLISHER **Rolling Bones Letterpress**

1 TITLE **Vietnam: A Book of Changes** AUTHOR **Mitch Epstein** DESIGN FIRM **Anthony McCall Associates, New York, NY** ART DIRECTOR **Anthony McCall** DESIGNER **Laura Howell** PHOTOGRAPHER **Mitch Epstein** TYPEFACE **Times New Roman** PRINTER **Arnoldo Mondadori Editore** PAPER **Cartiere Del Garda S.P.A., Gardamatt Art 150 gsm** PUBLISHERS **W. W. Norton & Co. and The Center for Documentary Studies, Duke University** 2 TITLE **The Killing Fields** AUTHOR **David Chandler** DESIGN FIRM **Twin Palms Publishers, Santa Fe, NM** ART DIRECTOR/DESIGNER **Jack Woody** PHOTOGRAPHER **Anonymous** TYPEFACES **Gill Sans Condensed** PRINTER **Nissha** PUBLISHER **Twin Palms Publishers**

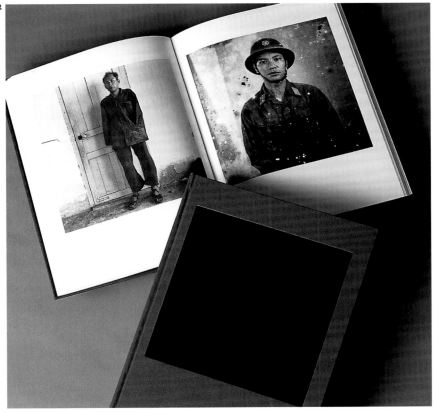

1 TITLE **One Hole in the Road** AUTHOR **W. Nikola-Lisa** ART DIRECTOR **Martha Rago** ILLUSTRATOR **Dan Yaccarino** TYPEFACE **Addled** PRINTER **Berryville Graphics** PAPER **Vellum Milkweed** PUBLISHER **Henry Holt and Company** 2 TITLE **Michael Ray Charles Exhibition Catalogue** AUTHOR **Marilyn Kern-Foxworth** DESIGN FIRM **Rigsby Design, Houston, TX** ART DIRECTOR **Lana Rigsby** DESIGNERS **Amy Wolpert and Lana Rigsby** ILLUSTRATOR **Michael Ray Charles** PHOTOGRAPHERS **Patrick Demarchelier, Sharon Seligman** TYPEFACES **Franklin Gothic, Roughhouse** PRINTER **H. MacDonald Printing** PAPER **Simpson Starwhite Vicksburg Tiara**

1 TITLE **NBA at 50** EDITOR **Mark Vancil** DESIGN FIRM **McMillan Associates, West Dundee, IL** ART DIRECTOR **Michael McMillan** DESIGNER **John Vieceli** PHOTOGRAPHERS **Various** TYPEFACE **Stone Sans** PRINTER **World Color** PAPER **Mead Signature Gloss 100# Text** PUBLISHER **Park Lane Press/Random House Value Publishing** 2 TITLE **Batman Collected** AUTHOR **Chip Kidd** ART DIRECTOR/DESIGNER **Chip Kidd** PHOTOGRAPHER **Geoff Spear** TYPEFACE **Bodoni Oldface** PRINTER **Imago** PAPER **170 gsm Nymolla Art Stock** PUBLISHER **Bulfinch Press**

1 TITLE **A Time Not Here** AUTHOR **Randall Kenan** DESIGN FIRM **Twin Palms Publishers, Santa Fe, NM** ART DIRECTOR/DESIGNER **Jack Woody** PHOTOGRAPHER **Anonymous** TYPEFACES **Gill Sans Condensed** PRINTER **Nissha** PUBLISHER **Twin Palms Publishers** 2 TITLE **Angry White Men** AUTHOR **Robbie McLaran** DESIGN FIRM **Johnson & Wolverton, Portland, OR** CREATIVE DIRECTORS **Alicia Johnson and Hal Wolverton** DESIGNERS **Jeff Dooley, Robin Muir, and Hal Wolverton** PHOTOGRAPHER **Robbie McClaran** PRINTER **Irwin-Hodson** PAPER **S. D. Warren Lustro Dull**

1 TITLE **Antonin Artaud: Works on Paper** EDITOR **Margit Rowell** DESIGN FIRM **Design Writing Research, New York, NY** ART DIRECTOR **J. Abbott Miller** DESIGNER **Paul Carlos** TYPEFACE **Walbaum (Monotype)** PRINTER **Stamperia Valdonega** PUBLISHER **The Museum of Modern Art, New York** 2 TITLE **Compound Fracture** PHOTOGRAPHER **Robert Flynt** DESIGN FIRM **Twin Palms Publishers, Santa Fe, NM** ART DIRECTOR **Jack Woody** DESIGNER/PHOTOGRAPHER **Robert Flynt** TYPEFACE **Linotype Didot** PRINTER **Nissha** PUBLISHER **Twin Palms Publishers**

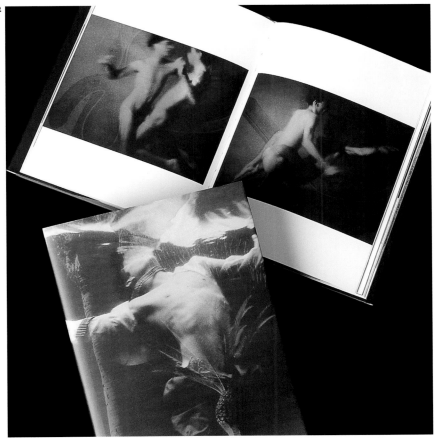

1 TITLE **S, M, L, XL** AUTHORS **Rem Koolhaas and Bruce Mau** DESIGN FIRM **Bruce Mau Design, Toronto, Ontario** DESIGNER **Bruce Mau** PHOTOGRAPHER **Hans Werlemann** PUBLISHER **The Monacelli Press** **2** TITLE **Push** AUTHOR **Sapphire** DESIGN FIRM **Alfred A. Knopf, New York, NY** ART DIRECTOR/DESIGNER **Virginia Tan** TYPEFACES **Dogma Black, Janson Text, Prestige Elite** PRINTER **Berryville Graphics** PAPER **Writers Offset #55** PUBLISHER **Alfred A. Knopf**

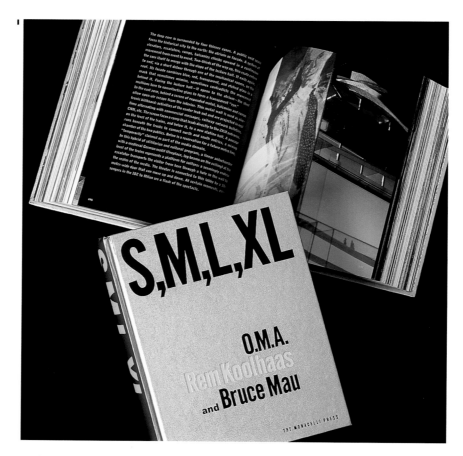

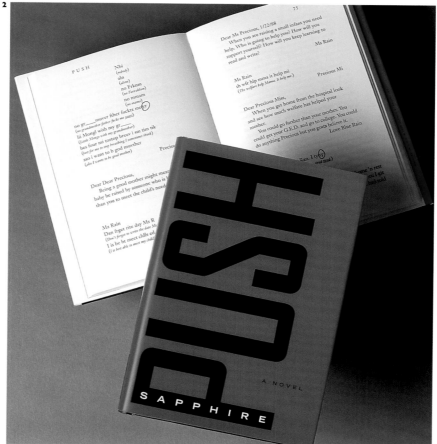

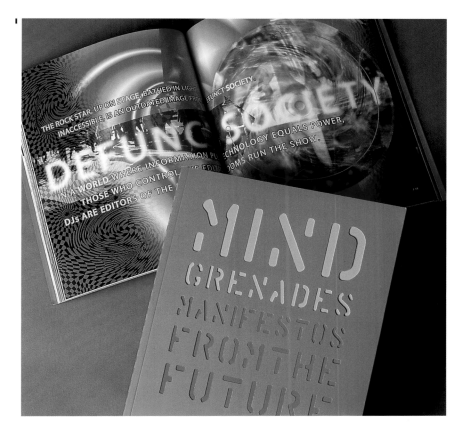

1 TITLE **Mind Grenades: Manifestos from the Future** AUTHORS **John Plunkett and Louis Rossetto** DESIGN FIRM **Plunkett + Kuhr, Park City, UT** ART DIRECTOR **John Plunkett** DESIGNERS **Adams/Morioka, Eric Adigard, Fred Davis, Max Kisman, John Plunkett, Thomas Schneider** ILLUSTRATORS **Eric Adigard, Jeff Brice, Fred Davis, John Hersey, Max Kisman, Nick Phillip, Johan Vipper** PHOTOGRAPHER **James Porto** TYPEFACES **Warehouse, Adobe Myriad** PRINTER **Tien Wah Press** PAPER **Ensogloss Artboard C25, Nymolla Matte Art** PUBLISHER **Wired Books** 2 TITLE **Cindy Crawford's Basic Face** AUTHOR **Kathleen Boyes** DESIGN FIRM **The Valentine Group, New York, NY** ART DIRECTOR **Robert Valentine** DESIGNERS **Jin Chung, Tina Lawfer, Robert Valentine** ILLUSTRATOR **Maurice Vellekoop** PHOTOGRAPHER **Michel Comte** PRINTER **Quebecor/Hawkins** PAPER **100# Jensen Gloss** PUBLISHER **Broadway Books**

1 TITLE **Under the Tuscan Sun: At Home in Italy** AUTHOR **Frances Mayes** DESIGN FIRM **Steve Tolleson Design, Inc., San Francisco, CA** JACKET/COVER DESIGNER **Steve Tolleson Design, Inc.** PHOTOGRAPHER **Frances Mayes** TYPEFACE **Trajan** PUBLISHER **Chronicle Books** 2 TITLE **Textile Arts of India** AUTHOR **Kokyo Hatanaka** DESIGN FIRM **Studio A, San Francisco, CA** JACKET/COVER CREATIVE DIRECTOR **Sarah Bolles** JACKET/COVER DESIGNER **Jana Anderson** TYPEFACE **Garamond** PUBLISHER **Chronicle Books**

1 TITLE **Shakespeare's Unruly Women Exhibition Catalogue** AUTHORS **Georgianna Ziegler, Frances Dolan, Jeanne Addison Roberts** DESIGN FIRM **Studio A, Alexandria, VA** JACKET/COVER DESIGNER **Antonio Alcalá** ILLUSTRATORS **Kenny Meadows, W. H. Mote** TYPEFACES **Adobe Minion, Kunstler** PRINTER **Hagerstown Bookbinding and Printing Company** PAPER **Mohawk Options** PUBLISHER **The Folger Shakespeare Libary** 2 TITLE **Private Matters** AUTHOR **Janna Malamud Smith** DESIGN FIRM **Cherrio Productions, New York, NY** JACKET/COVER ART DIRECTOR **Jean Seal** JACKET/COVER DESIGNER **Leslie Goldman** PUBLISHER **Addison-Wesley**

1

2

Shakespeare's *Unruly* Women

Janna Malamud Smith

1 TITLE **Native Nations Library Vols. I-IV** AUTHOR **Christopher Cardozo** DESIGN FIRM **Callaway Editions, New York, NY** JACKET/COVER DESIGNER **Jennifer Wagner** PHOTOGRAPHER **Edward S. Curtis** TYPEFACES **Centaur and Redrawn Franklin Gothic Extra Condensed** PRINTER **Palace Press International** PAPER **140 gsm Woodfree** PUBLISHER **Bulfinch Press**

WILLIAM FAULKNER

THE NEW TESTAMENT

translated by

RICHMOND LATTIMORE

1 TITLE **Soldiers' Pay** AUTHOR **William Faulkner** JACKET/COVER ART DIRECTOR **Francine Kass** JACKET/COVER DESIGNER **Megan Wilson** PHOTOGRAPHERS **Mole & Thomas** TYPEFACE **Engravers** PUBLISHER **Liveright** 2 TITLE **The New Testament** TRANSLATOR **Richmond Lattimore** JACKET/COVER ART DIRECTOR **Michael Ian Kaye** JACKET/COVER DESIGNER **Chip Kidd** PHOTOGRAPHER **Andres Serrano** TYPEFACE **Times New Roman** PUBLISHER **North Point Press**

1 TITLE **Patient: The True Story of a Rare Illness** AUTHOR **Ben Watt** DESIGN FIRM **Grove Press In-House, New York, NY** JACKET/COVER DESIGNER **John Gall** PHOTOGRAPHER **Marcelo Krasilcic** PRINTER **Coral Graphics** PUBLISHER **Grove Press** 2 TITLE **The Woman and the Ape** AUTHOR **Peter Høeg** DESIGN FIRM **Farrar, Straus & Giroux, New York, NY** JACKET/COVER DESIGNER **Michael Ian Kaye** PHOTOGRAPHER **James Balog/Tony Stone Images** PUBLISHER **Farrar, Straus & Giroux**

Stories in the Worst Way

Gary Lutz's work has appeared in *The Quarterly, Conjunctions, StoryQuarterly, Cimarron Review,* and *The Random House Treasury of Light Verse.* He is the recipient of a 1996 fellowship from the National Endowment for the Arts. He lives in Pennsylvania.

Jacket photograph by Nola López
Jacket design by Archie Ferguson

Alfred A. Knopf, Publisher, New York
http://www.randomhouse.com/

11/96

Stories in the Worst Way

Gary Lutz

Knopf

ISBN 0-679-42596-9 FICTION

52100>

9 780679 425960

These crucial, often darkly hilarious arraignments and instigations place before us a parade of defectives and solitaries, all running through the heart's entire repertory in pursuit of a fitting catastrophe of the self.

In "Certain Riddances," a cordovanned and cuff-linked office crank pushes his way into a final round of interoffice harassments. The sour-mouthed teenager of "SMTWTFS" comes down with a case of pointed, retaliatory homosexuality. In "Devotions," an offcast from couplehood recounts, *in extremis,* the downturns of three desolating marriages. The word-shy apartment dweller of "Esprit de l'Elevator" lets himself out of his sleep just long enough to explain away his suspicious solitudes to his neighbors. In "Not the Hand but Where the Hand Has Been," a guilt-ravaged father pours the secrets of his grown daughter's life into the narrow columns of the index he is compiling on the cheap for a university-press book he is certain no one will ever read.

Rendered in an alert, unnerving prose that records every last catch in the voice, each of the thirty-six elegant perpetrations in Gary Lutz's debut volume helps us get wind of our lives—and puts forth a new kind of writing: hectoring, matterful, fearless, sometimes aggressively sidelong, always perilously original.

FPT U.S.A. $21.00
Canada $28.95

continued from front flap

Astonishing, inspiring, witty, and perverse, *Zeros + Ones* is a love song to Ada, a soundtrack for the next millennium, a radical revision of our technoculture that will forever change the way we perceive our digital world.

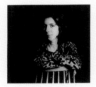

Sadie Plant is thirty-three. She received her Ph.D. from the University of Manchester, and is the author of *The Most Radical Gesture: The Situationist International in the Postmodern Age.* She has been a lecturer in cultural studies at the University of Birmingham and research fellow at the University of Warwick.

Visit Doubleday on the Web @ : http://www.bdd.com

jacket design: David J. High
author photo: Ming De Nasty

printed in the u.s.a.
1997

ADVANCE PRAISE FOR ZEROS + ONES

"ZEROS + ONES IS A BRILLIANT AND TERRIFICALLY SUSTAINED CYBERFEMINIST RANT: THE BEST AND MOST ORIGINAL BOOK I'VE YET READ ON THE HISTORY AND IMPLICATIONS OF UBIQUITOUS COMPUTATION."

}

WILLIAM GIBSON, AUTHOR OF NEUROMANCER

"SADIE PLANT HAS GIVEN US A WONDERFUL PIECE OF SCHOLARSHIP-CUM-INTUITION-CUM-INSPIRATION. SOLIDLY RESEARCHED AND GENUINELY INNOVATIVE, IT IS A BOOK THAT SHOWS US NOT ONLY WHERE WE HAVE BEEN BUT WHERE WE ARE GOING. I COULDN'T SEE IN THE NEW MILLENNIUM WITHOUT IT."
—PAT CADIGAN, AUTHOR OF SYNNERS AND FOOLS

" AS TECHNOLOGIES ENCROACH UPON EVERYDAY LIFE AND IDEOLOGIES MORPH INTO NEARLY UNRECOGNIZABLE FORMS, A FEMINIST PERSPECTIVE ON THE NEW MACHINE AGE IS INVALUABLE. AT ONCE HISTORICALLY GROUNDED AND EXUBERANTLY FUTURISTIC, SADIE PLANT TRACES WOMEN'S RELATIONSHIP TO COMPUTATIONAL DEVICES FROM THE INDUSTRIAL REVOLUTION TO THE INTERNET WITH PASSION AND PERCEPTION."
—MIKKI HALPIN, EDITOR OF STIM

US $23.95 / $32.95 CAN

ISBN 0-385-48260-4

52395

9 780385 482608

SADIE PLANT

ZEROS + ONES

zeros + ones

ZEROS + ONES + SADIE PLANT

DIGITAL WOMEN + THE NEW TECHNOCULTURE

DOUBLEDAY

$23.95 usa
$32.95 can

Not since *The Female Eunuch* has there been a book so radical in its scope, so persuasive in its detail, so exhilarating in its polemical energy. Beginning with Ada Lovelace and her unheralded contributions to Charles Babbage and his development of the Difference Engine, Sadie Plant traces the critical contributions women have made to the progress of computing. Shattering the myth that women are victims of technological change, *Zeros + Ones* shows how women and women's work in particular—weaving and typing, computing and telecommunicating—have been tending the machinery of the digital age for generations, the very technologies that are now revolutionizing the Western world.

In this bold manifesto on the relationship between women and machines, Sadie Plant explores the networks and connections implicit in nonlinear systems and digital machines. Steering a course beyond the old feminist dichotomies, *Zeros + Ones* is populated by a diverse chorus of voices—Anna Freud, Mary Shelley, Alan Turing—conceived as exploratory bundles of intelligent matter, emergent entities hacking through the constraints of their old programming and envisioning a postpatriarchal future.

continued on back flap

1 TITLE **Stories in the Worst Way** AUTHOR **Gary Lutz** DESIGN FIRM **Alfred A. Knopf, New York, NY** JACKET/COVER ART DIRECTOR **Carol Devine Carson** JACKET/COVER DESIGNER **Archie Ferguson** PHOTOGRAPHER **Nola López** TYPEFACES **Trade Gothic, Trade Gothic Bold Condensed** PUBLISHER **Alfred A. Knopf 2** TITLE **Zeros and Ones** AUTHOR **Sadie Plant** DESIGN FIRM **Doubleday, New York, NY** JACKET/COVER ART DIRECTOR **Amy King** JACKET/COVER DESIGNER **David J. High** TYPEFACE **Franklin Gothic Condensed** PRINTER **Miken** PAPER **100 lb. C/I/S** PUBLISHER **Doubleday**

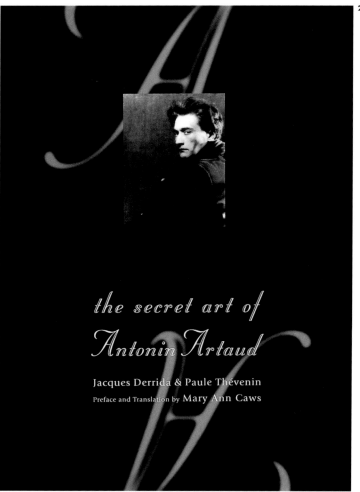

1 TITLE **Blind Pursuit** AUTHOR **Matthew F. Jones** DESIGN FIRM **Farrar, Straus & Giroux, New York, NY** JACKET/COVER ART DIRECTOR **Susan Mitchell** JACKET/COVER DESIGNER **Rodrigo Corral** PHOTOGRAPHER **Gary Powell** TYPEFACE **Trade Gothic** PRINTER **Phoenix Color** PUBLISHER **Farrar, Straus & Giroux** **2** TITLE **The Secret Art of Antonin Artaud** AUTHORS **Jacques Derrida and Paul Thévenin** DESIGN FIRM **The MIT Press, Cambridge, MA** JACKET/COVER DESIGNER **Ori Kometani** TYPEFACES **Stuyvesant, Giovanni** PRINTER **John P. Pow Company, Inc.** PAPER **S.D. Warren Lustro Gloss 80# Coated** PUBLISHER **The MIT Press**

1 TITLE **How, When, and Why Modern Art Came to New York** AUTHOR **Marius DeZayas** DESIGN FIRM **The MIT Press, Cambridge, MA** JACKET/COVER ART DIRECTOR **Jim McWethy** TYPEFACE **Geometric 415** PRINTER **Phoenix Color** PUBLISHER **The MIT Press** 2 TITLE **As Francesca** AUTHOR **Martha Baer** DESIGN FIRM **Broadway Books, New York, NY** JACKET/COVER DESIGNER **Roberto de Vicq de Cumptich** JACKET/COVER ILLUSTRATION **From a painting by Ingres** TYPEFACE **Meta** PRINTER **Jaguar** PAPER **Westvaco 80# Hibright** PUBLISHER **Broadway Books**

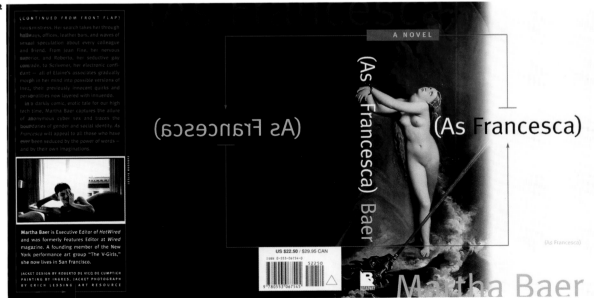

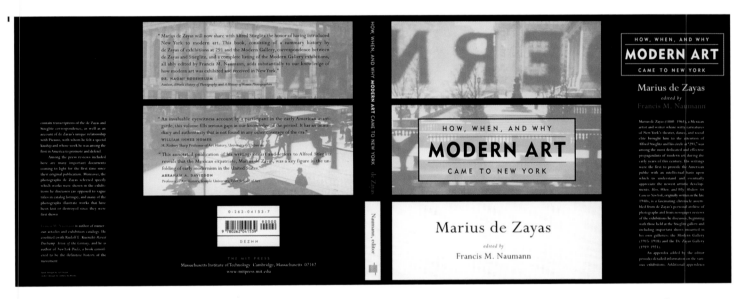

1 TITLE **Speaking Volumes/The World of the Book: Rethinking Design #3** EDITOR **Michael Bierut** DESIGN FIRM **Pentagram, New York, NY** JACKET/COVER ART DIRECTOR **Michael Bierut** JACKET/COVER DESIGNERS **Michael Bierut and Lisa Anderson** PRINTER **Peake Printer, Inc.** PAPER **Mohawk Options** PUBLISHER **Mohawk Paper Mills** 2 TITLE **Used and Rare** AUTHORS **Lawrence and Nancy Goldstone** DESIGN FIRM **Calvin Chu Design, New York, NY** JACKET/COVER ART DIRECTOR **Julia Kushnirsky** JACKET/COVER DESIGNER **Calvin Chu** PHOTOGRAPHER **Simon Lee** TYPEFACE **Mrs Eaves** PRINTER **Phoenix Color** PUBLISHER **St. Martin's Press**

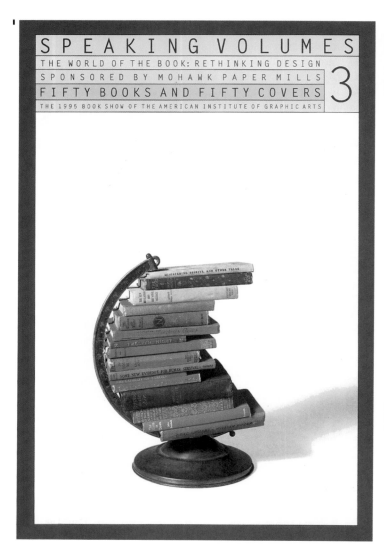

THE COLLECTED TALES OF
JOSEPH CONRAD

Edited by Samuel Hynes

"Conrad was the most consummate, the most engrossed, the most practical, the most common-sensible, and the most absolutely passionate man-of-action become conscious man-of-letters that this writer has ever known, read of, or conceived of."
— Ford Maddox Ford

Rooted in the seafaring tradition of story-telling, this superb assemblage of all nine of Joseph Conrad's tales–including *Heart of Darkness* and *Typhoon*–showcases his ability to transport the reader to unfamiliar sur-roundings. *The Collected Tales* displays the psychological complexity, clear narrative, and thrilling adventure that confirm Conrad not only as one of our most important writers, but also one of our most engaging. Edited and with an introduction by Samuel Hynes, and featuring a chronology of Conrad's life, as well as the author's own notes on the text, this is the most definitive collection of Joseph Conrad's tales available.

THE ECCO PRESS
100 West Broad Street
Hopewell, NJ 08525

Distributed by W.W. Norton & Company, Inc.
500 Fifth Avenue, New York, NY 10110

ISBN 0-88001-439-3

51800>

9 780880 014397

Cover designed by Foos Rowntree

Cover art *Seestücke* by Gerhard Richter, 1975

SAMUEL HYNES

The
COLLECTED TALES
of
JOSEPH CONRAD

ECCO

The
COLLECTED TALES
of
JOSEPH CONRAD

INCLUDES *Heart of Darkness*

EDITED BY SAMUEL HYNES

TITLE **The Collected Tales of Joseph Conrad** AUTHOR **Joseph Conrad** DESIGN FIRM **Foos Rowntree, New York, NY** JACKET/COVER CREATIVE DIRECTOR **Dirk Rowntree** PHOTOGRAPHER **Gerhard Richter** TYPEFACE **New Baskerville** PUBLISHER **The Ecco Press**

I TITLE **Spikes: Exploring the Neural Code** AUTHORS **Fred Reike, David Warland, Rob de Ruyter von Steveninck, William Bialek** DESIGN FIRM **The MIT Press, Cambridge, MA** JACKET/COVER DESIGNER **Jim McWethy** TYPEFACE **Geometric 415** PRINTER **Henry N. Sawyer Co.** PUBLISHER **The MIT Press** 2 TITLE **Push** AUTHOR **Sapphire** DESIGN FIRM **Alfred A. Knopf, New York, NY** JACKET/COVER ART DIRECTOR **Carol Devine Carson** JACKET/COVER DESIGNER **Archie Ferguson** TYPEFACES **Agency Gothic, Trade Gothic Bold Extended** PUBLISHER **Alfred A. Knopf**

1 Title **Boyhood** Author **J.M. Coetzee** Design Firm **Martin Ogolter Design, New York, NY** Jacket/Cover Art Director **Paul Buckley** Jacket/Cover Designer **Martin Ogolter** Photographer **Barbara Morgan** Typeface **Tera Cantante and Mrs Eaves** Printer **Coral Graphics** 2 Title **Battlefields and Playgrounds** Author **Janos Nyiri** Design Firm **Farrar, Straus & Giroux, New York, NY** Jacket/Cover Art Director **Michael Ian Kaye** Jacket/Cover Designer **Leslie Goldman** Photographer **Arthur Tress** Publisher **Farrar, Straus & Giroux**

1 TITLE **Porcelain: A Language of Their Own** AUTHOR **Chay Yew** DESIGN FIRM **Grove Press In-House, New York, NY** JACKET/COVER DESIGNER **Wendy Halitzer** PHOTOGRAPHER **Sky Bergman/Swanstock** TYPEFACE **New Caledonia** PRINTER **Castlereagh** PUBLISHER **Grove Press** 2 TITLE **The Theater and Its Double** AUTHOR **Antonin Artaud** DESIGN FIRM **Office of Paul Sahre, Brooklyn, NY** JACKET/COVER CREATIVE DIRECTOR **John Gall** JACKET/COVER DESIGNER **Paul Sahre** PHOTOGRAPHER **Man Ray** PRINTER **Castlereagh** PUBLISHER **Grove Press**

1 TITLE **Imaging Desire** AUTHOR **Mary Kelly** DESIGN FIRM **The MIT Press, Cambridge, MA** JACKET/COVER ART DIRECTOR **Jean Wilcox** PHOTOGRAPHER **Ray Barrie** TYPEFACE **Stone Sans** PUBLISHER **The MIT Press** 2 TITLE **A Parisian from Kansas** AUTHOR **Philippe Tapon** JACKET/COVER DESIGNER **Mary Ellen O'Boyle** PHOTOGRAPHER **Mark Steinmetz** TYPEFACE **Berthold Bodoni** PRINTER **Phoenix Color** PAPER **80 lb. Simpson C/I/S** PUBLISHER **Penguin USA (Dutton Imprint)**

1

2

PHILIPPE TAPON is a 28-year-old native Californian who has lived in Paris, Madrid, and London. He is currently working on his second novel.

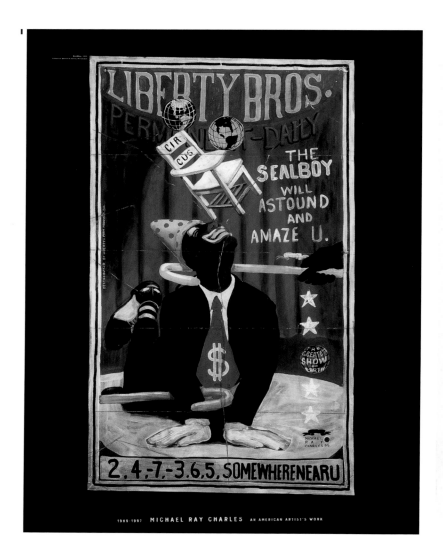

1 TITLE **Michael Ray Charles Exhibition Catalogue** AUTHOR **Marilyn Kern-Foxworth** DESIGN FIRM **Rigsby Design, Houston, TX** JACKET/COVER ART DIRECTOR **Lana Rigsby** JACKET/COVER DESIGNERS **Lana Rigsby and Amy Wolpert** ILLUSTRATOR **Michael Ray Charles** TYPEFACE **Stamp Gothic** PRINTER **H. MacDonald Printing** PAPER **Simpson Starwhite Vicksburg** **2** TITLE **Michael Ray Charles Exhibition Catalogue Envelope** AUTHOR **Marilyn Kern-Foxworth** DESIGN FIRM **Rigsby Design, Houston, TX** ART DIRECTOR **Lana Rigsby** DESIGNERS **Lana Rigsby and Amy Wolpert** ILLUSTRATOR **Michael Ray Charles** TYPEFACE **Stamp Gothic** PRINTER **H. MacDonald Printing** MATERIALS **Production Concrete Sack, Hand Stitched**

THE DEATH OF
SATAN

HOW AMERICANS HAVE
LOST THE SENSE OF EVIL

ANDREW DELBANCO

"Brilliant, passionate, erudite, and beautifully written. A stunning and moving ethical interpretation of . . . the concept of evil in American private and public life." —WENDY DONIGER, THE NEW YORK TIMES BOOK REVIEW

A SINGLE SHOT MATTHEW F. JONES

1 TITLE **The Death of Satan** AUTHOR **Andrew Del Banco** DESIGN FIRM **Farrar, Straus & Giroux, New York, NY** JACKET/COVER ART DIRECTOR **Michael Ian Kaye** JACKET/COVER DESIGNER **Rodrigo Corral** ILLUSTRATOR **Donna Mehalko** TYPEFACE **Futura** PRINTER **Phoenix** PUBLISHER **Farrar, Straus & Giroux** 2 TITLE **A Single Shot** AUTHOR **Matthew F. Jones** DESIGN FIRM **Farrar, Straus & Giroux, New York, NY** JACKET/COVER DESIGNER **Michael Ian Kaye** PUBLISHER **Farrar, Straus & Giroux**

1 TITLE **Writing History** AUTHOR **A.T. Cross Company** DESIGN FIRM **Philidor Company, Jamaica Plain, MA** JACKET/COVER DESIGNER **Scott-Martin Kosofsky** PHOTOGRAPHERS **Rolf Knudsen, Warren Jagger, Bob Young** TYPEFACE **Philidor Bell** PRINTER **Nimrod Press** PAPER **100# Westvaco Sterling Gloss** PUBLISHER **A.T. Cross Company 2** TITLE **Making It Real** AUTHORS **Luc Sante and Vik Muniz** DESIGN FIRM **Matsumoto Inc., New York, NY** JACKET/COVER DESIGNER **Takaaki Matsumoto** PHOTOGRAPHERS **Various** TYPEFACE **Univers** PRINTER **Hull Printing** MATERIAL **Mylar (Mirriboard)** PUBLISHER **Independent Curators Incorporated**

1 TITLE **Objects of Desire: The Modern Still Life** AUTHOR **Margit Rowell** DESIGN FIRM **Design Writing Research, New York, NY** JACKET/COVER DESIGNER **J. Abbott Miller** TYPEFACES **Mrs Eaves, Grotesque (Monotype)** PRINTER **Amilcare Pizzi** PUBLISHER **The Museum of Modern Art (New York)** 2 TITLE **The Book of Lamentations** AUTHOR **Rosario Castellanos** DESIGN FIRM **Drenttel Doyle Partners, New York, NY** JACKET/COVER CREATIVE DIRECTOR **Stephen Doyle** JACKET/COVER GRAPHIC DESIGNER **Gary Tooth** PHOTOGRAPHER **Stephen Doyle** TYPEFACE **Sabon** PRINTER **Coral Graphics** CLIENT **Marsilio**

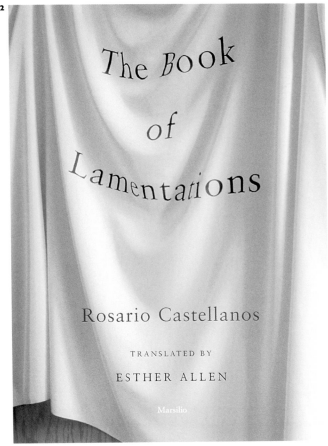

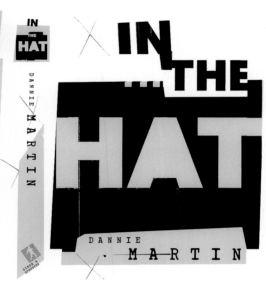

1 TITLE **In the Hat** AUTHOR **Dannie Martin** DESIGN FIRM **Simon & Schuster, New York, NY** JACKET/COVER ART DIRECTOR **Michael Accordino** JACKET/COVER DESIGNER **John Gall** PRINTER **Phoenix Color** PAPER **80# White Stock, Coated One Side** PUBLISHER **Simon & Schuster** 2 TITLE **Raymond Chandler: A Biography** AUTHOR: **Tom Hiney** DESIGN FIRM **Grove Press In-House, New York, NY** JACKET/COVER DESIGNER **John Gall** PUBLISHER **Grove/Atlantic**

1 TITLE **A Neutral Corner** AUTHOR **A. J. Liebling** DESIGN FIRM **Farrar, Straus & Giroux, New York, NY** JACKET/COVER ART DIRECTOR **Michael Ian Kaye** JACKET/COVER DESIGNER **Rodrigo Corral** ILLUSTRATION **Courtesy of the International Veteran Boxers Assoc.** TYPEFACE **M Headline** PRINTER **Phoenix Color** PUBLISHER **Farrar, Straus & Giroux 2** TITLE **The Writers' Game** AUTHOR **Richard Orodenker** DESIGN FIRM **Calvin Chu Design, New York, NY** JACKET/COVER ART DIRECTOR **Lisa Chornick** JACKET/COVER DESIGNER **Calvin Chu** TYPEFACES **Xeroxed Versions of Edition Sans, Times, and Fette Fraktur** PRINTER **Phoenix Color** PUBLISHER **Twayne**

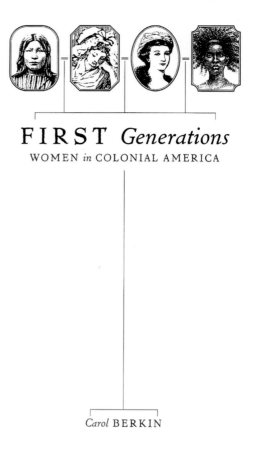

1 TITLE **Couplings** AUTHOR **Peter Schneider** DESIGN FIRM **Office of Paul Sahre, Brooklyn, NY** JACKET/COVER CREATIVE DIRECTOR **Michael Ian Kaye** JACKET/COVER DESIGNER **Paul Sahre** ILLUSTRATOR **Paul Sahre** TYPEFACE **Matrix Script** PRINTER **Phoenix Color** PUBLISHER **Farrar, Straus & Giroux** 2 TITLE **First Generations** AUTHOR **Carol Berkin** DESIGN FIRM **Leah Lococo Ltd., New York, NY** JACKET/COVER ART DIRECTOR **Michael Ian Kaye** JACKET/COVER DESIGNER **Leah Lococo** TYPEFACES **Cloister and Pabst** PUBLISHER **Farrar, Straus & Giroux**

1 TITLE **Monogamy** AUTHOR **Adam Phillips** DESIGN FIRM **Pantheon Books, New York, NY** JACKET/COVER ART DIRECTOR **Marjorie Anderson** JACKET/COVER DESIGNER **Kathleen DiGrado** TYPEFACE **Mantinia** PRINTER **Coral Graphics** PAPER **Tomahawk Cool White 50#** PUBLISHER **Pantheon Books** **2** TITLE **American Aurora** AUTHOR **Richard N. Rosenfeld** DESIGN FIRM **St. Martin's Press, New York, NY** JACKET/COVER DESIGNER **Henry Sene Yee** TYPEFACE **Caslon 224** PRINTER **Phoenix Color** PAPER **Hopper 60# Skytone** PUBLISHER **St. Martin's Press**

1

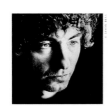

ADAM PHILLIPS is the author of *Winnicott; On Kissing, Tickling, and Being Bored; On Flirtation;* and *Terror and Experts.* Formerly the principal child psychotherapist at Charing Cross Hospital in London, he lives in England.

Jacket design by Kathleen DiGrado

PANTHEON BOOKS, NEW YORK

http://www.randomhouse.com/

1/97 Printed in the U.S.A. © 1997 Random House, Inc.

ISBN 0-679-44264-2

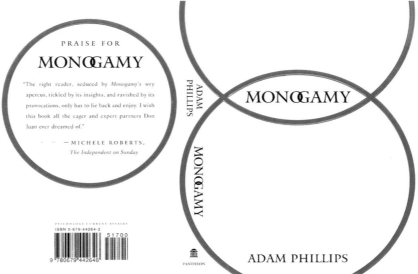

PRAISE FOR

MONOGAMY

"The right reader, seduced by *Monogamy*'s wry apercus, tickled by its insights, and ravished by its provocations, only has to lie back and enjoy. I wish this book all the eager and expert partners Don Juan ever dreamed of."

— MICHELE ROBERTS,
The Independent on Sunday

MONOGAMY

ADAM PHILLIPS

MONOGAMY

ADAM PHILLIPS

$17.00 U.S.A.
$23.50 Can.

All the present controversies about the family are really discussions about monogamy. About what keeps people together and why they should stay together. In this book of one hundred and twenty-one aphorisms, Adam Phillips asks why we all believe in monogamy, and why we find it so difficult to think about it.

Everyone knows that most people, however much they may love their partner, are capable of loving and desiring more than one person at a time. It may be reassuring, but it is in fact very demanding (and often cruel) to assume that only one other person can give us what we want.

At least in sexual matters, sharing seems to go deeply against the grain. Monogamy is so much taken for granted as the foundation of the family and of family values that, as with anything that seems essential, we are very wary of being critical of it. But as Phillips suggests, it is surely worth wondering why the faithful couple has such a hold on our imagination, and how it has come to be such an ideal.

2

(continued from front flap)

our country, could only dream. Revisionist, daring, and brilliantly conceived, this is a work of enormous power that indisputably rewrites the early history of our nation and champions the civil liberties on which the country was founded.

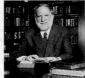

Born in Boston in 1941, the son and grandson of printers, RICHARD NEIL ROSENFELD is an independent scholar who lives in Chestnut Hill, Massachusetts. He holds degrees from Yale, Columbia, and Boston Universities, is a Councillor at the American Antiquarian Society, and is an Associate Fellow at Yale's Timothy Dwight College.

JACKET DESIGN BY HENRY SENE YEE

St. Martin's Press
175 Fifth Avenue, New York, N.Y. 10010
Distributed by McClelland & Stewart Inc. in Canada.
PRINTED IN THE U.S.A.

PRAISE FOR *AMERICAN AURORA*

"A magnificent achievement, *American Aurora* is both an original work of history and a rousing good story. The stirring emotions, the fiery arguments, and the mundane concerns of the people who lived through the early days of the Republic will be much better understood by the publication of this remarkable book."
—DORIS KEARNS GOODWIN, winner,
1995 Pulitzer Prize in History; author, *No Ordinary Time*

"No book has ever depicted more vividly America's crisis of freedom of the 1790s, the struggle that gave meaning for the first time to America's commitment to freedom of expression. *American Aurora* is essential reading for all who care about freedom in America."
—BENNO C. SCHMIDT, Jr., President, Yale University, 1986-92

"A piece of historical heresy, written by heretics of the time with the assistance of a kindred spirit ... If eternal vigilance is the price of liberty, its vigilant defenders of an earlier time may still have a message for the republic they cherished. That message resounds through these pages."
—EDMUND S. MORGAN, author, *The Birth of the Republic*

"An extraordinary story of our democratic freedoms that fundamentally alters how we view the country's beginnings. Every American must read this book."
—IRA GLASSER, Executive Director, American Civil Liberties Union

"A work of history as stirring as any work of fiction, *American Aurora* makes me think that the great American novel may not be a novel after all."
—LESLIE EPSTEIN, author, *King of the Jews*

"Professional historians and the general public will be equally surprised by what they find in *American Aurora*. This is a remarkable work."
—RICHARD D. BROWN, Professor of History,
University of Connecticut

ISBN 0-312-15052-0

AMERICAN AURORA

RICHARD N. ROSENFELD

ST. MARTIN'S PRESS

200 YEARS AGO
a Philadelphia newspaper claimed George Washington wasn't the "father of his country." It claimed John Adams really wanted to be king. Its editors were arrested by the federal government. One editor died awaiting trial.

THE STORY OF THIS NEWSPAPER IS THE STORY OF AMERICA

AMERICAN AURORA

A DEMOCRATIC-REPUBLICAN RETURNS

RICHARD N. ROSENFELD
FOREWORD BY EDMUND S. MORGAN

ISBN 0-312-15052-0 $39.95
$53.99 Can.

One of the most original and radical works of American history in recent years, *American Aurora* is the absorbing story of the nation's leading opposition newspaper from 1790 through 1800.

Richard Rosenfeld's dramatic epic traces the incendiary history of the young American nation in the 1790s, and chronicles the birth and near-death of civil liberties in that turbulent decade. Rosenfeld, who has exhaustively examined the *Philadelphia Aurora*, has chosen as his heroes its two young editors, Benjamin Bache, Benjamin Franklin's grandson, and William Duane, who fearlessly waged a decade-long campaign to keep America's Founding Fathers true to their original mission. They claimed that George Washington was not the true "father of his country," but a completely incompetent commander-in-chief; and that John Adams, his presidential successor, wanted a monarchy and was plotting to be king. As a result of their inflammatory articles, both editors were arrested. Bache died awaiting trial, and the paper was briefly silenced. Nonetheless, the *Aurora* was eventually successful in persuading the nation to oust Adams and to usher in a Jeffersonian democracy, of which Benjamin Franklin, the true father of ...
(continued on back flap)

1

BRIAN COLLINS teaches English at Cate School in California.

When in Doubt, Tell the Truth features 700 of the very best of Mark Twain's comments on the human and American conditions. Candid and colloquial, Twain's insights remain valuable to today's America as well.

On optimism: "There is no sadder sight than a young pessimist, except an old optimist."

On truth: "Truth is mighty and will prevail. There is nothing the matter with this, except that it ain't so."

On Congress: "Suppose you were an idiot. And suppose you were a member of Congress. But I repeat myself."

On taxes: "We've got so much taxation. I don't know of a single foreign product that enters this country untaxed except the answer to prayer."

On adversity: "By trying we can easily learn to endure adversity. Another man's, I mean."

On golf: "Golf is a good walk spoiled."

On the classics: "A classic—something that everybody wants to have read and that nobody wants to read."

On power: "The Autocrat of Russia possesses more power than any other man in the earth; but he cannot stop a sneeze."

On jokes: "The only way to classify the majestic ages of some of those jokes was by geologic periods."

COLUMBIA UNIVERSITY PRESS
New York

Jacket design: Teresa Bonner
Printed in U.S.A.

ISBN 0-231-10498-3

WHEN IN DOUBT, TELL THE TRUTH *and other* QUOTATIONS *from* MARK TWAIN

TWAIN • WHEN IN DOUBT, TELL THE TRUTH

COLUMBIA

EDITED BY BRIAN COLLINS

Mark Twain is one of the most beloved figures in American history, and one of its most gifted storytellers and critics; through his novels, essays, and his letters, he is probably one of the most quoted Americans of all time. *When in Doubt, Tell the Truth* perfectly captures the essence of Twain's unique gifts—the dark humor, the wry observations, and the keen insight into social and political realities, both particularly American and broadly human.

When in Doubt, Tell the Truth is an extraordinary collection of more than 700 of Twain's most memorable aphorisms, from his jokes—"What is the difference between a taxidermist and a tax collector? The taxidermist only takes your skin."—to his darker musings—"Man is the only animal that blushes. Or needs to." It celebrates Twain's gift for telling a story, and gives us his views on over 400 topics, including Adam and Eve, fountain pens, procrastination, gullibility, grammar, and politics.

In an eloquent introduction, Brian Collins surveys Twain's concerns as a writer and speaker, integrating the witty maxims of his early career with the darker observations of his later life. An easy-to-navigate collection arranged alphabetically by subject, *When in Doubt, Tell the Truth* brings the wisdom of Mark Twain to a contemporary audience.

2

[continued from front flap]

fearing scandal or professional censure. Baur brings uncommon empathy to their dilemma, whether they are male or female, patient or therapist.

In fact, as she shows, feelings of love and attraction do not disappear simply because they are forbidden. Describing the famous and infamous liaisons of such figures as Carl Jung, Anton Mesmer, Otto Rank, and others, Baur offers irrefutable evidence that intimacy has played a part in therapy since the beginning and continues to barge in despite regulations to suppress it. With a plea for common sense and open-minded discussion, she makes a powerful argument for confronting this issue in all its complexity, so that everyone who enters therapy — or is already in it — will be prepared to manage the risks of the intimate hour.

SUSAN BAUR, PH.D., is a clinical psychologist. She is the author of *Confiding: A Psychotherapist and Her Patients Search for Stories to Live By*; *The Dinosaur Man: Tales of Madness and Enchantment from the Back Ward*; and *Hypochondria: Woeful Imaginings*. She lives in New England.

JACKET DESIGN □ DAVID L. HIGH
JACKET PHOTOGRAPH □ CHRISTINE RODIN
AUTHOR PHOTOGRAPH □ ROBERT E. McCLOREY

Houghton Mifflin Company
222 Berkeley Street, Boston, Massachusetts 02116

ISBN 0-395-82284-X

9 780395 822845

90000

641270

BAUR

PRAISE FOR
THE INTIMATE HOUR: LOVE AND SEX IN PSYCHOTHERAPY

"Dr. Baur has written a remarkable book: wise, courageous, and timely — a book desperately needed at a time when the foundations of the intimate therapeutic hour are so threatened by the managed care juggernaut."
— Irvin D. Yalom, M.D., author of *Love's Executioner and Other Tales of Psychotherapy* and *Lying on the Couch*

"Reading Susan Baur's sane, moral book is like breathing fresh air in a room filled largely with exploitation and indifference on the one hand, hysteria and rigidity on the other, and dishonesty and silencing everywhere. Bravo for such common sense and real wisdom."
— The Reverend Carter Heyward, Ph.D., author of *When Boundaries Betray Us*

"This gracefully written, thought-filled book is a wonderful contribution to a discussion that has been burdened by black-and-white thinking."
— John K. Pearce, M.D., coauthor of *Exiles from Eden: Psychotherapy from an Evolutionary Perspective*

"Freud said life consists of love and work. If therapy is to be alive, it must entail both, and Susan Baur shows that it always does."
— J. Allan Hobson, M.D., professor of psychiatry, Harvard Medical School, and author of *The Chemistry of Conscious States*

"As viscerally engaging as it is intellectually challenging. A rare combination of historical research, case study, and even confession inform and enlarge this account of the long suppressed topic of sexual love and, yes, its tenacious and complex place in psychotherapy."
— Lauren Slater, author of *Welcome to My Country: A Therapist's Memoir of Madness*

the intimate hour

the intimate hour
LOVE AND SEX IN PSYCHOTHERAPY
SUSAN BAUR

HOUGHTON MIFFLIN

$23.95

"A REMARKABLE BOOK: WISE, COURAGEOUS AND TIMELY."
—IRVIN D. YALOM, M.D.

"How do two people sit across from each other in therapy, becoming closer and more intimate by the hour, without sometimes giving in to the full and natural expression of love? What happens when they do?" When Susan Baur set out to address these difficult questions, she found herself confronting powerful taboos. While many patients and even some therapists privately admitted to intimate feelings for each other, their stories went untold, silenced by prohibitions both legal and moral. Bringing supreme rationality to this explosive subject, Baur allows both sides to speak out for the first time, revealing the surprising spectrum of experience and feeling encountered when love slips into the therapy hour.

Drawing on hundreds of instances of mutual attraction, from historical annals to interviews with therapists, patients, and clergy, Baur shows that the stories to be told are rarely simple ones. Certainly there are clear-cut cases of abuse — and Baur is unequivocal in stating that sex has absolutely no place in therapy. But abusive relationships in fact make up only a small fraction of cases. Much more often, people find themselves occupying a gray area of emotion. There are those who are lovestruck, enamored of the attention they find for the first time. There are those who feel an overwhelming sympathy that they believe is reciprocal. And sometimes there are those who are really, truly in love. But whatever their feelings are labeled, these people are left with nowhere to turn for advice or help.

0397 [continued on back flap]

1 TITLE **When in Doubt, Tell the Truth** AUTHOR **Mark Twain** DESIGN FIRM **Columbia University Press, New York, NY** JACKET/COVER ART DIRECTOR **Linda Secondari** JACKET/COVER DESIGNER **Teresa Bonner** TYPEFACES **Snell, Serlio, and Galliard** PRINTER **Coral Graphics** PUBLISHER **Columbia University Press** **2** TITLE **The Intimate Hour** AUTHOR **Susan Baur** DESIGN FIRM **High Design, New York, NY** JACKET/COVER ART DIRECTOR **Michaela Sullivan** JACKET/COVER DESIGNER **David High** PHOTOGRAPHER **Christine Rodin** TYPEFACE **Caslon** PRINTER **Henry N. Sawyer** PUBLISHER **Houghton Mifflin**

336 FIFTY BOOKS/FIFTY COVERS OF 1996

1 TITLE **Elizabeth** AUTHOR **Sarah Bradford** DESIGN FIRM **Farrar, Straus & Giroux, New York, NY** JACKET/COVER DESIGNER **Michael Ian Kaye** PHOTOGRAPHER **Cecil Beaton** PUBLISHER **Farrar, Straus & Giroux** 2 TITLE **The Sense of Reality** AUTHOR **Isaiah Berlin** DESIGN FIRM **Farrar, Straus & Giroux, New York, NY** JACKET/COVER DESIGNER **Rodrigo Corral** TYPEFACE **Bauer Bodoni** PRINTER **Phoenix Color** PUBLISHER **Farrar, Straus & Giroux**

1 TITLE **Coyote v. Acme** AUTHOR **Ian Frazier** DESIGN FIRM **Farrar, Straus & Giroux, New York, NY** JACKET/COVER ART DIRECTOR **Michael Ian Kaye** JACKET/COVER DESIGNER **Chip Wass** ILLUSTRATOR **Chip Wass** TYPEFACE **Hand-Designed** PRINTER **Phoenix Color** PUBLISHER **Farrar, Straus & Giroux** 2 TITLE **The Giant's House** AUTHOR **Elizabeth McCracken** DESIGN FIRM **Michael Ian Kaye, Brooklyn, NY** JACKET/COVER DESIGNER **Michael Ian Kaye** PUBLISHER **The Dial Press**

1 TITLE **Suspicion** AUTHOR **Robert McCrum** DESIGN FIRM **Poulin + Morris, New York, NY** JACKET/COVER ART DIRECTOR **L. Richard Poulin** PHOTOGRAPHER **Susan Alinsangan/Graphistock** TYPEFACES **Bauer Bodoni, Rotis Sans** PRINTER **Haddon Printing** PAPER **Squire Antique** PUBLISHER **W. W. Norton & Co., Inc.** 2 TITLE **Payback** AUTHOR **Thomas Kelly** DESIGN FIRM **Alfred A. Knopf, New York, NY** JACKET/COVER ART DIRECTOR **Carol Devine Carson** PHOTOGRAPHER **Joyce Ravid** TYPEFACE **Alternate Gothic FC** PRINTER **Coral Graphics**

1

2

1996–1997 AIGA Conferences

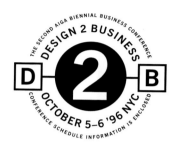

D E S I G N

Design 2 Business

The Second Biennial
AIGA Business Conference

October 5–6, 1996
New York, New York

2

The AIGA's Design 2 Business (D2B) conference was intended to help design professionals develop robust strategies to thrive in — not just survive — the balance of the 1990s and prepare for the century's turn. The fast-paced two-day program addressed the critical need for business intelligence as it pertains to the practice of design as a business; the process of designing for business; and the design profession's need to develop long-term alliances with business. D2B was one element in the AIGA's long-term strategy of helping designers become increasingly effective in solving the problems that face their clients — by improving their understanding of the challenges of business and mastering the challenges of the modern professional corporation. The AIGA's next biennial business conference will be held in New York City in the fall of 1998.

B U S I N E S S

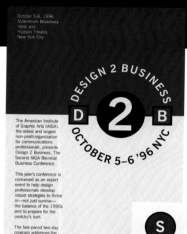

October 5-6, 1996
Millennium Broadway
Hotel and
Hudson Theatre
New York City

The American Institute of Graphic Arts (AIGA), the oldest and largest non-profit organization for communications professionals, presents Design 2 Business, The Second AIGA Biennial Business Conference.

This year's conference is conceived as an expert event to help design professionals develop robust strategies to thrive in—not just survive—the balance of the 1990s and to prepare for the century's turn.

The fast-paced two-day program addresses the critical need for business intelligence as it pertains to the practice of design as a business; the process of designing for business; and the design profession's need to develop long-term alliances with business.

S P E A K E R S

Aubrey Balkind
Founder and CEO of Frankurt Balkind Partners, New York, NY
Leads one of the largest and most innovative strategic communications agencies that integrate identity, design, advertising, and new media. Balkind is the recipient of the 1996 Ernst & Young Entrepreneur of the Year award.

Kenneth Carbone
Creative Director and Principal, Carbone Smolan Associates, New York, NY
Well known for work in the areas of brand identity, information systems, print, exhibitions, and architectural graphics, including projects for the Louvre, the Museum of Modern Art, Sotheby's, PBS, Bettman, Putnam Investments, and the World Bank (Washington, D.C.). Along with partner Leslie Smolan, developed graphics and merchandising program for Ken Burn's film Baseball and designed an international display system for Tiffany & Co. Recently completed a prototype store for the London retailer HMV.

Denise Caruso
Columnist, New York Times; Executive Producer, Spotlight; Contributing Editor, MSNBC's "The Site"
Longtime analyst and observer of the industries of digital technology and interactive media. Writes the Digital Commerce column for the New York Times; is executive producer of Spotlight, an executive conference for the interactive media industry; and a contributing editor for "The Site," produced by Ziff-Davis Television, which appears nightly on MSNBC. Launched (in 1994) Technology & Media Group, and information services company, for Norman Pearlstine's Friday Holdings. Previously, founding editor of Digital Media, then acclaimed as the seminal newsletter in the emerging new media industry, published by Seybold Publications. An early advocate of First Amendment rights in cyberspace, and one of the first journalists to focus on technology, commerce, and culture. Essays and analysis published in the Wall Street Journal, Wired and the Utne Reader. Served on the board of directors of the Electronic Frontier Foundation, and elected to the board of the Institute for Alternative Journalism in January 1995. Holds a BA in English from California

Polytechnic State University in San Luis Obispo, Calif. Lives and works in San Fransisco.

Dr. Pehong Chen
President, Chairman, CEO, and founder of Broadvision, Inc., Los Altos, CA
Developer of the first application system for dynamic, personalized marketing and selling on the Internet. The system is capable of transforming static websites into interactive community brands, virtual malls, or value-added services, enabling businesses to build long-term relationships with customers through personalized content, services and promotions.

Bob Clyatt
Executive Partner, i/o 360, New York, NY
Coordinates finance/accounting, marketing, and strategic planning as a counterpart to the four design partners' strengths. Educated at MIT (SM 1985) University of California Berkeley (AB 1980), and London School of Economics. Board member of the MIT Enterprise Forum of New York and co-author of Catalyst for Growth (John Wiley and Sons), an entrepreneur's guide with case studies of successful growth companies, due in the fall of 1996.

FrAsEr PAperS' festIVaL oF stUDent tALeNT

sTudeNt PoRtfOLio DIspLaY

StuDeNt rec

stUdeNt mEdaLLioN winNeRs

genERaTion eX-trAordiNaRY

An insTitUTe oF GrapHIC artS

Jambalaya!

The Design of Culture
Meets the Culture of Design

November 13–16, 1997
New Orleans, Louisiana

New Orleans is the American melting pot at a rolling boil, where French, British, Spanish, African American, and Native American cultures have combined to create breakthroughs in music, art, literature, and food. What better place for 2,000 of the country's best graphic designers to meet, talk, eat, drink, dance, argue, think, and learn how our work affects the world and how the world affects their work? Eighty presenters — designers and filmmakers, architects and chefs, journalists and cyberjockeys, moderated by John Hockenberry, network correspondent of NCB News — mixed it up in a memorable four-day stew. The AIGA's next national design conference will be held in Las Vegas in the fall of 1999.

J A M B A L A Y A !

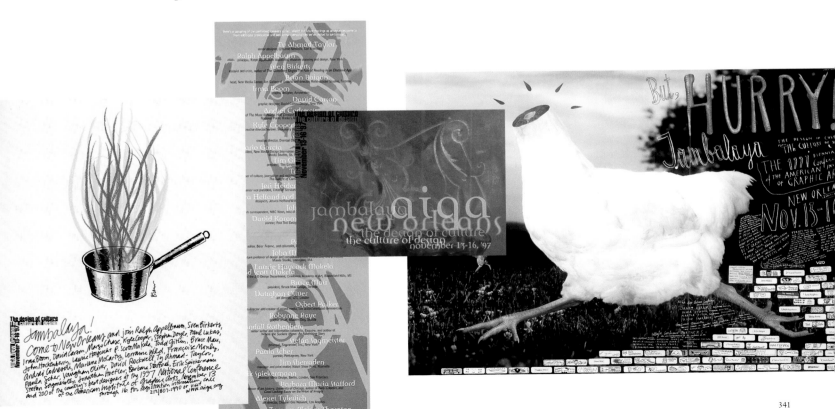

V S I

1996–1997 Visiting Exhibitions at the AIGA

Champion Alphabets Poster Auction
December 5, 1996
The Strathmore Gallery at the AIGA
Exhibition sponsored by Champion International
Twenty-six posters of alphabet letters, signed by the twelve
artists who designed them, were offered in silent auction,
with all proceeds going to the AIGA Capital Campaign.

American Center for Design 100 Show
December 11–30, 1996
The Strathmore Gallery at the AIGA
Exhibition sponsored by the American Center for Design
This exhibition recognizes work that represents significant
trends in communication design. Unlike most AIGA com-
petitions, the selection process is not by consensus: each
juror chooses work independently.

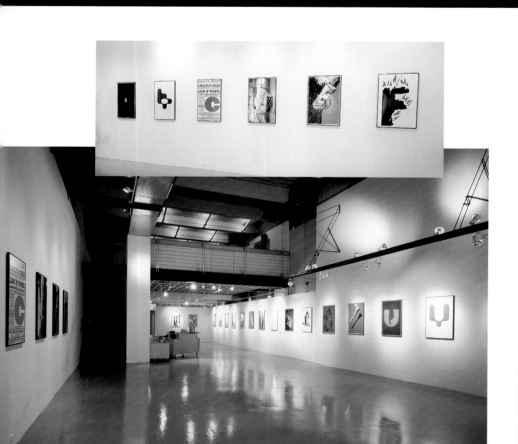

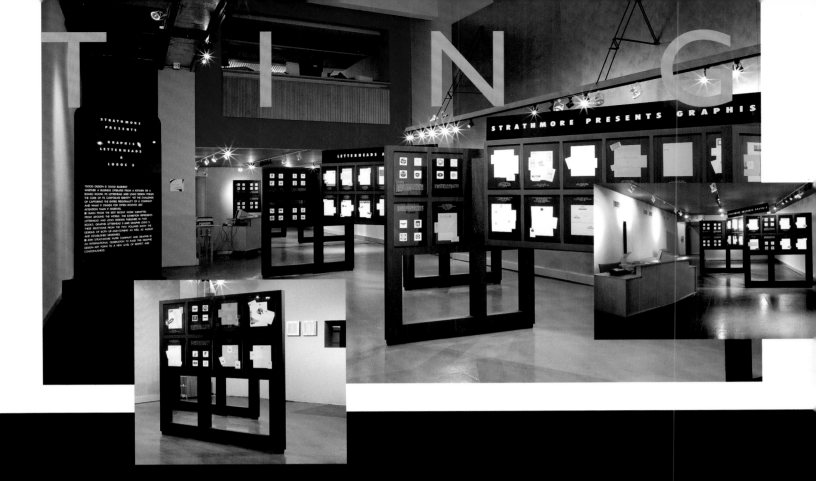

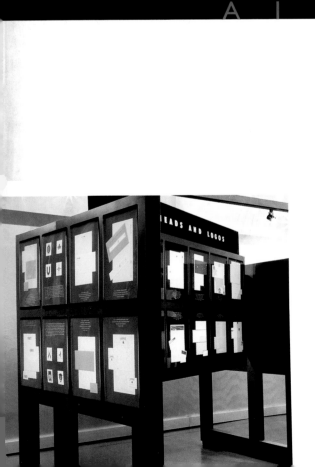

Strathmore/Graphis Letterhead Show
March 19–April 4, 1997
The Strathmore Gallery at the AIGA
Exhibition sponsored by Strathmore Papers
An exhibition of award-winning letterheads and
logos from Graphis.

I.D. Magazine 43rd Annual Design Review
August 13–September 26, 1997
Exhibition design and photography by The Rockwell Group
Exhibition sponsored by I.D. Magazine
An exhibition of the winners of I.D. Magazine's 43rd annual
design review and interactive media design review.

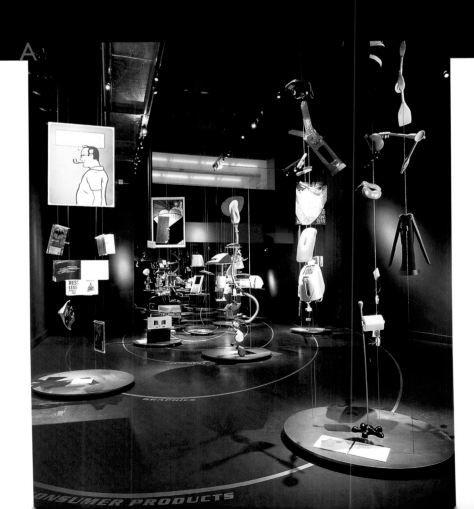